ITALIAN ART
1250–1550

Books by Bruce Cole

ITALIAN ART 1250–1550

THE RENAISSANCE ARTIST AT WORK

SIENESE PAINTING FROM ITS ORIGINS
TO THE FIFTEENTH CENTURY

SIENESE PAINTING IN THE AGE
OF THE RENAISSANCE

MASACCIO AND THE ART OF
EARLY RENAISSANCE FLORENCE

GIOTTO AND FLORENTINE PAINTING 1280–1375

AGNOLO GADDI

ITALIAN ART

1250–1550

The Relation of Renaissance Art to Life and Society

BRUCE COLE

ICON EDITIONS

1817

HARPER & ROW, PUBLISHERS, New York
Grand Rapids, Philadelphia, St. Louis, San Francisco
London, Singapore, Sydney, Tokyo, Toronto

Designer: C. Linda Dingler

Library of Congress Cataloging-in-Publication Data

Cole, Bruce, 1938–
 Italian art 1250–1550.

 (Icon editions)
 Bibliography: p.
 Includes index.
 1. Art, Italian. 2. Art, Renaissance—Early
Renaissance—Italy. I. Title.
N6915.C6 1987 709'.45 86-45087
ISBN 0-06-430904-5 87 88 89 90 91 10 9 8 7 6 5 4 3 2 1
ISBN 0-06-430162-1 (pbk.) 99 RRD-H 20 19 18 17 16 15 14 13 12 11

For Richard and Neil Cole
and
To the Memory of Judith Hook

CONTENTS

ILLUSTRATIONS

*The number in italics refers to the
page on which the illustration appears.*

ILLUSTRATIONS

ILLUSTRATIONS

ACKNOWLEDGMENTS

Many people have helped with this book, and it is a pleasure to thank them publicly: Doreen, Stephanie, and Ryan resolutely aided and endured during research and writing; Heidi Gealt always said it was possible; Barry Gealt and Peter and Julia Bondanella lent support and knowledge; Linda Baden gave counsel and helped with the words. The office of Research and Graduate Development of Indiana University furnished some much-needed funds. I am also beholden to Helen Ronan, James Czarnecki, Gus Medicus, Gloria Middeldorf, Gwen Gulliksen, Diane Vatne, Leslie Schwartz, and especially Bitite Vinklers and Pamela Jelley. At Harper & Row I was again privileged to work with Cass Canfield, Jr., that most encouraging and sympathetic of editors.

During the not always unpleasant task of writing I have often remembered words written by John Pope-Hennessy some twenty-five years ago:

With industry, method and average intelligence, it is comparatively easy to produce a mammoth volume in which footnote is piled on footnote and fact on fact. It is infinitely harder to achieve a distillation which deals only with essentials and which is addressed to all the faithful and not simply to one sect.

INTRODUCTION

Most of the books written on the history of Italian Renaissance art place the works of individual artists in chronological sequence and then arrange the artists by date. This organization helps us understand a certain linear development, and it makes orderly the large numbers of surviving Renaissance paintings and sculpture.

Such an arrangement, however, distorts as much as it clarifies, for it imposes a framework upon the works alien to the way Renaissance artists and patrons regarded the paintings and sculpture they made and bought. In truth, most Renaissance artists thought little about the chronology, the stylistic influences, and the progressions of style and content with which we now burden their work. Instead, they thought about type and function. As they considered the commission at hand, they attempted to fulfill all the many requirements of type and function necessary and traditional for the object they were about to make.

How did this process work? Let us hypothesize that an artist—the Florentine Sandro Botticelli, for example—was commissioned by an important family of his city to paint a panel [1].

As he thought about the work, Botticelli probably first considered the type of object commissioned—in this case a *spalliera*, a popular type of Renaissance painting usually destined for insertion in the paneling of a room in a large home. A *spalliera* had a specific function, form, and size; in fact, almost all the paintings and sculptures which survive from the Renaissance can be classified by type. Today most art is decorative, philosophical, aesthetically interesting, or novel; but in the vast majority of cases it is not made as a certain well-defined type with a specific purpose in mind.

This was not true in Botticelli's time. The *spalliera*, for instance, usually had a specific shape (rectangular), a specific location (a room in a Renaissance palazzo), and a specific range of mythological subject matter. Even the artist's composition and style often were adjusted to the type at hand.

So, when Botticelli began to ponder his commission, he recalled the *spalliere* he knew. He considered the shape, style, and

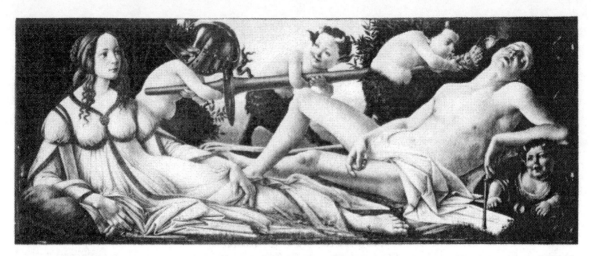

1. Botticelli, *Venus and Mars*, National Gallery, London. Botticelli's *Venus and Mars* contains a vein of humor absent in more serious expositions of the subject. The waiting Venus and the scampering satyrs playing at battle with Mars's armor and lance all gently mock the flaccid god of war, who is too exhausted to care.

subject traditionally associated with the type. Perhaps he did think about the commission in relation to his past work and the position it would hold in the history of art, but even so, these considerations would be subsumed to the requirements of the commission. The basic idea of the work, its foundation and conception, was generated through consideration of type and function rather than through chronological sequence. The evanescent stages of development we look for in the work of modern artists have little application in the Renaissance, where artistic change was rarely linear and was almost never rapid. Nor did the history of art play the important role it does in the works of today's artists, who are extremely conscious of the past.

Renaissance art was made to order. There were no art galleries, because the concept of art made without commission, without function, and without a designated location had not yet developed. Almost all Renaissance art resulted from a commission, frequently embodied in a legal contract. Such a contract would specify, often rigidly, the materials the artist was to use, the size and shape of the object to be made, the subject of the work, the time allowed for completion, and the quality of the finished piece. Little latitude remained for anything like our contemporary ideas of the absolute freedom of the artist. Instead, the Renaissance painter or sculptor worked in a system which rigorously delineated the nature and type of his labor and carefully set standards which he was bound to uphold.

Nonetheless, as we shall see in the chapters which follow, the boundaries of Renaissance art were remarkably flexible. Today there are few definable standards or measurements in art; consequently there are no real gauges with which to measure innovation or originality. In the Renaissance there were more borders for the

artist to push, and more mileposts against which development could be marked. The real revolutionaries in the Renaissance functioned within an ordered, traditional workshop system.*

The workshop was a businesslike association of master and apprentices who worked together in much the same way as did goldsmiths, potters, and other Renaissance craftsmen. These artistic associations were often family-based: fathers taught sons, and uncles instructed nephews. Whole clans of painters worked over generations in the cities of Renaissance Italy.

The apprentice would enter the shop when he (there are few records of women artists from the period) was quite young, probably in his early teens. He was under the control of the master, who would school him, over a period of several years, in the scores of tasks involved in the making of Renaissance art.

The artists of the Renaissance believed that hard work, intense study, and good training would make a fine artist. They were, in fact, right, for the general level of skill in all aspects of Renaissance art is very high indeed. The notion of the lone genius working in a fit of divine inspiration is a romantic idea totally alien to Renaissance artistic beliefs, although, in embryonic forms, such ideas stem from the late Renaissance.

Our idea of originality would have seemed surprising in the Renaissance, a period in which art was learned through imitation. The apprentice imitated the master in technique and style, and the best pupils were the ones who most quickly learned the lessons taught by the master. Art into art, the development of one artist's work from that of another, was the major characteristic of Renaissance style. The modern artist's drive to be independent, to be avant-garde, to create something never before created, is very different from the way people thought about art during the Renaissance.

In the twentieth century, we tend to think of each work of art as the product of an individual, of one mind and one pair of hands. The Renaissance person believed in the idea of cooperative art, the product of many hands. Except for the smallest painting or sculpture, members of a Renaissance shop worked together. The master was in charge of obtaining the commission, negotiating the contract, and then designing the work; but in its execution, especially in a large work, he was aided by helpers and apprentices. In

* Some of the material in this Introduction is covered in greater detail in my *Renaissance Artist at Work*, New York, 1983. That volume discusses the artist's social background, his training, and the nature and use of the various materials of Renaissance art.

most cases, it is therefore incorrect and also misleading to attribute the execution of a painting or a sculpture to a single artist.

For instance, various parts of a large fresco cycle might be done by several members of a workshop, but because the apprentices had learned through imitation of the master's work, the overall style was consistent, the painting seamless.

Many Renaissance artists show little or no evolution in their work; they were, after all, products of highly conservative work-shops where educational principles were based on careful imitation. Innovation for innovation's sake was not a part of the mentality of the Renaissance artist.

The position of the artist in society was also markedly different from what it is in our own time. Because Renaissance artists were so like other craftsmen in their training and in their outlook on what they made, they fitted well into the society in which they lived and worked. Renaissance artists were businessmen who cre-ated some of the most sublime examples of Western art; and business and art, as the Renaissance proved, do not always have to be antithetical.

Yet, once the work (especially one bound for a religious func-tion and location) left the artist's shop, it became something very unbusinesslike. Renaissance art was imbued with an iconic potency which we find hard to fathom; it was magical, supernatural, able to intervene directly in the life of the onlooker.

Religious paintings, for example, were placed at the altar on which the Mass, the central rite of the Catholic church, was performed. By their association with this most sacred ritual, which they often helped to illustrate, altarpieces were part of the rite's miraculous nature.

We tend to view art as formal or personal expression, and our attitude toward it is often highly contemplative. This was not true for the Renaissance man and woman, who saw in images an iconic power capable of changing their lives. Pictures and statues of Christ, the saints, the Madonna, and the devil and his attendant demons could transform themselves into living things ready to intervene in the worshiper's life for good or evil.

Until the very end of the Renaissance, it would probably be wrong to call anything produced for the church and much that was made for the home a *work of art*. Instead, these objects assumed a potency and sanctity that we today seldom associate with images. They were not seen historically, nor were they regarded as repre-

sentatives of a particular culture or style. They were dreams, hopes, ideas, and ideals made visual.

The following chapters discuss paintings and sculptures that are the products of the workshop system. Each was produced in the Italian peninsula between c. 1250 and c. 1550. These several hundred works do not—indeed, cannot—definitively describe or explain Renaissance art. In fact, there never existed a unified art style on the Italian peninsula during the period spanned by our examples, those years which we call the Renaissance.

In the Renaissance, the area of present-day Italy was occupied by scores of independent city-states, each with its own government, army, mint, and individual way of life. The mountainous terrain made for difficult communication and fostered isolation. In fact, the unification of the peninsula under a single government remained a dream until the middle of the nineteenth century, when the disparate states were at last united. Even today, Italy is a country characterized by many intense localisms, the heritage of its past.

This Renaissance localism, combined with the conservative system of artistic education and development, ensured the emergence of many distinct regional styles. Nor did proximity dilute local developments: the styles, and often the iconographic content, of paintings and sculpture produced in neighboring areas could vary widely. For example, Siena and Florence are only about fifty miles apart, but the nature and history of their styles are quite different. Of course, larger and more powerful cities could dominate smaller, dependent towns and villages in economic, political, and artistic matters. The content and purpose of each city's art are often highly particular. So, rather than an Italian Renaissance style, we have a Florentine, or Sienese, or Venetian, or Neapolitan style.

But there were also ties among the various artistic centers. Renaissance artists traveled to commissions; the more famous worked in several locations in the peninsula. Certain cities—Florence is the best example—had a fundamental sway on the rest of the peninsula, but even the strongest waves of stylistic influence could not fundamentally swamp the basic individuality of the art of a particular city or region.

Despite this remarkable profusion of styles springing from very local conditions, virtually all art created in the Renaissance arose from essential, shared motivations which permeated society.

By our seeking out these common underpinnings, it is possible to approach an understanding of the complex phenomenon we call, for convenience, Renaissance art.

This book explores how the function, type, and style of works made by Renaissance artists relate to the society for which they were made. Certain crucial forces in Renaissance society shaped both the artists and the objects they created; these forces, and not the arbitrary and often artificial chronological classifications and models so often applied to the art of the time, are the real keys to a fuller understanding of the manifold nature of one of the greatest periods of art.

The first three chapters discuss art by type and function. The primary spheres of Renaissance society—the domestic, the religious, and the civic—commissioned and used particular types of art with special functions and meanings. Looking at Renaissance art in terms of use clarifies both the role of the artist and that of the society in the making of art. The fourth chapter investigates portraits and landscapes, affording a glimpse of how the men and women of the Renaissance viewed themselves and their surroundings.

Not every type of work is included here. But the patterns of development and use which emerge from those works that are studied in detail give us broad avenues to follow in an exploration of any specific type.

Moreover, not every geographic area of the Italian peninsula is represented. Although works by artists from Deruta, Ferrara, Florence, Forli, Modena, Padua, Parma, Perugia, Pescia, Pisa, Rimini, and Siena are included, the majority of examples come from Tuscany and Venice, locations of the greatest and most seminal importance for Renaissance art. Ultimately, the choice of paintings and sculptures is personal and cannot please everyone. For those who wish to study other works or pursue further the issues and problems discussed in this book, bibliographical notes and a bibliographical essay are included.

The aim of this book is to have the nonspecialist see Renaissance art in the context of its age. Renaissance art is vibrant, animated. In its time, it filled the viewer with awe, fear, admiration, and excitement. These qualities are still encapsulated in the art, even in those works hanging like specimens on the antiseptic white walls of museums. If we are willing to see these paintings and sculptures with an empathetic and understanding eye, we can revive them and make them the living, powerful presences they were centuries ago.

I

DOMESTIC LIFE

In contrast to the nuclear family of today, Renaissance family structure encompassed several generations. Grandparents, parents, and children shared their rooms with aunts, uncles, and cousins. Often the houses of an extended family stood side by side on the same street, perhaps connected by elevated passageways. These family enclaves would sometimes grow into whole neighborhoods belonging to clans.

Contact among members of such large families was close and constant. Child rearing and education concerned not only the parents but other members of the extended family as well. Privacy, so cherished today, was almost unknown: rooms were shared by many occupants of all ages, and, in lieu of hallways, bedrooms often served as corridors, one opening onto the next. A Renaissance room might have many functions, serving as a place to entertain guests, as a dining room, and as a bedroom.

The urban Renaissance house began to take shape with the renewal of town life in Italy about the year 1000.[1] From the disintegration of the Roman empire until the eleventh century, Italy had only small and widely scattered urban centers. But about 1000, the rural population began to move in numbers to the cities.

Life in these early cities was perilous, as the first large dwellings reveal. Tall stone towers with slit windows shielded clans who waged vendettas or engaged in struggles for economic and political dominance. The concept of house as fortress was deep-rooted, and even homes from the end of the Renaissance incorporated hints of fortification.

With the increasing dominance of a central authority—either the communal government or the prince or the pope—the interfamilial struggles were quelled, and town life became more secure. Many of the towers were either destroyed or leveled to a uniform height, neutralizing the offensive advantage of the taller towers.

Toward the end of the fourteenth century, new houses began to appear that set the pattern for the rest of the Renaissance period. These houses were owned by only the wealthiest citizens, who alone could afford sizable structures built of stone and brick. The

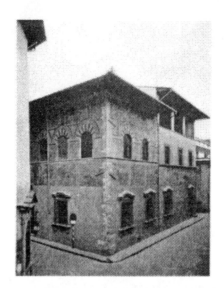

2. Palazzo Datini, Prato. The tightfisted Francesco Datini carefully supervised every detail of his palazzo, the largest in his native city of Prato. This home was to be a visual manifestation of his wealth and power. The palazzo now houses a charitable foundation operating with Datini's endowment.

poorer citizens lived crowded together in humble apartment-like dwellings often made of wood or other perishable material long since disintegrated.

An early urban house survives in Prato, a prosperous wool-producing city near Florence: the stone and brick palazzo of Prato's most famous citizen, Francesco di Marco Datini [2]. The son of a poor innkeeper, Datini made a fortune dealing in grain, cloth, and armor, trading through a vast network of offices and contacts spread across Europe. A stickler for detail, he collected and preserved his personal and business papers, which were found intact under a staircase in his home during the last century. Strangely enough, this meticulous accumulation, protected by luck and discovered by chance, has made Datini the best-documented figure of the fourteenth century.[2] His habits, predilections, and beliefs are all detailed in hundreds of pages of correspondence and contracts.

Constructed during the 1370s and 1380s, Datini's house was the largest and grandest in the city, although it was soon eclipsed by many of the fifteenth- and sixteenth-century palaces built in nearby Florence. The ground floor of the Palazzo Datini had an office, a guest room, a kitchen (there was another upstairs), and a courtyard. Unlike our American contemporary houses surrounded by lawns, Datini's palazzo, and Renaissance homes in general, turned inward, the walls enclosing a central courtyard that often supported an open loggia. This arrangement is an ancient one and

affords the inhabitants light, air, and a safe, protected place to enjoy the outdoors. As a result, the streets of Renaissance cities are devoid of green, while trees and gardens flourish within hidden courtyards.

Upstairs, Datini's house had guest rooms, bedrooms, the second kitchen, a small office or storeroom, and a large *sala grande*, or hall, probably used for entertaining and other semipublic gatherings. This room was in the center of the upstairs floor, with the surrounding rooms opening onto it. There seem to have been no rooms for the servants employed by Francesco and his wife, Margherita; rather, they slept on trundle beds or on the stairway landings or any other place where they could make themselves relatively comfortable.

Heat was provided by small earthenware warming pans filled with burning charcoal (something seen in Italy until just a few years ago) or by just two fireplaces. Wooden window frames held oiled fabric or, occasionally, glass. Light was provided by wax torches, lamps that burned olive oil dregs, or candles.

Blocklike, unadorned, the exterior of Datini's house is enlivened only by the original round-headed windows on the upper floor and by the streetside loggia, where the inhabitants could dry their clothes and look down on the life of the street below. Subsequent modifications have not enhanced the Palazzo Datini's undistinguished facade.

The Palazzo Rucellai in Florence [3] was built about seventy years (c. 1450) after Datini's home was completed. During the intervening decades, the palace began to evolve from the utilitarian structure of the Palazzo Datini into something resembling a large town house. This is evident in the harmonious, ordered facade of the Rucellai palace, designed by the architect Leon Battista Alberti, which incorporates classical architectural ornament and prominent entablatures.[3] Capped by a heavy cornice and anchored by a basement level of diamond ornament and benches, the building appears light and springy, very different from the Palazzo Datini and the many earlier fortress houses of Florence and the rest of the Italian peninsula.

Renaissance family structure dictated much of the plan of the Palazzo Rucellai and many other large urban homes of the Renaissance. The family's business generally was conducted on the ground floor. Often large arched openings built into this floor allowed easy access to the desks and counting tables of the employees who worked there. In this way, the family could consolidate its business

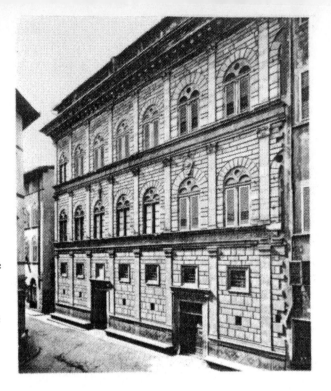

3. Palazzo Rucellai, Florence. Still occupied by the Rucellai family, the Palazzo Rucellai retains its original facade, designed by Leon Battista Alberti. Although modest in comparison with some homes of the next century, the Palazzo Rucellai was large by the standards of the mid-fifteenth century.

within the walls of its own house, go to work by simply descending a flight of stairs, and keep its inventory or capital safely under lock and key. This practice has survived to the present day in Italy, where even the most modern apartment houses have shops, often owned by the apartment dwellers, built into their ground floor.

The most important members of the extended family usually occupied the second floor, the most prestigious and commodious. Still called the *piano nobile* in Italy, this floor probably contained the *sala grande* and other comfortable, large rooms.

Less important members of the family and servants were relegated to the hotter, more cramped upper floors. Here, as in the Palazzo Datini, were found kitchens and storerooms. The kitchen was at the top of the house because the danger of fire was considerable; it was better to have this volatile area above than below.

Beginning in the fourteenth century, families of means began to spend time in country villas.[4] These were either newly constructed houses or renovated and enlarged older castles or farm buildings. As the Villa Chigi [4] outside Siena demonstrates, country dwellings usually differed considerably from the urban palazzo. While the palazzo turned away from the city street, the villa drew in the countryside through large loggias and windows. Hillsides were the favored sites for these homes, designed to provide a cool and restful place for the city dweller, as well as a stately backdrop for the considerable entertaining that took place.

Some of the villas were attached to working farms that provided the occupants with wood, olive oil, and wine throughout the year. These country commodities were always in demand, and even members of the artisan society, such as painters and sculptors, hoped to own a piece of land in the country not far from their city residence. Great families like the Medici had numerous villas, each with its attendant staff of farmers, housekeepers, gamekeepers (hunting was a favorite pastime), and grooms who tended the treasured horses in stables that themselves were sometimes remarkable structures. The type and character of the decoration of these villas were often very like those of the town house, although on occasion the more bucolic, rural nature of the country home was reflected in the paintings and sculpture.

4. Baldassare Peruzzi, Villa Chigi, called Le Volte, outskirts of Siena (drawing of c. 1600, Biblioteca Apostolica Vaticana). The Sienese Baldassare Peruzzi (1481–1536) was a painter, architect, and stage designer. This villa on the outskirts of Siena anticipates Peruzzi's famous Villa Farnesina in Rome (begun 1505), also built for the Chigi family of Siena.

Many of the rooms in Renaissance palaces and villas were decorated with paintings and furniture of the highest quality. One of the most remarkable features of the Renaissance dwelling was wall painting, usually in fresco.

Even Datini, who was certainly far from free with his hard-

earned money, had the walls of many of the rooms of his palazzo painted soon after he moved in. In the hallway was a large figure of Saint Christopher, an image that was thought to provide protection against sickness and death for those leaving the home. Datini also had figures of the Virgin and Christ painted above the doorways of several rooms.

But the merchant lavished the most attention and money on the decoration of several of the major rooms on the ground floor. In Datini's office [5] the entire wall surface was covered with paintings. About half of the wall is devoted to a forest scene populated by exotic birds and animals who wander below the frieze of tall, luxuriant trees. There is an overall pattern and decorativeness about this part of the wall that resembles tapestry design; and it may well be that these frescoes, and many like them, were cheap substitutes for tapestries.

Below the painted forest is a dado covered with color and geometric ornament; below this were squares of paint probably meant to simulate a marble basement level. The painted forest rests on the dado below it, but in no way is it suggested that the spectator is looking past the dado into a real woods. In both color and pattern, the artist, Agnolo Gaddi, has made certain that we read the fresco as decoration and not reality; both dado and forest combine to decorate in much the same way as would a good tapestry.

In the vault above are large coats of arms: those of the Datinis and of the Bandinis, the prominent Florentine family of Datini's wife. Datini was an insecure man acutely conscious of his humble origins, and this display of heraldry must have been meant to impress visitors to his house. To impress further, he had more coats of arms painted in the small fields in the office dado, and we can be sure that others were emblazoned on the furniture and cloth hangings distributed throughout the house.

5. Office, Palazzo Datini, Prato. From this office, now in a ruinous state, Francesco Datini (c. 1335–1410) directed his far-flung trading company, with offices in Genoa, Barcelona, Majorca, and elsewhere. The painter of this room, Agnolo Gaddi, had to sue Datini to collect his fee.

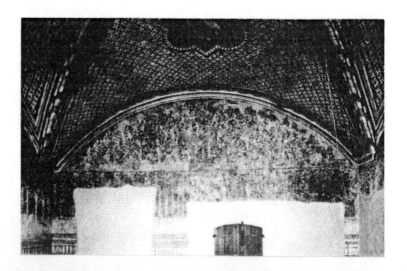

Pandolfo Petrucci was another well-known figure of the Renaissance who, like Datini, was anxious to impress his contemporaries with his wealth and family. Pandolfo was a fascinating, if repulsive, character who became the de facto lord of Siena about 1500. His large and handsome palace, now reduced to decrepitude, was the symbol of his wealth and power, both gained in highly suspect ways.

As Pandolfo began to make plans for the interior decoration of his house (completed 1508), he thought not of the panoramic forest scenes of the type found in the Palazzo Datini—for these had passed out of fashion—but of scenes that narrated individual stories from wall to wall.

For one of the major rooms in his palace, Pandolfo chose a number of mythological stories—among them The Triumph of Chastity; Love Disarmed and Bound; The Calumny of Apelles; The Festival of Pan; Coriolanus Persuaded by His Family to Spare Rome; and Aeneas's Flight from Troy—which were painted by famous artists who probably had been called to Siena specifically to work in Pandolfo's palazzo. Above the wall frescoes was a splendid ceiling (now in the Metropolitan Museum of New York) designed by the Sienese painter and architect Baldessare Peruzzi.

The frescoes and the ceiling were complemented by a beautiful floor of maiolica tiles, preserved in a damaged state in London and Berlin. Moreover, the walls were further decorated with a finely carved wooden wainscot divided by elegant pilasters, a few of which still survive. As in Datini's house, Pandolfo's coat of arms was placed throughout the palace.

Sometime about the middle of the nineteenth century, the frescoes and woodwork were removed from the palace and scattered. One of the most interesting paintings, *Scenes from the Odyssey* [6], is by the charming Umbrian painter Bernardino di Betto, nicknamed Pintoricchio (little painter) or Sordicchio (the little deaf one). Pintoricchio was a splendid storyteller whose major work is a luminous and anecdotal fresco cycle in the Piccolomini Library in Siena. Trained in the tradition of Umbrian painting of the fifteenth century, he was a natural decorator, a perfect choice to paint frescoes meant to grace the interior of a palace.

Telemachus, the son of Odysseus, occupies the central position in Pintoricchio's fresco. He greets his mother, Penelope, who weaves the shroud she unravels each night to forestall her suitors. Behind Telemachus, the hero, Odysseus, dressed as a beggar, enters the room. A comparison of the fresco and the text of

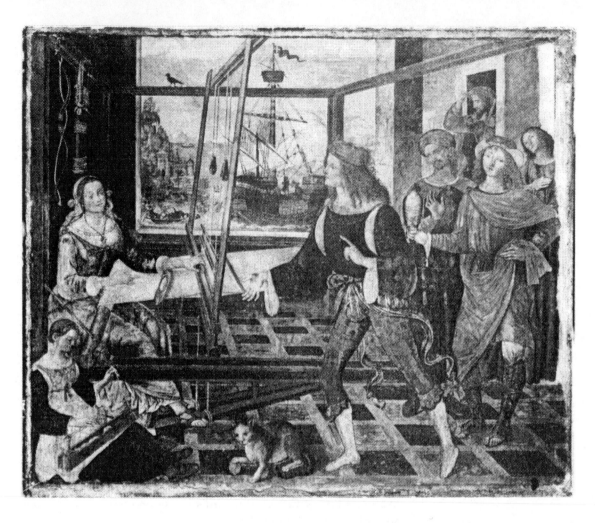

6. Pintoricchio, *Scenes from the Odyssey*, National Gallery, London. Bernardino di Betto (1454–1513), called Pintoricchio, was born in Perugia. He worked extensively in Umbria and Rome. One of his last major commissions was for the Piccolomini Library in Siena, on which he seems to have been assisted by the young Raphael.

the *Odyssey* reveals that the painter or, more likely, some learned person responsible for the painting's program, took some liberties with the setting and chronological sequence of the main story and the episodes narrated in the landscape beyond the window. These departures are characteristic of the free interpretation of the text in so many narratives drawn from myths or Roman history during the Renaissance. Fancy and imagination often came between word and picture.

Pintoricchio's composition is well suited to decorate the wall of a large Renaissance palace, for it contains a subtle and appropriate mixture of fashion, decorative pattern, and anecdote. The multi-colored floor pattern and the network of horizontals and verticals formed by the floor tiles, the architecture, and the loom weave all the elements into an animated decorative surface.

Anecdotal detail is as important as the story itself: the spec-

tator is delightfully distracted from the narrative by the cat, the bird perched on the window frame, the landscape's exotic mountains, and the details of the fashionable costumes worn by Telemachus and the man holding the hawk. This modish elegance meshes perfectly with the style and ease of the two right-foreground figures, who are quintessential Renaissance dandies, the sort of figures that must have frequented every court and palace of the time.[5] Foppish, self-conscious men are, in fact, one of the trademarks of Pintoricchio's work, and their appearance in his paintings must have pleased and amused his patrons.

Pintoricchio's fresco was, however, more than just a masterful piece of decoration; it also told a story of high morality and courage. Penelope had patiently waited years for Odysseus's return, never believing him dead and constantly fending off her suitors with the ruse of the shroud. Odysseus himself was an example of bravery and cunning much admired by the Renaissance. Those who saw the frescoes by Pintoricchio and his fellow artists on the walls of Pandolfo's palace would have been reminded of these qualities. This fresco, like many of the paintings in other Renaissance palazzos, was didactic in nature: it was meant both to instruct and to serve as an example for the men, women, and children who inhabited or visited the room.

Interior wall painting of quite a different order appears in one of the most famous rooms of the Renaissance: the Camera degli Sposi (Bridal Chamber) in the Palazzo Ducale of Mantua, which is graced by the frescoes of Andrea Mantegna. Mantegna, who completed this room in 1474, was from Padua, where he studied with the still-enigmatic painter Squarcione, a Paduan tailor turned artist. Heavily influenced by Donatello's extensive work in bronze for the Santo of Padua and strongly drawn to antique art, Mantegna evolved a style of crystalline clarity and almost obsessive detail.

His work in the Palazzo Ducale, a large complex of buildings, immortalized the lord of Mantua, Marquis Ludovico Gonzaga, and his family. This he did by portraying them, and attendant courtiers, on the walls of the Camera degli Sposi. As in the palazzo of Pandolfo Petrucci, the pictures tell a story, but in Mantua it is derived not from mythology but from contemporary events.

Although he is seated to the left in the scene usually entitled *Ludovico Gonzaga and His Court* [7], the marquis is, nevertheless, the center of attention. The subject of this fresco cannot be proved absolutely, but it appears that Ludovico has just received a papal

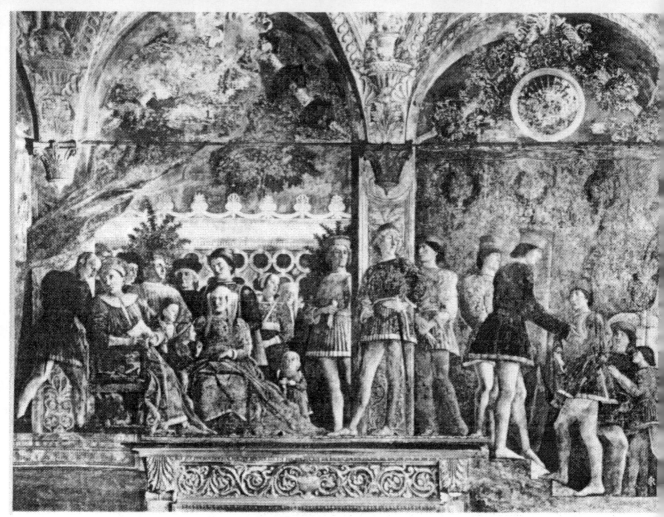

7. Andrea Mantegna, Camera degli Sposi, Palazzo Ducale, Mantua. The informal, close relationship of Mantegna's sitters is one of the most attractive aspects of the Camera degli Sposi. The network of emotional ties among the protagonists was as important to Mantegna as their social standing and wealth.

letter informing him that his son Francesco has been created a cardinal. This event, which honored father as well as son, must have been one of the highlights of Ludovico's life.

In the fresco, a chain of courtiers leads all eyes to Ludovico, who is surrounded by family and retainers. The marchioness, Barbara of Brandenburg, her children, including her little son, courtiers, and the family dwarfs (they had a suite of miniature rooms in the palace) give all their attention to the marquis as he receives the momentous news.

Mantegna's fresco does not "decorate" in the same sense as do Pintoricchio's or Gaddi's wall paintings, where the reality of wall and painted surface prevail. Although the disposition of the figures across the surface of Mantegna's fresco remains highly decorative, he has attempted to integrate the world of the painting with the world of the viewer. The painted space appears to be a continuation of the room's actual space; even the stone mantel of the fireplace is utilized as the courtiers stand on it and walk toward

it on painted steps. This illusionism is of a very different order and purpose than the tapestry-like painted forests on the walls of the Palazzo Datini and other early palaces.

With its emphasis on fashion, on graceful movement, on style, and on elegant pose befitting a courtier, this scene is one of the most accessible and accurate depictions of what life looked like in a great Renaissance household. Mantegna delighted in the accurate rendition of detail; he has given us here not drama but journalism, a brilliant and intimate fresco-snapshot of life in a Renaissance court.

Another aristocratic family of north Italy, the Este of Ferrara, also commissioned in the early 1470s a notable series of frescoes, for their Palazzo Schifanoia.[6] Built in Ferrara for entertaining and other social occasions, the Palazzo Schifanoia (schifanoia connotes "without care," or "carefree") had a large hall, the Salone dei Mesi (Hall of the Months), decorated with frescoes that center on astrological lore.

Today, many tend to think of astrology as a sort of harmless and amusing parlor game. But the heavens still ruled in the Renaissance, albeit with less than absolute power, and astronomy was an important component of Renaissance cosmology. Astrologers were scientists, of sorts, attributing events to astrological influence. Few members of Renaissance society would set out on an important journey, or begin a building, or marry, without first consulting their horoscope. Only religion was a more potent force in Renaissance society, and it was not always antithetical to astrology.[7]

There are three registers in the Salone dei Mesi. The top one illustrates, month by month, the triumphs of the ancient gods who once presided over humans. In the middle register are the signs of the zodiac and the deans, astrological personifications who held sway over ten-day divisions of the months. On the bottom register are the rural labors (related to the seasons) and scenes—among the most beautiful of the cycle—centering on Borso d'Este, who was made duke of Ferrara in 1471.

Borso d'Este Hunting (September), attributed to Ercole de' Roberti, a Ferrarese painter, is one of the most charming of these scenes of the lower register [8]. The duke and his hunting party pause in a fantastic landscape to watch a mounted falconer, who reins in his lively horse. Careful attention has been paid to the mounts throughout the fresco, for these were prized possessions and essential equipment of the nobles and all men of action.

Behind the group is a strange landscape punctuated by a nat-

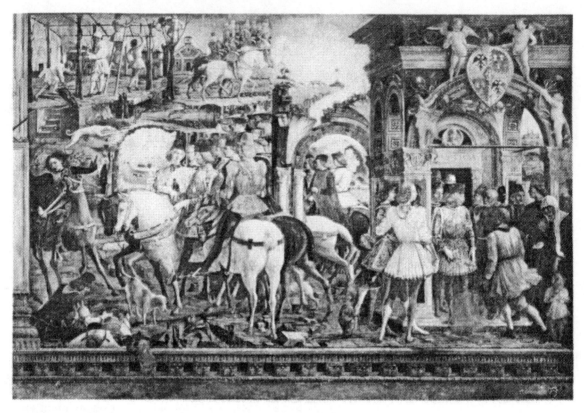

8. Ercole de' Roberti, *Borso d'Este Hunting*, Palazzo Schifanoia, Ferrara. During the second half of the fifteenth century, the school of Ferrara produced several distinguished artists, whose eccentric and often agitated narratives and figures decorate the walls of the Palazzo Schifanoia. The scenes are especially interesting for their combination of secular subject and astrological symbolism.

ural bridge and a shattered arch. Ruins abound in the frescoes of the Salone dei Mesi, references to the destructive and regenerative forces found both in the heavens and in man.

In this fresco and in many others in the room, the beauty and bounty of nature are celebrated in scenes of laborers in the vineyard, lush grass, and placid pools. The paintings sparkle with an effervescence fully appropriate for their function as decoration of a palace used for pleasure, a place to escape the cares of everyday life. Even the frescoes of the cycle that have been most badly damaged suggest freshness and gaiety.

Several important artists worked on the Salone dei Mesi, and consequently the room is one of the monuments of fifteenth-century Ferrarese painting. Like so many other regional styles, this little-known school was composed of several original and noteworthy artists. Among these were the painters of the Salone dei Mesi: Cosmè Tura, Francesco del Cossa, and Ercole de' Roberti. Each of these artists painted in a highly expressive, if often bizarre, style of great linear beauty and sparkling details.

One subject often encountered both in the palazzo and the

villa of the Renaissance was that of famous men and women, a series of images of renowned people from mythology, ancient history, the Old Testament, and contemporary life. Warriors, sages, kings, queens, and men of letters were portrayed in panel and fresco. Often these figures were chosen because they exemplified the virtues most valued by the Renaissance. Courage, sagacity, and fidelity are just several of the silent but forceful messages that emanated from these images.

An early example of this type was painted for the Villa Carducci at Legnaia, a house originally on the outskirts of Florence but now nearly overtaken by the city's modern sprawl. Here, about 1450, Andrea del Castagno, a bold and original Florentine painter, painted a series of famous men and women that covered a long wall in one of the villa's largest rooms, a room that was undoubtedly public.

Castagno's vigorous figures (now in the Uffizi, Florence) include: from antiquity, the Cumaean Sibyl, Aeneas's guide to the underworld and a prophet of Christ's coming; from the Old Testament, Queen Esther, the sagacious wife of Ahasuerus; from the world of letters, Dante, Petrarch, and Boccaccio; and from contemporary life, Pippo Spano, a renowned soldier of fortune. The latter image [9] is especially memorable for its metallic hardness, vigorous posture, and contrasting rhythms of feet and sword (which Pippo seems to flex with his bare hands).

These figures of famous men and women were like a Renaissance Hall of Fame, and Castagno's array of soldiers, queens, writers, and contemporaries still impresses with the authority of crisp, sharply articulated forms, vibrant color, and forceful personalities.[8] A visitor to the Villa Carducci could stand in the midst of these nearly life-sized heroes and heroines and imagine himself in extraordinary company.

The same sort of meshing of ancient and modern subjects is evident in several exquisite frescoes by Botticelli, now in the Louvre but originally from the Villa Lemmi, situated outside Florence; like the Castagno frescoes, these were discovered only in the nineteenth century. In the fifteenth century the villa was owned by the Tornabuoni, one of the most prominent Florentine families and art patrons of considerable distinction.

Two of Botticelli's frescoes, from an upper floor of the villa, are devoted to a kind of allegory, centering on a young man and woman—perhaps Matteo degli Albizzi and his wife, Nanna di Tornabuoni.

DOMINVS PHILIPPVS HISPANVS DESCOLARIS RELATO VPHTORIE THEVRO

9. Andrea del Castagno, *Pippo Spano*, Uffizi, Florence. Pippo Spano was a Florentine soldier of fortune of great fame. Born in 1369, he became commander of the Hungarian army in its wars with the Turks. Two other Florentine *condottieri* appear in Castagno's Villa Carducci frescoes.

14

The frescoes [10 and 11], made near the time of the wedding of the pair, probably about 1480, were originally framed by pilasters decorated with arabesques and set over a plinth. The framing must have made the enclosed paintings look as though they were seen through a loggia, much as the actual loggias of the villa framed the surrounding countryside.

In the damaged fresco depicting the woman meeting figures who appear to be Venus and the Graces, we see the mythological personages advancing with the graceful, sprightly steps so characteristic of Botticelli, one of the true connoisseurs of female beauty in the Renaissance. The measured placement of the bodies and the rhythm of feet, arms, and heads animate the left half of the fresco. In front of the fair, comely allegorical figures stands the woman, whose upright, almost stiff posture and dark dress contrast vividly with the much more supple, brighter group at the left. She holds a linen scarf into which Venus is about to drop a gift of flowers. Just to the right of the woman appears a putto, whose shield must have carried a coat of arms, a pedigree, so to speak. (This was quite common, as we know from the coat of arms of Datini's wife.)

Originally separated from its companion by a window, the counterpart to this fresco depicts a man meeting the seven Liberal Arts. Both paintings are set outdoors, the man's in a forest clearing and the woman's before a garden wall.

These paintings, with their brightly dressed, stylish figures in peaceful outdoor settings viewed through loggias, are both fine decoration and fitting images for the pastoral and often joyful life of the villa. But they also may have a deeper meaning, illustrating the aspirations of married life. The man, led by Grammar, will have his life enhanced and enriched by the Liberal Arts, whose personifications now greet him; the woman will be as beautiful and lithe as the Graces and as fertile and alluring as Venus, who drops blossoms into her scarf. All those who looked at Botticelli's remarkable frescoes would have been aware of their message, which was both optimistic and instructive.

Over the years Renaissance palaces and villas became larger and grander, slowly but surely evolving away from the house-fortress and simple country place. One of the most impressive of all the villas is the Farnesina, originally beyond the limits of Rome but now absorbed by the city.[9] Built about 1510 by the Sienese architect and painter Baldassare Peruzzi for a fellow Sienese, the wealthy banker Agostino Chigi (whose family's villa outside Siena has been mentioned earlier), the Villa Farnesina (it takes its name

10. Botticelli, *Woman Meeting the Graces,* Louvre, Paris. The identities of the man and woman in figures 10 and 11 are not certain, but their faces seem individualized enough to be portraits. The use of allegorical figures became common in later palace and villa decoration.

11. Botticelli, *Man Meeting the Liberal Arts,* Louvre, Paris.

from later owners) was an ideal Renaissance villa. Set in a garden, open to the air and light, perfectly scaled and gracious, the villa is an inviting and invigorating building. Inside, Chigi spared no expense on the elaborate decorative scheme, employing Peruzzi, Sodoma (an artist from the north of Italy who worked in and around Siena), and the famous Raphael.

The decoration of the villa includes a large, elaborate ceiling painting of Chigi's horoscope, which is, in a way, the central feature of the interior. The expanse and prominence of Chigi's painted horoscope remind us of the continuing importance of astrology in the Renaissance, even into the sixteenth century.

For Chigi's bedroom, Sodoma painted a fresco of the marriage of Alexander the Great to Roxana [12]. The fresco is frankly erotic and, like several other works from the time, clearly meant for the privacy of the bedroom. A painted rail marks the boundary between fictive space and the real room, yet the distinction between illusion and reality is blurred, as it is in so many palazzo and villa frescoes of the later Renaissance.

12. Sodoma, *Alexander and Roxana*, Villa Farnesina, Rome. Now overshadowed by his more famous contemporaries, Giovanni Antonio Bazzi (1477–1549), called Sodoma, was a capable, if uneven, artist. Although trained in Lombardy, he moved to Siena, where he had considerable success. His work for Agostino Chigi was one of his most important commissions.

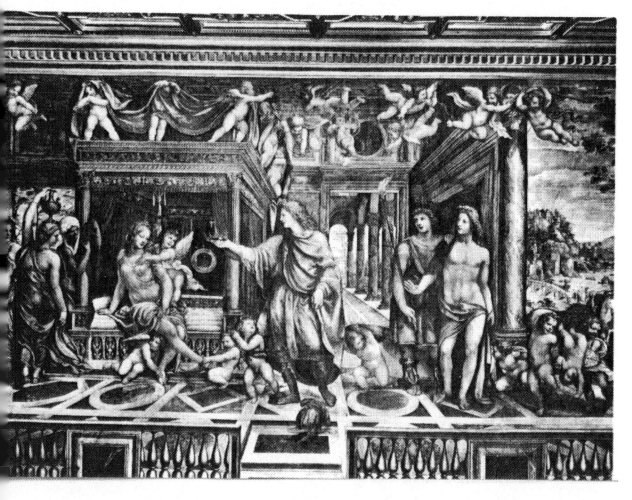

In the painted bedroom scene, Alexander offers his crown to Roxana, who sits on the side of a large canopied bed probably quite similar to the one in which Chigi slept. Hovering putti undress the bride, while other amoretti crowd the space above. The event is witnessed by maids at the corner of the bed and, at the right, by a scantily clad Hymenaeus, god of marriage. The color and sensuous forms of the fresco, the whirling, slyly smiling putti, and the demure Roxana and virile Alexander leave little doubt about what will soon happen. Such an openly erotic scene, devoid of moral lesson, would have been unthinkable even just a few years before, when the narrative message was still mainly concerned with prescribing correct conduct for the occupants and visitors of the house.

From about 1530 until well into the eighteenth century, the area of the mainland near Venice boasted numerous villas of architectural and decorative distinction. Many of these grand houses, some located on the waterways that webbed the area, were built by the architect Andrea Palladio, whose classical, restrained buildings were influential all over Europe and, through the agencies of Thomas Jefferson, in this country as well.[10]

The Villa Barbero at Maser, among the most exquisite of these structures, was extensively decorated in 1561 by Paolo Veronese, one of a group of remarkable sixteenth-century Venetian painters that also included Titian and Tintoretto.[11] Enchanting and whimsical, Veronese's large-scale landscapes with inviting vistas and distant mountains continue the long tradition of this type of fresco decoration, found as far back as the Palazzo Datini and other palaces of the late trecento and early quattrocento. Veronese's bucolic scenes [13] were fitting decorations for this villa, which, like many Venetian villas, was a serious working farm as well as a pleasure retreat and hunting lodge.

Veronese also painted a number of portraits on the villa walls: members of the patron's family, servants, and other figures look out from the ceiling or greet us from painted doorways. There is a happy, relaxed feeling about Veronese's decoration that harmonizes with the gracious villa and the casual, rural life for which it was designed and built.

Frescoes were only one decorative component of the well-furnished Renaissance home. Before the painted walls stood the furniture and accessories used for everyday life. One of the most common items found in the Renaissance home was the wooden cassone, or chest. Renaissance buildings did not have closets; instead, objects of all types were kept in chests of standardized sizes

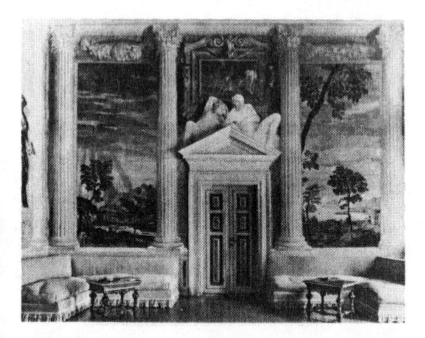

13. Paolo Veronese, *Landscape,* Villa Barbero, Maser. Paolo Veronese's frescoes strike the relaxed, bucolic note so appropriate for the Villa Barbero and other villas designed by the architect Palladio (1508–1580). These paintings open the room and, like the villas themselves, bring tamed nature inside.

ranging from tiny to very large. These chests must have been among the most ubiquitous and familiar objects of the Renaissance. Many of them were left undecorated: they were utilitarian objects, plain and simple. But others were important pieces of furniture handed down from generation to generation.[12]

Such chests usually came in matched pairs. Clothes, furs, linens, and other treasured items were stowed in the chests, which, like old steamer trunks, were often lined with fabric.

Many times the chests were expensive wedding presents, given by friends and relatives or as a betrothal token of the future groom. Most wedding chests were decorated to order: coats of arms of the bridal couple were affixed, and certain narrative scenes were painted to precise specifications. Proudly carried through the streets in the wedding procession, the chests proclaimed their owners' economic and social status.

Used constantly, most *cassoni* have been destroyed by wear. One preserved example, the famous Trebizond *cassone* of c. 1470 [14] in the Metropolitan Museum of Art, stands on feet, a characteristic shared with the few other survivors. Many of the chests were decorated with wooden moldings, which often were gilded and sometimes were skillfully carved: the Renaissance was an era of remarkable woodcarving.

Paintings covered the front, sides, and sometimes the lid of

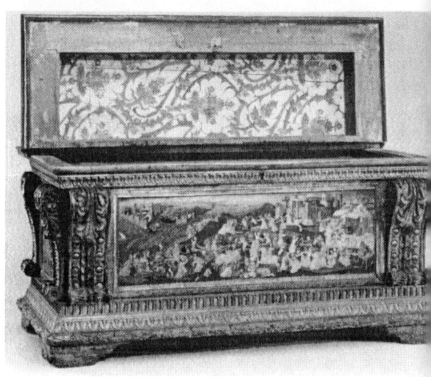

14. Florentine, *Trebizond Cassone*, The Metropolitan Museum of Art, New York. This *cassone* is unusual for its portrayal of a nearly contemporary event: the capture of Trebizond by the Turks in 1461 The purpose of this scene—historical, moral, cautionary—remains unknown.

the more expensive chests, like the Trebizond *cassone*. Selected with care, they were to be at once highly decorative and instructional, didactic exemplars for the family that would see them daily. The stories illustrated came from several sources: contemporary literature, ancient history, mythology, and the Old and New Testaments.

Many of the earlier *cassoni* decorations, produced before the middle of the quattrocento, were divided into fields, each division telling part of the story. The story illustrated in this fashion on a pair of chests painted about 1400 [15 and 16] now in the Bargello, Florence, and the Cini Collection, Venice, comes from one of the most popular sources for *cassoni, The Decameron* by the Florentine Giovanni Boccaccio. Written in the last half of the fourteenth century, *The Decameron* provided a rich compendium of stories that could be used to invoke many morals.[13]

A merchant, his wife, and a wise and magnanimous sultan are the protagonists in the story told by the Bargello and Cini *cassoni*. Imprisoned while on a crusade, the merchant is set free by the sultan, who remembers the hospitality he once received

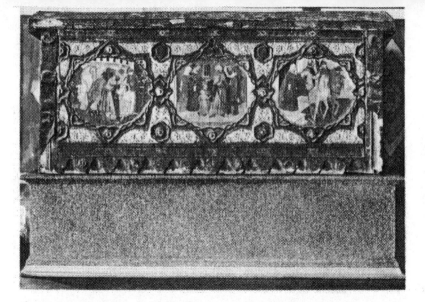

from the merchant. Magically transported back to his home, the merchant (who had been given up for dead) arrives just in time to save his faithful and obedient wife from a forced marriage.

Boccaccio weaves a good tale, full of action and suspense, exotic locations, and magic. It is a story morally satisfying: generosity and hospitality are repaid; goodness—even in a heathen like the sultan—prevails; and marital fidelity and wifely patience (many Renaissance merchants, like the one in the tale, were away for long periods of time) are rewarded. These virtuous messages would not have been lost on the Renaissance wife as she put the clothes away nor on the children, who must have been drawn to the small figures and exquisite color of the paintings.

Other popular stories were taken from ancient history, which was regarded with intense interest and admiration by the Renaissance as a dramatic and heroic period worthy of emulation.[14] Renaissance scholars revived many ancient texts and cleared others of the distorting accretions from the Middle Ages. In fact, the term "medieval" was invented by the Renaissance to derogate the period of time intervening between itself and the ancient world.

A pair of *cassone* panels [17 and 18] now in the North Carolina Museum of Art, by a Sienese artist working in the second half of the fifteenth century, exemplifies this use of ancient themes. Each a full-field painting (the format popular after the middle of the quattrocento), they depict Cleopatra's visit to Mark Antony and the battle of Actium.

Here the message is a warning: Cleopatra and Mark Antony's liaison and their injudicious behavior led to their suicides. Cleopatra was an extravagant woman to whom wealth meant little. Her influence on Mark Antony and their subsequent defeat at the hands of Augustus's fleet at Actium were examples of how unchecked

15. Florentine, *Scenes from the Decameron*, Bargello, Florence. The Renaissance viewer was fascinated and frightened by exotic figures like the sultan who figures in the story from the tenth day of Boccaccio's *Decameron* on this *cassone*. The popular legend of Saint Francis included a trial by fire before a sultan, and various exotic figures often appear in painted religious narratives.

16. Florentine, *Scenes from the Decameron* (detail), Bargello, Florence.

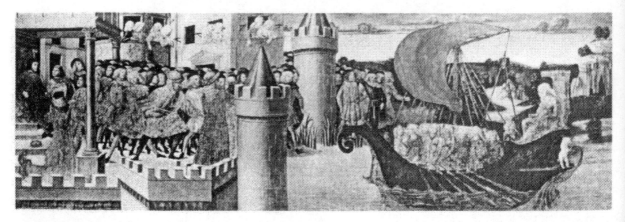

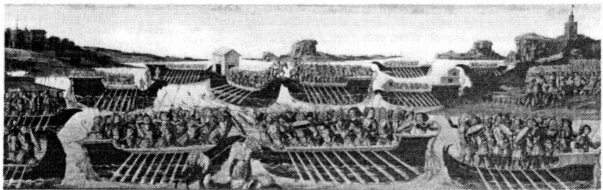

17. Neroccio de' Landi, *Visit of Cleopatra to Antony*, North Carolina Museum of Art, Raleigh. *Visit of Cleopatra to Antony* and its companion, *Battle of Actium* [18], are examples of the burgeoning interest in Roman history in Renaissance Siena. For the Renaissance, the Roman past was a storehouse of moral and admonitory examples suitable for both domestic and civic life.

18. Neroccio de' Landi, *Battle of Actium*, North Carolina Museum of Art, Raleigh.

passion could lead to a bad end. The modesty and chastity expected of Renaissance women were reinforced by this cautionary tale, which is more legend than fact.

The two *cassoni* of the Cleopatra and Mark Antony story are probably by Neroccio de' Landi, one of the finest artists of fifteenth-century Siena, and all of the characteristic fantasy and charm of his native city enliven the two paintings. Filled with svelte shapes and spirited actors wearing fashionable costumes, the panels conjure up a magical atmosphere of luxury and grace. Even the battle seems balletic, as the great galleys slip across the surface of the still water.

Characteristic of almost all *cassoni* are the many little figures that must have given the owners of these chests hours of delight. Neroccio's flaxen-haired maidens and lively courtiers are especially lovely and appropriate. Perhaps the most remarkable image of the *cassoni* is the ship that brings Cleopatra to Mark Antony. With its curved prow and billowing sail, the vessel glides across the sea, carrying its cargo of bright, eager-eyed maidens watched over by the enthroned Cleopatra. The mission of the ship is never in doubt:

its rudder is held by a cupid who steers the galley safely into the port, where Mark Antony, enthroned like Cleopatra, waits.

Besides scenes from ancient history (often, as in the case of the Cleopatra and Mark Antony tale, highly embroidered with fantasy) and mythology (such as Jason and the Argonauts and the Labors of Hercules, to name just two of the themes depicted on chests), many *cassoni* illustrated stories from the Old Testament.

The story of the Queen of Sheba and King Solomon, one of the most popular of these, appears on a pair of *cassoni* painted about 1465, now divided between museums in Boston and Birmingham, Alabama. Both paintings [19 and 20] are by the Florentine Apollonio di Giovanni, perhaps the most famous *cassone* artist of the Renaissance. Some workshops of painters specialized only in painted chests, and Apollonio's large shop is documented by his still-surviving ledger listing commissions. Many of the *cassoni* produced there must have been made on a sort of assembly line, where the master and his apprentices used and reused designs and motifs.[15]

Apollonio's *Journey of the Queen of Sheba,* with its vast panorama of undulating hills generously dotted with small, well-dressed figures, epitomizes his production. Many spirited horses and the obligatory (if funny) camels for exoticism help make up the train of Sheba, who sits enthroned near the center wearing a hat very

19. Apollonio di Giovanni, *Journey of the Queen of Sheba,* Birmingham Museum of Art, Birmingham, Alabama. Apollonio di Giovanni's *cassone* workshop seems to have been one of the largest Florentine specialty workshops of the fifteenth century. This *cassone,* like its companion in Boston [20], was probably turned out by artists working from a limited repertory of subjects and types suitable for *cassone* decoration.

20. Apollonio di Giovanni, *Meeting of Solomon and the Queen of Sheba,* Museum of Fine Arts, Boston.

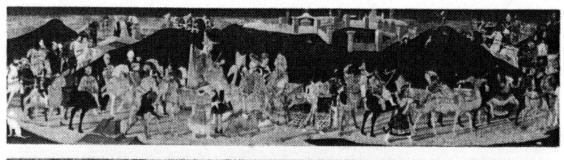

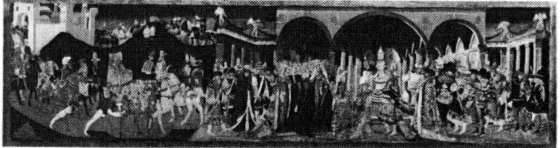

like the type worn by pilgrims in the early Renaissance. The entire scene resembles the cavalcade of the Magi, and, in fact, Sheba's journey to Solomon was seen as a prefiguration of the Journey and Adoration of the Magi. This aspect of the *cassone* panel probably would not have escaped those who used the chest it decorated and those who gave it as a gift.

In the second chest the story continues with the arrival of the queen and her meeting with Solomon in Jerusalem. The chests work together thematically, formally, and compositionally. Each has the same long format and numerous small figures, and the landscape of the first panel continues on the left half of the second panel. Moreover, the predominant left-to-right direction of Sheba's train carries onto the left half of the second *cassone*, as though the riders have come in from the first panel, although in fact, they come through the gate at the upper left. Many of the pairs of *cassoni* from the Renaissance were tied together with similar broad continuities of format, size, and rhythm.

In the right section of the second *cassone*, Solomon and Sheba meet before a splendid temple complete with rows of columns carrying graceful arches. Solomon, dressed in costly and ornate robes, is a magnificent counterpart to the queen. This meeting, too, had implications outside of the event itself. Solomon—the wise male ruler, the model of good judgment blessed by God—was a figure to be emulated. And Sheba, although a considerable ruler in her own right, acknowledged by her homage to Solomon her humility and, by implication, the superiority of this wise man, just as the Renaissance wife was expected to acknowledge her husband's superiority.

Cassone paintings functioned on many levels, as these two panels reveal. They offered pleasure for the eye, entertainment for the intellect, and instruction for the character. Generations of mothers and grandmothers explained these admonitory tales to their children.

The moralizing tone was less apparent on the painted lid panels, if we can judge from the very few surviving examples. One of these extant lids [21], probably the inside, is now in the Indiana University Art Museum. A joyous and buoyant work painted about 1465, it depicts two putti on dolphins. From the long trumpets held by the putti hang flags bearing the arms of two famous Florentine families: at the left, the Pazzi and at the right, the Borromei. The coat of arms to the viewer's left (and to the right of the bearer) is always, in heraldic terms, the most important; because of its

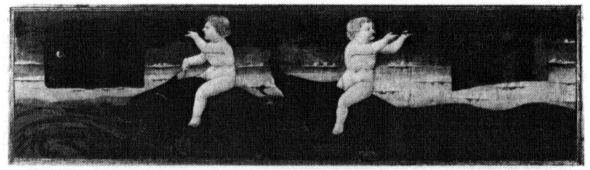

pride of place we therefore know that the Pazzi emblem belongs to the husband. Further heraldic reference is made by the leaping, dolphin-like sea creatures, which were also part of the Pazzi coat of arms.

The style of the painting stems from the workshop of Apollonio di Giovanni, and, in fact, an entry in his shop book records a *cassone* made for a wedding between a Pazzi groom and a Borromei bride. This chest, therefore, was made for members of these two wealthy Florentine families, and the lid served as a visual record of this event.

Apollonio conceived this painting as a kind of animate coat of arms, which would quickly convey the circumstances surrounding the chest's commission and the identity of the owners. Surely other *cassoni* were personalized in a similar way.

Several other lids depict full-length reclining figures of men and women, seemingly idealized figures without any apparent symbolic or allegoric references. In one particular pair [22 and 23], the male is dressed in the height of late-fifteenth-century fashion, complete with elaborate coif and multicolored hose. However, the female is nearly nude, covered only by a long sash that leaves her breasts exposed. Precisely because she lacked the symbolism or the allegoric qualities of a Venus or some other classical goddess, this nude must have been striking and risqué. She is, moreover, one of the first of a long line of nude or nearly nude females who soon began to grace the walls of bedrooms and private studies.

Toward the end of the fifteenth century, the fashion for painted *cassoni* began to wane. Patrons now wanted elaborately carved wooden chests, splendid products of the woodworker, not the painter. These ornate, sculptured *cassoni* still exist in considerable numbers.

But even as the painted *cassone* was eclipsed, the painted wall panel emerged, incorporating the format, size, subject, and purpose of the *cassone* panel. Paneling (which was probably considerably cheaper than tapestry) lined the walls of many Renaissance

21. Workshop of Apollonio di Giovanni, *Two Putti Astride Dolphins*, Indiana University Art Museum, Bloomington. The Pazzi, whose arms appear in this painting, were a powerful Florentine family. After a failed coup against the Medici in 1478 (in which Giuliano, the brother of Lorenzo de' Medici, was killed), the Pazzi were either captured and executed, or they fled the city.

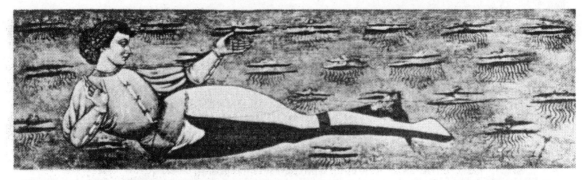

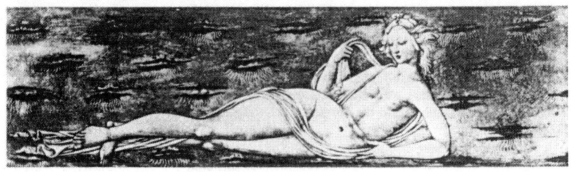

22. Apollonio di Giovanni, *A Youth,* whereabouts unknown. This painting on the inside of a *cassone* lid and its companion [23] would have been out of sight when the *cassoni* were closed. Opening the *cassoni,* especially that with the nude, must have created a mild surprise for those unfamiliar with the paintings inside.

23. Apollonio di Giovanni, *Nude,* whereabouts unknown.

houses; it was not only decorative, but it also helped insulate the chilly stone or brick walls of most villas and palazzos.

The paintings, either set in the paneling or sometimes forming a sort of attached backrest for a person sitting on a *cassone,* were carefully framed and sometimes surrounded by pilasters and columns of exquisite workmanship. In a sense, the function of these pictures—*spalliere,* as they are called in Italian—was somewhat analogous to the wall fresco: to provide decoration and narrate stories, often with a moral or didactic purpose.

As in *cassone* painting, several related pictures were used. The Florentine artist Paolo Uccello used three panels, probably painted about 1450, to tell a story for a bedchamber later used by Lorenzo de' Medici, the famous first citizen of fifteenth-century Florence. Uccello's panels, now in Florence, Paris, and London, may have hung high on Lorenzo's bedroom wall, separated by some sort of elaborate framing perhaps made up, in part, of carved pilasters.

Together the panels narrated the key events in the rather obscure battle of 1432 in which the soldier of fortune Niccolò da Tolentino, fighting for the Florentines, defeated their hated rivals the Sienese, at San Romano. Exactly why these panels were com-

missioned and what, if any, meaning they conveyed outside the victory is unclear.

The painting in the Uffizi [24], originally the central panel, depicts a crucial event, the unhorsing of Bernardino della Carda, the enemy commander. The very decorative, tightly interwoven visual fabric of the Uffizi panel, usually entitled *The Rout of San Romano*, is characteristic of *cassone* panels. The choice of subject also might have been influenced by chest decoration, as battle scenes often appear on *cassoni*.

Uccello has responded to the dictates of type and function by making his figures and their actions fantastic. Not for a second do we believe that this is a real battle; rather, it is the high stylization of an event. The wonderful rearing horses, the pattern of spears, the grid of form, and the quiltlike landscape all create a storybook world far removed from real combat and real bloodshed. Uccello has brilliantly transposed his story from the battlefield to the realm of fabulous knightly combat.

Not all panel paintings followed the *cassone* format: some of the paintings made for palazzo rooms could be very large. The so-called *School of Pan* [25], by the Tuscan artist Luca Signorelli, measured nearly 2 by 2.5 meters. It was destroyed in Berlin during the Second World War, and the tragic loss is compounded by the fact that it was Signorelli's masterpiece and one of the finest myth-

24. Paolo Uccello, *Rout of San Romano*, Uffizi, Florence. Uccello (1397–1475) had a particular interest in horses. His war chargers prance and snort, but never seem much fiercer than a child's stuffed animal. He was the perfect choice for a battle scene meant to decorate a private room in a villa or a palazzo.

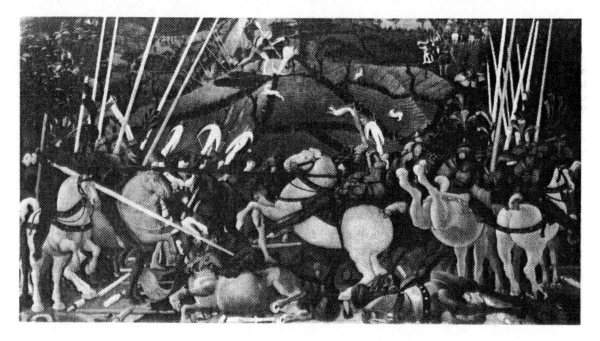

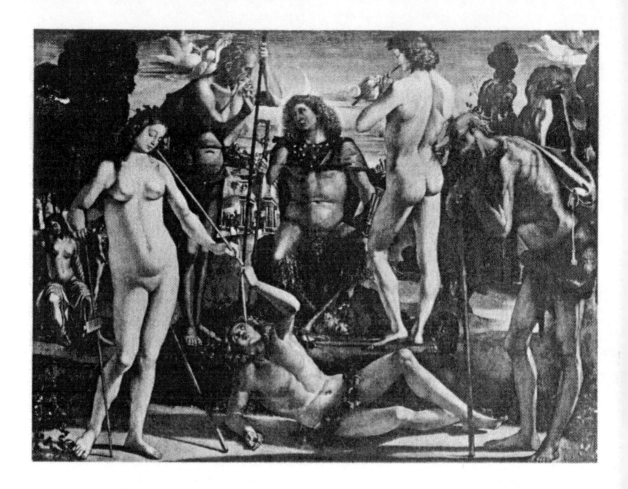

25. Luca Signorelli, *School of Pan*,
destroyed. The Umbrian artist Luca
Signorelli (active 1470–1523) seems
to have influenced Michelangelo's
figural style. Here the arcadian
atmosphere also anticipates Venetian
mythological painting of the early
sixteenth century.

ological paintings of the Renaissance. Discovered in Florence only
in the second half of the nineteenth century, it has been identified,
although not conclusively, with a lost painting made by Signorelli
about 1490 for Lorenzo de' Medici.

In Signorelli's painting, classical gods idle in the long shadows
of a late summer afternoon, lulled by the sweet sounds of the pipes
played by Pan's followers. Signorelli has caught perfectly the del-
icate melancholy of Pan, a sad but compelling creature with goat's
legs and horns, who rules this still, golden arcadia.

Each of the substantial figures (all strongly influenced by Sig-
norelli's study of sculpture, both ancient and contemporary) has
been kept close to the picture plane, near the spectator. This dis-
position of the figures creates a grid that, with the background
trees and weird rock formations to the right, makes *School of Pan*
highly decorative, appropriate for the interior of some grand room
in a Renaissance palazzo. One of the wonders of this remarkable

work is Signorelli's ability to harmonize the strong emotional qualities of the subject with the painting's function as room decoration.

A less bucolic view of nature was expressed about 1505 by the Florentine artist Piero di Cosimo in several *spalliere* originally placed in the palazzo of the wealthy Florentine Francesco del Pugliese. A panel [26] from this series, now in the Metropolitan Museum of Art, New York, illustrates a hunting scene where strange primitive creatures (or what the quattrocento considered primitive) flit through a primeval forest.

Violence reigns as animals attack other animals and as men attack the animals and each other: primitive life is pictured as chaotic and dangerous. It has been postulated that the series to which this panel belongs illustrated the development of civilization, partially through the control of fire. Indeed, in our panel the many individual struggles are seen against the smoke of a raging forest fire on the left horizon. The smoke from this fire, the strange, twisted rock formations, and the dark woods exude an ominous foreboding perfect for the primeval creatures who inhabit it.

Piero di Cosimo has given his patron a vision of a world unseen. Other such strange leaps of imagination may have been common on *spalliere*, but the lack of surviving examples makes this just a hypothesis. In any case, Piero di Cosimo was an eccentric and often disturbing artist.

Because *spalliere* in many ways supplanted *cassone* panels, it was only natural that many of the stories painted on the chests

26. Piero di Cosimo, *Hunting Scene*, The Metropolitan Museum of Art, New York. This painting is of particular interest because of the rare Renaissance depiction of primitive men in a primeval wilderness. Also noteworthy is the implication that humankind has evolved from a savage, warlike state.

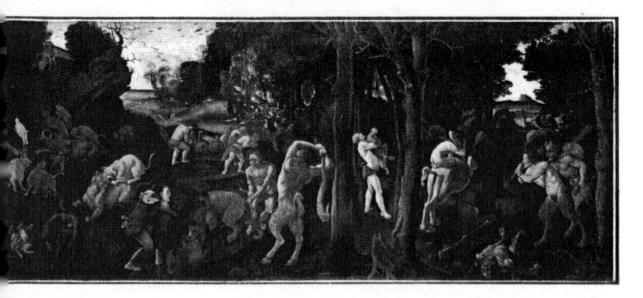

would reappear on the wall panels. This is certainly the case with Boccaccio's writings, especially his *Decameron,* which had great popular appeal throughout the Renaissance.

Until the middle of the nineteenth century, a well-known *spalliera* series, now divided between the Prado in Madrid and a private collection, was still in the Palazzo Pucci in Florence, most likely its original home. Probably commissioned to celebrate the wedding of Gianozzo Pucci and Lucrezia de Piero Bini, the panels were painted about 1483 by Botticelli.

The panels' subject comes from a famous story found in day eight of *The Decameron.* Nastagio degli Onesti, a wealthy young man of Ravenna, falls hopelessly in love with the daughter of a noble of that city. When, after much imploring, his love is not returned, he takes up residence in one of the pine woods outside the city. While dejectedly wandering in the woods one Friday [27], he sees a beautiful young woman being pursued by a mounted knight and two mastiffs. When he tries to save the woman, the knight addresses him by name, identifying himself as the spirit of Guido degli Anastagi, a citizen of Ravenna who had killed himself because the woman he now pursued, also a spirit, spurned and mocked his love.

As a punishment for her wicked behavior, the woman had been condemned to be forever chased, caught, and killed by Guido, who then cut out her heart and fed it to the ravenous dogs. Then the woman miraculously revived and the chase began anew. Seeing this, Nastagio decides to invite his love and her family to a great feast in the pine woods the next Friday, at the hour at which the horrible, ghostly spectacle took place. While seated at the table, the guests see the woman once again murdered by the knight. The significance of the appearance, explained by Nastagio, was immediately understood by his beloved, who resolves to marry him.

What a caveat for those who spurn true love! Three of the four panels are devoted to detailed depictions of the death of the cruel and cold woman. The moral of the story must have been clear to every woman of the Renaissance: love must be returned, and a man must be obeyed. Botticelli's paintings leave no room for equivocation.

Other *spalliere* espoused equally pointed themes: the stories of Lucretia, Virginia, the patient Griselda, to name just three of many, all instructed women and girls to be brave, faithful, loyal, chaste, and principled. The Continence of Scipio, the Judgment of Solomon, and dozens of other such stories set examples of wisdom, courage, and magnanimity for men and boys.[16]

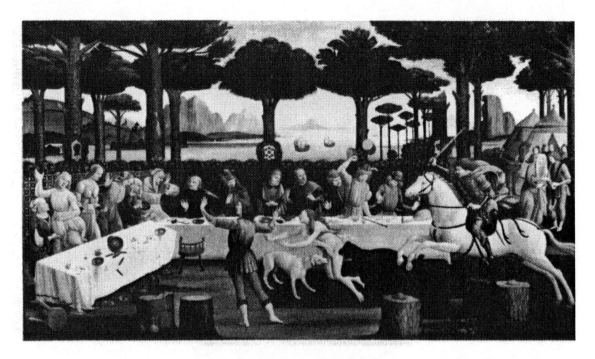

On occasion, series of ancient heroes and heroines were painted on *spalliere*. These groupings, very much like the wall frescoes of famous men and women discussed above, were found inside the palazzo or villa on panels arranged around the walls of rooms.

A group of these famous heroes and heroines, produced by several artists in Siena during the last decade of the fifteenth century, survives probably intact, although some of the paintings have suffered varying degrees of damage.[17] The eight panels include: Alexander the Great, Scipio Africanus, Artemisia, the Old Testament figure of Judith, and Claudia Quinta, a virtuous and chaste Roman heroine.

The painting of Claudia Quinta [28], by Neroccio de' Landi, is notable both for the grace of its form and color and for its subject. Claudia Quinta (her story is found in Ovid) was accused of unchastity, a charge that she disproved when the goddess Cybele showed her divine favor, and the falseness of the accusation, by enabling Claudia to single-handedly pull to shore a grounded boat bearing an image of the goddess. The Latin inscription on the painted pedestal below the figure explains Claudia Quinta's triumph, cites her chastity, and tells the viewer that prudence and virtue will prevail. The same pedestal is adorned with putti holding small crescents, the symbol of the powerful Piccolomini family, probably the patrons of the series to which the Claudia Quinta belongs.

27. Botticelli, *Episode from the Story of Nastagio degli Onesti*, Prado, Madrid. The Bible, Ovid's *Metamorphoses*, and *The Decameron* by Boccaccio, from which Botticelli took the story of Nastagio degli Onesti, were the three principal sources of Renaissance pictorial narrative.

28. Neroccio de' Landi, *Claudia Quinta*, National Gallery of Art, Washington, D.C. The Piccolomini, whose crescent moon emblem appears in this painting, were one of the great families of Siena; they produced two popes—Pius II and Pius III—and were important patrons of the arts.

On occasion, series of paintings were commissioned to dec- orate the libraries or studies of large palaces or villas. The walls of these *studioli* often were lined with elaborate paneling, sometimes skillfully decorated with intarsia. One such remarkable Renaissance study belonged to Duke Alfonso I of Ferrara, for which Giovanni Bellini made the large painting, *Feast of the Gods,* probably begin- ning it about 1505. Alfonso's *studiolo,* like others, was decorated by several paintings with linked themes. This fashion of deco- rating *studioli* became popular during the second half of the quattrocento, a derivation from older types, such as *cassoni* or *spalliere.*[18]

Alfonso was a distinguished patron with fine taste: he not only commissioned Bellini, one of the most accomplished Venetian artists of his generation, but also the foremost Venetian painter of the sixteenth century, Titian. After trying to employ no less a

light than Raphael following Bellini's death in 1516, Alfonso commissioned Titian to paint three bacchanalian scenes: *Bacchus and Ariadne* (National Gallery, London), *The Andrians,* and *Venus Worship* (both in the Prado, Madrid). Alfonso's study was a reflection of its owner's wealth, discrimination, learning, and style. The fact that it depicted sensual and titillating scenes drawn from antiquity—then the latest fashion—must also have impressed all those lucky enough to be admitted to the room in the castle of Ferrara.

Bellini's *Feast of the Gods* [29] must have set the mood for Alfonso's room, for the painting is both bucolic and voluptuous. In a sylvan setting (the background has been reworked by Titian, perhaps in an attempt to make it harmonize with his own paintings in the room), the gods take their leisure, drinking and making love. A relaxed, intimate quality about the work at once puts us at ease, creating the perfect ambience for a room where one goes to find peace and quiet. The beautifully paced rhythms of the figures (in Bellini's original background, they were echoed by a row of carefully placed trees, now visible only in X ray), the billowing leaves, and the distant mountains impart a oneness with a benevolent, pantheistic, summery nature, seen before in Signorelli's *School of Pan*.

Taking its story from Ovid, the painting illustrates the goddess Cybele entertaining the gods. Lulled to sleep by the wine, Lotis, goddess of chastity, is unaware that her skirts are about to be lifted by Priapus, god of fertility. However, he is foiled by the ass, who brays loudly, waking the drowsy gods and goddesses, who all laugh at the hapless Priapus. But, in fact, Ovid's narrative has supplied only the skeleton for the picture. The main actors—Priapus and Lotis—are there, at the right, but the painting is more about mood and nuance than about narrative action. The dominant feelings are those of languor and eroticism, fostered, in part, by a god who has slipped his hand between the kneeling Cybele's legs in the picture's center.

This shift in focus from the didactic to the erotic begins to be evident about 1500. We see how the theme of chastity, which plays so strong a role in Neroccio's Claudia Quinta and many other moralizing works from the quattrocento, now has been relegated to a secondary role. The real subject of Bellini's painting is not the dangers of wine nor the escape of Lotis; it is the sensual enjoyment and eroticism of a group of gods, who look very much like us.

Throughout the sixteenth century, large wall paintings became more obviously erotic; the sexual charge perceived in Bellini's *Feast*

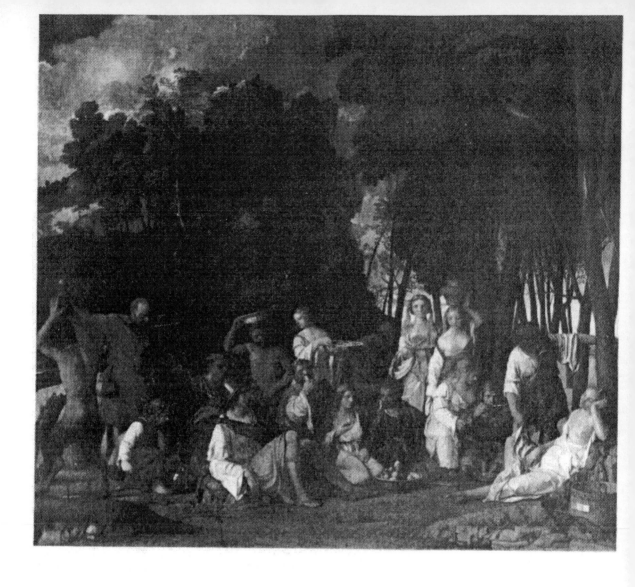

29. Giovanni Bellini, *Feast of the Gods*, National Gallery of Art, Washington, D.C. Giovanni Bellini (active c. 1460–1516) came from a family of painters. His father, Jacopo (active c. 1424–1470), and his brother Gentile (active c. 1460–1507) were artists, as was his brother-in-law Andrea Mantegna (active 1441–1506). Giovanni was over seventy when he completed this picture in 1514.

of the Gods likewise energizes many pictures meant to hang on the walls of palazzos and villas.

No moralizing or cautionary overtones burden *Jupiter and Io* [30], painted in the 1530s by Correggio, who was born near Parma. One of the most distinguished painters of the first half of the sixteenth century, he was influenced, but not overpowered, by Raphael and Michelangelo, whose inventions he incorporated in his own original, sweet style.

The size of *Jupiter and Io* (164 × 70 cm.) and its tall, narrow format reveal that it, like many other contemporary wall paintings, no longer conformed to the standard rectangular shape of the earlier *spalliere*. Nor did these later paintings necessarily provide moral

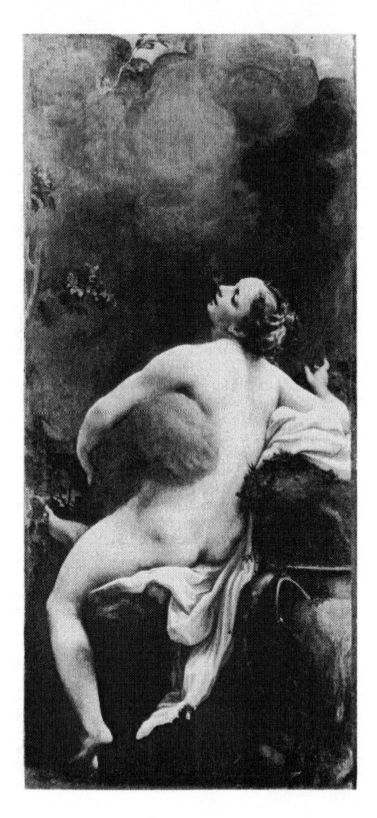

30. Correggio, *Jupiter and Io,*
Kunsthistorisches Museum, Vienna.
The companion picture to *Jupiter
and Io, Abduction of Ganymede,* is
also in Vienna. Two other paintings
by Correggio (*Leda* in Berlin and the
Danaë in Rome) seem to have
belonged to the same series made for
the Gonzaga palace at Mantua.

instruction or guidance on behavior, as did many of the earlier *spalliere* and *cassoni*.

Correggio's painting belonged to a series of mythological pictures he did for Federigo Gonzaga, duke of Mantua, who counted the powerful god Jupiter among his ancestors. To escape his ever vigilant wife, Jupiter (the Greek Zeus) turned himself into a cloud to seduce the beautiful mortal maiden Io. We see the climactic moment of the encounter. Embraced by the soft cloud, which is metamorphosing into Jupiter (his face appears just above Io's head), the woman is transported to a state of ecstasy and abandonment revealed most expressively by the sinuous rhythms of her thrown-back head and yielding arms and legs.

In concept, design, and execution, Correggio's painting is an erotic masterpiece, a frank and voluptuous portrayal of seduction, sexual delight, and the power of the gods over mortals. The nude Io, the perfect Renaissance beauty, remains an archetypal image of the soft, yielding woman seen in painting from Correggio to Picasso.

In the Late Renaissance, images of gods and goddesses, either alone or engaged in some narrative action, began to be objects treasured for themselves alone. They were still composed to decorate the rooms they graced, but they now were considered in much the same way we consider them: independent easel paintings or sculptures as notable for their form and the fame of their artists as for their function and didactic message.

This changing attitude is noticeable in one of Titian's masterpieces, the so-called *Venus of Urbino* [31], now in the Uffizi, Florence. There is uncertainty about the identity of the woman, because in 1538 the work's first owner, Guidobaldo II della Rovere, soon to become duke of Urbino, called the picture simply "the nude woman." Perhaps she was a famous courtesan or maybe just Titian's model; whatever her earthly identification, the woman is now known as Venus. Besides being the sensuous love goddess, Venus was also a symbol of marital fidelity, perhaps signified by the dog at her feet. The very fact that there exists some ambiguity about the figure's meaning demonstrates that the traditional admonitory types were undergoing substantial modification.

Possibly there were those in the Renaissance who saw moralistic overtones in Titian's picture, but surely their number must have been small, for the image they beheld is among the most inviting, direct portrayals of female sexuality ever painted. Stretched out on a rumpled bed, in an elegant, well-appointed room, the

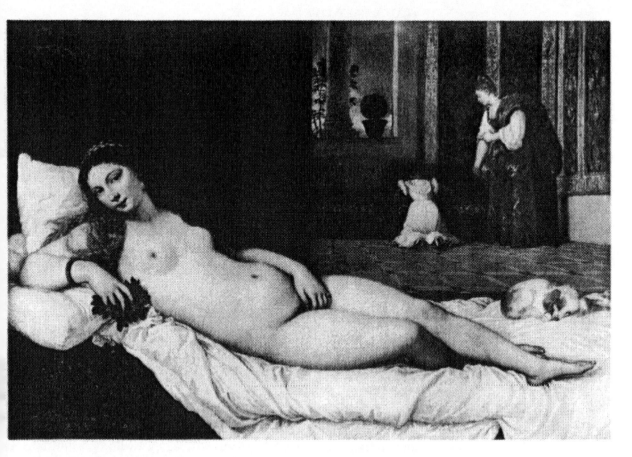

beautiful, fleshy woman gazes at the spectator, fully conscious of the provocative power of her soft hair, glowing skin, and exposed breasts. Like a Fragonard nude of the eighteenth century, or a Victorian painting of amply endowed, scantily dressed women disguised as Greeks or Romans, *Venus of Urbino* is an erotic object painted for pleasure and titillation: it is also, from Titian's hands, a great painting. It is interesting to note that a leering contemporary of Titian stated that, in comparison with the artist's *Danaë*, now in Naples, *Venus of Urbino* looked like a nun.

Titian's painting, although independent in spirit, is still reminiscent of the earlier *spalliere* in its shape; and its subject, although now seen in a different context, is found on the inside of *cassone* lids. With the decline of the painted *cassone* in the second half of the quattrocento, the lid decoration, like the subjects painted on the sides of the chest, was transferred to the wall. In this connection, it is interesting to note that the women in the background of the *Venus of Urbino* are in a large palazzo, selecting clothes for the nude woman from *cassoni*.

31. Titian, *Venus of Urbino*, Uffizi, Florence. This work depends on the Dresden *Venus* by Giorgione (1478?–1510), an early and important painter of the Venetian Renaissance. Titian, however, has awakened Giorgione's sleeping Venus and thus has established a direct and much more sensual relation with the viewer.

In his use of substantial forms and warm colors, and in the ample development of the central figure in space, Titian masterfully suited his pictorial style to his subject. Perhaps the most pivotal choice he made was to use oil paint. The range of the individual hues and the saturation of the warm, deep colors are characteristics of oil. So too is the freedom of the brush, which could flick and dart across the surface, breathing life into the lovely woman and her surroundings; the desire to make such sensuous and living images created the demand for oil paint in the first place. The older wall paintings, with their less erotic, more didactic intent needed the clarity and precision afforded by their tempera medium.

Another example of the brilliant and appropriate use of oil is a Late Renaissance mythological wall painting, Paolo Veronese's splendid *Venus and Adonis* [32] of the 1580s. The circumstances of this painting's commission are unknown, but surely it was meant to decorate a large room in a palazzo or villa, probably the latter, since its theme is concerned with hunting, a sport often engaged in by the owners of villas and their guests. It originally had a companion piece, *Cephalus and Procris,* now in Strasbourg, which was linked in composition and theme.

Veronese's *Venus and Adonis* gives us an intimate view of a touching, ill-fated love affair. Venus, nicked by Cupid's arrow, falls madly in love with the beautiful Adonis. As the goddess had always feared he would be, Adonis is killed by a wild boar during a hunt. Where the blood from the fatally gored hunter fell to the earth, scarlet anemones bloom.

In Veronese's picture, the sleeping Adonis lies sprawled across Venus's lap. As she fans the young man, the worried goddess looks at the hunting dog, hugged by a putto, who seems to be humorously parodying the two lovers. But many of those who saw this masterful picture, with its ominous sky, would have seen beyond the idyllic, tender moment to the death of Venus's beloved. They would also have been reminded of the death of Christ by the Pietà-like configuration of the bodies of the two principals. There can be little doubt that Veronese himself was aware of these associations and consciously used them in his picture to make his figures more human, and thus more universal. In fact, it is not the lush palette of reds and golds, nor the mysterious twilight, nor the taut intertwining of the monumental figures that make this such a memorable image; rather, it is the knowledge that these two gilded lovers are at the brink of tragedy. It is their humanity, rather than their godliness, that moves us.

32. Paolo Veronese, *Venus and Adonis,* Prado, Madrid. This dazzling work and its companion by Veronese, *Cephalus and Procris* (now in Strasbourg), were described in 1584 as Veronese's "most recent and exceptionally beautiful paintings." About 1650, both pictures were acquired by the painter Velázquez for the Royal Collection of Spain.

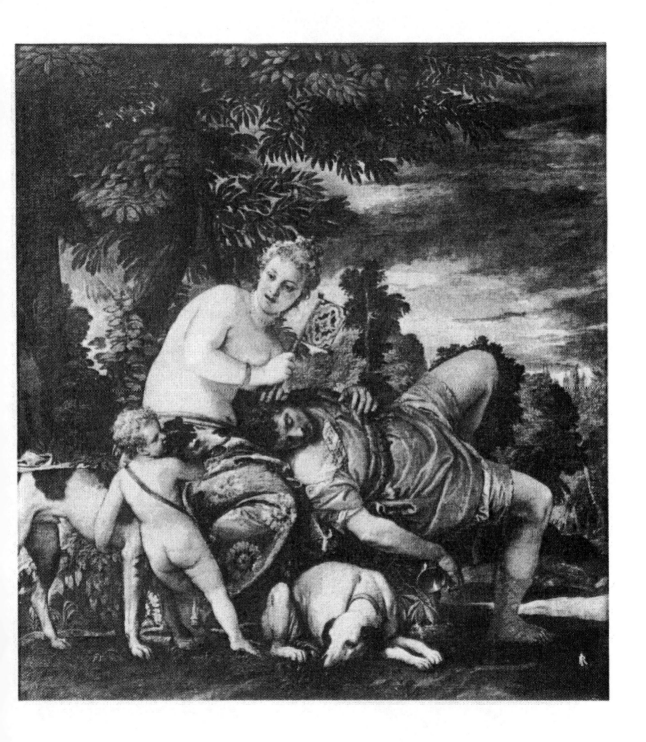

Veronese's painting implicitly demands the engagement of the viewer by its poignant evocation of emotion. How far wall paintings have developed from the simpler, less empathetic, exhortatory images that first began to decorate palaces and villas around the middle of the quattrocento. The paintings of Veronese and his Late Renaissance contemporaries are the final transformation of the type, although in much of their subject matter, shape, and location they remain firmly indebted to the past.

We have already seen that many of the *cassone* and *spalliera* paintings were obliquely concerned with Christian ethical values, but dogma and ritual found overt expression in the many types of religious paintings and sculpture found in the house.

The largest palaces and villas had separate chapels very like those found in the major churches, although on a smaller scale. Here the occupants of the house participated in the Mass, their worship enhanced by painted and sculpted images.

A splendid cavalcade of the Magi [33], painted by the Florentine Benozzo Gozzoli, encircles the famous chapel of the Palazzo

33. Benozzo Gozzoli, Chapel, Palazzo Medici, Florence. Gozzoli's liberal use of gold and the splendor of his decoration are indicative of the wealth and status of his Medici patrons.

Medici. Completed about 1460, the great painted train of the Magi fills the small room with tapestry-like patterns of form and color. The sense for overall decoration, so common to the first frescoes designed for the more utilitarian rooms of the large Renaissance home, is also apparent in Benozzo's chapel paintings.

Fresco cycles were the exception rather than the rule for the domestic chapel: seldom was there enough room to paint such extensive works. Instead, single paintings such as the now-detached fresco *Madonna of the Pazzi* [34], painted about 1450 by a close follower of Andrea del Castagno (the author of the remarkable series of famous men discussed above), filled the available wall space. The enthroned Madonna with saints was painted on a villa wall, a round window occupying the now-blank circular area at the top of the painting.[19]

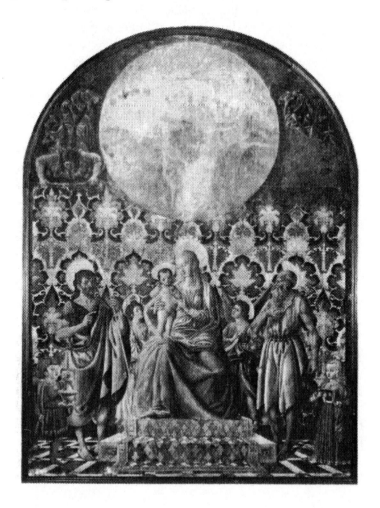

34. Follower of Andrea del Castagno, *Madonna of the Pazzi*, Palazzo Pitti, Florence. Here a close follower of Andrea del Castagno (active c. 1442–1457) has left charming portraits of a little boy and girl of the Pazzi family. The Castello Trebbio, the original location of this fresco, was purchased by the Pazzi in 1439; it remained in the family's possession until the nineteenth century.

Colorful and expansive patterns form the wall hanging and the carpet on which the Virgin's feet are placed. These festive patterns probably would have been out of place in the sober surroundings of a church, but they are quite in keeping with the other tapestry-like wall decorations of contemporary villas and palaces. The fresco's function as a private devotional image also is reflected by the inclusion of a small boy and girl to either side of the front of the throne. These charming children, who hold flowers while glancing shyly at the viewer, are obviously members of the family; in fact, they have been tentatively identified as the twins Onetta and Renato Pazzi, children of Piero di Pazzi, the putative patron of the fresco. Because this was a private painting in a domestic setting, the patron could personalize it in a way impossible within the more public, tightly controlled precincts of a church. The result is that the artist has been able to paint two intimate, endearing portraits that add to the warmth and charm of this happy fresco.

These private chapels were equipped with altars and altarpieces; usually the latter were, like the chapel itself, small in size. Because of the modifications to most palaces and villas over the centuries, many of the altarpieces have been removed from their original locations and are scattered throughout the museums and private collections of the world.

Fortunately, however, a few of these altar paintings can be traced back to their original locations, including the one that stood on the altar of the chapel in the Medici palace. This painting [35], now in West Berlin, was done about 1460 by Fra Filippo Lippi and depicts the Adoration of the Christ Child by the Virgin, the young Saint John the Baptist, and Saint Bernard; a benevolent God the Father with outstretched hands and the Holy Spirit in the shape of the dove occupy the upper part of the altarpiece.

This is not a large picture, and its dimensions perfectly suited the chapel for which it was painted. Moreover, its extensive rocky landscape and woods harmonize perfectly with the openness of Benozzo's Magi frescoes, which originally surrounded it. Lippi's *Adoration* was the physical and spiritual center of the chapel, the reason for the cavalcade of the Magi and its ultimate destination: the extensive train of Benozzo's figures begins and ends at the altar that the *Adoration* once occupied. Not only do the frescoes and the altarpiece have a symbiotic spiritual relation, they are linked by location, color, and decorative function as well.

Altarpieces were also made for rooms other than those used exclusively as chapels. One of these types was the portable triptych,

35. Fra Filippo Lippi, *Adoration of the Christ Child,* Staatliche Museen, West Berlin. The commission for the altarpiece of the chapel in the Palazzo Medici, the home of Florence's most powerful family, must have been one of the most prestigious Florentine commissions of the fifteenth century. This is demonstrated by the many later paintings influenced by the style and content of Lippi's altarpiece.

a small altarpiece with a central panel and two folding wings.[20] This type of altarpiece originated during the early years of the fourteenth century, a scaled-down version of the larger triptych types (see Chapter II) popular at the time.

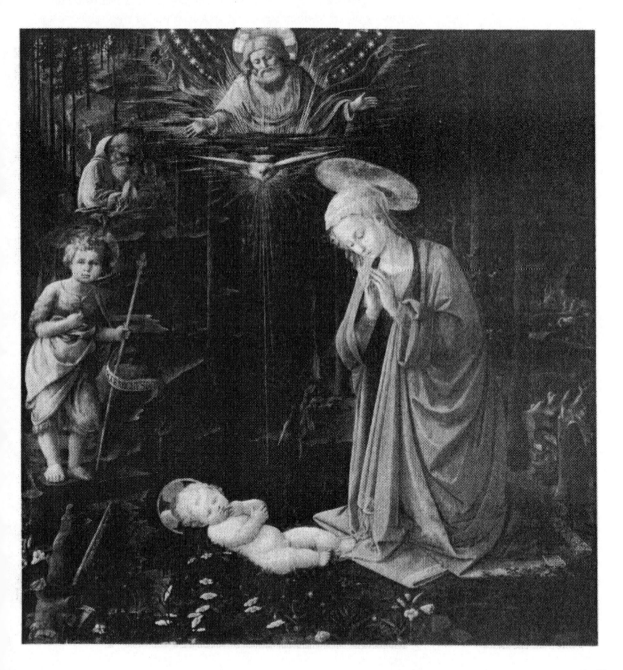

The size, shape, and construction of the portable triptych enabled it to function as a movable altarpiece. This small version could be set up in various rooms in the living quarters (sick room, improvised chapel, dining room) and probably at the office or shop as well. Moreover, the portable triptych could serve as an altarpiece for many of the various lay social organizations of the Renaissance. It could, if it was small enough, also be carried with the owner on a trip.

These small triptychs were conceived and constructed to be portable. Each of the hinged outside wings covered one half of the center panel, ensuring that the holy images would be protected from damage. Because they were visible when the altarpiece was not in use, the backs of the wings were decorated with figures or painted to look like marble.

A triptych [36] from about 1375, now in the Indiana University Art Museum, by the Sienese artist Niccolò di Buonaccorso is typical of the earliest type of portable triptych. Set on a decorated base, the work displays the characteristic panel shape and crocketed frame of many fourteenth-century triptychs. The tempera painting on the back of the wings and central panel skillfully imitates marble;

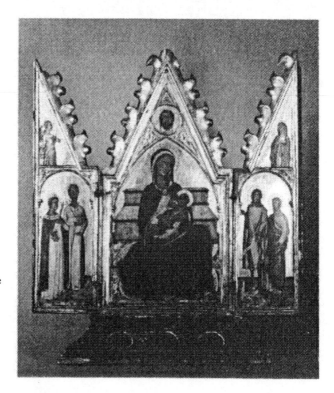

36. Niccolò di Buonaccorso, Triptych, Indiana University Art Museum, Bloomington. Many of the surviving triptychs of this type lack the base and the carved frame decorations, which frequently broke as the work was moved. This example retains the fictive marble often painted on the back of the center panel and wings.

when the triptych is closed it presents a handsome, highly deco-rative appearance.

When opened, the wings reveal a central panel occupied by the Madonna of Humility. The Virgin is seated on the ground before what appears to be a short flight of stairs; in this way her humbleness and her closeness to the spectator are emphasized. Each of the side wings contains several saints, all probably specified by the owner of Niccolò's triptych. There is a delicacy about the individual figures and the shape and the frame of the panels that is in perfect accord with the triptych's portable, precious nature.

By the time of Niccolò's altarpiece, the portable triptych had already begun to decline in popularity. From its apex about 1340, the type gradually lost favor until by the middle years of the fif-teenth century it was rare. However, in some places in the Italian peninsula, notably Siena, the portable triptych still was produced into the sixteenth century.

One of these late triptychs [37], dated 1487, is by the Um-brian artist Niccolò di Liberatore of Foligno, called L'Alunno, an eclectic and highly productive artist active during the second half of the fifteenth century. Rectangular in format, with the wings divided into two pictorial fields, his triptych is very different from the earlier example by Niccolò di Buonaccorso. The altarpiece is no longer occupied by images of the Madonna, Child, and saints, but is devoted to a series of five separate narratives, each with its own landscape background. In the center is the Crucifixion, the hub around which scenes of the Agony in the Garden, the Way to Calvary, the Pietà, and the Resurrection revolve. Instead of centering on several holy images, Niccolò di Liberatore's painting is a series of independent, illusionistic narratives, each illustrating one step in the process of Christ's death and resurrection, a se-quence perfectly suited to its function as an altarpiece before which the Mass was said. The static, timeless image of Niccolò di Buo-naccorso's triptych has been replaced by a more temporal arrange-ment; this major contextual change, as we shall see in the next chapter, was paralleled by large altarpieces made for churches.

An even more miniaturized altarpiece for domestic worship, the diptych, was probably used for private devotion, meditation, and protection rather than for formal liturgical service.[21] As its name denotes, the diptych was made of two hinged panels that closed just like the covers of a book, and, in fact, many of the diptychs were no larger than this volume.

Diptychs were the most popular during the early part of the

Renaissance, although scattered examples survive from the fifteenth century. These small panels were truly portable; slipped into a large pocket or a saddlebag, they could be carried anywhere by their owner and set up at night by the bed or on a nearby chest.

Several subjects were often found on diptychs: the Crucifixion and the Madonna Enthroned; the Dead Christ and the Madonna and Child; Saints and the Madonna and Child. The backs of the panels, visible when the diptych was folded, were sometimes painted to imitate marble and show the owner's coat of arms.

A small Sienese diptych [38] from about 1400, now in the Philadelphia Museum of Art, is painted with a Madonna and Child on the left wing and Saint Jerome on the right wing. Perhaps the patron was a namesake of the saint, or in some other way specially attached or devoted to him. If this is the case, the choice of Saint Jerome personalizes the painting, enhancing the intimacy of this object designed for personal devotion.

In fact, the Sienese painter of this diptych has skillfully suited his style to the intimate nature and size of the diptych by depicting cozy interior settings of the rooms (note the tiny book and spindles of the Madonna, the finely inlaid desk of Saint Jerome) and by making the figures themselves delicately appealing, almost as though they were artfully made dolls. Although some painters—such as Duccio, the founder of the Sienese school of painting—could make

37. Niccolò di Liberatore, called L'Alunno, Triptych, National Gallery, London. Niccolò di Liberatore belonged to a generation of Umbrian artists working during the late fifteenth century. Eclectic and of varying skill, these painters produced simple narrative paintings for many small towns of the region.

38. Sienese, Diptych, Philadelphia Museum of Art. The identity of the artist responsible for this little diptych is unknown. It has been attributed to Pellegrino di Mariano, Tommaso da Modena, and to an anonymous Sienese painter working about 1400. The latter now seems the most likely.

even tiny diptychs look monumental, their small size and scale on the whole reflect many affinities with miniature manuscript painting.

Unlike diptychs and triptychs, meant for wealthy patrons, there were what might be termed "popular" religious paintings, intended for a humble domestic setting. It appears that these works were inexpensive, meant for the modest home of an artisan or small shopkeeper rather than for a large palace or villa.[22]

A small triptych (originally it was a rectangular panel, but it has been sawed into its present shape) in the Longhi collection in Florence may well be the sole surviving example of this type of object, once produced in quantity. Representing the Madonna and Child Enthroned flanked by four saints [39], it is a scaled-down copy of larger altarpieces found in churches.

Painted during the early years of the fourteenth century, probably by a Tuscan artist, the work displays a crudity of design and execution that leads one to believe that its author was working outside the conventional standards of painting, which were more accomplished and sophisticated. There is an almost folklike stridency and naive quality about the Longhi altarpiece, which arises from the strong patterns of alternating red, green, and white on the throne, the hot-red cloth of honor behind the Madonna, and the red halos. The background, carelessly painted yellow to imitate gold, suggests that this was a low-cost, popular altarpiece.

Perhaps the author of this little picture ran a shop specializing

39. Florentine, Altarpiece, Collection Roberto Longhi, Florence. The crudity of this work suggests that it was painted by an artist trained outside the Renaissance workshop system. Every artist who went through the long apprenticeship of the workshop had a level of craft higher than that seen here.

in cheap, quickly produced images that were made in imitation of famous works found in churches.[23] Such images as the one in the Longhi collection must have been discarded as fashion changed, but it is probable that there was a whole class of similar objects, just as in the nineteenth century there existed a type of saccharine religious print that has now almost disappeared from popular devotion.

Another popular painted object from the Renaissance house is the so-called *desco da parto*. These wooden trays, usually painted on both sides, are called birth platters or salvers, because they were used to carry sweets to a new mother; in fact, they were often probably given as wedding gifts.[24] Such trays were equipped with a lip to keep objects from falling off them. Until about 1400 most trays were twelve-sided, but shortly after this date the circular tray came into fashion. Probably the tray was left as a present and then treasured and used in the house. Sets of maiolica ware (a type of tin-glazed pottery) were also used for the same purpose. However, as we shall see, many of the trays called *deschi da parto* in fact must have been given to the bride at the time of her marriage, as talismans of fertility.

Now in the Metropolitan Museum of Art in New York, a salver [40 and 41] meant for the new mother is by Bartolomeo di Furosino, a minor Florentine artist. Dated 1428, it depicts, on the front, a bedroom in which we see the new mother and baby, and on the back, an infant in a landscape. Such domestic scenes afford rare glimpses into the intimate setting of the birth chamber. The mother is the center of attention; she is visited by friends and attended by servants, who bring her food on trays very like the one on which the scene is painted.

Giving birth, like many other momentous occasions in the life of the Renaissance man or woman, was often a much more public event than it is today. Even intimate events, such as the consummation of a marriage, which we consider of the utmost privacy, were scrutinized for compliance with religious-legal requirements.

On the back of the Metropolitan Museum's birth salver is a large, chubby nude infant ringed by an enigmatic inscription: "May God grant health to every woman who gives birth and to the father . . . may [the child] be born without fatigue or peril. I [the nude child in the landscape] am an infant who lives on a [rock?] and pees silver and gold." We have lost the meanings of the inscription,

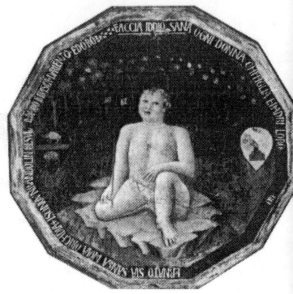

40. Bartolomeo di Furosino, *Birth Scene,* The Metropolitan Museum of Art, New York. It is not known where these double-faced birth salvers were kept in the Renaissance home. Perhaps they were hung on a wall when not in use; in this way their talismanic images could be seen every day.

41. Bartolomeo di Furosino, *Infant,* The Metropolitan Museum of Art, New York.

the pinwheel the child holds, and the sword he wears. On each side of the infant are coats of arms, probably the mother's at our right and, to our left, the father's.

Obviously the back of the Metropolitan salver is a sort of talisman, a charm to protect against the dangers of childbirth, which claimed so many victims during the Renaissance. As in many painted and carved objects from the period, there is here a magical element, a sort of spell to ensure an easy birth and health for the father and mother.

Certainly, the salver in the Metropolitan Museum was a true birth tray, or *desco da parto,* used to carry sweets to the new mother. Other salvers, however, seem to have had a different purpose. One of these, from about 1470 (now in the North Carolina Museum in Raleigh), by the workshop of the Florentine Apollonio di Giovanni, depicts a Triumph of Chastity on the front, and, on the back, two nude boys [42 and 43].

Triumphs—of Fame, Chastity, Love, and Death—were common on Renaissance *cassoni* and painted trays. Taken from Petrarch's *Trionfi,* they were used to make certain moral points. Apollonio's salver extols the virtue of Chastity.[25] For the Renaissance, Chastity meant, besides purity, modesty and humility, qualities demanded of the good bride, and an object such as the North Carolina Museum *desco* serves as a continual exhortation of virtue.

Unicorns pull a triumphal cart carrying Chastity, who holds a palm leaf. Unicorns symbolized female chastity and purity: the horn of the beast, it was believed, purified whatever it touched.

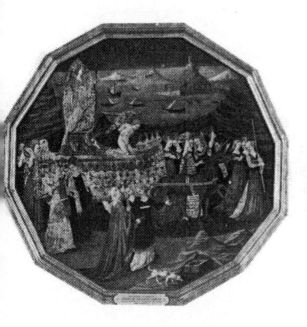

These symbols may also have had reference to the bride's virginity, for the imagery of this and similar *deschi* suggests that they were wedding gifts rather than birth presents.

Such speculation is reinforced by the images on the back of the Raleigh salver, where two nude boys stand beneath the customary coats of arms, probably those of the families of the bride and groom. One of the boys urinates on a seed pod held in the outstretched hand of the second youth, who carries another pod in his left hand. The seed pod is, of course, a symbol of fertility, and urination must have had a similar symbolism; recall the inscription on the back of the Metropolitan Museum salver.

Taken together, both sides of the Raleigh *desco* suggest the salver celebrated a wedding or betrothal. Like most Renaissance objects, it functioned on many levels: as a reminder of virtuous conduct, as a fertility charm, as a useful object, and as decoration.

The theme of the bride's submission to the husband, so often seen on *cassone* panels, also appears on a fifteenth-century *desco* [44 and 45], now in the Museum of Fine Arts in Boston. Painted in Ferrara by an artist close to Lorenzo Costa (one of the painters who worked on the frescoes of the Palazzo Schifanoia), it depicts on its front the Meeting of Solomon and Sheba, that classic tale of womanly adoration and submission. Like the *cassone* paintings of the same subject [20], the *desco* furnished a famous model of correct wifely behavior, and it was also pondered by the family's children, who would have absorbed its not-so-subtle message.

42. Workshop of Apollonio di Giovanni, *Triumph of Chastity*, North Carolina Museum of Art, Raleigh. The large, elaborate floats seen in many paintings of Renaissance Triumphs probably reflect the actual conveyances used in civic and religious processions of the time; many were designed by famous artists.

43. Workshop of Apollonio di Giovanni, *Two Nude Boys*, North Carolina Museum of Art, Raleigh. Putto-like boys are often seen on the backs of *deschi*. Holding seed pods or cornucopias, or fighting, they must have had a talismanic power to ensure fertility.

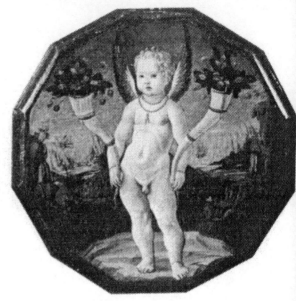

44. Ferrarese, *Meeting of Solomon and the Queen of Sheba,* Museum of Fine Arts, Boston. It has been suggested that this composition is a copy of a work by the Florentine painter Domenico Veneziano (active c. 1438–1461). Although part of an independent local school, the painters of Ferrara borrowed freely from the Florentines and other Tuscan painters.

45. Ferrarese, *Putto,* Museum of Fine Arts, Boston.

The salver in Boston would have given great visual delight as well, for the meeting takes place in one of those idealized cityscapes so dear to Renaissance artists. Centered on a temple seemingly inspired by the work of the distinguished Florentine architect Leon Battista Alberti, the stage-set architecture, with its springy arches and smooth columns supported on a checkerboard pavement, provides a sprightly but dignified setting for the elegant groups of men and women in the trains of the two protagonists.

On the back of this twelve-sided *desco* (a form already a bit old-fashioned by the time of the painting, c. 1460) is a large, winged putto. Wearing necklaces of coral (coral protects against evil) and holding two cornucopias in his hands, he occupies the center of an extensive landscape. The cornucopias, overflowing with blooms, and the florescent landscape are obvious visual metaphors for fertility, analogous to the seed pods held by the children in the Raleigh salver. Like that *desco,* the Boston painting must surely have been presented not at a birth, but at a betrothal or wedding.

In most surviving examples of *cassoni, spalliere,* and *deschi,* the moral lessons are aimed at the bride: it was her conduct that determined the lineage and stability of the family, and the paintings are, in fact, agents of social control. There are, however, several paintings that seem directed toward the husband. One of these is a salver [46] now in the Ca' d'Oro in Venice, an early work of about 1495 by the Sienese artist Girolamo di Benvenuto depicting the Choice of Hercules, an ancient theme that fascinated the Renaissance.

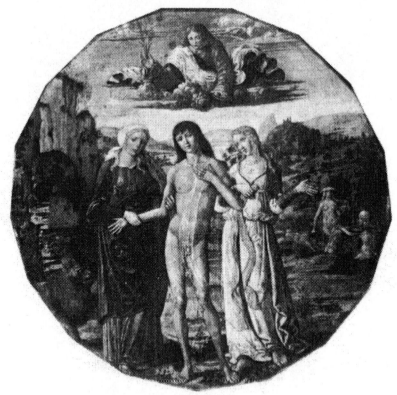

46. Girolamo di Benvenuto, *Choice of Hercules*, Ca' d'Oro, Venice. Girolamo di Benvenuto (1470–1524) belonged to a generation of painters active in Siena during the early sixteenth century. He and his contemporaries were the last Sienese artists working in the strong traditional style of the Sienese school. After the middle of the century, the city lost its last vestiges of political and economic freedom and became dependent on Florence.

Standing between the beautiful figures of Virtue, at the left, and Vice, at the right, Hercules is torn between the two. Above, a flying figure (probably Father Time) blesses the nude youth. The steep and rocky path of Virtue, which Hercules is about to choose, contrasts markedly with the soft hills and plains at the right, where nude men and women luxuriate in limpid pools. The message is clear: the hard and steep path of Virtue is the correct—and only—moral choice.

This salver is made specially beautiful by its lithe, wonderfully intertwined figures and its panoramic, atmospheric space. A number of salvers such as this testify to the skill and artistry lavished on what must have been a treasured object of the Renaissance home.

Many other painted objects from the Renaissance dwelling have perished over time. Some types survive in such small numbers that it is difficult to say much about their use and popularity: one of these is the painted shield, which is known only in several extant examples. These shields, such as the one [47] by Andrea del Castagno depicting the youthful David (now in the National Gallery of Art, Washington, D.C.), surely were never meant to stop a sword's blow. By the middle of the fifteenth century, when

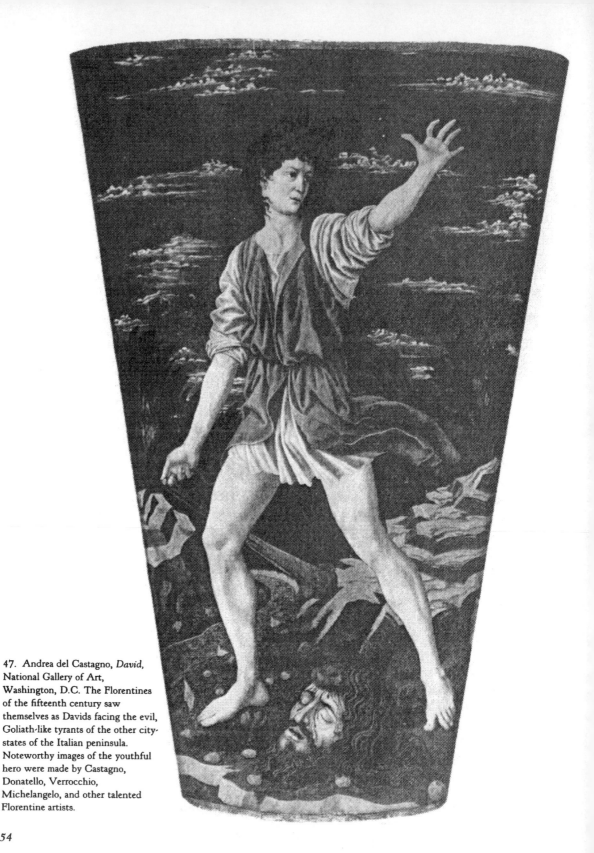

47. Andrea del Castagno, *David*,
National Gallery of Art,
Washington, D.C. The Florentines
of the fifteenth century saw
themselves as Davids facing the evil,
Goliath-like tyrants of the other city-
states of the Italian peninsula.
Noteworthy images of the youthful
hero were made by Castagno,
Donatello, Verrocchio,
Michelangelo, and other talented
Florentine artists.

the Washington shield was painted, steel armor was in use, manufactured by armorers famed for their strong and beautiful products. Castagno's leather shield was meant for display, perhaps for use in a parade or other ceremonial occasion.

The shield's decoration skillfully acknowledges both its shape and its traditional function. David's vigorous pose, spread across the surface of the object, first catches our attention, then sends it, through his outstretched arms, hands, and legs, across the painted surface. The figure's wide-set limbs, moreover, form a triangle that gently counters the larger, inverted, truncated triangle of the shield itself.

All the figurative elements of the painting—the robust, youthful hero who towers over the head of the slain Goliath; the harsh, rocky landscape; the swiftly gliding clouds—form an action-filled image very much in keeping with the traditional, martial, role of the shield. The ferocity depicted on the Washington shield certainly must have been desired by both patron and artist alike.

The Renaissance house also contained many pieces of elaborately painted furniture.[26] Surviving parts of painted beds indicate that these important objects were often decorated by prominent artists with both religious and mythological scenes. We have already seen that many painted chests from the period survive, but there were also painted cabinets and other pieces of furniture, which now exist only in fragmentary form. Other household objects, such as mirror frames, were also often decorated, sometimes by artists of remarkable talent.

Five small panels from about 1490, by the Venetian painter Giovanni Bellini, are parts of a now-fragmentary mirror frame. A sort of miniature version of the large-scale paintings that graced the walls of Renaissance homes, they illustrate complicated allegories [48] set into landscapes of great calm and gentleness. The importance of this commission to Bellini can be measured in the high quality of the design and the care taken in the painting of the panels: the Renaissance did not necessarily consider the commission for a painted mirror frame as less important than a commission for an altarpiece. Bellini's masterful little panels help us see in what high esteem the Renaissance held the decoration of functional objects.

Dozens of skillfully painted objects, many of a type or with a function unfamiliar to us, furnished the Renaissance palace or villa, which was itself decorated with frescoes and wall paintings, many by the distinguished artists of the time. Moreover, within

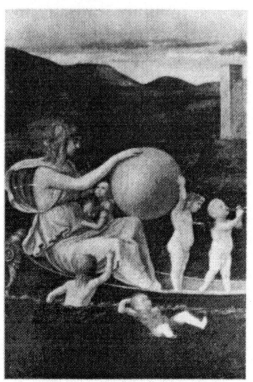

48. Giovanni Bellini, *Allegory,* Accademia, Venice. The exact meaning of many Venetian allegories escapes us. Bellini's little picture, like others of the period, has a subject whose meaning was probably apparent only to a small circle of learned patrons.

the types themselves there is a diversity and inventiveness that make them among the most fascinating survivors of the period.

The Renaissance home also housed many carved and cast objects, each of a specific type. One of the most popular of these was a small image, usually of the Virgin and Child, often set within a niche or tabernacle formed by fluted pilasters supporting a pediment. These objects could easily be hung on the walls of the rooms used for sleeping or eating. They seem, for the most part, to have been made of inexpensive materials and, consequently, to have been cheap enough to be extremely popular. A number of paintings depicting sacred scenes taking place in a home show us how these little tabernacles looked in their original settings.

Terracotta was the preferred material for the little tabernacles; it was extremely durable and cheap, and—with its glazed and enameled surface—its luminous, shining color must have enlivened even the darkest room of a Renaissance villa or palace.[27] Because of the demand for these terracotta tabernacle reliefs, highly successful compositions were molded and produced in many examples. "Mass production," however, did not diminish the quality of most of the tabernacles, which, like the fine example by Luca della Robbia

of about 1460 [49], now in the Metropolitan Museum of Art, are among the most felicitous products of the Renaissance artist's shop.

Set in a protecting niche decorated with the owners' coats of arms, the youthful Madonna and the plump, nude Child of the Metropolitan relief are attractive and accessible. The closeness of the holy pair, their intimacy and vulnerability are emphasized in such reliefs. These are perfect images for domestic contemplation: neither dogmatic nor forbidding, they invite empathy and offer solace.

Moreover, their presence in the home enlivened the eye even as it comforted the soul. The Metropolitan relief, for example, is beautifully enameled and gilded. The figures are colored with the milky white glaze so characteristic of Luca della Robbia's holy beings, the eyes are picked out in blue, and the hair was originally highlighted with gold. A strong contrast to the ethereal luminescence of the figures is provided by the shell-like niche, which is a bright blue decorated with gold on the moldings.

More expensive, unique images were produced by sculptors working in marble or other types of stone. Often molds would be made of the stone originals to produce copies in the less expensive terracotta or stucco.

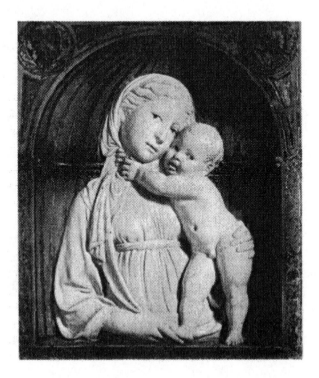

49. Luca della Robbia, Tabernacle, The Metropolitan Museum of Art, New York. Many of the objects made by Luca della Robbia (1400–1482) were replicated by his shop and sold in considerable number. Such replication was not considered derivative, but was seen as a perfectly acceptable way to disseminate a particular object, such as a small tabernacle.

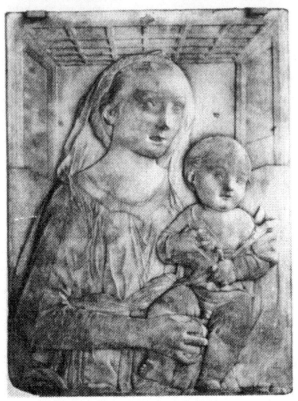

50. Francesco di Simone Ferrucci, *Madonna and Child*, Victoria and Albert Museum, London. Francesco di Simone Ferrucci (1437–1493) was a Florentine whose style derived from several major sculptors, including Desiderio da Settignano and Verrocchio. This *Madonna and Child* depends closely on the style of Desiderio da Settignano.

A particularly charming example of a Madonna and Child relief in stone is that by Francesco di Simone Ferrucci, now in the Victoria and Albert Museum, London [50]. Carved and designed with liveliness and energy, the beautiful young mother and her round-faced son are appealing and familiar. Dressed like a young matron of the fifteenth century, with her hair shaved high on her head and her eyebrows elegantly plucked, Francesco di Simone Ferrucci's Madonna must have been both accessible and comforting to the family in whose house she was placed. The intimacy of the work is further enhanced by the carved enclosure. With its rectangular windows or doors at the sides and its coffered ceiling above, it could be a room in any palazzo of the fifteenth or sixteenth century. The familial joy of this happy relief demonstrates the artist's understanding of its function as a religious image intended for a domestic setting; size, imagery, and the impressive sense of intimacy engendered by the figures all make this point.

Besides molded and carved reliefs, there were a number of Madonna and Child pictures on panels found throughout the Renaissance home. These were often about the same size as the sculptural reliefs, and they often shared similar elements, such as framing or niches. They probably were not altarpieces; rather, they seem

for the most part to have been simple devotional images, much in the manner of religious prints: they were protective images to admire, and sources of inspiration, but they were not part of liturgical ritual.

A Madonna and Child [51] now in the National Gallery of Art in Washington, D.C., shares many compositional and emotional elements with the modeled reliefs from the same period. Painted by Filippo Lippi about 1440, it is reminiscent of the Madonna and Child relief by Luca della Robbia in the Metropolitan Museum of Art.

The subject of the Madonna and Child pervaded Renaissance imagery, and to the most inventive artists it always presented a challenge. There were scores of ways that the two figures could be drawn or carved, and the psychological interaction of Mother and Child presented another set of options. Thus this simplest of subjects offered an almost infinite range of expression.

Filippo Lippi's painting encloses the two young figures in a niche, as did Luca's relief. The holy beings approach the spectator both physically and psychologically, but the mood is more somber than in Luca's playful work. Filippo's Madonna seems troubled, her gaze apprehensive; she holds her son close, in an almost distracted way. A tremor of Christ's passion, crucifixion, and his mother's sorrow runs through this painting.

Images of the Madonna and Child in small bronze relief were also found throughout the Renaissance home. Expensive and hard to work, bronze was a luxury material used for many small objects that graced the palazzo or villa.[28] Some of these objects were religious in nature—reliefs and statues of holy figures, small narrative panels, and so forth—while others were frankly secular. In fact, the latter were among the first objects made exclusively for connoisseur collectors.

One bronze type, called an *image de chevet* (bedside image), was a little relief often attached to the curtains that surrounded the grand beds of the Renaissance.[29] The bed's headboard, painted with sacred figures, and the *image de chevet* would watch over the sleeper, protecting him or her during the night.

A bronze bedside Madonna and Child relief from about 1450, by a Florentine sculptor working in the manner of Donatello, is known in many examples [52]. Bronze images, like those in terracotta, were often duplicated during the Renaissance. The fact that this little bronze Madonna and Child survives in numerous examples suggests that it must have been popular indeed.

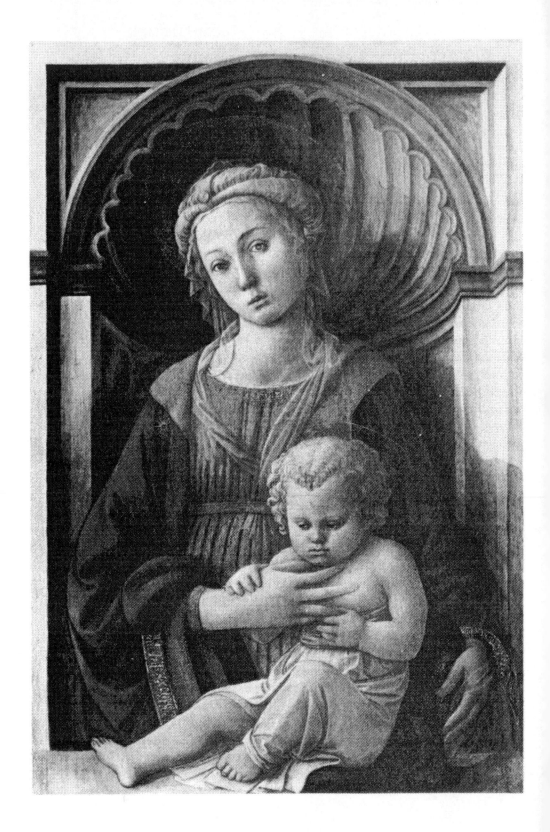

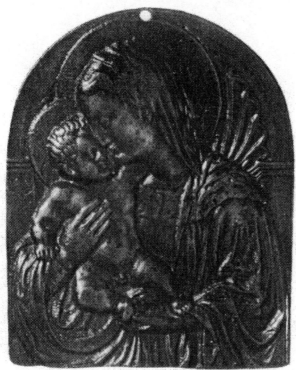

Perhaps based on a famous Madonna and Child marble relief in Berlin by Donatello, known as the *Pazzi Madonna,* the bronze *image de chevet* (the example illustrated here is in the National Gallery of Art, Washington, D.C.) incorporates the same shell niche we have observed in the Luca della Robbia and Filippo Lippi versions of the subject. Here, however, there is a tragic intensity as the serious Madonna holds her baby close to her while she stares sorrowfully into his little face. There is a remarkable compression and economy in this small composition.

Renaissance sculptors also produced small bronze reliefs of subjects other than the Virgin and Child.[30] Illustrating both traditional religious subjects and the mythological stories and figures so favored by the Renaissance patron, these reliefs were mounted on a wall or placed on a shelf, pinned to a hat, hung around the neck, or attached to a cloak or robe.

Another popular subject for the small bronze relief was Saint Sebastian. The saint, shot through with arrows, is tied to a column on a fine relief of about 1500 in the National Gallery of Art, Washington [53], attributed to the sculptor known as Moderno.

Because he recovered from his many arrow wounds, Sebastian became the plague saint (later to be replaced by San Rocco, or Saint Roch). His image would protect against the endemic plague

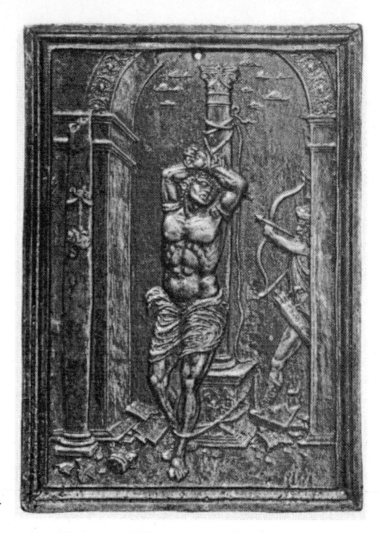

53. Moderno, *Saint Sebastian*, National Gallery of Art, Washington, D.C. Small bronze plaquettes of both religious and secular subjects were collected throughout the Renaissance. Moderno was perhaps the most prolific maker of plaquettes, his output consisting of at least fifty-nine different examples.

that often burst into epidemic proportions, killing vast numbers in town and countryside. Like those of Saint Christopher, images of Saint Sebastian abounded.

Small bronzes such as the one by Moderno were personal in the most literal sense of the word: they were worn on the body or kept close to the owner on the bed's curtains or headboard. However, these little reliefs, or plaquettes, were more than just simple amulets; they were often highly refined, technically sophisticated works of art. The Washington bronze, with its careful, accomplished modeling, elegant figures, and scudding clouds, is, despite its size, a polished performance by a talented artist, a masterful adaptation of figure to size and material.

Moderno's evocation of a pagan interior decorated with statues of the gods and goddesses alludes to both Sebastian's and Chris-

tianity's triumph over paganism. Similar moralizing allusions allowed a wide range of Classical motifs and images to enter the art of the Renaissance, but never to dominate it; like the background in the Moderno *Saint Sebastian,* they passed through a Christian lens.

This attitude toward the ancient pagan myths informs another bronze plaquette, also in the National Gallery of Art, Washington. By the North Italian artist Andrea Briosco, called Riccio—perhaps the greatest designer of Renaissance small bronzes—the relief of about 1510 represents Venus chastising Cupid [54].

Obviously, this plaquette did not possess the occult power of Moderno's *Saint Sebastian* or the *image de chevet* with the Madonna and Child. It was not meant to be a talisman. Rather, it was valued and appreciated for its considerable formal qualities. The complicated pose of each fleshy figure, the relationship be-

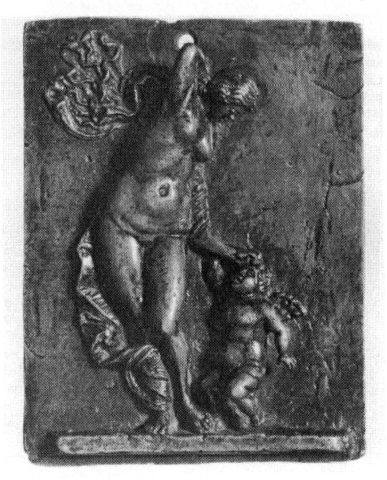

54. Riccio, *Venus Chastising Cupid,* National Gallery of Art, Washington, D.C. Cupid, son of Venus, was a mischievous creature whose arrows caused much trouble among gods and humans. He was often punished for his misdeeds by Venus, Diana's nymphs, or Minerva.

63

tween the two active bodies, and the contrast of Venus and Cupid with the smooth expanse of bronze on which they are set, like elegant figures in a stately frieze, are all masterly.

Yet, the Renaissance owners of such plaquettes did look beyond their formal elegance and refined craftsmanship. These objects—like the *cassoni,* the frescoes, and the paintings hanging on the walls—emitted messages, albeit sometimes of great subtlety, about moral conduct; these messages were amplified by sermons, by books, and by the society in which both patron and artist lived.

For example, Riccio's *Venus Chastising Cupid* is both a skilled work of art and a representation of the celestial Venus (often depicted nude), who, as a symbol of divine and eternal love, chastises Cupid for his misdeeds. Such a Venus could be seen as a symbol of the chaste, divine, and eternal and also as a beautiful, corporeal figure; the two views must have helped reconcile the conflicting moralizing and sensual desires of Renaissance patrons.

Little plaquettes such as *Venus Chastising Cupid* may have been attached to furniture or to columns, occasionally worn, or simply collected. Displayed in special cabinets or just arranged on a sideboard or chest, they testified to their owner's refined taste and wealth. In fact, plaquettes such as the superb *Grazing Bull* [55] by the Paduan artist Bartolomeo Bellano, with its daringly foreshortened bull set against the abstract expanse of bronze, must

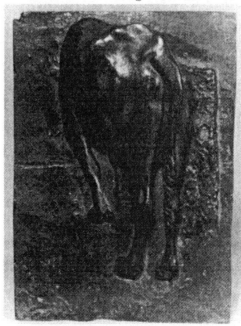

55. Bartolomeo Bellano, *Grazing Bull,* Ca' d'Oro, Venice. Renaissance artists made many bronze images of animals. Bronze frogs, birds, snakes, crabs, and many other creatures—some of them cast from life—enlivened Renaissance household decoration.

have been one of the first type of objects actively sought out by a new type of patron: the collector.

These neophyte collectors were inordinately fond of objects made of bronze. Although costly and difficult to work, bronze was durable and highly suitable for detailed, small-scale castings that could be easily handled and displayed. Bronze both challenged and rewarded the sculptor, whose virtuosity and artistry were honored, in turn, by collectors rapidly becoming connoisseurs.

Bronze statuettes were found in the Renaissance home from about the middle of the fifteenth century on.[31] Much in demand, the type engaged even the most famous and talented sculptors, and, by the sixteenth century, it had developed considerable complexity.

Vecchietta, a Sienese painter and sculptor, created an accomplished bronze statuette, *Winged Figure with Cornucopia* [56], now in the National Gallery of Art, Washington. Probably from about 1470, this comely female is a marvel of balance and poise. The elegant carriage of the body and the splendid modeling of the gleaming bronze were exactly the kinds of brilliant solutions to formal problems (how to put the figure in space, how to proportion it, how to relate its mass to the surrounding space) that were just beginning to interest collectors.

Yet, aside from the considerable formal qualities of the piece, there are other reasons why such a statuette might be welcomed into the Renaissance home. Undoubtedly inspired by antique art, the winged statuette with its large cornucopia must represent Abundance, the foundation of well-being. Also, the scallop shell on which the figure stands is a symbol of fertility and birth. The two symbols—cornucopia and shell—thus relate the statuette to the salvers, *spalliere,* and other Renaissance objects that were fertility talismans.

Antique art and mythology strongly influenced the makers of bronze statuettes, but these artists never sacrificed their own idioms or styles to the classical past, which they viewed not as part of their own tradition but as an almost inexhaustible well of inspiration.

Nowhere is this independence of interpretation and form seen better than in the statuettes of Riccio, the author of the *Venus Chastising Cupid* relief discussed above. Riccio's memorable statuette (c. 1500) of two satyrs [57] demonstrates once again that the small-scale bronze was capable of attaining the pinnacle of artistic originality and quality.

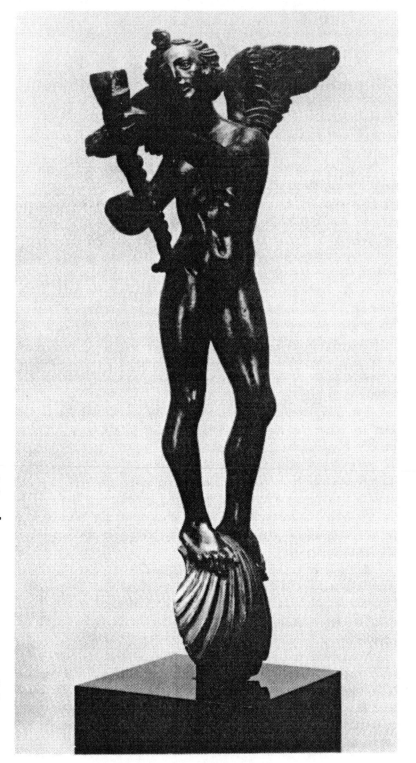

56. Vecchietta, *Winged Figure with Cornucopia*, National Gallery of Art, Washington, D.C. Lorenzo di Pietro, called Vecchietta (1410–1480), like several of his Sienese contemporaries, worked in paint, stone, and bronze. He was especially skillful in the latter and was awarded the important commission for the large bronze tabernacle for the high altar of the Siena cathedral.

57. Riccio, *Two Satyrs*, Victoria and Albert Museum, London. Andrea Briosco, called Riccio (c. 1475–1532), was born in Padua. Strongly influenced by Donatello, he was one of the principal sculptors in and around Venice. He is perhaps the greatest Renaissance master of the small bronze plaquette and statue.

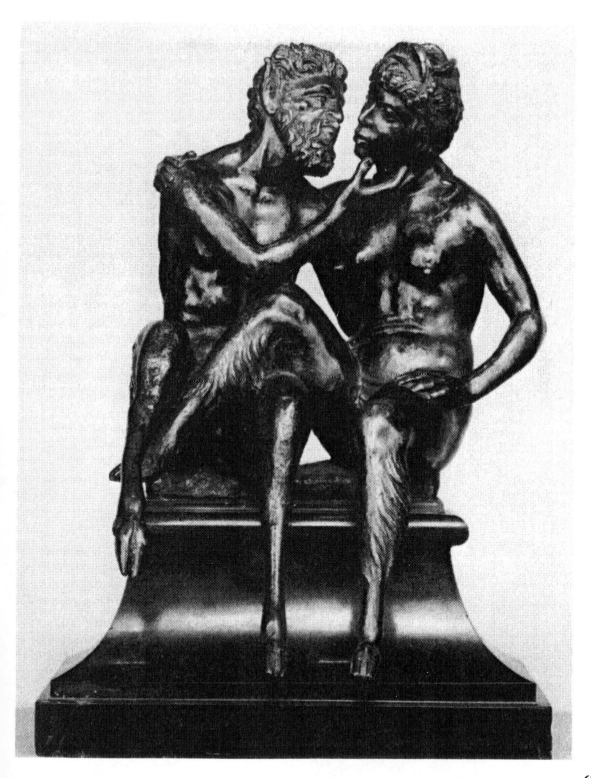

Half man, half beast, satyrs were mythological beings noted for their lust, and their presence in Renaissance painting and sculpture is often frankly erotic. Riccio had a different view of these creatures. As we see from his bronze statuette, they seem touchingly human and vulnerable in their tender embrace. Perched upon a pedestal, their legs intertwined, arm in arm, they are portrayed not as the libidinous creatures of so many paintings and sculptures by Riccio's contemporaries but as thoughtful, wistful beings very like their human counterparts. This air of sadness, perhaps caused by the satyrs' realization that they are the victims of their own overpowering lust, makes them both pathetic and approachable. In this statuette and in many other depictions of satyrs and mythological creatures, Riccio has succeeded in bringing to life and humanizing beings that many other artists portrayed as only stock figures without emotional dimension.

The skillful and subtle intertwining of the two bodies and the agility and delicacy of pose also would have been readily appreciated by the connoisseur who collected Riccio's piece. But the great period of virtuoso bronze statuettes was yet to come, during the sixteenth century, when sculptors such as Giambologna and his contemporaries set themselves to the challenge of creating these objects.

These artists made an amazing variety of statuettes: saints and other religious figures; court dwarfs; gods and goddesses from the vast ancient mythology; allegorical figures; Old Testament heroes; equestrian portraits of famous rulers; and animals. The bronze statuette had evolved into an important work of art, and sculptors vied to make the most complicated and technically demanding pieces for discerning and acquisitive collectors.

On occasion these statuettes, like Giambologna's *Samson and the Philistine* of about 1575, now in Toledo, Ohio, grew to be quite large, some over a meter high [58]. This glowing bronze must have been a commanding presence, even in the large rooms of a Renaissance palace or villa.

Perhaps part of a series of heroes (recall the hero portraits in Castagno's Villa Carducci frescoes), Giambologna's statuette is heavily influenced by antique art. Yet the particular conceptualization and realization of the human body in action is clearly a product of the Renaissance. The two monumental men engaged in the titanic struggle are compelling both as Old Testament figures and as complicated, highly accomplished interlocked nudes. Giambologna's composition of quick rhythms, sharp angles, and subtle

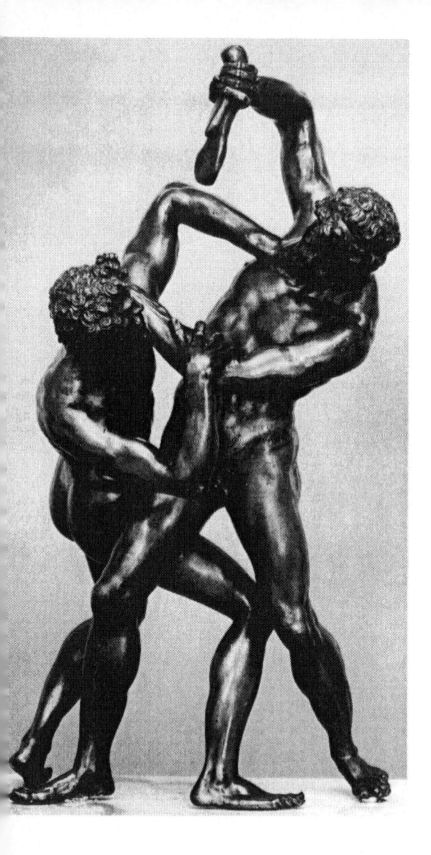

58. Giambologna, *Samson and the
Philistine,* Toledo Museum of Art,
Toledo, Ohio. Samson and the
Philistine was an ideal subject for
Giambologna (1529–1608). The two
figures in violent action gave the
sculptor a welcomed opportunity to
demonstrate his mastery of figural
composition and to show his
complete command of the
demanding medium of bronze.

diagonals—all penetrated by the surrounding space—excites from every view. The straining might of combat has been harnessed to produce a sophisticated, powerful work. In the hands of Giambologna and his contemporaries, the bronze statuette gradually assumed some of the monumental characteristics of large-scale sculpture meant for public display.

There were many objects—including bells, boxes, and bowls—that are now considered almost strictly utilitarian but were fashioned into extraordinary works of art for the home.[32] Certainly, these things were prized, but they were also used daily; like the statuettes, *spalliere,* and other items of the Renaissance decorative ensemble, they were part of the everyday domestic world.

A Venetian bronze doorknocker [59] from the mid-sixteenth century (now in Cleveland) demonstrates the care taken with even the most utilitarian components of the Renaissance house. Either a grotesque face or the head of Medusa, this hideous image is alive with the scaly slithering of intertwined snakes. Perhaps meant to

59. Venetian, Doorknocker, Cleveland Museum of Art. Some Renaissance doorknockers, such as this Venetian example, were considerable works in their own right. Such bronzes would have been cast in several examples for the various doors of a Renaissance palazzo.

ward off evil, it is a powerful decoration. Both its considerable size and its amplitude of design would have fit perfectly with the large doors of the Renaissance palazzo. It is a virtuoso demonstration of the metalsmith's art: the cold bronze has been transformed into scales, skin, and hair, and then back again into bronze in the medallion of the goose above the distorted head. There must have been scores of equally accomplished doorknockers on the villas and palaces of the Renaissance.

Bronze also was fashioned into useful objects for the writing desk. Inkwells, sandboxes to blot the ink, and lamps were all made in quantity, sometimes by artists of the highest talent.

Riccio's inkwell of about 1510, now in Oxford [60], demonstrates to what level even such mundane objects could rise during the Renaissance. Made in the shape of a faun holding a reed pipe and a pot—the inkpot itself—this graceful object is a marvel of poise and balance. The faun's sinuous body, with its curved back and beautifully developed legs, expands into space with a slow,

60. Riccio, Inkwell, Ashmolean Museum, Oxford, England. The bronze sculptors of the Renaissance made several objects for the desk. These included inkwells, sandboxes for blotting ink, bells, lamps, and small statuettes. Cheaper versions of these furnishings could be had in glazed and painted terracotta.

71

elegant rhythm. The plaintive face of the nude faun, so like those of Riccio's satyrs (fig. 57), charges the work with emotion and elevates it into the realm of the most profound of Renaissance sculpture.

Small bronze oil-burning lamps were made in great quantity during the Renaissance. They were more prestigious and fancier than the thousands of terracotta lamps that illuminated the Renaissance home. Often these bronze lamps were in the form of strange figures. A lamp [61] by a follower of Riccio working about 1520 is an amusing example of the Renaissance love of the grotesque, seen in paintings of bizarre half-man, half-animal creatures, in the fondness for horrible practical jokes, and in the period's fascination with dwarfs, kept as sorts of human pets by several princely courts.

In the lamp, a figure grasping his legs reveals a small bowl for the oil; when the lamp was hung on a chain and lit, flames would have issued from between the figure's legs and thus given meaning to the distorted facial expression. Undoubtedly, this was meant to be a funny object, although today its humor seems crude and cruel.

The simple mortar was one of the most useful objects of the

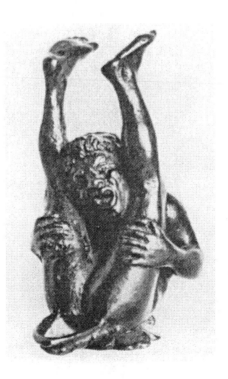

61. Follower of Riccio, Lamp, Bargello, Florence. The Renaissance bronze lamp came in many forms, including human, satyr, and animal. Many of the lamps, like this one, were purposely grotesque. Such shapes must have seemed particularly eerie when illuminated by their flame.

Renaissance home. This ancient vessel for grinding was often made from wood or stone but the finest and most costly were of bronze. By the Renaissance, the mortar had assumed a form perfectly suited to its function. Bronze mortars were often equipped with bronze pestles for smashing and grinding food or drugs.[33]

A mortar [62] now in the Corsi Collection, Florence, exemplifies the care embodied in such objects. Probably from about 1450 (because of an absence of inscribed dates, mortars are difficult to date with accuracy), this little mortar bears a coat of arms on its front and decorated bands on its sides and back. The proportional relationships among the rim, the sloping bowl of the mortar, and the recessed foot are masterful and monumental. The flying handles are equipped with two grips in the form of a lion and a lioness. These, in height and width, perfectly counterbalance and relieve the more severe shape of the bowl of the mortar. A lively ensemble of shape and line, convexity and concavity, this humble but refined mortar reveals the same sense of design that infuses Renaissance objects ranging from the utilitarian household appliance to the complex fresco cycle decorating the walls of a duke's villa.

As we have seen, throughout the Renaissance there developed certain types of domestic painting and sculpture. These types, produced by artists from the most famous to the least known,

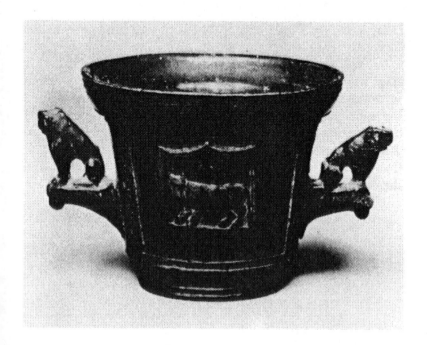

62. Florentine (?), Mortar, Corsi Collection, Florence. Mortars, especially those in use in the pharmacy, were vital for the considerable amount of grinding and blending done before the age of packaged powders and preparations. A weighty bronze pestle would have been used with this mortar.

combined to make the rooms of the Renaissance dwelling among the most splendid in history.

Yet, the types of painting and sculpture produced for the Renaissance house were not wholly works of art in our sense of the term, nor were they purely decorative, like wallpaper or modern abstract wall hangings. Rather, they all had a function. Sometimes it was a physical function, like that of the lamp or mortar. Often there was both a physical and intellectual function, like the subtle message of the *cassone* about the qualities most valued in a wife. The walls of a Renaissance house were alive not only with color and line, but also with moral and didactic messages. Other objects afforded protection from sudden death, the plague, and a host of other Renaissance fears.

It was also in the Renaissance home that the modern notion of a work of art was born. During the first half of the sixteenth century, wealthy citizens and princely rulers alike began to purchase and collect objects mainly for their quality, beauty, and rarity. These prestigious articles included gems, cameos, small bronzes, and other things from the classical past that so enthralled the Renaissance. But Renaissance collectors also purchased the art of their own time. Works like Giambologna's *Samson and the Philistine* now were appreciated mainly for their formal and technical beauty and refinement. Objects were, for the first time, being seen with nearly the same sort of aesthetic detachment with which we today view art. Their content was becoming secondary to their form.

This new view of the artists' production marked a crucial stage in the history of art, and its ramifications were not limited to types produced for the domestic interior, but reverberated throughout almost every branch of artistic activity. Nowhere is this developing attitude seen better than in the history of types destined for public worship. It is to these types and their functions that we must now turn, for the church and its contents mirror the major concerns and ideals of Renaissance art and life.

II
WORSHIP

The home was often the site of certain religious or quasi-religious functions, including betrothal and extreme unction, and, in the chapels of the great palaces and villas, the celebration of the Mass. But the religious ceremonial that paced the lives of most men and women of the Renaissance took place in the church, in a space planned, built, and decorated for these events.[1]

Each Renaissance church was designed to facilitate worship [63]. The ritual of the Mass was performed at the altars, the spiritual and physical foci of the church. Most churches had more than one altar; the larger structures had many—located in private chapels, in special structures called monks' choirs reserved for the use of the clergy, or in the aisles.

63. Santa Croce, Florence. This view down the nave of Santa Croce gives some idea of the huge size of this Franciscan church, begun about 1290. Even before Santa Croce was finished, several of its chapels appear to have been purchased by wealthy Florentine families.

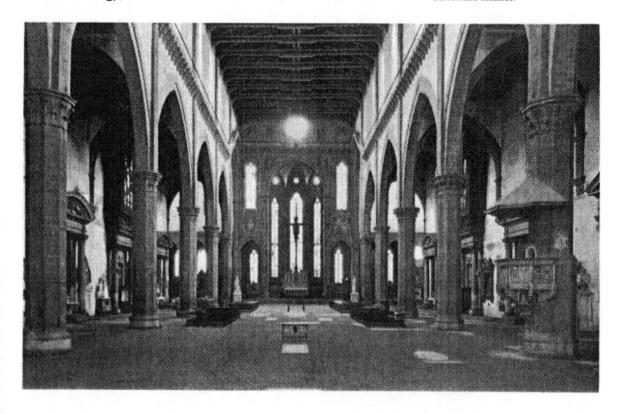

Renaissance churches varied in size and purpose. Each of the major cities had a duomo, or cathedral, the seat of the bishop. Cathedrals usually were built and maintained by the commune or the local ruling families or clans, and they were bound up with the city's identity, although in function and design they were usually like most other churches, only much larger.

Many of the religious orders built their own churches; some, especially the structures erected by the Franciscans and Dominicans, were huge. Intended for the large audiences that came to hear famous preachers (who sometimes had to preach in the piazzas outside the church because of the enormous crowds), these structures had many altars.

There were also many smaller, neighborhood churches. Although of modest scale with just several altars, sometimes they were decorated extensively with sculpture and frescoes. Other simple churches in the countryside served a rural flock.

Monasteries, purposely built away from the temptations of the city, dotted the countryside.[2] Often these were self-sufficient, equipped with dormitories, farms, hospitals, and libraries. They also contained churches, some of considerable size, decorated and furnished much like comparable churches in urban areas.

Because each Renaissance church was in many ways unique, we cannot speak of a typical example. However, a composite structure of medium size can be imagined. Such a church would have a nave set off from the flanking aisles by piers or columns. A transept would run perpendicular to the nave. This transept would probably contain a number of chapels, which, although entered from the transept, were set off from it by steps or by a gate. Somewhere near the high, or principal, altar—perhaps at one end of the transept—would be a sacristy where the priests would robe and where various liturgical objects would be kept.

The large churches of the orders had a number of buildings designed for the needs of the religious community. Dormitories, refectories, kitchens, cloisters for exercise and reflection, libraries, and meeting halls were all part of the larger religious institution.

Regardless of the size of the church, its primary function was to shelter the altars on which the Mass, the central ritual of Christian dogma, was performed. On the altar, behind it, and around it were objects we now call art, but which for the Renaissance were holy things intimately associated with the Mass. To understand something about the nature of the Mass is to understand how this association developed.[3]

For the believer, the Mass is a miracle: during its performance by a priest, Christ lives among the communicants. The wafer and the wine on the altar are transformed miraculously into the body and blood of Christ, the divine-human who died for mankind's redemption and salvation. Every time the Mass is said, this great miracle occurs, and with it comes hope of redemption and salvation for the individual communicant. The entire ritual is transcendent, wrapped in the supernatural: the Mass recapitulates Christ's life, death, and resurrection.

Each of the entities associated with the Mass—the church itself, the altar, the altarpiece, and many others—partook of the miraculous nature of the sacred event. Each was infused with a supernatural power drawn from a mystical realm far removed from considerations of aesthetic or philosophical content. The painted and carved images of Christ and the saints were not viewed as neutral, lifeless representations; instead, they were potent super-natural beings that could, and often did, intervene in the life of the worshiper. Like the wine and the wafer of the Mass, the holy images could be filled with a living presence.

This iconic view of images did not start in the Renaissance, of course; it can be traced back to the origins of almost every society. It was a facet of all Western art until the end of the Renaissance, when, as we shall see, it underwent substantial transformations.

The greatest concentration of paintings and sculpture in a church usually centered on an altar in a chapel. Chapels were often owned by families, who sometimes bought and sold them. More-over, they were often the final resting place of the members of the family who owned them. Renaissance men and women wanted to be buried in a church, as close as possible to an altar. They left money for the upkeep and decoration of their chapels and for Masses to be said for them in perpetuity.

This sepulchral function of the chapel and its decoration was nearly as important as the chapel's function as a location for an altar. The great themes of life, death, and resurrection that ran through the service of the Mass were bound up with the lives of the worshipers; the promises of redemption, salvation, and eternal life of the Mass made the chapel a natural burial place for the owner and his family. Many Renaissance wills document the care with which the testator ensured that he or she was buried in the family chapel and that the chapel was maintained in good condition and appropriately decorated.

One of the most important and earliest of family chapels is in Padua, a city just south of Venice. Built in the early fourteenth century by the wealthy Scrovegni family, it was decorated by Giotto about 1310 [64]. In one sense the Scrovegni Chapel is not typical: it was a palace chapel attached to the large home of the Scrovegni rather than to a church. But, except for its size, which is indeed large for a chapel, it is much more like the chapels in scores of Renaissance churches than those in most palazzos.

The Scrovegni Chapel was constructed for two purposes: as a place for the family to hear mass and as a burial ground. Both functions are reflected in its architecture, its decoration, and in the subjects of the stories painted by Giotto on its walls.

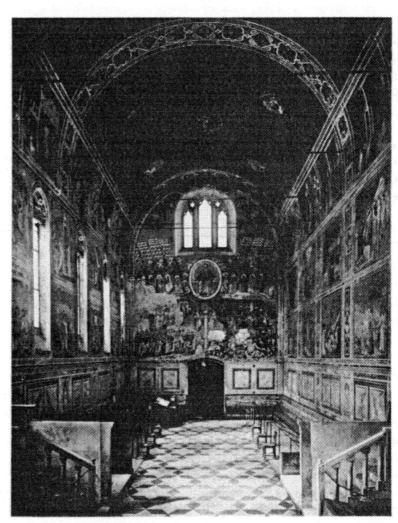

64. Scrovegni Chapel, Padua. In the Scrovegni Chapel, Giotto (1267–1337) had an opportunity afforded few artists of his time: the walls of the new chapel were blank, and it was Giotto's task to plan the entire decoration from floor to vault. The result was not only a splendid work of art, but a decorative scheme of seminal importance for the history of the Renaissance chapel.

As the visitor enters the chapel, his gaze falls upon the tomb of Enrico Scrovegni, the enlightened patron who commissioned Giotto to paint the walls. Scrovegni's tomb and the chapel's adjacent altar are the centerpieces of the decorative scheme.

Giotto's frescoes begin with episodes from the lives of the Virgin's parents and end with the Passion, the Resurrection and the Ascension of Christ. These stories are placed in three registers between a painted blue vault, decorated with stars and roundels, and a fictive marble basement level with Virtues on one wall and Vices on the other.

Narrative action begins in the upper register to the right of the altar wall with the Expulsion of Joachim from the Temple. The stories proceed from left to right across the top register to the entrance wall. The action resumes on the top register of the opposite wall, continuing until it again reaches the altar wall. The middle and lower registers follow the left-to-right path around the chapel. Following the action from left to right, top to bottom, the spectator becomes a participant in the unfolding sequence and its meaning.

The altar and entrance walls are devoted to stories of supreme importance. The center part of the altar wall is covered by the Annunciation, the moment of Christ's divine conception. The chapel itself is dedicated to the Annunciation. Opposite the Annunciation, on the entrance wall, is a gigantic scene of the Last Judgment. In this, the largest painting in the Scrovegni Chapel, Christ sits enthroned, flanked by his Apostles and surrounded by crowded scenes of heaven and hell.

The scheme of the Scrovegni Chapel is brilliantly clear. Spiraling in front of the altar and the tomb of the patron Enrico Scrovegni are the episodes of the life of Christ and his ancestors. These stories of Christ's worldly incarnation represent the passage of time between the moment he enters our world—the Annunciation—and the moment we enter his—the Last Judgment. It is no accident that the last image the spectator sees as he leaves the chapel is the judging Christ above the door.

Now, all this was carefully planned by Giotto, Scrovegni, and their religious advisers to make several major points. As Christ lived, died, and was resurrected, so shall the worshiper (and especially Enrico Scrovegni, who would lie next to the altar) live, die, and be resurrected and redeemed. No Renaissance visitor to the Scrovegni Chapel would have seen its decoration only as paintings, as masterful but mundane works of art; instead, he would have understood that the altar, tomb, and complicated fresco cycle

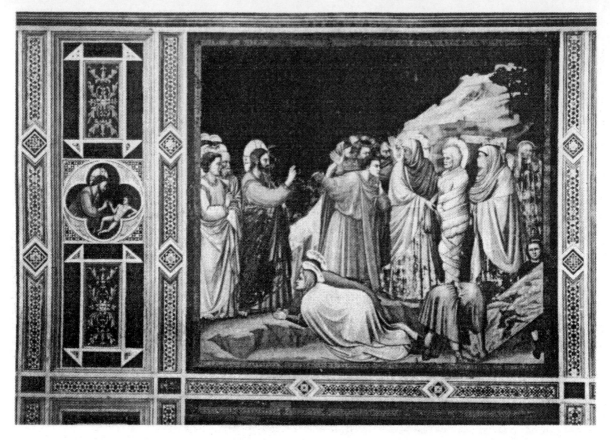

65. Giotto, *Raising of Lazarus,* Scrovegni Chapel, Padua. The power of the divine to give and restore life is demonstrated in Giotto's *Raising of Lazarus:* life is given not only by Christ to Lazarus but, in the little scene in the left border, to Adam by God. The depiction of such restorative power was most appropriate for a burial chapel.

worked together to express the great truth embodied in the Mass, performed in the chapel every day.

Even the individual scenes on the walls have several layers of meaning. Stories such as the Raising of Lazarus [65], the Wedding at Cana (where Christ turned water into wine), or the Last Supper (where the Eucharist was instituted and the Apostles first took Communion) would be understood as episodes in the history of Christ, and also as strong references to the Mass and thus to the eventual resurrection and salvation of both Scrovegni and the communicant.

In the Scrovegni Chapel, Giotto established the iconographic and formal structure and syntax of chapel decoration. His ideas were to have immense importance for several centuries. Nowhere are these interrelations among the various parts of a chapel, first envisioned by Giotto, better seen than in the Strozzi Chapel [66]. Built about the middle of the fourteenth century, this chapel occupies one end of the transept of the large Dominican church of Santa Maria Novella in Florence.

The Strozzi, like the Scrovegni, were a wealthy and important family in their city, and the various branches of the family built and decorated several chapels in Florentine churches. The Strozzi

Chapel in Santa Maria Novella is especially noteworthy because it is raised above an ancient cemetery that abuts the church.

The center of the tall, narrow chapel is occupied by an altarpiece of 1357 by Andrea di Cione, called Orcagna, one of the most influential painters working in Florence about the mid-century [66]. Surrounding Orcagna's altarpiece are contemporary frescoes by his brother Nardo di Cione, which cover the chapel's walls.

The altarpiece and the frescoes were planned together to convey the momentous message of the Last Judgment. On the window wall [67], to either side of the window, men and women are raised from the dead. Not only do they come from below—the location of the ancient cemetery underneath the chapel—but they leave tombs just like those in the floors of many Florentine churches, including Santa Maria Novella.

The two long walls of the chapel are occupied by huge frescoes

66. Orcagna, *Strozzi Altarpiece,* Santa Maria Novella, Florence. Although in a damaged state, the Strozzi Chapel retains much of its original mid-fourteenth-century decoration. This altarpiece, the frescoes, and even the stained glass have all survived.

67. Nardo di Cione, *Last Judgment*,
Santa Maria Novella, Florence.
Nardo di Cione (active 1343–1366),
along with his brother Orcagna, the
painter of the *Strozzi Altarpiece*,
was one of the major Florentine
figures of the fourteenth century.
His huge *Last Judgment, Paradise*
[68], and *Hell* [69] frescoes in the
Strozzi Chapel are his major work in
the medium.

of paradise and hell [68 and 69]. These awe-inspiring paintings
are crowded with figures. In the *Paradise* the shallow space makes
the figures occupy the very foreground of the fresco; it is as though
the crowds of the blessed actually throng into the narrow space
of the chapel itself.

In the hellscape all is confusion and menace. Inspired by
Dante's nearly contemporary *Divine Comedy,* Nardo's hell is a vast
demonic world reserved for the punishment of the newly con-
demned sinners. Here is evil, opposite the paradise fresco directly
across the chapel.

The worshiper in the Strozzi Chapel stands in the center of
a huge Last Judgment, a judgment that is activated by two painted
figures of Christ. The more ephemeral of these is painted above
the window, which separates the narrow frescoes depicting the

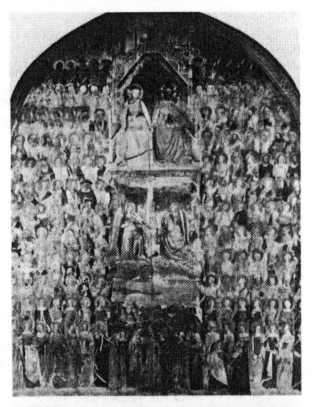

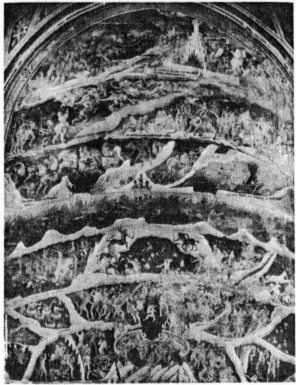

68. Nardo di Cione, *Paradise*, Santa
Maria Novella, Florence.

69. Nardo di Cione, *Hell*, Santa
Maria Novella, Florence.

83

blessed and the damned rising from their tombs. High up and almost obliterated by the light that streams in from the window, this judging Christ seems more spirit than flesh.

The real hub of action, the source of the drama unfolding around him, is the rigid, hierarchical Christ in the center of Orcagna's polyptych, which occupies the middle of the chapel. All action seems to spring from this altar, the location of the ritual of the Mass. Enclosed in a fiery mandorla (an almond-shaped glory of red and blue seraphim and cherubim), Christ impassively presents a book to Saint Thomas and a key to Saint Peter. Flanked by Mary and Saint John the Baptist, two figures prominent in Last Judgment scenes, the imagery of the central part of the polyptych parallels traditional images of the Christ of the Last Judgment, such as the one by Nardo di Cione above the window. Moreover, on the altarpiece's outermost wing, the prominent Saint Michael, the weigher of souls, reinforces this association with the Last Judgment. Each of the staring, uncomfortably crowded figures of this most iconic and awesome of altarpieces is perfectly suited to occupy the vortex of the vast panorama of the Last Judgment that swirls around the chapel.

The symbiosis of the various elements of a chapel, although on a more personal scale, can also be observed only a short distance from the Strozzi Chapel. Next to the choir in the church of Santa Maria Novella is another Strozzi chapel, purchased by the Florentine merchant Filippo Strozzi from the Boni family in 1486. Filippo was a wealthy, powerful Florentine, the owner of one of the largest palaces in the city. The large chapel, so close to Santa Maria Novella's choir, would have befitted his status as a wealthy citizen and a descendant of the Strozzis who lay in the chapel decorated by Nardo di Cione and his brother Orcagna.

From the first, Filippo must have wished to make the new chapel both a burial place for himself and a monument to his patronage. To this end he engaged the painter Filippino Lippi and the sculptor Benedetto da Maiano. Filippino's frescoes (completed in 1502) transformed the chapel's walls into wide vistas populated by wonderfully contorted, often violently active, figures.

The paintings around the walls are programmatic, concerned with death and resurrection. Two scenes cover the right wall. Below, Saint Philip, the namesake and patron of Filippo Strozzi, banishes a dragon who lived under a temple of Mars [70]—a huge, sweeping Renaissance fantasy of a classical temple, complete with a statue of its deity. Saint Philip's deed at the temple of Mars leads

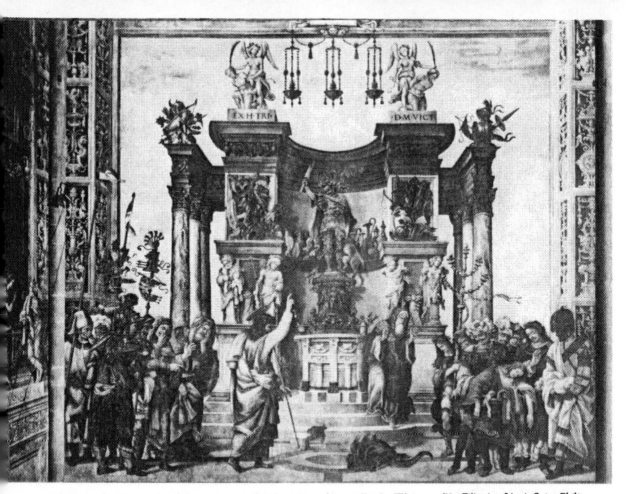

to his crucifixion, which occurs in the lunette above [71]. The old saint's cross is hauled into position as pagan soldiers and citizens watch.

The opposite wall shows two stories of Saint John the Evangelist. In the lower field, before a magnificent cityscape under a dramatic, cloud-streaked sky, Saint John raises Drusiana from the dead. Above, across from the crucifixion of Saint Philip, is the attempted martyrdom of Saint John. But the boiling oil in which the saint is immersed has no effect, and John emerges from the pot unscathed. Like the Drusiana narrative, this story is a testimony to the saint's power over death, a theme most suitable for a burial chapel.

The ceiling of this Strozzi chapel is covered with frescoes of Old Testament patriarchs, while the window contains paintings of Saint Philip and John the Evangelist. The two saints stand watch over the tomb of Filippo Strozzi. Benedetto da Maiano decorated the tomb with one of his loveliest reliefs, a Madonna and Child enclosed in a garland of roses and flanked by cherubim and flying angels. Full of life and joy, the comely Madonna and her

70. Filippino Lippi, *Saint Philip Banishing a Dragon*, Santa Maria Novella, Florence. Filippino Lippi (1457–1504) was the son of the painter Fra Filippo Lippi. He was commissioned to paint the Strozzi Chapel in 1487, but the completion of the work occurred only in 1502; such long delays were common in the Renaissance.

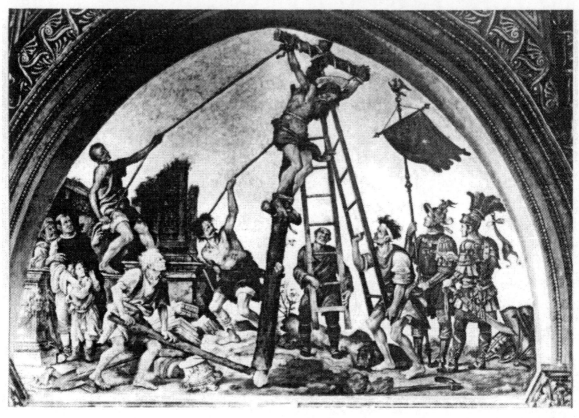

71. Filippino Lippi, *Crucifixion of Saint Philip,* Santa Maria Novella, Florence.

playful son look down toward Filippo's sarcophagus, watching over the patron and forecasting the bliss of paradise for both Filippo and the communicants who have heard the Mass said in his chapel.

The pattern of chapel decoration that began in the Scrovegni Chapel and its earliest descendants—the covering of the walls with narrative frescoes, the altar with its altarpiece, and the inclusion of a tomb—continued throughout the Renaissance. Of course, there were numerous variations on this theme.

The private chapels were built for a patron and his family and were actually owned by the individual, much as one would own a house or another item of real property. But there were other types of chapels, of a more public nature. These structures dotted the Italian peninsula; perhaps the most famous is the Sistine Chapel, which utilizes many of the traditional elements of private chapel decoration on a grander scale.

Begun by Sixtus IV in 1475, the Sistine was the popes' chapel; located next to the papal residence, it was the most important chapel in Christendom. It also was to become the location for the conclave of cardinals called to elect a new pope. Thus it was not only of great ecclesiastical importance, but it was also more public

and ceremonial than the private chapels in churches or, in the case of the Scrovegni Chapel, connected to secular palaces.

The esoteric, complicated iconographic program of the Sistine Chapel evolved over many years, reflecting the learning of the ecclesiastics who commissioned it and who met and prayed in it.[4] The lower band of frescoes, painted by a number of artists during the last decades of the fifteenth century, ran along each of the chapel's long walls. These registers narrate, on the left side when facing the altar, stories from the life of Moses and, on the right side, scenes from the life of Christ. This opposition, in its simplest terms, was meant to demonstrate that Christ was Moses' heir, that his was the New Law predicted in the Old Testament. The typological idea of legitimate succession was of preeminent importance to the papacy. Indeed, one of the most prominent frescoes is *Christ Giving the Key to Saint Peter,* a narrative that demonstrates in graphic form the legitimacy of the pope's succession from Christ himself.

Michelangelo's ceiling frescoes of nine episodes from Genesis are indisputably the most famous paintings in the Sistine Chapel [72]. Originally, Michelangelo's great patron, Pope Julius II, wanted the ceiling painted with decorative motifs interlaced with twelve seated Apostles, a scheme with origins in the fourteenth century. This program eventually was abandoned, probably because the artist thought it "a poor thing," in contrast to narratives from Genesis. These episodes, begun in 1508, of Creation, the Fall and Expulsion, and the story of Noah are the prehistory of the Old and New Testament scenes that decorated the lower walls.

Several decades later (1534–1541) Michelangelo returned to the Sistine Chapel to paint a large Last Judgment on the altar wall, a fresco that, in its scale and location, reminds one of the Last Judgment by Giotto in the Scrovegni Chapel.

All the chapels that have been discussed—from the Scrovegni to the Sistine—were functional and programmatic. Their frescoes and sculpture both decorate and narrate. All the painted and carved objects tell stories perfectly suited to the chapels' uses as the location of an altar, as a burial place, or as a great ceremonial chamber. Altarpiece, fresco, tomb, and other sculpture were all part of a carefully planned, unified scheme to enhance the sacramental nature of the chapel.

The altarpiece was the pictorial focus of the spiritual heart of the chapel, the altar.[5] To the Renaissance worshiper, the altarpiece had many intertwined meanings. From its earliest form as an

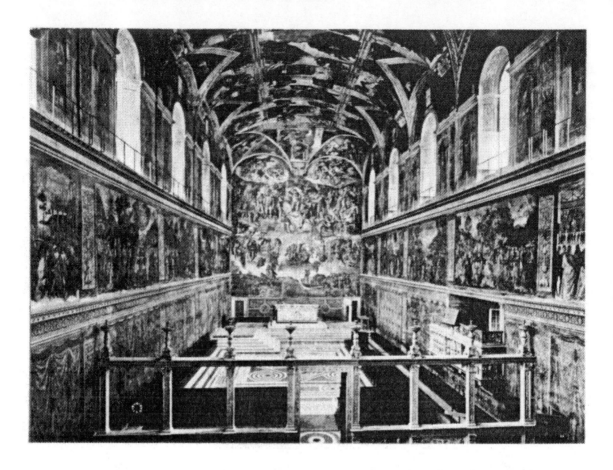

72. Sistine Chapel, Vatican City. Like the paintings of the great church of San Francesco at Assisi from about two centuries earlier, the Sistine Chapel frescoes were by artists from several locations in the Italian peninsula. In addition to Michelangelo, Ghirlandaio, Botticelli, Perugino, and Pintoricchio worked there.

awesome icon, it had evolved, by the end of the Renaissance, into a beautiful, expensive art object, the personal work of skilled painters—something still to be revered for its subject but also to be admired for its color, form, and workmanship.

The tales the altarpieces told—episodes from the Bible or legends of the holy figures—were viewed as historical narratives and studied for their spiritual, moral, and didactic value or the virtue of their protagonists. These were at once instructive works that helped the viewer to lead a moral life and good entertainment, meant to be savored and enjoyed.

But the most compelling, immediate meaning of the altarpiece was liturgical, for it stood on the altar before which the Mass was performed.[6] During the Mass the consecrated wafer (the Host) and the wine are miraculously transformed into the body and blood of Christ. This transubstantiation is the heart of the ritual. The living Christ exists among the worshipers, offering the possibility of redemption and salvation through his sacrifice on the cross.

This doctrine of transubstantiation is difficult to comprehend,

and the worshiper was often aided in his or her understanding of the ritual and the miracle by the altarpiece placed above the altar. The painting helped the communicant visualize what he could not see. Much more than mere decoration, the altarpiece embodied and illustrated much of the miracle of the Mass.

An altarpiece [73] from about 1480 by the distinguished Venetian painter Giovanni Bellini elucidates these mystical functions. In this *Resurrection of Christ,* the worshiper sees the risen Christ miraculously brought back to radiant life. Just as the priest raises the consecrated Host heavenward during the Oblation, so the resurrected Christ floats above the altar. Bellini's altarpiece illustrates in graphic form what has taken place during the Mass.

There are other liturgical implications in the altarpiece. The altar was often called the tomb of Christ, and the depiction of Christ rising out of his sarcophagus would have made a striking parallel in the minds of the communicants. The white clothes of Christ likewise would have been seen as an analogue to the corporal (the white linen cloth on which the Eucharistic elements are placed), which was symbolic of both Christ's swaddling clothes and his shroud.

Other, more subtle, references to death and rebirth—both for Christ and the communicant—can be read in the late-winter landscape, which hints of the first tender signs of spring, in the dawning sky behind Christ, and in the rabbits, symbols of fertility, scampering across the hills. Everywhere, life triumphs over death through the miracle of Christ's divine resurrection, and the primordial truths of night and day, summer and winter, death and renewal are symbolized and affirmed by image meshed with ritual.

Altarpieces, like domestic decoration, came in many types, which often overlapped in both form and function; and, like all types of Renaissance art, altarpieces changed over the centuries. This change was a combination of modifications in religious beliefs, the developments of new types of imagery, and the dictates of fashion, the desire for the new. Since many of the fundamental developments of Renaissance art were initiated and carried out in the altarpiece, its history reveals much about the artistic and spiritual climate of the age.[7]

One of the earliest forms of the altarpiece was the image of a single saint or other holy figure, either standing or enthroned. The popularity of many of these altarpieces stems from the importance of saints in the life of the Renaissance. Almost every Renaissance person was named after a saint, and that saint's day

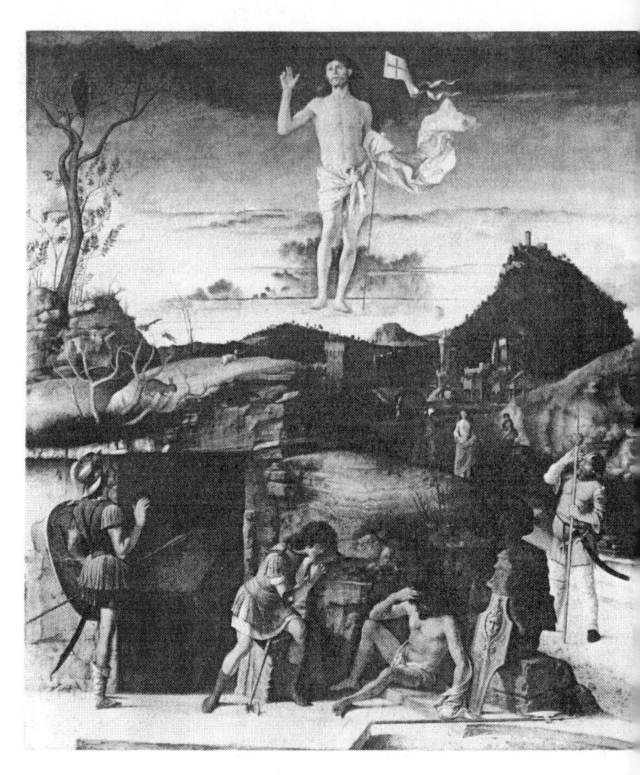

had particular significance in his or her life; in fact, the saint's day, and not the person's actual birthday, was celebrated. Each holy figure, especially the hundreds of saints, had special charac' teristics. Not only were they portrayed with specific physical traits and clothing—Saint Peter, for instance, was always white-bearded, tonsured, and dressed in long robes—but each could be implored for a certain type of protection or aid.[8]

We have already seen that Saint Christopher protected the believer from sudden death and that his image was frequently placed in homes and public buildings. Other saints could be called on for other types of aid. Saint Nicholas of Tolentino, for example, pro' tected against shipwreck, Saint Sebastian against the plague, Saint Apollonia against toothache, and so on.

An extensive body of saint lore pervaded the Renaissance. It was a time when doctors were extremely learned but almost pow' erless to help the victims of plague and other illnesses. Mental illness, quite common during the era, was thought to be caused by evil spirits. Endemic warfare and unrest in both town and countryside also made life difficult and dangerous. Solace from troubles and salvation from illness were offered by the saints, whose miraculous powers could be transmitted through their images.

One of the earliest of these is found on an altarpiece [74] by Bonaventura di Berlinghiero, dated 1235, in the small Tuscan town of Pescia. Saint Francis is surrounded by scenes from his life. Painted only several years after Francis's death in 1226, it is one of the first pictures of this beloved saint, who was already famous throughout the Italian peninsula by the time Bonaventura began the altarpiece.

Bonaventura's painting tells us much about the roles of altar' piece and saint alike. We see at once that the central image of Francis is very different from our romanticized and often saccharine idea of this fabled figure. Instead, in a hard, abstracted style, Bona' ventura depicts the saint as gaunt, ascetic, and looming. Here is not the sweet, sunny Francis who happily wanders in Umbria, but an iconic, powerful holy man.

The format of Bonaventura's single-panel altarpiece (known as a gabled dossal) perfectly expresses the role of the saint. Set squarely in the middle, he is flanked by six scenes from his legend. He is the generating force of these scenes, and he dominates them by his spiritual and physical presence.

Half of the scenes are devoted to healing: Francis cures a child, a cripple, and a certain Bartolomeo da Narni. The inclusion

73. Giovanni Bellini, *Resurrection of Christ,* Staatliche Museen, West Berlin. Giovanni Bellini's use of light as a symbol of divinity in a pantheistic landscape of great beauty perfectly expresses the miraculous nature of the Resurrection. The day's rebirth, the end of night and darkness, seems to emanate from the shining figure of Christ levitating in the dawn sky.

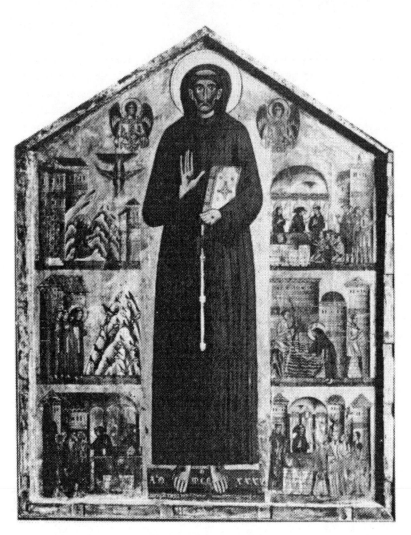

74. Bonaventura di Berlinghiero, *Saint Francis and Scenes from His Legend,* San Francesco, Pescia. Bonaventura di Berlinghiero (recorded 1228–1274) was one of a group of thirteenth-century painters active in the Tuscan town of Lucca near Pescia. These Lucchese artists had a sizable influence on the earliest Florentine painters.

of healing scenes, usually in equally high proportion, in similar Saint Francis altarpieces indicates that the saint's contemporaries saw his image as a powerful curative force.

Surely many of those who heard the Mass recited in front of Bonaventura's altarpiece hoped for a miraculous cure. As the intense, imploring little figures in the narrative scenes plead for a miracle, so the worshipers looked to the ascetic saint for salvation from both bodily and mental affliction. So strong was belief and the yearning for salvation that many records from the period attest to the miraculous transformation of painted images into real ones. These supernatural apparitions healed and saved countless worshipers, or so the Renaissance believed.

All of the images of Bonaventura's altarpiece are set down in the idiom of the mid-thirteenth century. The geometricizing, ab-

stract construction of the figures and the high stylization of the mountains and buildings set in a confusing and uncertain space consummately express the miraculous and unworldly nature of Francis. Part talisman, part healer, part intercessor, the gaunt saint roused a host of ambivalent feelings, ranging from fear to wild hope.

Shortly after the first years of the fourteenth century, the gabled dossal depicting a standing saint surrounded by scenes from his or her life declined in popularity. Partly this was due to a more human and immediate perception of the holy figure, something engendered by Francis himself, and partly to the changing fashion in altarpiece type that is so characteristic of the Renaissance.

Yet, there are very few cases where a type disappears entirely. This is shown by an altarpiece (completed in 1444) by Sassetta, one of the finest and most inventive artists of fifteenth-century Siena. Destined for a church in the small Tuscan town of Sanse-polcro, the now dismembered and dispersed altarpiece was an elab-orate object painted on both sides with many scenes. On the back was a large image of Saint Francis surrounded by eight scenes from his legend [75]; above the saint there was another panel, repre-senting him embracing the crucifix, an object of his special devotion.

75. Sassetta, Reconstruction of the Sansepolcro altarpiece. Sassetta's double-faced altarpiece in Sansepolcro was removed from its original location and later broken up. Pieces are now scattered in Italy, France, England, and the United States.

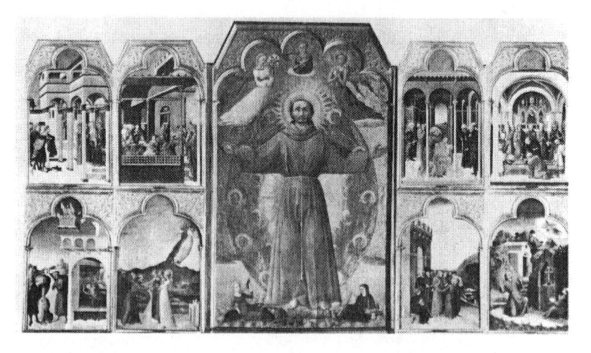

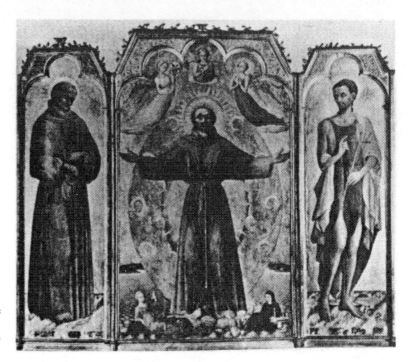

76. Sassetta, *Saint Francis in Ecstasy*, Berenson Collection, Florence. The joyful, ecstatic nature of Saint Francis's spirituality is marvelously captured in Sassetta's moving image from the Sansepolcro altarpiece. The idea of Francis as the ascetic, miraculous healer has given way to a saint consumed by religious rapture.

Despite this altarpiece's overall complexity, it is Francis [76] on whom our attention is riveted. As in the earlier image of him in the Pescia altarpiece, he dominates the space around him and is the motivating force for the entire altarpiece. The surrounding side scenes are satellites revolving around the gold-encrusted central image.

This is not the stern, healing Francis of the Pescia altarpiece, but a more delicate, more human figure, seen in a moment of the highest ecstasy. Set against a placid green sea, which laps against distant mountains on the horizon, the saint tramples three Vices underfoot, while three Virtues form a sort of living halo above. A fiery mandorla of cherubim surrounding Francis adds its vibrant hues to this beguiling image.

By the time of the Sansepolcro altarpiece, Francis already had been romanticized. No longer the austere icon of the Pescia altarpiece, he was now viewed as a much gentler, more peaceful spirit. The jagged energy of the miracle worker has been supplanted by a radiant spirituality, which spills over into the surrounding scenes. None is dedicated to a miraculous cure; indeed, scenes of Francis's healing become progressively rarer after the middle of the fourteenth century.

Through the skillful manipulation of illumination and the evocative, peaceful landscape, Sassetta endows the side scenes with

a grace and ethereality absent from the much harsher, less human-
ized narratives in Pescia. The little stories that once flanked Saint
Francis in Ecstasy sympathetically portray the saint as meek, be-
nevolent, and mystical. The shining light envelops both people
and landscape, infusing the small panels with a peaceful pantheism
very distant from the abstracted, nervous atmosphere of Bonaven-
tura's narratives.

Giovanni Bellini, who may have seen Sassetta's Sansepolcro
altarpiece on a visit to the town, painted several images of Saint
Francis. One of these, the so-called Saint Francis in Ecstasy (about
1485), now in the Frick Collection, is among the most distin-
guished pictures of the Renaissance and a major milestone in the
development of the altarpiece [77].

In the altarpieces by Bonaventura di Berlinghiero and by Sas-
setta, the supernatural function was apparent: these were images
to be adored and worshiped, and their relation to the Mass was
clear. But in Bellini's painting this function is not so obvious.

Although it is often called Saint Francis in Ecstasy, the paint-
ing's true subject is elusive; it might be the Stigmatization of Saint
Francis or Saint Francis Composing the Canticle to the Sun (one
of his most famous songs). Or perhaps it is simply a depiction of
this most pantheistic of saints amidst the bounty and beauty of
the natural world he so loved.

This very ambiguity tells us we are looking at a new type of
altarpiece. Bellini's Saint Francis is both an altarpiece and a pictorial
meditation on a lush, tranquil, early-spring world, where the rays
of the rising sun just touch the distant towers and fields. The
picture is as much about the rightness of man's place in nature
and nature's divine spirit as it is about Saint Francis, his life, or
his miraculous powers.

Whatever the painting is labeled, it seems not to depict a
particular narrative moment, nor is it particularly concerned with
a powerful representation of the saint, as he was depicted by Bona-
ventura di Berlinghiero and Sassetta. The welcoming fertile land-
scape, the clouds moving across the bright blue sky, and the inspired
saint transported by the tranquillity and holy beauty of what he
sees have none of the iconic majesty of the earlier images. Francis
and his world are accessible and immediate; they leave us refreshed
but not awestruck.

The same progression in the images of single saints, and Saint
Francis in particular, can be seen in the history of one of the most
popular and durable of altarpiece types: the Madonna and Child
with attendant holy figures.

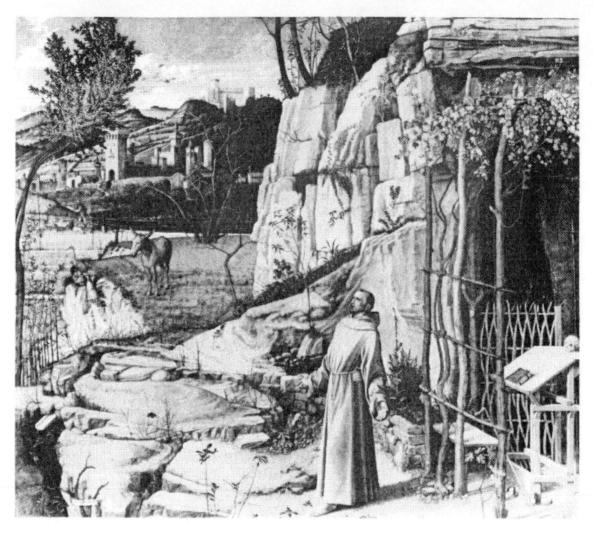

77. Giovanni Bellini, *Saint Francis in Ecstasy,* Frick Collection, New York. This remarkable painting is an early example of the atmospheric light-filled landscapes that became a notable feature of Venetian painting in the next century; Giorgione, Titian, Tintoretto, and Veronese were all indebted to this important aspect of Bellini's art.

Like the early dossals of Saint Francis, many of the earliest formats of this type were gabled rectangles, frequently of considerable size. These large works were often the principal altarpieces for churches or spacious chapels. Towering and majestic, in size alone they were impressive.

Madonna and Child were, of course, the central figures of Christian devotion, and their likenesses appeared everywhere in Renaissance life. The image of the young mother holding her infant son was fixed indelibly in the visual memory of each Renaissance man and woman, for it was an image they saw and adored throughout their lifetimes.[9]

This image combined the two sacred beings who anchored the worshiper's beliefs. The infant Christ was human and vulnerable, while the youth and tenderness of his mother made her an

appealing, approachable figure. She was seen, like the saints, as an intercessor with Christ; and because Christ was her son, her entreaties to him were the most effective. The cult of the Virgin, like the old pagan cults of great goddesses, was one of the most visible and powerful features of Renaissance religion.

By about 1300 the image of Madonna and Child had achieved the majesty and grandeur we see in an altarpiece by Duccio di Buoninsegna, the founder of the Sienese school of painting. Duccio was commissioned to paint a large altarpiece [78], now known as the *Rucellai Madonna,* with the Virgin, Child, and angels, for the chapel of the Brotherhood of Saint Mary (the Laudesi) in the Florentine church of Santa Maria Novella.

78. Duccio, *Rucellai Madonna,* Uffizi, Florence. Along with Giotto, Duccio (documented 1278–1318) was the wellspring of fourteenth-century Tuscan painting. That he was given the commission for a painting as large and important as the Rucellai altarpiece demonstrates the extent of his popularity even in Florence, a rival of his native Siena.

The middle of the altarpiece is squarely occupied by the lovely Madonna and the blessing Child on her knee. Both sit regally on a spindly throne covered in costly brocade. Angels kneel or hover around the throne, attending the holy figures. Richly textured, filled with elegant shapes, and set against a field of shimmering gold, this is a majestic image, to which the worshiper, like the flanking angels, pays homage.

Duccio's idiom is perfectly suited to this particular conception of the Madonna and Child. The highly decorative fields of subtle colors (blues, pinks, greens, purples), the stylized faces, and the abstract areas of gold infuse the altarpiece with an unearthly, radiant spirit. While not as harsh or ascetic as Bonaventura di Berlinghiero's Saint Francis in Pescia, Duccio's painting shares much of the same supernatural feeling.

Some of the spirit of Duccio's Madonna remains in one of the most important altarpieces of the Renaissance, Giotto's Ognissanti Madonna, of about 1310 [79]. Its monumental, realistic holy figures forged a new relationship with the spectator, and with this work a new stage in the development of Renaissance painting began.

Giotto's dignified figures seem to displace space, to stand upon the ground with real substance and weight. Although still placed against a gold background, the figures seem to extend both backward, into the picture, and forward, toward the spectator's space.

The majestic mother and her sturdy son are immediate, believable as human beings. The construction of their bodies and the way the bodies are revealed under the clothing give the holy figures a physicality lacking in their counterparts in Duccio's altarpiece. The manner in which the Virgin and Child seem to make contact with the viewer is new as well. And the framing of both major figures in a throne that itself carves out space reveals how Giotto has deliberately broken the iconic boundaries that separated the worshiper from the images in Duccio's altarpiece.

The increasing realism of the sacred figure and the surrounding space, characteristic of the fifteenth century, is already apparent in Giotto's Ognissanti Madonna. In fact, in this and in several other works, Giotto sets the stage for much of the interpretation of religious imagery for the remainder of the Renaissance.

The solidity and weight of the Ognissanti Madonna had an almost immediate impact on Renaissance painting. About 1320, Giotto's influence appears in an altarpiece by the Sienese Pietro Lorenzetti. This altarpiece [80], in the Tuscan town of Arezzo, is

79. Giotto, *Ognissanti Madonna*, Uffizi, Florence. The *Ognissanti Madonna* (originally commissioned for the church of Ognissanti) is one of the cornerstones of Florentine painting. This altarpiece and other works by Giotto were studied by generations of artists, including Masaccio, Leonardo da Vinci, and Michelangelo, who made several youthful studies from Giotto's frescoes.

99

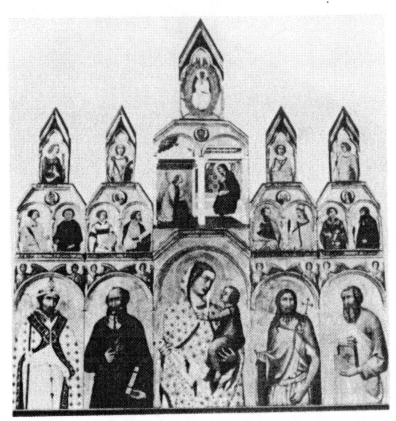

80. Pietro Lorenzetti, Altarpiece, Pieve di Santa Maria, Arezzo. Pietro Lorenzetti (active 1320–1348) was probably a pupil of Duccio. Influenced both by his teacher and Giotto, he developed the personal, expressionistic style seen in this and other altarpieces. Pietro, his brother Ambrogio, and Simone Martini were the major figures in Sienese painting after Duccio.

a polyptych, a type of four or more combined panels that became popular during the first half of the fourteenth century. Constituted of panels of half-length figures (the Virgin and Child and four saints) that support small panels of half-length saints and the Annunciation, this polyptych is both physically and iconographically more complicated than the simpler *Ognissanti Madonna* type.

The large half-length saints, who show the influence of Giotto, either point or turn toward the polyptych's heart: the Madonna holding her bright, young Child. In this register of the polyptych the holy figures participate in a silent dialogue of gesture, glance, and movement.

However, the horizontal movement across the surface of Pietro Lorenzetti's polyptych is countered by a vertical axis running from the Madonna and Child, through the Annunciation, up to the pinnacle, where Mary ascends into heaven. Three great events in the life of the Virgin, and in the history of Christianity, are thus portrayed, giving focus to the polyptych. This is fitting, since Pietro Lorenzetti's altarpiece was made for a church dedicated to Mary.

Each altarpiece, of whatever type, has a specific connection

with the location for which it was commissioned. There were no standard, generic formulas for the iconography of the altarpiece; each was custom-made for a particular location with a particular set of needs.

Often the central theme or figures were chosen, as in Pietro Lorenzetti's altarpiece, to reflect the dedication of the particular church or chapel. Many times the saints picked were the namesakes of the patron or his family. On occasion the subject was selected because the particular church or chapel had a relic of a saint or, perhaps, a fragment of the Holy Cross or the Crown of Thorns or some other precious, sacred object. Each altarpiece told a slightly different story, in a unique way.

Some polyptychs were much simpler than Pietro Lorenzetti's, just a central panel flanked by four or six saints; others were much more complex, elaborate iconographic machines with rows of saints, pinnacles, little panels on the sides of the frames, and much other decoration. The size of an altarpiece, like its iconography, often depended on its location (and the size of its patron's purse).

Toward the middle of the fourteenth century, Orcagna, the most dramatic and intense artist to supplant the now-fading last pupils of Giotto, painted a full-length polyptych [81] notable for its harshness and the isolation of its figures, qualities very different from the much more rational and accessible works just discussed. Now in the Accademia, Florence, this altarpiece by Orcagna sequesters its various figures in their compartments. Lost in thought, unaware of each other (with the exception of Saint

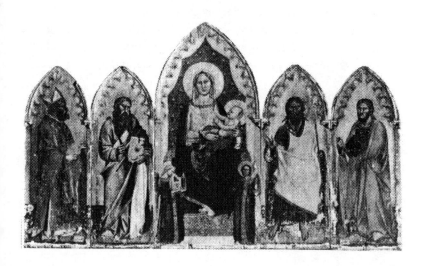

81. Orcagna, Altarpiece, Accademia, Florence. Especially interesting are the varied positions of the flanking saints, which range from the frontal Saint John the Baptist to the nearly profile Saint Nicholas at the far left. Although designed by Orcagna, parts of this altarpiece seem to be by the hand of an assistant.

Nicholas, who turns to look at the Madonna), these detached holy beings are very different from the much more unified and focused subjects of the earlier works by Giotto and Pietro Lorenzetti. The range of emotion in Orcagna's polyptych has been purposely restricted; introverted and masklike, the faces of the saints radiate none of the religious ecstasy or excitement of the works by the older artists. Moreover, the solid, earthbound figures of Giotto and Pietro Lorenzetti are gone. In their stead, Orcagna has created figures that seem to hover just above the ground: this is seen most dramatically in the hirsute John the Baptist to the Madonna's left.

Color in the earlier altarpieces is both decorative and functional: it gives the figures weight and helps them occupy space. But in the works of Orcagna and a number of his contemporaries, harsh color in clashing patterns splinters the surface of the painting and negates space. Orcagna has rejected the unity and harmony of the earlier paintings in favor of a discordant depiction of the holy figures.

The art of Orcagna and his contemporaries in Florence, and to some degree in neighboring Siena, often is explained as a reaction to the great plague of 1348, which depopulated many cities in the Italian peninsula. It is argued that the stridency and isolation of the paintings reflect the prevailing psychological tenor of the survivors, who felt guilt and the need for penance for the plague that God had visited on them.[10]

This argument may have some merit, but it is too simple. Painting and sculpture are subtle arts, and their creation is dependent on many factors, some of them unique to their creators. Moreover, although subject and interpretation might change rapidly, style—those characteristics of form, color, line, light, and so forth that make up imagery—is not immediately conditioned by events. If the change in subject is both substantial and sustained, then style will gradually adjust to the new situation: but the key word is gradually.

So, while the plague might have had some effect on art, that effect was usually limited to the subject. What, then, explains the marked shift by Orcagna and members of his circle away from the idiom of the earlier part of the century? Some of this shift might simply be a result of patrons' and artists' desire to revive the ancient, and therefore sacred, visual and iconographic vocabulary of the period before Giotto. Such revivals are common in the history of art; and it may be that this revisionism was stimulated by the plague and the feeling that the present time, and perhaps its art,

had gone too far, and that the past offered a more secure and ordered conception of religious imagery.

Whatever its causes, the disturbing art of mid-fourteenth-century Florence soon was eclipsed by new idioms and interpretations. In Florence the path that Giotto had mapped early in the fourteenth century was traveled anew by several artists of great talent and presence. The most important and prophetic of these figures was Masaccio, whose short but brilliant career laid much of the groundwork for painting in the Italian peninsula during the next several centuries.[11]

Masaccio's earliest extant work (dated 1422) is a small, modest triptych (a larger version of the portable type we have already seen in the chapter on domestic life) from the church of San Giovenale in Cascia, a small town not far from his native San Giovanni Valdarno. For this triptych [82], and, indeed, for his earliest style, Masaccio is indebted partially to the harsh and hierarchic idiom found in Orcagna's Accademia altarpiece. But he also has looked beyond that iconic style to the early fourteenth century in general, and to Giotto in particular. The stolid Madonna and her Atlas-like child are both weighty, space-displacing beings who remind one of the monumental central figures of the Ognissanti altarpiece. Moreover, the volume of space encompassed by the curving throneback and the protruding step on which the Madonna's feet rest also stems from that seminal altarpiece by Giotto.

But Masaccio makes a decisive innovation by unifying all the

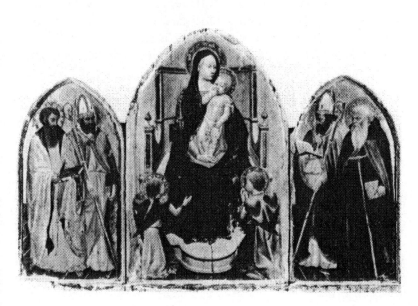

82. Masaccio, Altarpiece, Uffizi, Florence. This is the first known work by Masaccio (1401–1428), painted when he was only twenty-one. It is not known if the altarpiece was painted while Masaccio was still living in his hometown of San Giovanni Valdarno—near the painting's original location—or if it was done after he had moved to Florence to begin his brief but remarkable career there.

holy beings in a convincing, rational space. Not only do the expressive saints on the wings overlap, creating a sense of space, but the floorboards on which all the triptych's figures are placed recede toward a single point on the horizon line. In other words, through the use of one-point perspective, where all the orthogonal lines converge on the horizon line, Masaccio has given his work a unity and rationality only implied in the *Ognissanti Madonna* and unwanted in Orcagna's stern altarpiece in the Accademia. The spectator's space flows into the painting, and the painting's holy figures seem, for the first time, capable of entering our world.

This realignment of spectator to image signals a profound change in the conceptualization and actualization of religious imagery, a change as fundamental as the one between Duccio's *Rucellai Madonna* and the Ognissanti altarpiece by Giotto. The San Giovenale altarpiece secularizes the holy figures by bringing them into the worshiper's space; but the sacred beings also sanctify human space by their divine presence. The iconic barriers, vestigial in Giotto's great Ognissanti altarpiece and vigorously reasserted in Orcagna's altarpiece, were decisively shattered by Masaccio. How this new conception of space and figure was developed by Masaccio and his contemporary, the sculptor Donatello, is still a mystery, although their work is the end result of a gradually developing humanization of religious imagery that finds its beginnings in the generation of Cimabue and his fellow artists, a development that we have already seen in the various images of Saint Francis.

Although Masaccio's innovations in this and other works made a profound impact on a small circle of Florentines and a smattering of artists from other centers in the Italian peninsula, they remained relatively obscure for almost a quarter of a century.

If, for instance, we look at an altarpiece [83] by the Sienese artist Giovanni di Paolo, painted about 1450, we see a very different pictorial world. The spectral, elongated figures swaying across the polyptych are very different from the sturdy, surefooted beings of Giotto or Masaccio. There is an instability and spatial ambiguity about this painting that leaves the figures' exact relation to the viewer unclear. Yet, in the central panel, the figures of the Madonna and Child and the wide throne that occupies the entire space are all influenced by the painting of Masaccio and his Florentine contemporaries.

Giovanni di Paolo has been selective: he has mined the Sienese artistic tradition for much of what he has painted in this polyptych, and he has been influenced, but not overwhelmed, by Masaccio's inventions. Instead of the clarity and straightforward presence of

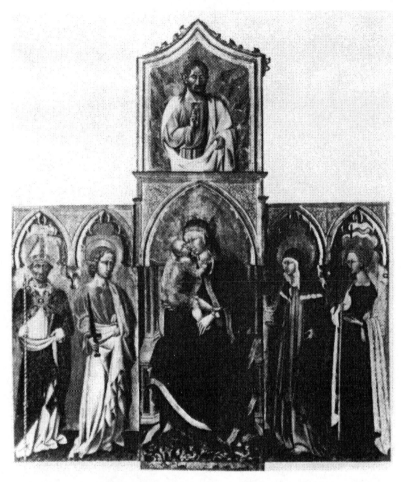

83. Giovanni di Paolo, Altarpiece, Pinacoteca, Siena. In this work, painted about the middle of the fifteenth century, there remain many stylistic debts to the earliest Sienese artists. Tradition was a central part of Sienese art, and the city's painters and sculptors continually reworked styles and motifs from the past.

the San Giovenale altarpiece, he has visualized mystical, hovering holy figures who have only a tenuous spatial and physical contact with the viewer.

Style alone does not explain the great diversity between the paintings by Giovanni di Paolo and Masaccio. At heart is a more fundamental difference in the perceptions of the sacred and the supernatural held by the artists, the cities in which they worked, and the patrons who paid them. Separated by only about fifty miles, Florence and Siena were light-years apart when it came to visual and spiritual traditions. The broad, peninsula-wide developments that we can trace in our survey were modulated always by regional or local peculiarities; sometimes, certain areas or schools isolated themselves from the major developments in other centers, or, in many cases, so transformed the innovations of other places as to make them their own.

Even in Florence itself, Masaccio's ideas underwent substantial modification and, sometimes, amplification. In the Florentine

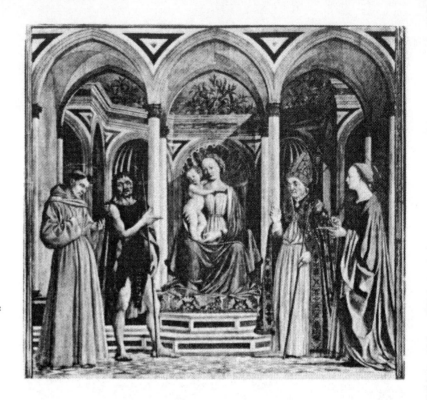

84. Domenico Veneziano, *Saint Lucy Altarpiece*, Uffizi, Florence. Domenico Veneziano was an influential Florentine artist of the first half of the fifteenth century. He is first documented in 1438; in the next year he worked in Santa Maria Nuova, Florence, with his young assistant, Piero della Francesca. Domenico died in 1461.

Domenico Veneziano's *Saint Lucy Altarpiece* [84] of about 1450, now in the Uffizi, the nascent unification of the San Giovenale triptych and Masaccio's other works was brought to fruition.

Now fully united on the surface of a single panel, the Madonna and the saints surrounding her all share the same space and time. The setting, a contemporary Florentine palace courtyard, is made even more convincing by the light, which is logical and consistent, again following the lead of Masaccio. The desire to rationalize space made the triptych form obsolete.

Psychological unity with the worshiper is created by the outward glance of the Madonna and by Saint John the Baptist, who directs our attention to the holy pair at the center. Such an arrangement of figures flanking the Madonna and Child is often called a *sacra conversazione* (sacred conversation), but this term is misleading, for the holy beings seldom seem to converse. Instead, they are often isolated, rapt in adoration of the Madonna and her Child, totally absorbed in meditation on the divine spirit that they all sense so keenly. By their actions they invite the worshiper to join them in their adoration of the Child and to contemplate the meaning of his life and death, a meditation crucial for the Mass recited before this altarpiece. These beautiful figures are interlocu-

tors who lead the worshiper into the meaning of the ritual being performed by the priest.

But Domenico Veneziano's picture is not all seriousness and abstraction, for it takes place in a joyous environment filled with sunlight, color, and shapely form. The patterns on the robes, the myriad textures, the softness and luminosity of the flesh, and the dancing pastel colors of pink, light green, soft blue, yellow, and sharp red give the altarpiece a sparkling life. How different all this is from the serious, monumental Giotto or the stern, forboding Orcagna.

During the second half of the fifteenth century, the altarpiece with the Madonna, Child, and saints was modified in its psychological and emotional tenor. Numerous altarpieces not only presented the holy figures in a variety of environments and poses, but they also began to create moods. Certainly, the creation of psychological content is not the invention of the period after 1450, for we have already seen that paintings from Cimabue onward had very specific, often quite powerful emotional and supernatural messages. Yet, the later paintings, those made from the second half of the fifteenth century onward, conveyed subtler, more enigmatic, more complex, and sometimes more disturbing overtones.

Giovanni Bellini's Madonna, Child, John the Baptist, and an unidentified female saint, now in the Accademia, Venice [85], are set within a panoramic landscape made both chilly and luminous by a pale winter sky. The atmosphere of the hushed landscape, with its distant blue mountains, captures the meditative mood of the large figures, who occupy a space separated from the spectator by only a low parapet.

The cold, pale tones of the sky, streaked with a band of yellow near the horizon, and the muted greens, browns, blues, and reds of the frieze of foreground figures help develop the still and serious mood. Color is used here not only to create form and space, but also to establish the quiet, sad reverence that is the painting's dominant note. Like landscape and cloudscape, color, in Bellini's hands, takes on profound emotional and spiritual overtones.

The sad Madonna holding her nude and vulnerable Child with the utmost tenderness and solicitude is as beautiful and distant as the landscape behind her. Her companion saints are isolated, lost in distant thoughts, wonderfully enigmatic. The emotional content of this altarpiece (painted about 1500) is as important as the forms and personages that cover its surface; feeling, form, symbol, and atmosphere all merge into a complex, many-layered whole.

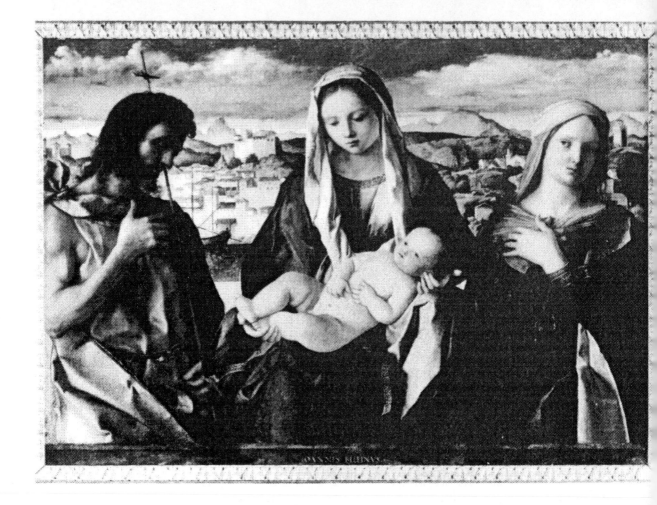

85. Giovanni Bellini, *Madonna, Child, and Saints,* Accademia, Venice. Giovanni Bellini painted a series of altarpieces of the Madonna, Child, and saints. The artist's powers of invention are demonstrated by the remarkable differences in form and feeling among the individual paintings of the series.

Bellini's introspective altarpiece expresses only one of a wide range of feelings seen in the painting of the second half of the fifteenth century. The altarpieces of Carlo Crivelli, a close contemporary of Bellini and an artist who arises from the same artistic tradition, demonstrate the range of interpretations of the Madonna, Child, and saints.

Crivelli's altarpiece [86] with the Madonna, Child, and Saints Jerome and Sebastian, now in the National Gallery, London, is still in its original frame and retains its predella (the small lower series of scenes illustrating episodes from the lives of the holy protagonists pictured above). Frame, predella, and the profusion of form in the central panel create a magnificent decorative ensemble. Crivelli's painting, from about 1490, reminds us that even in the late fifteenth century the altarpiece remained an object, a sumptuous and costly demonstration of the wealth of the patron who commissioned it.

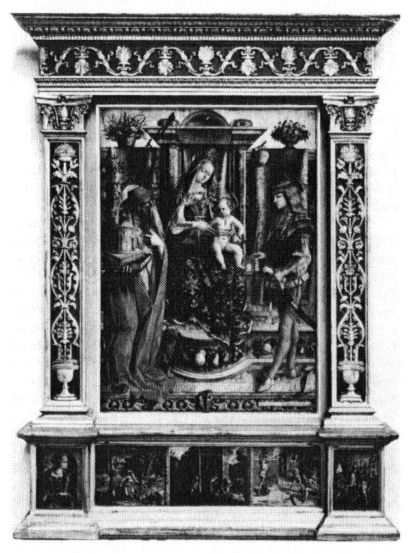

86. Carlo Crivelli, Altarpiece, National Gallery, London. Carlo Crivelli (active c. 1457–1495) was a Venetian who fled the city one step ahead of the law—he seems to have abducted a woman. Much of his best work was done in provincial towns far from his native city. His isolation from major centers of art seems to have helped create his powerful, if idiosyncratic, style.

The considerable amount of gold on Crivelli's altarpiece and the richness of its frame clearly mark it as a work of importance.

The enthroned Madonna, slightly offset to our left, the embroidered cloth at the left side of the picture, and the hot-red color and physical closeness of Saint Jerome holding a model of a church all shift the balance of the picture toward the left. But a profusion of forms and textures—flowerpots, oversized cucumbers, apples and other fruits and vegetables, fabrics, architectural details and decoration—abounds in the picture, distracting attention from this imbalance.

The frenetic energy of the composition is amplified by the spectral figures of Saints Jerome and Sebastian to either side of the Madonna. Intense and self-conscious, they seem to belong to a

different race than the equally complex but more familiar figures in Bellini's nearly contemporary altarpiece. Even Crivelli's comely Madonna has oddly angular arms and weird, clawlike fingers.

As in much of Crivelli's other work, there is a strange, passionate, almost neurotic feeling about these nervous figures, seen both in the altarpiece's main field and in its predella. Form and color, which in Crivelli's painting tends to be saturated and applied in fields, are placed at the service of a strongly idiosyncratic vision. Crivelli's altarpieces, like Bellini's, are imprinted with the singular personality of their author.

At the end of the fifteenth century, artists' relations both to their patrons and to the society in which they worked subtly changed. Several men of great talent, including Leonardo da Vinci, Michelangelo, and Raphael, began to imagine themselves in a different sphere from the valued craftsmen who, like their co-workers in other trades, were an integral and unspectacular part of the cooperative structure of Renaissance society. Instead, these men and their propagandists, such as the artist-writer Vasari, began to emphasize their special calling and innate talent. Painting and sculpture, until now the predictable products of long training and hard work, became instead, in several cases, the inspirations of geniuses who could effortlessly create masterpieces. There was a concomitant shift in the way some paintings and sculpture were viewed: no longer perceived only in terms of function, type, and image, for the first time objects were prized as works of art.[12] Their prestige, cost, aesthetic structure, and the fame of their authors were the new criteria by which these paintings and sculptures were evaluated. Collectors eagerly bought works sight unseen, not bothering much about their subject matter or type but desiring only a work from the hand of this or that master.

The same collectors also began to appreciate works for their unique solutions to certain fundamental formal problems, among these the placement of figures in space, the foreshortening and construction of figures, the portrayal of the nude. The display of artistic virtuosity in painting and sculpture was now something highly valued.

These new attitudes are reflected about 1506 in an early altarpiece [87] by Raphael, now in the Palazzo Pitti, Florence. Called the *Madonna del Baldacchino* after the baldachin that covers the holy figures, it is a good example of the large altarpiece type found throughout the Italian peninsula about 1500. The educated connoisseur or collector of the time would have appreciated the skill

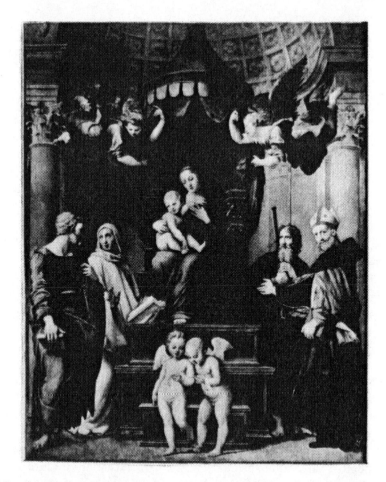

87. Raphael, *Madonna del
Baldacchino*, Palazzo Pitti, Florence.
Raphael Sanzio (1483–1520), of
Urbino, was the son of Giovanni
Santi, a painter. After working in
Perugino's shop, Raphael lived,
between 1504 and 1508, in
Florence, where he painted this large
altarpiece for the chapel of the Dei
family in the church of Santo
Spirito.

of Raphael's figure construction and the fluidity of the figures
correctly and adeptly placed in space. The geometry of the pic-
ture—the way the Madonna forms the apex of a triangle whose
sides move down through the outer standing saints—or the so-
phisticated relation between Madonna and Child or between the
two chubby putti would have been judged successful solutions to
challenging formal problems. The solutions would have been as
important as the function of the painting as an altarpiece. In fact,
to some minds the formal aspects of the work now would have
been more compelling than its functional qualities as a sacred pic-
ture. It is exactly this divestment of the iconic, supernatural qual-
ities of art that eventually led to our own attitude of art for art's
sake.

At first this new attitude was shared by just a small number
of patrons and artists; most Renaissance people must have looked
at Raphael's *Madonna del Baldacchino* as their ancestors had looked
at altarpieces for centuries. But it was the small circle of collectors,

painters, and sculptors, fascinated by this new formalistic approach to art, who were the harbingers of modernity.

Formal problem-solving aside, Raphael's altarpiece remains a work of majesty and power. The large, volumetric saints around the soft, young Madonna sound notes of dignity and serenity that reverberate throughout the picture. Like the beautiful flying angels, we look upon the holy figures with hushed reverence. There is a stillness and economy in this picture the equal of any previous altarpiece; Raphael was able to make the work both a fascinating and complex formal exercise and a reverent and moving sacred object.

To this point we have seen what might be called the altarpiece of images: the type of altarpiece that presents images arranged for the viewer's worship and contemplation. But there also existed another important type of Renaissance altarpiece, that which narrates an event. These narrative altarpieces are as old as the image types and coexisted with them throughout the history of Renaissance painting.

The narrative altarpiece most often depicted events from the life of Christ from the Annunciation to the Ascension, but there are also examples given over to events and legends from the lives of Mary and other holy figures. Many types and their examples proliferated, but most evolved in a like fashion.

From the early fourteenth century, the Annunciation was a popular subject for the altarpiece. The incarnation of Christ, the beginning of the Christian drama, Mary's supreme moment—all aspects of the Annunciation drama suited an object to be placed on the altar at which the Mass was performed.

Simone Martini's beautiful Annunciation altarpiece [88] of 1333 was made for an important chapel in the cathedral of Siena. Flanked by two saints on separate panels, the drama unfolds against a background of gleaming gold. The ardent Gabriel kneels before the Virgin, who recoils at the sight of his resplendent winged form. The two ethereal figures sway across the golden surface, impossibly tall and graceful beings enveloped in yards of costly material. Their silhouettes are wonderfully attenuated and alive, each creating its own pattern across the gold.

Simone's exquisite figures belong in a sphere far more rarefied than the viewer's mundane realm. His beautiful, gracious *Annunciation* is still as iconic and remote as the stark *Saint Francis* by Bonaventura di Berlinghiero (fig. 74) or Duccio's *Rucellai Madonna* (fig. 78), or many other early altarpieces. Although it depicts

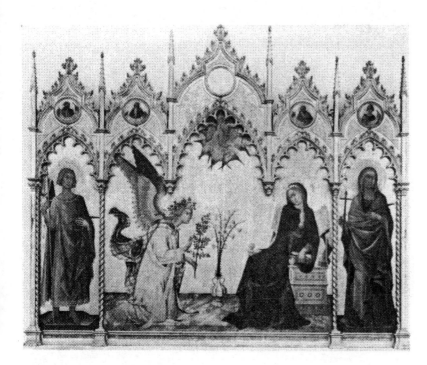

88. Simone Martini, *Annunciation,* Uffizi, Florence. Trained by Duccio, Simone Martini (active c. 1315–1344) was his master's most faithful heir. Simone's fame spread well beyond Siena, and he obtained commissions from Naples to southern France.

an event, it is a drama that takes place in a supernatural world shared by all these paintings, a world that extends and enhances the supernatural power of the Mass.

By the early fifteenth century, Annunciation altarpieces had begun to reflect the changes we have seen in other types. A large painting [89] from about 1440 by Fra Filippo Lippi, in the church of San Lorenzo in Florence, reveals how the story had metamorphosed. Instead of being played before a glimmering abstract field of gold, Lippi's drama has been domesticated. Surprised while she is reading, the Virgin greets Gabriel, who seems to have walked down the steps at the left, rather than alighted fresh from heaven. Everywhere, Lippi dwells on the familiar details of a Renaissance courtyard. Through the well-proportioned arches behind the angels there are tall, graceful trees and a city silhouetted against the sky. This view, inspired by the Tuscan world so familiar to Lippi and his contemporaries, is another anchor in reality, a means both to ground the event in the life of Renaissance Florence and to de-emphasize the iconic properties so prevalent in works like Simone Martini's heavenly drama of a hundred years earlier.

Both the composition and style of Lippi's *Annunciation* are part of this new reality, which brings the holy events inside the walls of the Renaissance city and consequently transforms the city into a sacred place. The construction of the building is in one-point perspective, that system of setting down the physical world

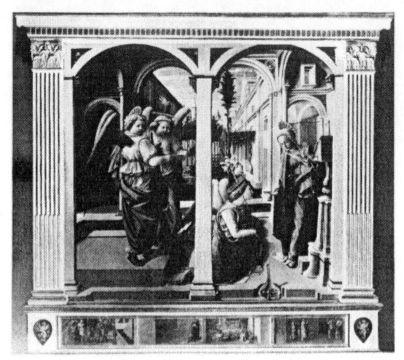

89. Fra Filippo Lippi, *Annunciation*, San Lorenzo, Florence. The Annunciation was a favored subject of Fra Filippo Lippi. This version, perhaps the finest of all, is of particular interest for its luminous architecture and the gardenscape with grape arbor.

in which all the orthogonal lines recede to a central vanishing point on the horizon. This system for representing reality corresponds no more to our actual perception of the world than does the flat, gold field of Simone Martini's *Annunciation.* But it does afford a proportional, rational method of placement and recession: the narrative is set within an ordered, mathematical grid, and the entire system is centered on the spectator, who views the narrative from the center of the altarpiece.

Lippi's figures are more convincingly scaled and proportioned than Simone's celestial beings. They are humans who behave as would the spectator. Throughout the second half of the fifteenth century, there was an increasing interest in the figure. Artists became preoccupied with the body's construction and with the correct articulation and proportion of its various parts. Artists—students and masters alike—spent much time studying the figure in sketches that ranged from spontaneous studies of the model to fully worked-out drawings. This newfound interest in the figure and in its correct and convincing placement in space is a concomitant of the increasing realism of the Renaissance altarpiece, a realism that tied the figures and the drama in which they acted closer to the world of the spectator.

Like the Madonna and Child with saints type, the Annunciation was susceptible to the imprint of artistic personality. No-

where is this clearer than in the strange and haunting *Annuncia-tion*, of about 1525 [90], by Lorenzo Lotto.

Although painted decades later than Fra Filippo Lippi's *An-nunciation*, Lotto's altarpiece demonstrates the same interest in the details of the domestic interior. The action is set in the bedroom of a large palazzo, whose loggia is seen through the open door. The covered bed, the shelf holding the books and candlestick, and the Virgin's nightcap and towel hanging from hooks make the scene familiar and down-to-earth.

Despite the familiar setting, Lotto's scene is unusual and dis-turbing. The coy Virgin, who, inexplicably, turns away from the angel and looks out toward us; the leaping, frightened cat (perhaps a symbol of evil); and the disjointed angel all invest the scene with a strangeness that must arise from the painter's psyche. Lotto's interpretation of the central event has become so enigmatic and deeply personal that it defies full analysis and understanding by the worshiper. From the iconic world of Simone Martini, where form and style are in the service of the divine, to Lotto's idiosyn-cratic altarpiece is a long way indeed.

Like their shapes and sizes, the subjects of altarpieces changed, often to reflect modification in theological concerns. Although such trends developed slowly, there are certain broad patterns that can be discerned at various times in the Renaissance. Some subjects appear early in the thirteenth century and continue unabated through the sixteenth century; others have a short popularity and are seldom seen again.

As an altarpiece subject, the Baptism of Christ had a long and eventful history. First painted in considerable numbers in the fourteenth century, it soon became a standard subject for the nar-rative altarpiece. Christ's baptism by John was regarded both as an act of ritual purification and as a rebirth, two themes closely connected with the Mass. Of course, baptism was also a rite of initiation into the church and one of the seven sacraments, the great ritual acts which conferred grace.

Niccolò di Pietro Gerini's *Baptism of Christ* [91], now in the National Gallery, London, is an early Florentine example of the use of this subject as the narrative hub of an altarpiece. Painted during the last years of the fourteenth century, it presents the scene as the altarpiece's center, framed between the standing figures of Saints Peter and Paul. These two founders of the church (tra-ditionally thought to have been martyred on the same day) are highly appropriate brackets for a scene of baptism, the ritual act

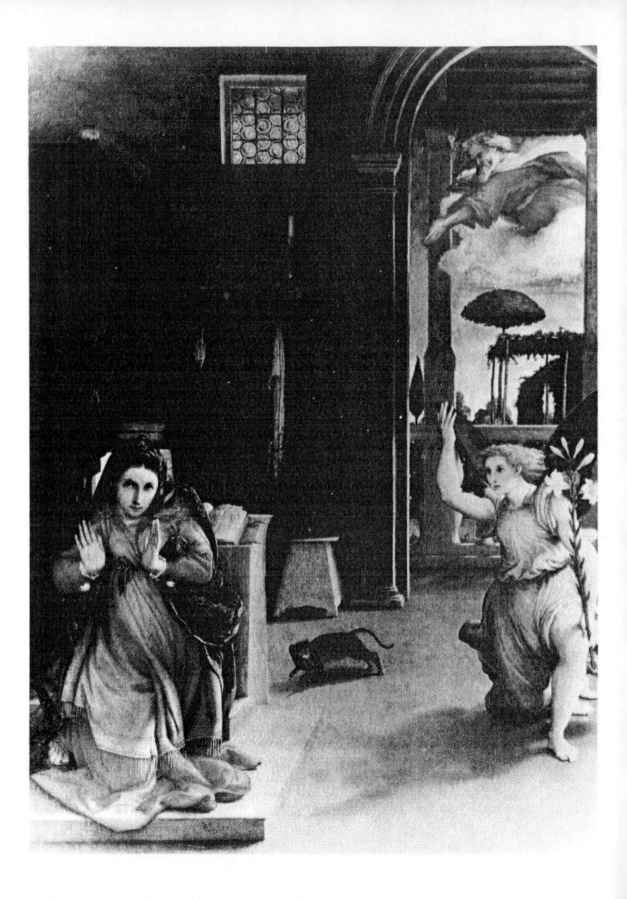

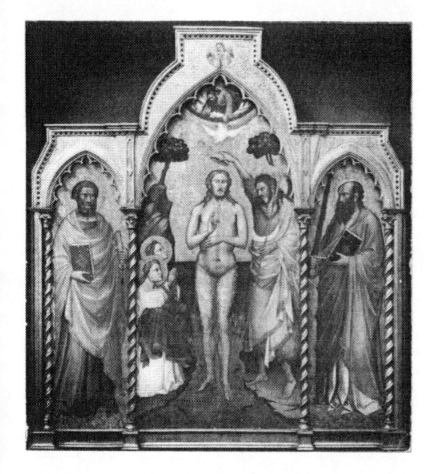

90. Lorenzo Lotto, *Annunciation*, Pinacoteca Civica, Recanati. Lorenzo Lotto (c. 1480–1556), of Venice, was a restless, highly introspective painter who worked principally on the mainland. His account book survives, and it is a fascinating source of information on both the artist and his art.

91. Niccolò di Pietro Gerini, *Baptism of Christ*, National Gallery, London. Niccolò di Pietro Gerini (active c. 1368–1415) belonged to the generation of Florentine painters working during the late-fourteenth and early-fifteenth centuries. A prolific (but uninspired) artist, he found numerous commissions in Florence.

of initiation into the church itself. Moreover, this is not just any baptism, but Christ's.

The centrality of baptism to the church is stressed by Gerini's hierarchic, frozen picture. Christ stands at exact center, rigid and commanding, attended by two adoring angels and the baptizing John. The stiff figures and the brittle landscape work with the frontal, symmetrical image to make the *Baptism* an impressive portrayal of solemn ritual. Of course, the iconic nature of Gerini's *Baptism* is something shared by many paintings from the second half of the fourteenth century and is matched closely by the altarpiece in the Accademia by Orcagna, discussed above.

By the middle of the fifteenth century there were substantial changes in the depiction of the Baptism of Christ. The stern, almost fierce quality of many of the earlier pictures had been substantially humanized. Christ's baptism certainly remained a central ritual of the church, but now it also was seen as an episode from life and history, and consequently it was invested with a worldliness absent in many of the early versions of the story.

Piero della Francesca's *Baptism of Christ* [92] of about 1460 was detached from its flanking figures of saints and now stands alone in the National Gallery, London. But even in its isolation, we see something far removed from the bare essentials of Gerini's narrative. The drama occurs in a holy land very like the fertile Tuscan hills; through this gentle landscape runs the Jordan, looking just like those countless little streams in the Tuscan countryside. Christ, the Baptist, and the pearly angels who stand so gracefully still have been brought down to earth and placed in the landscape outside Sansepolcro, Piero's hometown and the location for which the *Baptism* was made.

Landscape now plays a major role. In fact, in Piero's picture, the holiness of the ritual act is both matched and reinforced by the light-drenched countryside. The gently rolling hills dotted with vineyards, the blossoming trees, and the luminous blue sky partake of the holiness of the radiant figures in the foreground. This little stretch of Tuscan countryside, in Piero's hands, has been sanctified by the presence of the divine figures, who perform their ritual act eternally.

The increasing humanism of Renaissance society in the fifteenth century is the major motivation for the basic conceptual and formal differences between the altarpieces by Niccolò Gerini and Piero della Francesca. In the latter's altarpiece Christ is more human and accessible, although he and the other figures are still not easily understandable. Yet, the bright, optimistic world of Piero's painting, with its clear blues, whites, greens, and reds, entices in a way alien to the much more iconic and distanced image by Gerini.

By the early sixteenth century, the Baptism had reached a new stage of development. On the whole, altarpieces were now much larger (this was partially due to the use of canvas and oil paint) and often were devoted only to the narrative itself; flanking saints, however, still accompanied the narrative in a small number of cases.

92. Piero della Francesca, *Baptism of Christ*, National Gallery, London. Piero's altarpiece was painted for the priory of San Giovanni Battista at Sansepolcro. Two flanking saints on separate panels and a predella were added to the *Baptism* by the Sienese artist Matteo di Giovanni. It is unclear whether these additions, which remain in Sansepolcro, were originally to be painted by Piero.

In Paolo Veronese's *Baptism of Christ* [93], painted about a century after Piero's altarpiece, the flanking saints are gone. We are aware only of the psychological and physical drama unfolding before our eyes; this is more *picture* than *altarpiece,* more story than ritual or dogma. The development of the altarpiece from icon to work of art, from a spiritual meditation to an exciting essay in style and form, is illustrated by a comparison between Veronese's *Baptism* and the altarpiece of the same subject done by Gerini

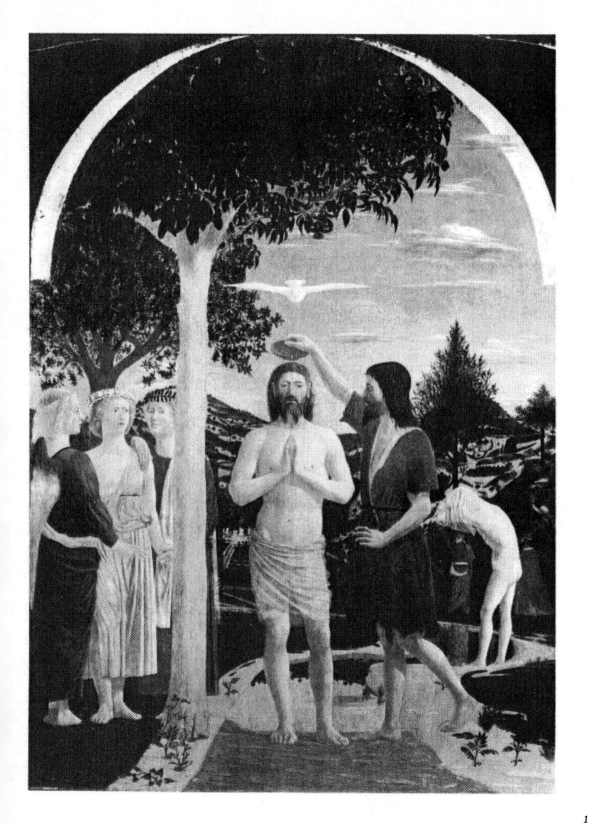

119

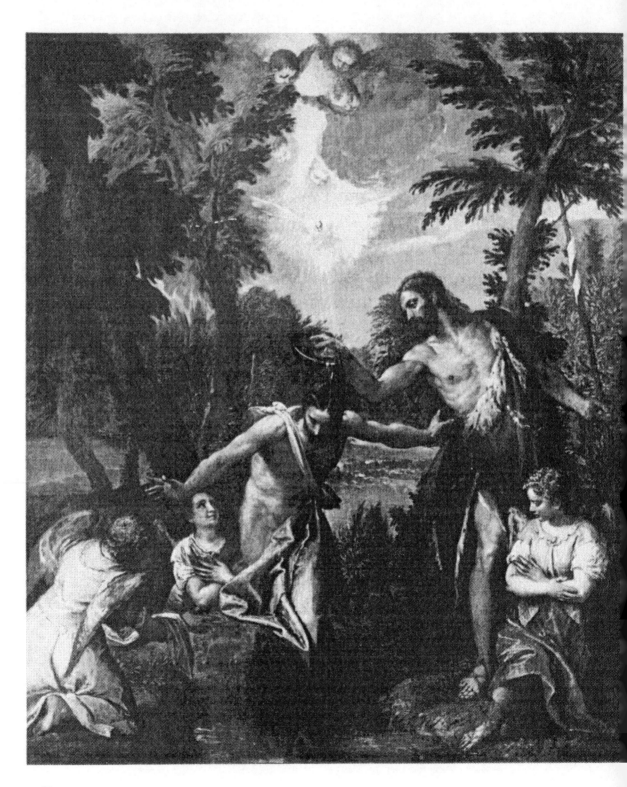

nearly two centuries earlier. In Veronese's *Baptism* the balance has shifted: art has replaced icon.

Landscape in Veronese's *Baptism* is the dominant element; the lush, almost tropical atmosphere sets the scene and mood for the foreground action. Saturated pinks, greens, and other high-pitched colors enrich the natural world surrounding the holy figures and add notes of celebration to the *Baptism*.

Each of the figures is a virtuoso work of placement and fore-shortening. The complicated poses of Christ and the angels hold our attention and make us marvel at Veronese's facility. We are also aware of a sensuality not present in the other versions of the narrative seen thus far: the luxuriant forest, the almost aqueous atmosphere, the heavy, costly robes, and the smooth, luminous skin of John the Baptist and Christ add a tactile immediacy to the ritual act.

Undoubtedly, Veronese's altarpiece still stood as a comple-ment and enrichment to the Mass said at the altar, and it was thus perceived by many of those who stood before it; in this respect it is still very much in the tradition of the earliest of the Baptism altarpieces. But, to the connoisseur, it was something new: a work of art.

To an increasingly sophisticated audience, the form of the work—its shapes, colors, lines, and other visual particularities—was now equal to the subject and imagery that it portrayed. Our notion of a work of art as the sum of a number of formal and philosophical ideas given shape by an artist was nascent in many of the religious and secular paintings and sculptures of the early sixteenth century.

The sculptured tabernacle was, with the altarpiece, the other important object that occupied the altar or the walls around it. Usually carved of stone or molded of terracotta, these tabernacles held the sacred wafer used in the Mass. They were, like the example (commissioned in 1441) by Luca della Robbia in Peretola [94], the receptacles for the Host, Christ's holy body, and, consequently, they were sacrosanct.[13]

The tabernacle often borrowed its structure and decorative details from contemporary architecture. Placed under a pediment or lunette supported by pilasters, a small door or grille closed the compartment that held the Host. These doors themselves were works of art. Often made of bronze and sometimes gilded, they

93. Paolo Veronese, *Baptism of Christ*, J. Paul Getty Museum, Malibu. As his name implies, Paolo Veronese (1528–1588) was born in Verona. However, his major painting was for Venice, where he worked from the 1550s. Although he is much admired for his mythological pictures, many of his religious paintings, such as this *Baptism*, are remarkable for their sincere piety.

94. Luca della Robbia, Tabernacle, Santa Maria, Peretola. Made of marble and glazed terracotta, this tabernacle was commissioned in 1441. Originally it was placed in the chapel of Saint Luke in the Florentine church of Sant'Egidio, but it was later transferred to Santa Maria in Peretola near Florence.

were decorated with figures of Christ holding a cross, with the blessing God the Father, or with other figurative or geometric motifs.

Other parts of the tabernacle also were embellished with fig-ures. The pediment or lunette at the top of the tabernacle might be decorated with a blessing God the Father, an Entombment, or a Pietà. Angels, often flanking the door, were also a common part of the tabernacle.

The angels, the God the Father, and the Deposition or other image referring to Christ's death were all functional as well as decorative. They, like the Pietà—the image of the dead Christ held by his mother—gave concrete form to the invisible Eucharistic miracle.

The Pietà or another image of the sacrificed Christ was brought even closer to the worshiper by the pax [95]. This was a portable image of Christ or the Virgin and Child that was held by the priest and offered to the communicant to kiss. Held by a handle in the back, the pax was often made of bronze or some

95. Bartolomeo Bellano, *Pietà*,
National Gallery of Art,
Washington, D.C. Born about 1440,
the Paduan Bartolomeo Bellano may
have worked as a boy with Donatello
while the latter was in Padua.
Bellano became one of the principal
sculptors of his native city, where he
died in 1497.

other metal that would withstand much use.[14] Some painted
wooden paxes exist, although such a fragile object could not have
survived heavy wear.

Much of the imagery on the bronze paxes is hierarchical. The
frontal and symmetrical dead Christ or the dead Christ and angels
were memorable images that reinforced the wonder of the Eucharist.
Moreover, the physical immediacy of the body held out by the
priest for the communicant's kiss brought Christ very near indeed.
The images of Virgin and Child served the same function, although
in them the sacrificial role of Mary and the incarnation of Christ
were also factors.

Another religious type of considerable importance was the
painted crucifix.[15] This was not an altarpiece, but usually placed
on a rood screen or hung above the altar. Sometimes suspended

from the ceiling of an individual chapel or from the nave ceiling, these crucifixes were on occasion very large, over life-sized. Like the altarpiece, the crucifix was tied to the liturgy, for it depicted the body of the sacrificed Christ. This image of the crucified Christ would have been another visualization of the miracle of the Mass, of that moment when the Host became the body of Christ.

In the earliest examples of the crucifix, Christ is seen alive. Surrounded by scenes from his Passion on the apron (the projection of the cross around Christ's torso) and placed below a top panel (*cimasa*) often depicting the Ascension or Pentecost, the earliest crucifixes are complicated iconographic structures illustrating the triumphal Christ, the deity who conquered torment and death to redeem and save mankind.

This image of Christ, as a powerful triumphant divinity, is rendered in a style completely suited for such a being. A large crucifix [96] from Pisa from the last years of the twelfth century, one of the earliest surviving examples, demonstrates the abstract

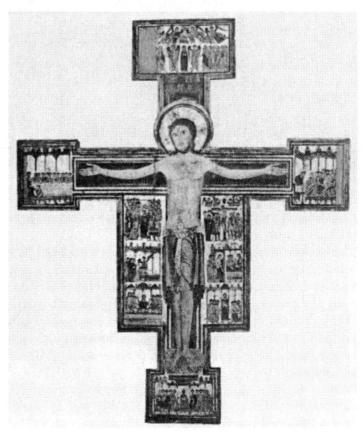

96. Pisan, Crucifix, Uffizi, Florence. Twelfth- and thirteenth-century Pisan painting was often of a high quality. The bustling commercial city of Pisa was one of the early major centers of the Italian peninsula, and its wealth encouraged patrons and artists alike.

and almost pictographic idiom of the type. Vigorous and powerful, but unrealistic and summary, Christ and the little scenes are set down in a pictorial shorthand that removes them from our reality. Christ is stern and commanding, and his supernaturalism is stressed; his triumph over the torment of his Passion and death is the real subject of the painting. These early crucifixes are haunting images that stay in the mind long after one has left their presence. In their scale, style, and hierarchical grandeur, they perfectly express Christ as a potent, awesome icon.

In the thirteenth century, perhaps because of the spread of the humanistic spirituality of Saint Francis and other fundamental shifts in religion and society in the Italian peninsula, the crucifix underwent modifications. By the end of the thirteenth century, as we can see in a splendid cross [97] by the Florentine artist Cimabue, Christ had become more human. Still large, impressive, and monumental, Christ is, nevertheless, more accessible. Also, the apron has been suppressed. But the single most important change has occurred in Christ's state, for in Cimabue's cross, he is dead. No longer viewed as the superhuman being who could soar above his torment and death, now Christ is conceptualized and pictured as physically mortal, a human who died on the cross. The many *cimase* showing the Resurrection or the blessing Christ that continued to surmount the crucifix certainly demonstrated Christ's eventual triumph over death, but the central idea of the crucified savior had changed.

The pictorial language in which Cimabue and his contemporaries set down their images of the crucified Christ had also changed in order to convey the new ideas about his being. The abstraction and stylization of the earlier crosses has given way to a more realistic, more anatomically correct portrayal of the figure. There remain many ties with the stylized and pictographic past, but clearly Cimabue was working toward a new and more comprehensible reality, a reality where Christ is less iconic and more like the worshiper.

The movement toward realism by Cimabue and his contemporaries found its fruition in the Santa Maria Novella crucifix [98] by Giotto, of about 1300.[16] Here Giotto has set down a fully realistic dead Christ free from vestiges of schematism. Now the figure slumps on the cross, muscles strained, stomach sagging. The weight and gravity of the figure are breathtaking. A natural light falls across the figure, adding drama and defining form. Only the core of the drama, free from the traditional decorative conventions,

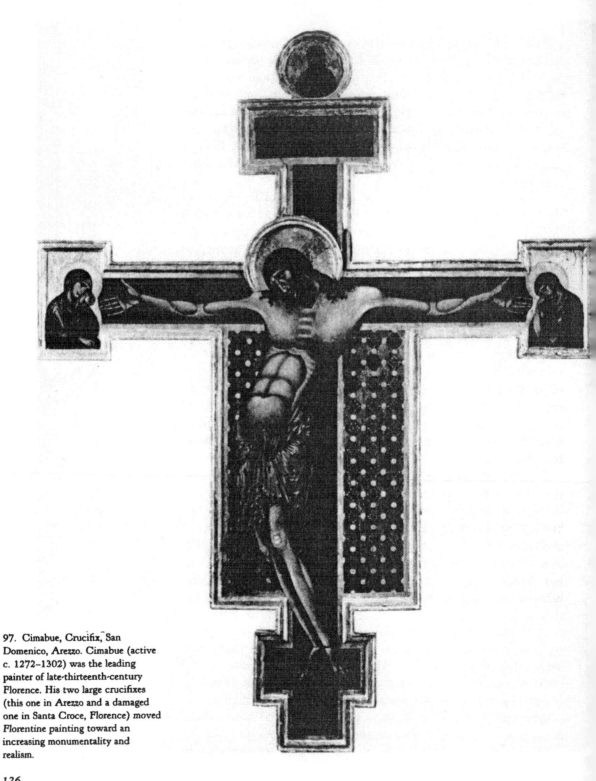

97. Cimabue, Crucifix, San
Domenico, Arezzo. Cimabue (active
c. 1272–1302) was the leading
painter of late-thirteenth-century
Florence. His two large crucifixes
(this one in Arezzo and a damaged
one in Santa Croce, Florence) moved
Florentine painting toward an
increasing monumentality and
realism.

126

is presented; the worshiper confronts the lifeless, but human, body of Christ.

Giotto's Santa Maria Novella crucifix had widespread influence. The sweeping inspiration of this prototype made it impossible for most artists to return to the style of previous crucifixes, so radically had the renowned Giotto altered the conception of the type. But the years around 1300, the time of Giotto's cross, were the last that such large crosses were produced in considerable numbers. Certainly, various types of painted and carved crucifixes continued to be made, but the large painted cross of the type first seen in the twelfth century disappeared about 1300. Perhaps the new-found reality introduced by Giotto, making Christ so human and believable, divested the type of the grandeur its huge size demanded.

One type of crucifix sometimes left its location above the altar to be carried in processions. Probably of very early origin, the processional crucifix could be either painted or carved. The carved versions, such as a splendid wooden one [99] made in Florence in the first half of the fourteenth century, depicted only the crucified Christ. Often these had movable arms, which could be folded down to the sides. Some of the figures were detachable from the cross. These features of the carved crucifix allowed it to be used in the religious processions common during the Renaissance. Since

98. Giotto, Crucifix, Santa Maria Novella, Florence. Giotto may have studied with Cimabue, but in his own painting he brought Cimabue's incipient naturalism to fruition. Although revolutionary, Giotto's Santa Maria Novella crucifix inspired many copies throughout Tuscany and influenced even quite provincial artists.

99. Florentine, Crucifix, Museo dell'Opera del Duomo, Florence. Sculpture in wood was much practiced during the Renaissance, but only a fraction of the work survives. The fragile nature of the material has led to the loss of many statues and reliefs by artists of distinction.

the figure of Christ could be detached from the cross and the arms could be moved down to the sides, the wooden figure could be turned from a Christ of the Crucifixion into a Christ of the Lamentation or Entombment.[17] Such a figure could also be used in a religious drama or on the Good Friday enactment of the Passion.

Other wooden figures had similar roles. Often the entrance to a chapel was flanked by an Annunciation group much like the one of about 1420 by Jacopo della Quercia in San Gimignano [100]. The figures of the annunciatory angel and the Virgin were both decorative and part of the general Eucharistic symbolism that pervaded chapel decoration, for the incarnation of Christ at the Annunciation was likened to the miraculous incarnation of transubstantiation. The Annunciation group, placed to either side of

100. Jacopo della Quercia, *Annunciation Group,* Collegiata, San Gimignano. Jacopo della Quercia (1374?–1438) was a talented Sienese sculptor whose fame spread far outside his native city. His interest in the dynamics of the human anatomy influenced the young Michelangelo decades later.

the entrance wall, would, therefore, be a most fitting introduction to the chapel and the altar.

These statues were of wood because they, like the crucifixes, were taken down for processional use; the lightness of wood allowed for easy carrying. Mounted in carts or simply set up as tableaux, these figures, often brightly and realistically painted, could be utilized in religious processions. Many of the figures, especially of the Virgin, are carved without much detail, because for procession they were dressed in real clothes, much the way similar figures still are dressed in southern Italy.

There were also other wooden statues in the large chapels, often Crucifixion or Deposition [101] groups. Most popular in the early part of our period, these were often large, sometimes nearly life-sized. Made of brightly painted wood, these vigorously carved figures have come down to us only in scant number; the overall survival rate for wooden sculpture from the Italian Renaissance is poor.

These wooden figures, and the terracotta groups that we will soon survey, have a tableau-like quality about them, and they may, in fact, have some relation to the various sacred dramas of the Annunciation, Lamentation, and other scenes performed by costumed actors both inside the churches and in the piazzas before them. The silent interactions that occur among the various members of the sculptural groups, the expressive, dramatic poses of the fig-

101. Tuscan, *Deposition Group*, Duomo, Volterra. Many of the wooden Crucifixion and Deposition groups have been destroyed or dispersed over time. An isolated crucifix or a mourning Virgin or Saint John the Evangelist often are the only survivors of these powerful wooden tableaux.

ures, and even the costumes may have both influenced and been influenced by the many sacred dramas that unfolded inside the Renaissance church.

The most dramatic sculptural groups, however, are not in wood but in terracotta, and the finest of these were produced about 1500 in the central Italian area now called Emilia-Romagna.[18] Around Bologna, Modena, and Ferrara, terracotta sculpture reached its zenith in the works of several artists.

Niccolò dell'Arca's *Lamentation Group* [102] of 1463 in Bologna, like many of the figural groups in wood and terracotta, is intensely realistic. There is, moreover, a piercing display of grief in Niccolò's group that is also characteristic of the type, although in Niccolò's hands there is a unique wildness about the individual figures.

The figures in Niccolò's group are not static images; rather, they are in dramatic action, unified by their responses to the still body of Christ. Their vivid emotions are expressed wonderfully by contorted bodies, once pigmented, and flying drapery, which elevate the scene to a high dramatic pitch.

Of course, these groups would have been tied closely to the Eucharistic rite. Placed behind or near an altar, they would have reminded the communicant that the altar was Christ's tomb, from which he would rise during the Mass; that he was sacrificed for the redemption and salvation of mankind; and that he was the offering of his mother, who stands above him with hands clasped in numb grief. Nowhere else in the Renaissance is the Eucharistic visualization of Christ's sacrifice portrayed with more unflinching realism.

Another of these surviving terracotta groups (there must have been many of them, in all parts of the Italian peninsula) is closely related to the tradition of Niccolò dell'Arca. By Guido Mazzoni, dating about 1480, this Lamentation [103] is more subdued, quieter; it is, however, as convincing as Niccolò's. Both groups are realistic: each artist has paid careful attention to facial features, texture, and details of costume. But the realism of Mazzoni's almost life-sized figures is so convincing that they seem to be breathing; the skillful painting and design resemble some superb wax works.

Nowhere else in the long history of Italian Renaissance art are the holy figures so disturbingly realistic as they are in Mazzoni's series of terracotta groups. It is as though Christ and his devoted cadre really exist in the chapels and niches of the churches they

102. Niccolò dell'Arca, *Lamentation Group*, Santa Maria della Vita, Bologna. Niccolò dell'Arca (c. 1435-1494) seems to have been born in Bari, a city in southern Italy. The appellation dell'Arca derives from the sculptor's extensive work on the Arca of Saint Dominic in the church of San Domenico, Bologna.

103. Guido Mazzoni, *Lamentation Group*, San Giovanni della Buona Morte, Modena. In 1473, Guido Mazzoni (active 1473-1518) was recorded in Modena as supervising a pantomime for the entrance of Eleonora of Aragon. Such pantomimes must be related to the remarkable physical and emotional ties among the realistic figures in the sculptor's terracotta work.

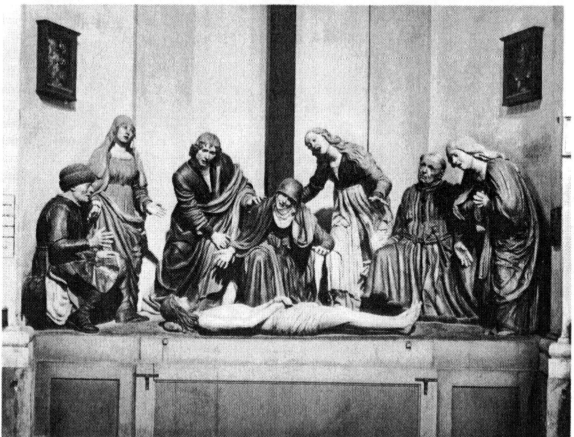

dominate with their unsettling presence; the body of Christ, the center of the Eucharistic miracle, is made startlingly real.

There were also various types of single statues in the Renaissance chapel.[19] Above the altar stood figures of Christ, in varying size, of wood, stone, and bronze. There were also many statues of saints. A chapel dedicated to Saint Paul, for instance, might have had a nearly life-sized statue of the saint, such as the haunting one [104] from about 1475 by the Sienese artist Vecchietta, on or near the altar. Such figures allowed the worshiper both to visualize the saint, who might also be portrayed in the chapel's frescoes or altarpiece, and to address prayers and pleas directly to his or her image. Many of these statues of saints were the objects of a particular devotion, which arose from their special protective powers. Even today in Italian churches, there is usually one statue or picture of a saint (often a very plaintive or ecstatic image) singled out for special attention and devotion by the worshipers.

The tomb was connected closely with the altar and its attendant figurative imagery. Resurrection and salvation are the essence of the Mass, and these aspects of the ritual gradually led to the practice of burial within the church: by the time of the Renaissance, churches were burial grounds. One of the principal reasons for the erection of a chapel, as we have seen, was to provide a burial place for the patron and his family. Moreover, the burial site would be protected by the church itself, and money could be left for upkeep of the chapel and the tombs. Additional funds could be bequeathed by the donor for the saying of Requiem Masses in the chapel.[20]

The tomb, which could be located in a chapel or in almost any other part of the building, was thus a highly important feature of the Renaissance church. Usually a costly object, its design, size, material, and location were measures of the status, wealth, and power of its occupant. Like any other common object with a long history and wide geographic distribution, the tomb developed many types, from the simplest memorial to the grandiose, complex structure that was architectural in both size and nature.

It appears that the most common type of Renaissance tomb was a simple rectangular slab of stone, such as an example [105] in Santa Croce, Florence, which was set into the floor of the church. The slab was inscribed with the name and dates of the occupant buried beneath it and with a coat of arms or other simple, often geometric, decoration. Sometimes the coats of arms and the border decoration were picked out in bronze or in different-colored marble or other stone, but simplicity was the general rule. Such

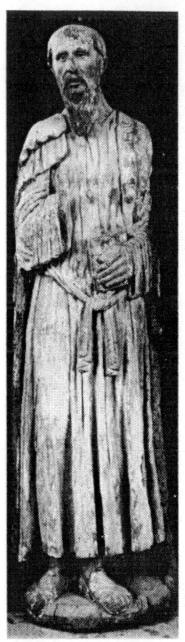

104. Vecchietta, *Saint Paul*, Museo Horne, Florence. Nearly life-sized wooden statues were carved with frequency by Sienese artists. Vecchietta, who had a special affinity for the material, executed saints, angels, and Virgins of wood.

105. Florentine, Tomb slab, Santa Croce, Florence. This elegant tomb slab of colored marble and bronze is one of many fifteenth-century examples in the Florentine church of Santa Croce that have a dignity and sobriety in keeping with their function.

tombs were found in the floor of the chapels, aisles, and naves of most Renaissance churches.

More complex, and probably much more expensive, were the slabs decorated with effigies of the defunct. Made either of stone or bronze, for centuries these likenesses set in the floors have been walked on with impunity; consequently, many of the effigies have been worn to such a ruinous state that only their barest outlines are now recognizable.

Donatello's tomb for Giovanni Pecci, who was the bishop of Grosseto, a city in southwestern Tuscany, is an early bronze version of the figurative tomb slab [106]. In his will Pecci (who died in 1426) carefully specified the details and site of his burial in the cathedral of Siena, and it can be assumed that the major elements of his tomb (size, material, effigy) were faithfully supervised by his heirs and executors.

All slab tombs had to be more or less level with the floor; in stone this was achieved by incision, and in bronze, by the type of

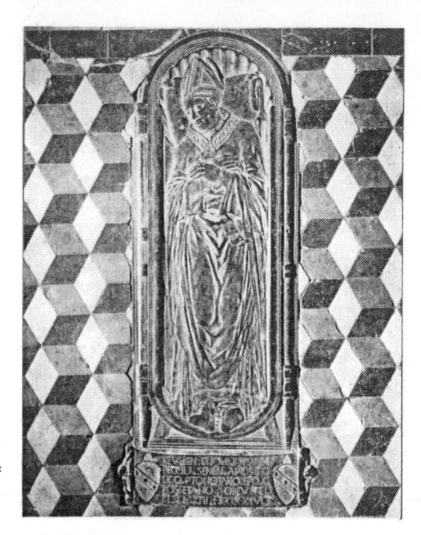

106. Donatello, Pecci tomb slab, Duomo, Siena. In his will, Giovanni Pecci not only left instructions for his burial (to be in an honorable part of the Siena cathedral), but he also specified how his funeral was to be financed.

very low relief seen on the Pecci tomb. Like all great artists, Donatello has brilliantly turned a necessity (the low relief) into a virtue. Using the illusionistic possibilities afforded by the linear low relief, he has realistically portrayed the bishop on his bier. The bier and its occupant, whose head rests on a pillow, must have reminded the contemporary worshiper of the lying-in-state ceremony practiced in the Renaissance: before burial, the defunct was brought into the church on a bier, where he or she was watched over by members of the family and was the object of liturgical services. It was this public moment that Donatello memorialized in this tomb slab. It is most unlikely that Donatello actually saw Pecci lying in state in the Siena duomo, but he combined all the elements associated with such events into a convincing representation.

It is also unlikely that Donatello knew what Pecci looked like.

He has probably given us a generic portrait of a cleric that emphasizes his role as a bishop more than his personality or appearance.

A later type of tomb, related to the slab by its figural imagery, was freestanding. A good example of this type is the tomb of Ilaria del Carretto [107], the wife of Paolo Guinigi, lord of Lucca. Ilaria died in 1405, only two years after her marriage.

Her tomb, by Jacopo della Quercia, is much more complex and grand than the usual slab tomb. More than just a commemorative plaque or slab, it, and many of its type, are monuments, memorials to the defunct. Ilaria's tomb, carved about 1406, consists of a sarcophagus decorated all around with putti carrying garlands. This continuous frieze, one of Jacopo's happiest inventions, gives a rhythm and motion to the base of the sarcophagus that animates the entire tomb and makes a poignant contrast to the effigy of Ilaria, who lies lifeless above it. One of the most admired works of Italian Renaissance sculpture, Ilaria is touchingly portrayed as a youthful and comely woman stilled by death. Not the formal, lying-in-state depiction seen in the Pecci tomb slab, this is a more intimate and personal memorial, which moves the viewer by its beauty and calm.

Here Jacopo della Quercia has turned the effigy into something greater than the simple depiction of the image of the defunct. In the hands of gifted artists, the tomb could become something that we value not only for its form and commemorative function, but also for its profundity and subtlety of insight.

A more formal, complex, and costly freestanding tomb of the later type is that of Pope Sixtus IV in the Vatican [108]. By Antonio and Piero Pollaiuolo, this large bronze, begun shortly after the pope's death in 1484 and completed in 1493, consists of the recumbent effigy of Sixtus, the builder of the Sistine Chapel, on a slab decorated with reliefs of the Virtues. This slab is supported by a chamfered base covered with relief figures of the Liberal Arts.

Not only is this monument larger and more complex in design than any we have seen so far, but it is more programmatic. Its display of the Virtues and the Liberal Arts (derived from classical and medieval sources) adds a dimension beyond simple commemoration, for it reflects the complex scholastic and scholarly cast of Sixtus's mind. Here is a decorative program that begins to tell us something about the mind and accomplishments of the defunct.

From the thirteenth century, large tombs, which could not be accommodated by the limited floor space of the church, were built into or attached to the wall. The wall tomb, an expensive

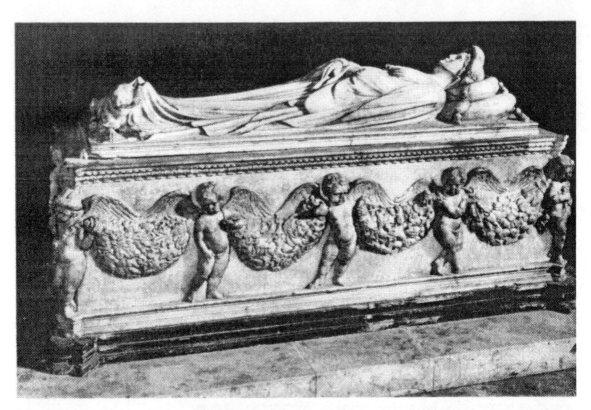

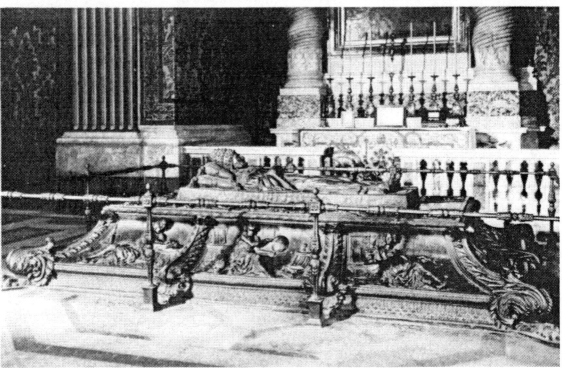

project, soon became one of the most characteristic features of the Renaissance church, and it was often used to honor men and women of fame and status.

An early example of the wall tomb is that of Cardinal Riccardo Petroni, carved for the Siena cathedral about 1318 by the Sienese sculptor Tino di Camaino [109]. This large and ambitious structure (which has been moved from its original location in the church) consists of several levels.

Petroni's sarcophagus is supported by four caryatids who stand on a varicolored marble ledge. The cardinal's effigy rests on a marble base. The body is attended by four angels: two behind and one each at the head and feet, who draw back the curtain to reveal the cardinal's body. Above are three elaborate niches, much like

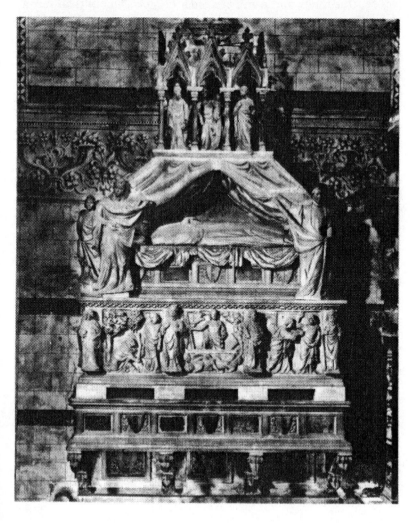

107. Jacopo della Quercia, Tomb of Ilaria del Carretto, Duomo, Lucca. Ilaria del Carretto was the second wife of Paolo Guinigi of Lucca. She had two children: a boy in 1404, and a girl in 1405. Ilaria died in December 1405, from complications following the birth of her daughter.

108. Antonio and Piero Pollaiuolo, Tomb of Pope Sixtus IV, Grotte Vaticane, Vatican City. Sixtus IV (Francesco della Rovere, 1414–1484) was a learned Franciscan who enriched the Vatican library and built the Sistine Chapel. His nephew Giuliano became Pope Julius II, the patron of Michelangelo's Sistine ceiling.

109. Tino di Camaino, Tomb of Cardinal Riccardo Petroni, Duomo, Siena. Tino di Camaino (c. 1285–1337) seems to have been a pupil of Giovanni Pisano, the sculptor of the facade of the Siena cathedral. Besides the Petroni tomb, Tino was commissioned to do tomb-monuments for important men and women in Florence, Pisa, and Naples.

the wings and framework of contemporary altarpieces, which contain the Virgin, Child, and two saints.

The figural decoration on the Petroni monument is related to the decoration of the altarpiece in its emphasis on the death and resurrection of Christ. Each of the three relief scenes on the sarcophagus—the Noli Me Tangere, the Resurrection, and the Doubting Thomas—deals with the miraculous victory of Christ over death. They are also, like the decoration of the altarpiece or tabernacle, enmeshed with the meaning and ritual of the Mass, which was performed at the altars near the Petroni tomb in the duomo of Siena.

Petroni's effigy, which lies in state, is shown to us by angels who will soon close the curtains on the cardinal's earthly existence. Hence, this tomb, and many of similar design, is more than just a lifeless monument. Instead, it is an animated drama, a sort of narrative, in which Petroni's body is seen suspended momentarily between earth and heaven as it awaits divine resurrection and salvation. And above, at the tomb's crown, the Madonna, Child, and saints watch over the cardinal. The entire tomb, from its wide ledge below to the point of its crowning arch, works both to memorialize the cardinal and to demonstrate the certainty of his resurrection and entry into heaven.

The size and complexity of the wall tombs reflect their function as monuments honoring the famous. For instance, when Carlo Marsuppini, the state chancellor of Florence, died in 1453, he was honored with a large wall tomb [110], in the Florentine church of Santa Croce, finished before 1464 by Desiderio da Settignano. The honorific and secular nature of the tomb is clear from the inscription on the sarcophagus: "Stay and see the marbles which enshrine a great sage, one for whose mind there was not world enough. Carlo, the great glory of his age, knew all that nature, the heavens, and human conduct have to tell. O Roman and Greek muses, now unloose your hair. Alas, the fame and splendor of your choir is dead." Not only did this tomb honor Marsuppini; it also shed glory on the church in which he was buried and on the city that employed him and that he served so well.

Surrounded by an elaborate architectural framework—which probably ultimately derives from the canopy, or the tentlike curtains, of tombs such as that of Cardinal Petroni in Siena—the recumbent effigy of Marsuppini is the focus of the monument. Tipped outward toward the spectator, the body of Marsuppini lies on a bier covered with drapery, which, like the rest of the

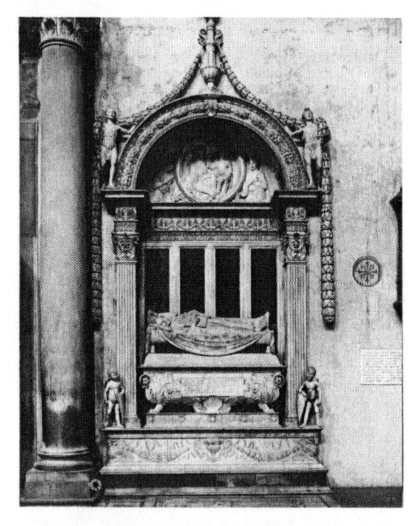

110. Desiderio da Settignano, Tomb of Carlo Marsuppini, Santa Croce, Florence. Carlo Marsuppini (1399–1453), of Arezzo, was a humanist who taught Greek in Florence. Before becoming chancellor of Florence he served as a papal secretary.

tomb, was pigmented. Like Donatello's Pecci tomb slab, Marsup-pini's effigy evokes the lying-in-state that preceded burial. Two angels (who look very much like Roman putti) stand on either side of the delicately carved sarcophagus, and the Madonna and Child appear in a tondo in the tomb's lunette; but in contrast to the Petroni tomb, obvious references to resurrection do not appear. The Marsuppini tomb is, in fact, of a different order: half sacred, half a memorial to the learning and service of the chancellor, it is more worldly and personal, a record and image of a man whom his contemporaries wished to immortalize as a citizen.

For the very important, the tombs grew to great size; they became tomb-monuments. One of the largest and most impressive of these wall tombs is that of the doge (the titular head of Venice) Niccolò Tron (died 1473), in the church of Santa Maria dei Frari

in Venice [111]. This multilayered structure was executed by the sculptor Antonio Rizzo and his workshop during the 1480s. There are five separate registers on the Tron tomb. The lowest consists of the standing figure of the doge accompanied by Charity and Prudence; Tron is the first of the doges to be depicted as alive on a tomb. It is this living, commanding doge who is in the closest contact with the viewer; flanked by Virtues, it is he who sets the tone of the tomb.

The second register is made up of the epitaph, reliefs, and pages with shields bearing Tron's coat of arms. In the next level is the actual sarcophagus of the doge, with his recumbent effigy—an effigy that, because of its height, is much harder to see than the standing figure of the doge on the first level. On the level above the sarcophagus are niches containing more Virtues, and above these is a lunette level containing the Risen Christ and the angel and Virgin of the Annunciation.

The program of the Tron tomb-monument runs through its five levels: at the bottom we see Tron as he was in life, a commanding figure of ancient, civic authority. Accompanied by Virtues, he is seen once more on his sarcophagus, while above, the Risen Christ both prefigures and assures the doge's own resurrection. The Annunciation and the Risen Christ are also the great, mystical landmarks of Christ's divine life, closely tied to the rites of the Mass said in the church. The relation between the Risen Christ and Tron's sarcophagus would have reminded the viewer of many contemporary scenes of the Resurrection, forging thereby a not unwelcome link between the doge and his Savior.

The tendency toward the glorification of the individual and the personal identification with Christ is seen even more startlingly in the tomb-monument [112] of the warrior doge Pietro Mocenigo, who died in 1476. Completed by the sculptor Pietro Lombardo in 1481, and probably paid for with booty gained by Mocenigo's military conquests, its centerpiece is a figure of the doge in armor. Standing on his own sarcophagus (much in the same way Christ stands on his in the Resurrection), the doge is flanked by two pages carrying his baton of authority and a shield bearing his coat of arms. On the front of the sarcophagus are two reliefs of Mocenigo's famous victories, which can be compared to the two other reliefs on the base of the monument, depicting the trials of Hercules. Mocenigo is accompanied on the tomb by vividly carved armed warriors who occupy the niches at the sides and who support his sarcophagus.

111. Antonio Rizzo, Tomb of Niccolò Tron, Santa Maria dei Frari, Venice. Antonio Rizzo (active 1465-1499) was from Verona, but worked extensively in Venice. For the Tron tomb, which appears to have been partially painted, Rizzo left much of the actual execution to his shop.

140

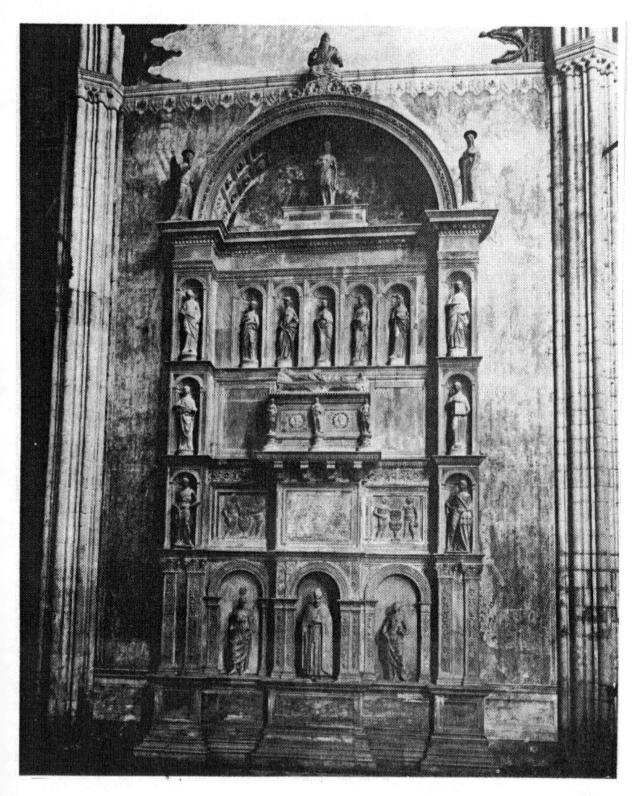

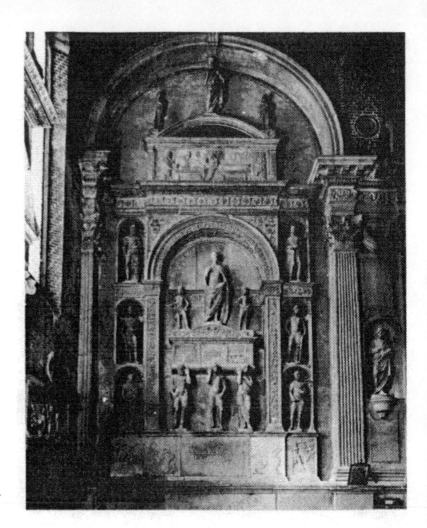

112. Pietro Lombardo, Tomb of Pietro Mocenigo, Santi Giovanni e Paolo, Venice. Although born in Lombardy, Pietro Lombardo (died 1515) was active in Bologna, Mantua, Treviso, and Venice, where much of his major work was done. He and his shop were responsible for a series of large tomb-monuments in Venetian churches.

At the top of the tomb stands the Risen Christ, his pose and gesture strongly resembling the standing figure of the doge below. Moreover, like Mocenigo, Christ stands above his sarcophagus, which is seen in the relief of the Three Marys at the tomb below his feet. Neither as complex nor as massive as the Tron tomb, the Mocenigo monument nevertheless makes an even bolder association between the defunct and Christ, something impossible before this time. Mocenigo is seen not only as a living ruler, a warrior, and a great conqueror, but he also shares some of the attributes of Christ who, in this tomb at least, has been relegated to a secondary position high above the viewer's head.

Thus far we have seen how the church and chapel were furnished with altar, tabernacle, altarpiece, tombs, frescoes, and sculpture, which worked together to form an iconographic and

decorative complement to the Mass and its miraculous properties of rebirth and salvation. Other objects made by painters and sculptors—baptismal fonts, pulpits, decorated organ lofts, to name just a few—were also found throughout the church.

But the work of the Renaissance artist overflowed the confines of the church itself. Works of art enhanced many of the ancillary structures that played an important supporting role in the functioning of the church: the dormitories, libraries, meeting halls, cloisters for the religious to walk and meditate in, cells for sleeping, and many other specialized buildings that surrounded the larger churches.

One necessary building in the monastery or convent was the refectory, or dining hall, usually a large, simple room containing a head table for the most important members of the religious community and their guests, with other tables placed perpendicularly to it. Here the meals were eaten while the scriptures were read; always the refectory was pervaded with the spirit of prayer, meditation, and devotion.

The quasi-religious nature of the refectory was emphasized by the paintings that decorated it. These were usually devoted to a dining scene from the scriptures or legends of the saints, most often the Last Supper, although paintings of the Crucifixion were sometimes commissioned. The Last Supper, the first Communion of the Apostles and the event at which the Eucharist was instituted, completely expressed the sanctity accorded meal-taking in the refectory.[21]

An early example of the Last Supper on the wall of a refectory is Taddeo Gaddi's fresco [113] at Santa Croce, Florence. Painted about 1360, and therefore an early example of refectory decoration, Taddeo's painting occupies the lower part of a wall containing other frescoes by him. In the wall's center is the Crucifixion with the Arbor Vitae, or Tree of Life, a complicated genealogical theme of special interest to the Franciscan friars. Below the cross of Christ, from which the various inscriptions of the Arbor Vitae spring, are saints—Anthony, Dominic, Louis of Toulouse, and Francis—who were not present at the Crucifixion. Thus, the fresco does not represent the historical Crucifixion, the actual moment of Christ on the cross, but rather an image meant for contemplation and meditation, appropriate for a refectory. Beyond this aspect of the fresco, the Crucifixion is also appropriate because it represents the Holy Cross, the Santa Croce of the Franciscan church whose refectory it decorates. Moreover, Christ's sacrifice and the presen-

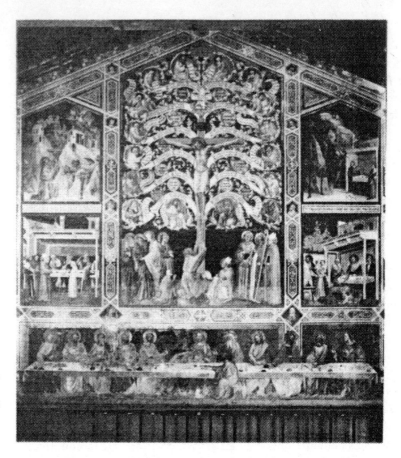

113. Taddeo Gaddi, Refectory fresco, Santa Croce, Florence. The Florentine Taddeo Gaddi (c. 1300–1366) was a long-time pupil of Giotto. One of the most productive members of his generation, Taddeo was an important interpreter of his master's style.

tation of his body in the center of the wall were central to the Eucharistic ritual around which the church itself was built.

Surrounding the Crucifixion are four scenes: at the top left is the Stigmatization of Saint Francis, the most important event in the life of the patron saint of the Franciscans. The other three scenes all concern eating. These scenes, of a Priest at His Easter Meal Receiving Word of Saint Benedict's Hunger, of Saint Louis Feeding the Poor and Sick at Santa Croce, and of the Magdalen Washing the Feet of Christ, all have been chosen because they include a table and food. Once again, the function of the room has dictated the choice of the subject.

The Last Supper at the lower part of the painting has a fascinating spatial relationship with the frescoes just discussed, for it seems to be in front of them, rather than a part of the wall on which they are painted. Table and diners overlap the surrounding painted decorative borders, effectively creating the illusion that they are in front of the fresco—and hence in the real space of the refectory. Christ and the Apostles seem, in other words, to be in the space of the viewer.

This projection into the room makes Christ and the others at the table the principal diners in the refectory of Santa Croce. In fact, their table would have been directly behind the head table occupied by the most important friars, which was itself raised slightly above the other tables in the room. The presence of Christ and his Apostles sitting in the refectory before an image of the Crucifixion would have sanctified the room and emphasized the sacramental nature of Christ's sacrifice and its fundamental importance for the church to which the refectory was attached.

Taddeo Gaddi's Santa Croce refectory frescoes are unusually large and iconographically complicated. Smaller churches often had less grand refectories, with simpler decoration scaled to their needs. The Last Supper [114] by the Florentine painter Domenico Ghirlandaio in the refectory of the church of Ognissanti in Florence is, for instance, perfectly suited to a more modest milieu.

Like the fresco by Taddeo Gaddi, Ghirlandaio's *Last Supper*

114. Domenico Ghirlandaio, *Last Supper*, Ognissanti, Florence. Domenico Ghirlandaio (1449–1494) ran a large, well-commissioned shop that furnished late-fifteenth-century Florence with numerous frescoes and altarpieces, all filled with bright color, clear narrative, and much charming anecdotal interest. In the 1480s, Michelangelo was an apprentice in Ghirlandaio's workshop.

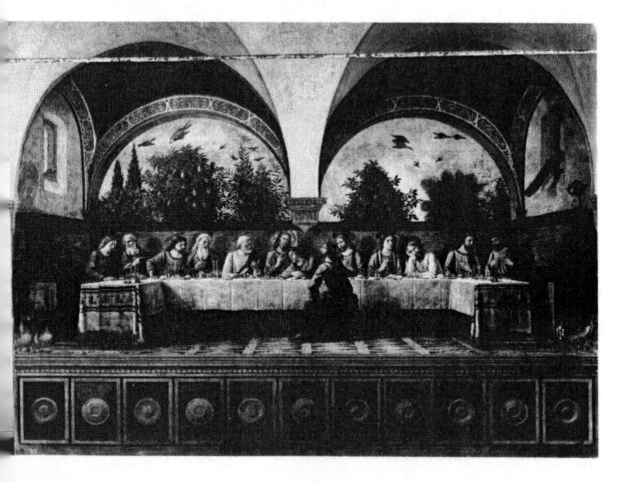

(painted in 1480) occupies the entire end wall of the room. Also, like Taddeo's, it probably paralleled the head table, which was set on a raised platform before it.

Ghirlandaio has placed his *Last Supper* convincingly within the refectory's space; the painted ceiling vaults and the size and shape of the painted space are logical continuations of the refectory. Even the window and the light that streams through it match the actual fenestration and light of the room. What an inspiring illusion for the ecclesiastics who dined and meditated here, to break bread with this holiest of companies.

Ghirlandaio has reinforced the realism of his picture's space and its relation to the room by a detailed depiction of figures and objects, illuminated by the clear light falling from the window at the picture's left side. The animated Apostles, each pictured in the act of responding to Christ's statement that one of them would betray him, are vividly and crisply portrayed with a realism that must have been much appreciated by Ghirlandaio's contemporaries. Moreover, the objects on the table—rolls, cherries, knives, glasses—are rendered with realistic detachment.

The Last Supper continued to be used as a subject for refectory decoration in the later Renaissance, the most famous example being Leonardo's ruined but often copied example in Milan. But it was in Venice in the sixteenth century that the dining theme for refectory decoration reached its apogee, in the works of the talented and prolific Paolo Veronese. This artist's gigantic painting [115] of 1573 for the refectory of the Dominican convent of Santi Giovanni e Paolo (now in the Accademia, Venice) was so exuberantly ostentatious that Veronese was summoned to appear before the Inquisition to explain why there were jesters and soldiers and other degrading things in it. Veronese's answers demonstrate that he appears to have had only a vague idea of the subject of his own work, for he called it *Last Supper in the House of Simon*, thereby conflating two separate events. Under pressure from the Inquisitors, he agreed to make certain changes, but he got around any substantial modification by renaming the scene *Feast in the House of Levi*, a subject that allowed for the sort of diversified, rowdy crowd that surrounds Christ and the Apostles in Veronese's painting.

Clearly, the traditional features of the Last Supper and its relation to the refectory are part of Veronese's canvas. Placed behind massive columns of a lodge, but connected to the room by two flights of stairs, the table occupies the length of the room, just as it did in the earlier examples of the subject.

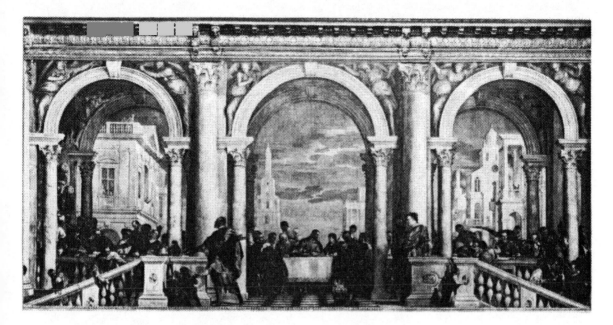

Now, however, the theme has been divested of much of the spiritual and functional nature that it had in the earlier frescoes of Taddeo Gaddi and Domenico Ghirlandaio. The sacramental emphasis has been replaced by a much more secular, boisterous spirit, which complements the newfound grandeur of the architecture and the stage-set cityscape behind. This is a painting very much about painting: about the skillful construction of the figure and its placement in space, about bold, dramatic gesture, and about color. Like the altarpieces of the Late Renaissance, some by Veronese himself, this refectory painting was above all a work of art, to be appreciated for its formal qualities and not for the message of its subject. That Veronese knew little of the subject matter of this huge canvas is clear from his fuzzy response to the Inquisitors. What he really wanted to do was to paint a skillful, impressive work. And, it was just this attitude that probably caused the Inquisitors to question him closely. Nonetheless, in its sheer size, in its dazzling color, and in its wonderful evocation of the sumptuous materialism so beloved by the Venetians, it remains one of the most impressive examples of its type.

The range of sacred objects made for the Renaissance church and its ancillary buildings was vast. In this chapter we have seen only a few of the most popular and widespread types, but these will demonstrate how much artistic production was located in and around the church. From the same objects we can also discern something about the programmatic nature of church decoration, its crucial relation to the Mass, and its connection with burial in

115. Paolo Veronese, *Feast in the House of Levi*, Accademia, Venice. This huge (5.55 × 12.80 m.) scene was originally painted for the Dominicans of Santi Giovanni e Paolo of Venice. Besides this painting, Veronese executed several other huge depictions of the Last Supper for Venetian refectories.

the church. Each object had its ancient, traditional function, but all were inexorably bound together by the common ritual and the common set of beliefs, hopes, and fears of the worshiper. This commonality, so characteristic of Renaissance society, is also of crucial importance for the arena to which we now turn—the civic world.

III

THE CIVIC WORLD

The civic world, the communal part of Renaissance society that existed outside the church and the private home, was the source of many commissions for painters, sculptors, and architects. It was a corporate world that encompassed the government, the guild organizations, the hospitals, and scores of other important institutions.

Although it was communal and civic in nature, this world was not secular, for no institution of Renaissance life was truly secular. The moral precepts and protection of the church extended (or were supposed to extend) into all functions and levels of society. Business transactions and personal behavior were governed by higher moral laws. Moreover, many of the governments, guilds, and lay brotherhoods of the Renaissance city were quasi-religious in nature; there was, in short, no separation of church and state, of the sacred and the secular, in the Renaissance.

Art commissioned by prince or commune could be found throughout the Renaissance city, from its characteristic, encircling walls to its seat of government. Protective city walls, erected and maintained by the commune, were more than symbolic: often they were the city's only line of defense against the many marauding mercenary armies so common in the Renaissance. In times of tranquillity the great gates that breached the walls gave the visitor his or her first introduction to the city.[1] Often such gates were decorated with frescoes and statues.

In 1430, for example, the Florentine Bicci di Lorenzo painted a fresco [116] in a lunette above the Porta San Giorgio (Saint George's Gate) of his native city. This lunette depicts the Madonna and Child Enthroned flanked by Saints George and Leonard. Although at first glance this fresco looks like an ordinary religious image, it makes a number of iconographic references to the city to which the gate gives entrance. The rose that the Madonna holds so prominently probably refers to Santa Maria del Fiore (Saint Mary of the Flower), the cathedral of Florence and the city's principal church. The Saint George refers, of course, to the gate

116. Bicci di Lorenzo, *Madonna and Child with Saints,* Porta San Giorgio, Florence. Bicci di Lorenzo (1373–1452) was part of a Florentine family of artists. His father, Lorenzo di Bicci, was a painter, as was Bicci's son Neri. None of the family achieved artistic distinction.

that the fresco decorated; moreover, the cross of Saint George's banner is part of the coats of arms of Florence.

Often sculpture appeared on the gates both to protect the citizens and to aid those leaving the city. The Madonna and saints, in a scale large enough to be visible from street level, blessed those below.

From the largest city to the smallest mountain town, the omnipresent gate had strong symbolic importance for the Renaissance. In the fifteenth century it took on some of the connotations and associations of the Roman triumphal arch, the gateway through which conquerors passed with their spoils.

For the entrances of famous and powerful people—the pope, exalted members of the clergy, visiting rulers—artists were called on to erect temporary arches of lightweight, perishable material. Some of these arches were elaborate affairs, carefully designed, with images of considerable iconographic complexity. These arches were not only erected near the city portals, but also were placed in the major piazzas of the city. None of these fascinating ephemera of wood, cardboard, papier-mâché, or other such material have actually survived, but we know something of how they looked from artists' designs, from detailed contemporary descriptions, and from prints depicting the elaborate entry processions, ceremonies, and festivals that frequently occurred within the Renaissance city walls.

A reflection of these temporary arches is perhaps seen in one of the most elaborate of the Renaissance stone gateways, the en-

trance to the Castelnuovo in Naples [117]. The idea for this arch seems to have originated during the triumphal entry of Alphonso I of Aragon in 1443; its authorship is uncertain, but the most likely candidate is the talented sculptor Francesco Laurana.

Referred to in contemporary documents as a triumphal arch, the multilevel structure is complicated, with reliefs and statues depicting the departure of Alphonso and his victorious return. These themes certainly come from Roman arches, which were the obvious inspiration for many of the triumphal arches of the Renaissance. Such scenes not only would have pleased those patrons strongly interested in classical art, but they would have associated their subjects, by inference and type, with the mighty victors of Rome and the myth of Rome itself.

Alphonso's arch was further ornamented with statues and reliefs of the Virtues, and by Victories, saints, allegorical figures, and coats of arms. Much of this imagery was appropriate for any public monument and, as we have seen, appears on the tomb, that other monument made to celebrate the earthly glory of an individual.

Renaissance governance took many forms: it could be pontifical (the Church owned much of central Italy); it could be ducal, with a single ruling family and its satellite court controlling a city and countryside; or it could be communal. Regardless of the type

117. Arch, Castelnuovo, Naples. A Dalmatian, Francesco Laurana (c. 1430–c. 1502), the probable creator of this arch, led a wandering artist's life. His work took him, among other places, to Naples, Urbino, Sicily, Marseilles, and Avignon.

of government, the city usually contained one building in which the ruler or governing body exercised power.

Many of the aristocratic rulers lived in castles or palaces lo-cated in the towns. These buildings were awesome symbols of authority, which sheltered and protected the occupants. Also used as storehouses, armories, and prisons, by their size and strength they asserted and reinforced the authority of their inhabitants. In such castles the decoration and its symbolism were often personal, aimed at emphasizing the pedigree and feats of the noble family.

In the republics (which were, in fact, tightly knit oligarchies with very narrow power bases) there were public buildings or town halls in which the government met. Usually large and cen-tered in the oldest part of the city, the town hall and the piazza before it were the location for numerous paintings and sculpture.

Both castle and town hall were furnished with a chapel, often large, where the lord or the various members of the government could pray and participate in the Mass. In their decoration and iconography, these chapels resembled those found in the churches of the city. Their presence in the halls of government epitomizes the interrelation between the state and religion in the Renaissance.

On occasion the outside walls of the government buildings were painted with gruesome frescoes depicting wrongdoers being executed or expelled from the city.[2] Because such frescoes were exposed to the elements, they have almost all been lost. One of the very few to survive, however, reveals something of their character.

This damaged fresco [118], sometimes attributed to the Flor-entine artist Jacopo di Cione, is unusual in its shape and imagery. It centers on the figure of Saint Anne, who presides over the expulsion of Walter of Brienne, the duke of Athens. With the aid of the oligarchical leaders and a mob of citizens, Walter had been made the despot of Florence for life. When the duke's decisions and actions began to displease the Florentines, he was expelled, on the sixth of August, 1343. In the fresco, originally in the debtors' prison, the Florentines, dressed in armor, kneel before the saint, who, as a sign of approval, grasps the staff of one of the city's standards (bearing the same cross seen on the Porta San Giorgio fresco). To the right of the saint is the Palazzo Vecchio, or Palazzo della Signoria, the seat of Florentine government. Before a newly empty throne at the extreme right, the duke skulks away, his broken weapons littering the ground around him.

Many of the frescoes on the exteriors of Renaissance town

halls must have had the same didactic simplicity seen in the Florentine example, where the saintly presence graphically demonstrates the rightness of communal action. Easy-to-grasp, straightforward narration must have been the guiding force behind the many such images painted on the walls of public buildings.

We know little about the scenes of executions and pictures of criminals painted on these same walls, for all have been destroyed. They, like the fresco of the expulsion of the duke of Athens, must have served as stern warnings that the commune would not tolerate wrongdoing by its citizens nor tyranny by its leaders.

The inside of the town halls also bore numerous images. Although many shared related subjects, there was no typical program for the walls of such buildings, as there was for chapels or refectories. Many of the town halls were structurally altered during the Renaissance. These alterations, and the changing nature of those who governed, resulted in frequent modification of the decorations.[3]

One of the rare town halls to retain much of its Early Renaissance decoration is the Palazzo Pubblico of Siena. Already in

118. Jacopo di Cione(?), *Expulsion of the Duke of Athens,* Palazzo della Signoria, Florence. The Frenchman Walter of Brienne, duke of Athens, was a soldier whose main claim to fame was his relationship, by marriage, to the house of Anjou. His curious title comes from his father, who had been lord of the duchy of Athens, a state formed by the Fourth Crusade.

use by the first years of the fourteenth century, the Palazzo Pubblico remains today the seat of Sienese government and the secular center of the city. The various councils that made up the complicated structure of the Sienese oligarchical government met in its large chambers, decorated to reflect this function.

The relation between governance and the decoration of the Palazzo Pubblico is clearly seen in the Sala della Pace, the large meeting place of one of the most powerful bodies of the Sienese government. Three of the four walls of this space are covered with frescoes painted by the Sienese Ambrogio Lorenzetti during the late 1340s.

On one of the short end walls Ambrogio painted a learned and complicated allegory of good government [119]. This fresco, which is a compendium of much medieval political thought, presented the rulers of Siena with visual embodiments of the ideas and principles behind good government; in both images and sym-

119. Ambrogio Lorenzetti, *Allegory of Good Government*, Palazzo Pubblico, Siena. The learned symbolism of this allegory was probably devised not by Ambrogio Lorenzetti (active c. 1319–1348), but by a Sienese scholar. He and the painter would have then worked out the appearance and disposition of the figures.

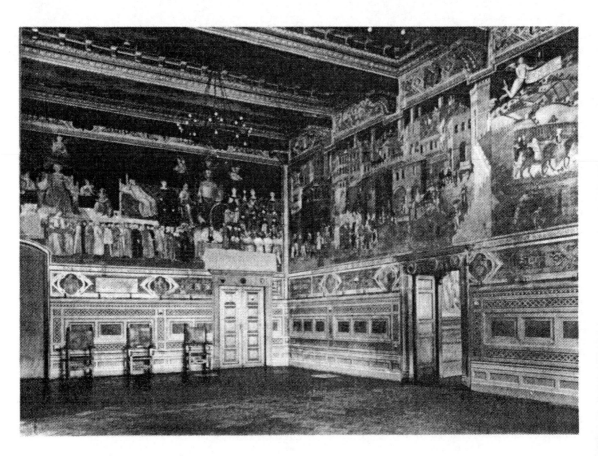

bols, Ambrogio Lorenzetti gave form to ideas of the well-governed city and countryside.

The effects of good and of bad government are on the two long side walls. To the right of the *Allegory of Good Government* basks the well-governed town [120], in reality Siena, with its striped duomo and hilly streets, where commerce, construction, and education all thrive in harmony and peace. The commerce of the Renaissance town was its economic lifeblood, and here this primacy is stressed.

The safety of the city and its good relations with the surrounding countryside are also celebrated on this wall. Hunting parties lightheartedly leave the city through an imposing gate, while peasants freely enter, herding animals and bringing provisions for the citizens.

Outside the walls is a sunny, hospitable countryside [121] filled with cultivated fields of grain, olive trees, and vineyards, all tended by busy farmers. This pastoral world is fertile and peaceful, the perfect complement to the well-governed town. Both the countryside and the town prosper in peace precisely because those who govern them are able rulers—wise, just, and aware of the needs of their citizens; in other words, they rule in accord with the principles set forth in the *Allegory of Good Government* on the end wall.

In *Good Government,* the painted landscape extends across half of the fresco. From the Sala's windows, where the painted landscape ends, one looks down from the heights of the Palazzo Pubblico, across the hill on which it sits, and into the countryside surrounding Siena—the same countryside depicted in the *Good Government* fresco. The meaning is wonderfully clear: Siena is the well-governed city, peaceful and prosperous.

Across from the tranquil town of the *Good Government* fresco is a ruined, pillaged city, the victim of bad government. Beyond, bands of soldiers rove a bleak and barren countryside. It is a hostile, destitute place, the very antithesis, both physically and emotionally, of the smiling hills and happy farmers of the facing painting.

The function of the Sala della Pace frescoes is obvious: they served as highly visible testaments to the necessity of good government by those councilors who met and governed in this room. A similar message but in a different form is found in the spacious main hall, the Sala del Mappamondo, adjoining the Sala della Pace. Here, on one of the end walls, is a large fresco [122] of the Madonna, Child, angels, and saints, a type called the Maestà, or Maj-

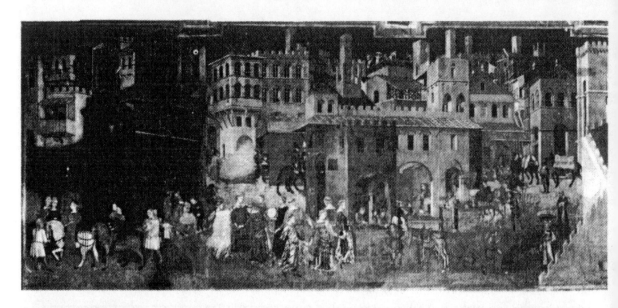

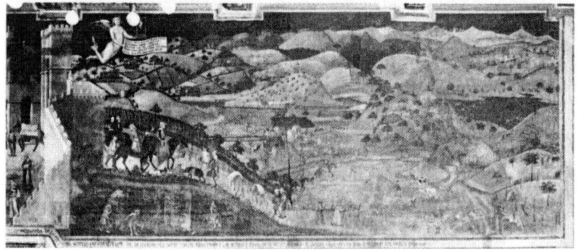

120. Ambrogio Lorenzetti, *Good Government*, Palazzo Pubblico, Siena. This view of the well-governed town is one of the earliest and most accurate cityscapes in European art. It affords a rare glimpse of everyday communal life in a Tuscan hill town.

121. Ambrogio Lorenzetti, *Good Government*, Palazzo Pubblico, Siena. Many of the crops seen in Ambrogio Lorenzetti's countryside are still cultivated around Siena. Today, as in Ambrogio's day, the area is renowned for its olive oil and wine.

esty. The distinguished Sienese artist Simone Martini painted it in 1315, returning only six years later to modify and repair it.

The meaning of the painting is revealed by the inscription under it and by the saints, all special patrons of Siena, who kneel in front of the Madonna and her Child. Each locality in the Italian peninsula had its guardian saints, who were worshiped with special veneration. The inclusion of the protectors of Siena in Simone's *Maestà* gives this large fresco a civic meaning: the Virgin is implored by the kneeling saints to show favor to Siena, in general, and to those who rule the city, in particular. The Virgin, moreover, was Siena's principal patron and the object of special reverence in the city; her image was everywhere; she was Siena's divine ruler.

In Simone's *Maestà* even the canopy under which she sits is emblazoned with the Sienese coat of arms!

At the base of the fresco a long inscription exhorts the rulers of Siena to please the Virgin by ruling wisely. Thus the entire *Maestà*—Virgin, Child, saints, angels, inscription—is layered with civic and religious meaning, all meant to guide those who held the reins of government. In this it shares the message of the Sala della Pace frescoes, but with an added power: it intercedes with the Virgin for those who rule, and it places them in a hierarchical progression that extends from the divine to the ruled.

The practice of furnishing pictorial exemplars for those in power continued throughout the years of the Renaissance in Siena and elsewhere. As late as the 1530s, the Sienese artist Domenico Beccafumi was commissioned to paint a series of ceiling frescoes [123] in the Sala del Concistoro (another council chamber) in the

122. Simone Martini, *Maestà*, Palazzo Pubblico, Siena. The tradition of the Maestà with specific civic references was strong in Siena; other examples are found in works by Duccio and Ambrogio Lorenzetti.

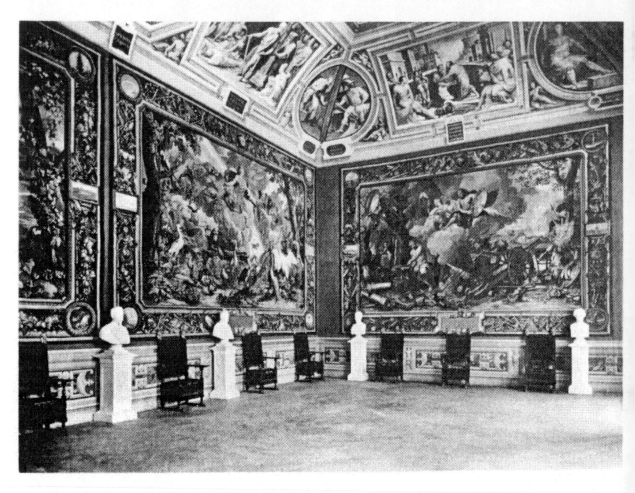

123. Sala del Concistoro, Palazzo Pubblico, Siena. Domenico Beccafumi (c. 1486–1551) was the major figure in Sienese art of the sixteenth century. His inventive and strange paintings influenced Siena's style for decades.

Palazzo Pubblico, which, in their type if not in their form, are the heirs of the paintings by Ambrogio Lorenzetti and Simone Martini.

In Beccafumi's paintings the subjects have been taken from Roman history, a new and fascinating source with special meaning for the Renaissance.[4] Beccafumi's frescoes extol the fierce patriotism of the Romans and their willingness to put the state above all else. Whoever devised the program for the Sala del Concistoro searched the Roman texts for illustrations of selfless duty to one's country and the dangers of tyrants. The frescoes of the room were paradigms, like the examples by Ambrogio Lorenzetti and Simone Martini, to be emulated by those in power who sat in the room.

The government of Siena, like that of most Renaissance republics, was formed of councils and other bodies empowered for only a short time; change and rotation, to protect against entrenchment and tyranny, were central features in the system. Those who entered into government would always have before their eyes Bec-

cafumi's graphic examples of what was expected of them, and, in the several scenes of executions, what would happen to those unfaithful to the city's high principles.

The interest in the antique in general, and in Rome in particular, extended beyond works like Beccafumi's frescoes. We have already seen the influence of Roman art on the triumphal arch of the Castelnuovo in Naples and, in Chapter I, on paintings made for the domestic interior. The fabled and heroic civilization of Rome, a world much admired and studied by the Renaissance, was a rich source of stories that illustrated civic virtue.

In the large Sala del Mappamondo of the Palazzo Pubblico of Siena there were also scenes of more recent history. These were huge frescoes illustrating the victories of the Sienese army in the territories that it conquered. Painted not only to illustrate the power of the state, but also to impress visitors (both compatriots and foreigners), these frescoes were simultaneously documentation and propaganda for the city.

Similar frescoes, but on an even grander scale, were planned about 1500 for the major chamber in the Florentine town hall, the Palazzo della Signoria, often called the Palazzo Vecchio.[5] Two of the most famous Florentine artists of the Renaissance—Leonardo da Vinci and Michelangelo—received the commissions. The intended location for the paintings, their proposed huge size, and the renown of the two artists attest to the importance of these paintings to the Florentines. Each of the frescoes was to be on an enormous wall of the newly constructed Sala del Gran Concilio, the great assembly hall. The room was the center and showplace of the Florentine government, all its decoration propagandistic.

Leonardo was commissioned to paint the battle of Anghiari of 1440, and Michelangelo was to do the battle of Cascina of 1364, a Florentine victory over the Pisans, who had recently (1494) been liberated by the French. Both frescoes were to glorify the prowess of the Florentine militia, and the battle of Cascina was to be a not-so-subtle exhortation for the reconquest of Pisa (an event that took place in 1509, about five years after Michelangelo had been commissioned).

Leonardo completed his fresco; but the experimental technique and material he used were unstable, and the fresco rapidly deteriorated. A number of copies [124] show a whirl of mounted warriors engaged in hand-to-hand combat. We can only imagine the energy and excitement of Leonardo's huge fresco (it was about twenty meters long and eight meters high), with its swirling, rearing horses.

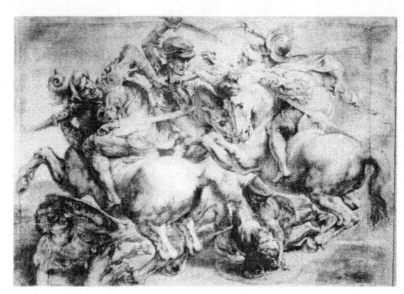

124. Peter Paul Rubens, Copy after center of Leonardo's *Battle of Anghiari,* Cabinet des Dessins, Louvre, Paris. Rubens's grisaille was done about fifty years after the destruction of Leonardo's fresco and is probably based on an engraving or drawing made firsthand. Nevertheless, in the force and dynamism of the riders, Rubens gives the best re-creation of the power that must have been conveyed by Leonardo's huge painting.

Michelangelo's fresco, intended to be equally large, was never executed (the artist moved to Rome to work for Pope Julius II), and the cartoon that he made for it was destroyed, perhaps through overzealous copying by other artists. A copy [125] of the central section of the cartoon reveals that the heart of Michelangelo's fresco was not the battle at all, but a scene in which the Florentines are called into action from the river where they have been swimming. This historical episode gave Michelangelo a splendid opportunity to show the nude male figure in strenuous action. Perhaps the choice of interpretation of these battles had been left up to the artists: this would explain Leonardo's beloved horses and Michelangelo's nude bathers.

According to the original plan, the decorative program of the

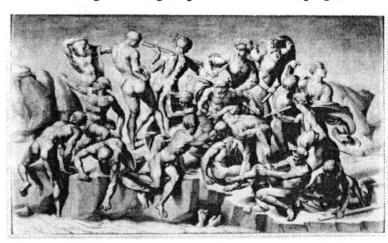

125. Aristotile da Sangallo, Copy of center of Michelangelo's *Battle of Cascina,* Holkham Hall, Norfolk, England. No part of Michelangelo's cartoon for *The Battle of Cascina* has survived; only the central section is here recorded by Sangallo. However, a number of Michelangelo's splendid drawings for the cartoon still exist.

Sala del Gran Concilio of the Palazzo Vecchio prescribed that mixture of religion and state so characteristic of the Renaissance town hall. An altarpiece with all the patron saints of the city and a statue of the Savior (Christ was the principal patron of the Florentines) would have been set up in the room. Again, religion sanctions government, the two worlds intermingling here as they do in the great hall of the Palazzo Pubblico in Siena, where battle scenes and a huge Maestà are placed on contiguous walls.

Toward the end of our period, painted ceilings elaborately framed in wood became fashionable both in the palazzo and in the town hall.[6] (These two structures have many ties, and some of their types and decoration underwent similar development during the Renaissance.)

This new fashion for ceiling decoration is seen in the Palazzo Ducale—the home of the doges, the ancient aristocratic rulers of Venice. Generations of Venice's artists had a hand in its decoration, producing one of the most visually embellished seats of government on the Italian peninsula.

About 1583, Paolo Veronese, a celebrated Venetian painter, executed the huge *Apotheosis of Venice* [126] for the ceiling of the Sala del Maggior Consiglio. Located above the doge's throne, and set into a ceiling alive with paintings surrounded by deeply carved and gilded frames, Veronese's *Apotheosis of Venice* adds its dramatic forms and vibrant color to the overall grandeur of the ensemble.

Veronese's foreshortened figures are painted from the vantage point of the viewer. Called *di sotto in su,* this illusion of a view upward from below is effective and dramatic, and it found no better practitioner than the mature Veronese.

The figures in the *Apotheosis of Venice* encircle the allegorical Venice herself. By the middle of the fifteenth century, allegory and allegorical representations of places, states of mind, the elements, and so forth had become common. Such abstract conceptions were more complex and less specific in their presentation than the battle scenes and religious images painted earlier, which continued to decorate the town hall or ducal palace. The emergence of allegory is important, for it signifies a growing secularization of civic imagery; in fact, allegorical figures were soon to rival traditional religious imagery.[7]

High on a cloud bank, crowned by a Victory who flies above, the majestic figure of Venice in Veronese's *Apotheosis* is surrounded by her many attendants (themselves allegorical figures),

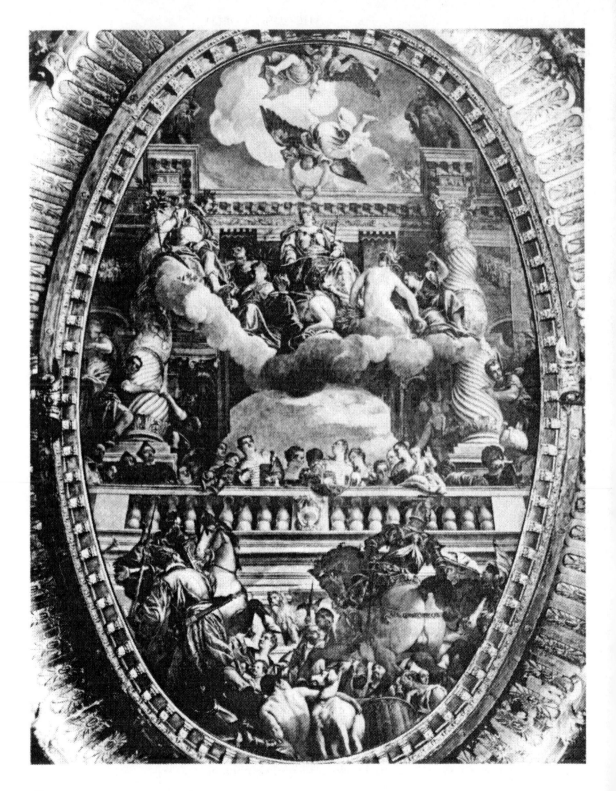

162

just as the doge enthroned below is surrounded by his subordinates.

Venice's court floats before a great building with twisting columns and deeply carved entablature. On the building's balcony are animated, well-dressed figures, many of whom must be portraits of the artist's contemporaries. Below the balcony are more figures and several magnificent, rearing horses. The power of this fresco arises from the grandeur of the architecture and the dramatic upward sweep from the lowest figures to the flying angels and billowing clouds above. As we have seen in his *Feast in the House of Levi* (fig. 115), Veronese was a consummate organizer of vast spaces and teeming crowds. The *Apotheosis of Venice* is complex yet coherent, exciting yet controlled, a testament to Veronese's complete mastery of composition.

Thus far we have looked at wall and ceiling painting in the powerful and wealthy cities of the Renaissance, but there were many other lesser centers, where decoration existed on a smaller, less costly scale.

Most often the decoration of the modest town halls of these small cities echoed that of the town halls of their larger neighbors. In fact, much of the architecture, city planning, and imagery of the provincial centers followed the examples of the greater cities. Throughout the Italian peninsula the smaller towns developed as satellites around the major urban centers, which offered protection, trade, and intellectual stimulation.

In the small Tuscan town of Sansepolcro, dependent on the larger city of Arezzo, which itself was in the constellation of Florence, there is a good example of town hall decoration done on a modest scale: the famous *Resurrection* [127] of about 1470 by Piero della Francesca, a native son. Although modest in size, this fresco, in what was once the city's administrative building, is a monumental and heroic vision.

In the pale, first light of dawn, when the clouds are still streaked with pink, the shining Christ emerges from his sarcophagus into a still, waiting world. A great stability is achieved by the triangle formed by the shoulders, head, and body of Christ. Rhythms created by the patterns of the trees, the curve of the hills, and Christ's flag counterpoint the stability of the composition.

But this masterpiece is something more than a memorable image of the Resurrection, for it is also a figurative symbol of the town of Sansepolcro. *Sansepolcro* means "holy sepulcher," Christ's tomb. According to legend, the town was founded by two pilgrims returning from the Holy Land with relics from the tomb of Christ.

126. Paolo Veronese, *Apotheosis of Venice*, Palazzo Ducale, Venice. Begun by Titian and carried on until Tiepolo in the eighteenth century, sumptuous allegorical ceiling painting was a particular skill of Venetian artists. Veronese's *Apotheosis of Venice* was an important precursor of Baroque ceiling decoration.

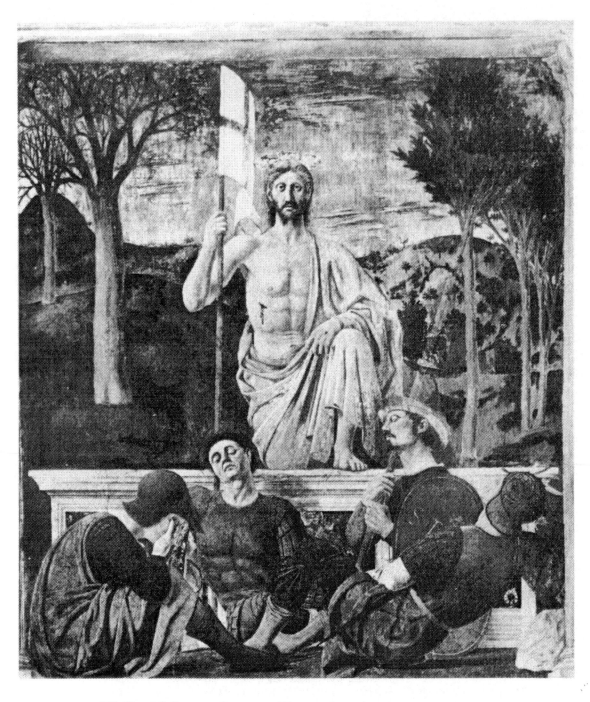

127. Piero della Francesca, *Resurrection,* Pinacoteca, Sansepolcro. Piero della Francesca (c. 1420–1492) painted several of his most notable works for the provincial Tuscan city of Sansepolcro. He also received commissions from the courts of Ferrara, Urbino, and Rimini.

The city's coat of arms also bears the image of Christ's resurrection. For Sansepolcro, as for the more famous cities of Florence and Siena, the sacred image enhanced, directed, and made holy the civic setting in which it was placed.

Civic buildings invariably fronted on piazzas, or public squares. Upon these urban clearings the dramas of town life were staged: large crowds could gather to hear speeches, watch an execution, or witness the entry of a famous ruler or church dignitary. The piazzas were sunlit oases amidst the warren of dark streets so characteristic of most Renaissance towns. Here citizens could meet and walk in the sun, or admire views of the surrounding buildings across the expanse of open space.

Just as the space of the church was sacred and connected to the miracles of the liturgy, so the piazza, as the setting for numerous events of great civic importance and symbolism, became a space of communal significance. Consequently, it was natural that the decoration of the piazza would reflect some of the meaning and importance of the buildings around it. And, although the piazza in front of the ducal palace or the town hall had perhaps the greatest importance of any in the city, other piazzas, located before other secular and sacred buildings, were also spaces fraught with civic and holy meaning.

Freestanding statues, often life-sized or larger, frequently graced the piazzas, a practice dating back to the Romans and endemic in Mediterranean culture. During the Middle Ages not much large-scale sculpture was produced for the piazza, but in the fourteenth century interest in such decoration revived.

A good example of the power credited to images erected in the piazza (and to the iconic power of images in general) is found in the story of the Sienese, who unearthed a Roman statue of Venus. Proud of their find, they erected it on the piazza before the Palazzo Pubblico. Shortly after Venus had been installed on the piazza, several calamities befell the city. Some citizens blamed the pagan Venus; not wishing to take any chances, the Sienese took her down, smashed her to pieces, and, during the night, buried her in the territory of Florence, Siena's hated and feared rival.[8]

Venus's short stay in the piazza of the Palazzo Pubblico is an extreme example of the transitory nature of the embellishment of the Renaissance piazza. Statues and other forms of decoration would change as the nature of the government, its philosophy, and its aims changed.

An illustration of this is afforded by the history of the dec-

oration of the Piazza della Signoria [128], the large square in front of the town hall of Florence. This ancient, irregularly shaped paved area is bounded by the Palazzo della Signoria and by the Loggia della Signoria (also called the Loggia dei Lanzi), a large structure built in the fourteenth century to shelter crowds from the elements.

The Piazza della Signoria has been the location of many of the major events in Florence's life from the fourteenth century to today. An evening stroll through the present-day piazza is still likely to provide a variety of sights, from a crowd listening to a political speech to jugglers and fire-eaters performing before small knots of people. It is here that friends meet for a drink and some

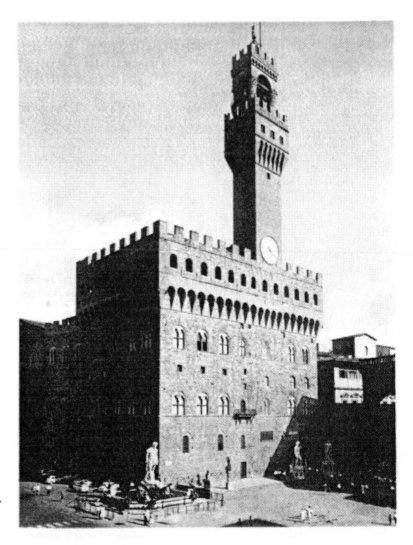

128. Piazza della Signoria, Florence. The Piazza della Signoria, which takes its name from the assembly that governed Florence from the adjacent Palazzo della Signoria, was established in the thirteenth century when the houses of defeated foes of the city were razed.

gossip; the space is always animated by throngs of citizens and tourists.

Anything installed in the piazza had special significance. Thus, after the Medici were expelled from Florence, the life-sized bronze statue of Judith and Holofernes [129], done about 1460 by Donatello, was confiscated from their palace and placed, in 1495, in the Piazza della Signoria, to symbolize the Florentine victory over the Medici.

Although (to our eyes at least) it seems a bizarre subject for domestic decoration, the story of Judith and Holofernes was very much in keeping with the type of admonitory art so often encountered in the Renaissance home. We have already seen in Chapter I how mythological and Old Testament subjects served both as cautionary tales and as examples for the occupants of the house; and the chaste and righteous Judith's victory over the corrupt Holofernes demonstrated how justice and virtue overcame vice.

When the statue was removed from the Palazzo Medici following the expulsion of its owners, its meaning was enlarged; once erected in the Piazza della Signoria, it became a symbol of civic virtue triumphant over tyranny. It also became an allegory of the expulsion of the despotic Medici by the people of Florence. The statue served as a warning to would-be tyrants both within and without the city's walls. All these wider meanings associated with the story of Judith and Holofernes inspired the statue's placement in the great civic space of Florence.

In the early sixteenth century the *Judith and Holofernes* was replaced by one of the most famous statues of the Renaissance, the *David* [130] by Michelangelo. Originally commissioned for the cathedral of Florence, *David* (completed 1504) was placed, instead, in the highest civic venue, the Piazza della Signoria. Here, Michelangelo's colossus became a symbol of Florence. David, the youthful hero who had killed the giant Goliath, was likened to Florence, the virtuous little city, ever vigilant against tyrants. This symbolism did not arise with Michelangelo's statue, but dates back to the earlier centuries of Florentine history.[9] Nevertheless, Michelangelo gave the symbol new life by investing his *David* with both memorable monumentality and watchfulness.

At the time of the commission of *David*, the first decade of the sixteenth century, the Florentine government was oligarchical and republican. The Medici had been expelled, but they and their allies were still powerful, still feared. Michelangelo's heroic *David*,

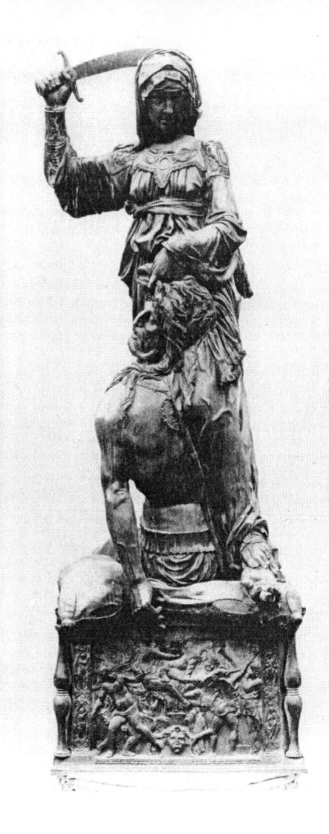

129. Donatello, *Judith and Holofernes*, Palazzo della Signoria, Florence. It is not known if *Judith and Holofernes* was originally made for the Palazzo Medici, nor exactly how it was set there. The statue has recently been removed from the Piazza della Signoria and placed in the Palazzo della Signoria.

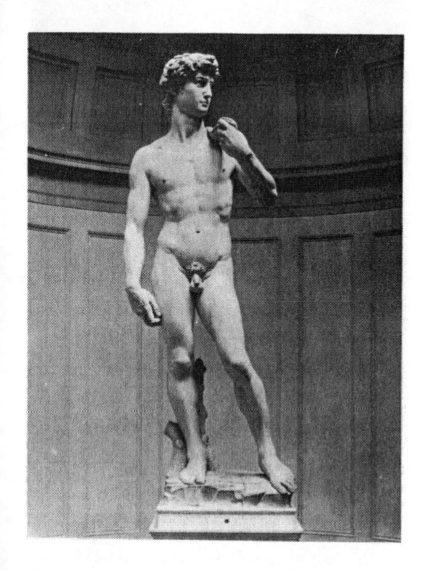

130. Michelangelo, *David*, Accademia, Florence. In the nineteenth century *David* was removed from the Piazza della Signoria and installed in a specially constructed room in the Florentine Accademia. The replica that replaced it is still seen in the piazza today.

consequently, both symbolized the city and protected it. That it can so well express these meanings and, at the same time, be such a powerful work of art is a testimony to Michelangelo's mastery.

So pleased were the Florentines that they commissioned Michelangelo to do another monumental statue as a counterpart to *David,* of Hercules and Cacus. After many complications and setbacks, the commission was reassigned to the mediocre sculptor Baccio Bandinelli, who finished it [131] in 1534—under the rule of the Medici, who had by force returned to Florence.

Originally *Hercules and Cacus* was meant to symbolize the commune and its strength, but the Medici co-opted the figure and used it as a symbol for their own considerable power. In fact,

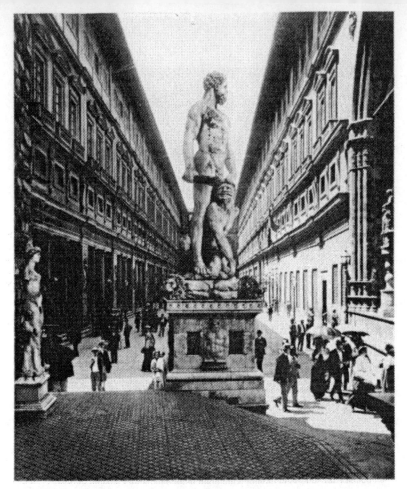

131. Baccio Bandinelli, *Hercules and Cacus*, Piazza della Signoria, Florence. Son of a Florentine goldsmith, the sculptor Baccio Bandinelli (1493–1560) was patronized by, among others, the Medici. The ill-conceived *Hercules and Cacus* was ridiculed as soon as it was placed in front of the Palazzo Vecchio.

132. Benvenuto Cellini, *Perseus Holding the Severed Head of Medusa*, Loggia della Signoria, Florence. In his autobiography, the goldsmith and sculptor Cellini (1500–1571) gives a fascinating and exciting account of the difficult casting of *Perseus*. It remains one of the most accomplished works of Renaissance bronze technology.

Cosimo I, the famous Medici duke, often used Hercules as a personal emblem.[10] This transmigration of meaning illustrates how the decoration of any piazza was liable to change both in the physical objects that decorated it and in the meanings that those objects assumed.

In 1554 another figure with considerable symbolic meaning was set up in the Loggia della Signoria adjacent to the Piazza della Signoria: Cellini's superb *Perseus Holding the Severed Head of Medusa* [132]. This beautiful but gruesome work was commissioned by Cosimo I, the absolute ruler of Florence.[11] Figurative bronze reliefs on the base include, on the side facing the piazza, *Perseus Liberating Andromeda*. This scene may be an allegory of the reconquest of Florence by the Medici and their allies, an act Cosimo surely considered a liberation from the republican government that had been formed after his family's expulsion.

Symbolic meanings charged the main image as well. Perseus stands looking into the piazza, his left hand presenting the horrible severed head of Medusa to the square. On the literal level, here was the head of a monster that could turn the viewer into stone;

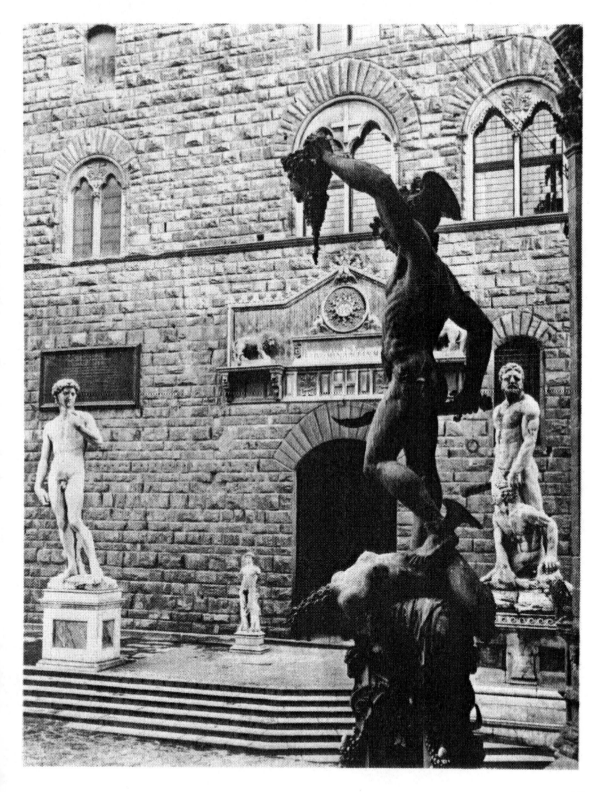

on a more subtle level, Perseus' bloody trophy must have reminded the spectator that the Piazza della Signoria was the site of public executions. These associations were purposely evoked by the strange but beautiful figure commissioned by Cosimo both as a work of art and as a symbol of his power and authority. Every citizen who stood in the piazza situated before the seat of government would feel the duke's power over life and death.

Perseus, with its references to beheading, must also have been seen as a pendant to Donatello's *Judith and Holofernes,* which had been moved from in front of the Palazzo della Signoria into the Loggia della Signoria. These two statues were soon joined by a third, the *Rape of the Sabines* [133], by Giambologna.

Finished in 1583, Giambologna's statue marks an important development both in the history of the decoration of the Piazza della Signoria and in the history of Renaissance art. The group

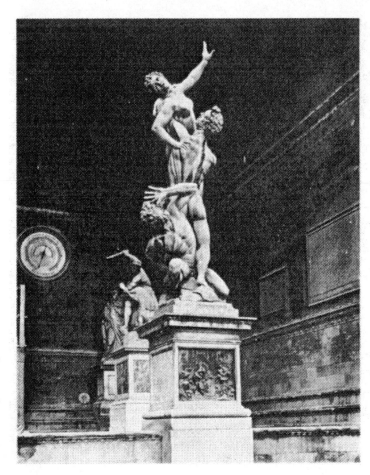

133. Giambologna, *Rape of the Sabines,* Loggia della Signoria, Florence. Giambologna (1529–1608) was born Jean Boulogne in Douai, Flanders. After study in Rome, he began to work in Florence, where he received major commissions. Through his many masterful small bronzes, Giambologna's style had a wide diffusion in sixteenth-century Europe.

was originally conceived by the Flemish sculptor as a solution to the complicated problem of weaving figures together in three dimensions, a problem first explored with great skill by Donatello in the *Judith and Holofernes,* the work that probably spurred Giambologna to begin his own statue. Because Giambologna's group was a formal exercise, it had no title; but when it was erected in the loggia, where it stood along with *Judith and Holofernes* and Cellini's *Perseus,* it became necessary to name it. The figures in such violent, twisting motion suggested the Rape of the Sabines, and this title was given to the statue.

The very fact a work could be made without a subject—that is, that it could originate as an attempt to solve a formal rather than a contextual problem—was something new in the history of Renaissance art. Giambologna's *Rape of the Sabines* takes one step further those altarpieces for churches and those domestic pictures that, about 1500, began to be appreciated more for their artistic nature than for their message. Such an attitude, which is much like our own conception of art in embryonic form, was one of the Renaissance's principal contributions to the history of art. Paintings and sculptures were losing the iconic impact that had made them such powerful, and often awesome, objects.

Not only the makers of art, but the consumers of art as well, partook of this new attitude, which prized comely formal configuration as much as it valued civic messages. And, in this case at least, the decision to install Giambologna's group may have been, ultimately, political: the Medici dukes who ruled Florence with an iron hand wished no symbolic rallying point for republican sentiments and aspirations.

One of the last works to be placed in the piazza was the large equestrian statue [134] of Duke Cosimo I by Giambologna, executed in 1594–1598. Completed after the death of Cosimo, this monument commemorates the first Medici duke and the first absolute ruler of Florence and so stands as a symbol of Medici power. This equestrian figure, consequently, made a poignant and ironic comparison with *Judith and Holofernes* (fig. 129) by Donatello, until recently placed just across the piazza from it.

One type of piazza decoration with a long history and widespread popularity was the equestrian figure. The statue of Cosimo I in the Piazza della Signoria belonged to a tradition already several centuries old. The first Renaissance equestrian figures memorialized one of the indispensable constituents of Renaissance society: the soldier of fortune.

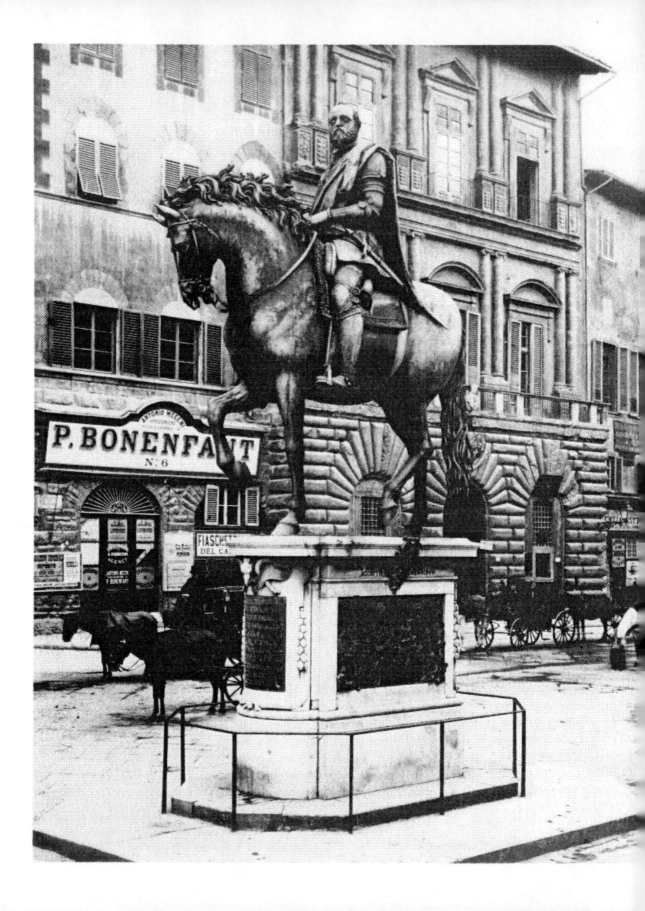

The Renaissance image of the mercenary captain (the *condottiero*) had its beginnings in the fourteenth century. In the absence of large standing armies, soldiers of fortune alone ensured the safety of towns and villages throughout the Italian peninsula. The mercenary captain and his company of soldiers were hired when the communal or ducal rulers needed more arms and men than they were able or willing to gather. Many of these commanders were unscrupulous and alternately rescued and besieged their noble or oligarchical patrons, who, nevertheless, never stopped admiring them.[12]

For the Renaissance, the painted or carved image of an armed leader on a charger epitomized power. Equestrian images were admired as much for the mount as for the rider, for in the Renaissance the horse was a status symbol, and its appearance was expertly judged and appreciated. There exists no good analogy in today's society, although perhaps a fire-engine-red Ferrari or a jet fighter may conjure up some of the same feelings.

The idea for the mounted figure probably arose, at least in part, from the Roman equestrian statue. Several of these still survived in the Renaissance, including the most famous of all: the Marcus Aurelius statue that now stands in the Piazza del Campidoglio in Rome. During the Renaissance the figure of the quasi-divine Roman emperor was transmuted into the soldier of fortune or the ducal ruler and, by association, it gained some of the majesty and power of the ancient prototype. Such association is similar to the Renaissance reutilization of the triumphal arch and other creative borrowings from antiquity meant to enhance the status and prestige of the modern ruler.

The earliest extant Renaissance equestrian figure is a painting [135] by Simone Martini in the Palazzo Pubblico in Siena. This huge fresco (some ten meters across) faces the large *Maestà*, also by Simone (fig. 122). Painted about 1330, this figure of a soldier of fortune named Guidoriccio da Fogliano is intended to show that Siena had military, as well as spiritual, power.[13]

Simone's *Guidoriccio* is both a portrait and a narrative; it shows the warrior and his mount, wearing articles emblazoned with the soldier's device, as they reconquer two rebellious cities in the Sienese territory. Horse and rider stand alone, dominating the uninhabited countryside and the forts, and brilliantly expressing the fresco's true function as a demonstration of the might of Siena and its soldiers. Visitors to the Palazzo Pubblico would turn from the huge, impressive *Maestà* with the city's patron saints to be

134. Giambologna, *Duke Cosimo I,* Piazza della Signoria, Florence. Cosimo I (died 1569) was the son of Giovanni delle Bande Nere, a professional soldier who had fallen in battle. When Cosimo took control of Florence in 1537, he was only eighteen and totally inexperienced. However, he soon proved himself a brilliant and resolute ruler (he became grand duke of Tuscany). Cosimo was also a patron of considerable discernment who used art for political and dynastic purposes.

175

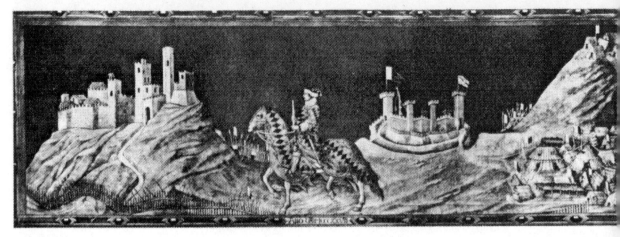

awed by Simone's powerful image of the conquest of the rebels; this was a message that would, of course, not be lost on the many citizens from territories under Sienese control who came to the Palazzo Pubblico on business. Simone's fresco also continued the military theme in the Palazzo Pubblico that was established by the other large frescoes of cities under Sienese rule and of famous battles.

Other equestrian figures were made throughout the fourteenth and early fifteenth centuries. Some of the most interesting, but least known, were of impermanent materials such as papier-mâché. Probably meant to be cheap, quickly built substitutes for bronze or wood, these statues have all disappeared.

The genesis of one equestrian monument through several mediums can be traced in the well-known image of Sir John Hawkwood (whom the Florentines called Giovanni Acuto) in the cathedral of Florence. Hawkwood was a famous soldier of fortune much admired by the Florentines, whom he had served. When he died in 1394, Hawkwood was given a state funeral and was interred temporarily in the choir of the cathedral. Plans had already been made to construct a large marble monument, which would also incorporate Hawkwood's tomb. Agnolo Gaddi, a prominent Florentine painter and designer of sculpture, was commissioned to plan the monument; but before actual construction was under way, the king of England asked for Hawkwood's remains. A tomb in the cathedral thus became impossible. Instead, according to documents, Gaddi painted a fresco on the north wall of the church meant to simulate the marble monument originally planned.

Gaddi's fresco remained until it was covered by another large fresco [136] of Hawkwood, painted by Paolo Uccello in 1436. Because this second fresco is painted to simulate marble and because it contains a sarcophagus, it probably reflects something (the idea at least) of Gaddi's painting, which it covered.

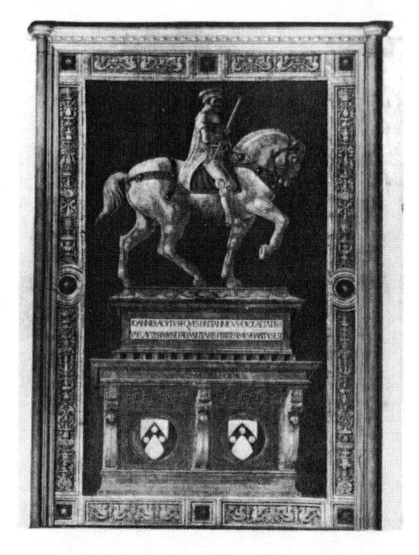

136. Paolo Uccello, *Sir John Hawkwood*, Duomo, Florence. Sir John Hawkwood (c. 1320–1394) was born in Essex. After fighting in France, he moved to Pisa to lead that city's troops against the Florentines. From 1377 he fought for Florence, where he was much admired.

The commission to paint the image of a soldier could not have gone to better hands, as we know from Uccello's battle pictures made for the Medici palace. All the pomp, grandeur, and display of a military parade are wonderfully captured in Hawkwood's huge, striding horse and its armored rider. The almost storybook-like simplification of the man and his mount, the abstraction of their forms, removes them from quotidian reality and makes them glamorously unreal: here is the ideal image of the soldier of fortune. The world of Uccello's *Hawkwood*, like the world of Uccello's battle paintings, is a make-believe one, where blood is never shed nor courage lost, and splendidly decorative soldiers and their exquisite mounts are always on parade.

Clear references to the tomb-monument originally planned

appear in the sarcophagus-like structure on which the horse stands and in the inscription describing Hawkwood's prowess as a captain of war, a legend that would also be fitting for an actual tomb. Moreover, the sarcophagus rests on a table supported by columns, which resembles an altar table. This similarity is no accident: the association of the rider and his sarcophagus with an altar would give an appropriate sacramental quality to the entire image. No such obvious connection between the function of the church and an equestrian painting such as Simone's *Guidoriccio* was necessary in the Palazzo Pubblico, but for a fresco in the cathedral of Florence, such a linkage was probably vital.

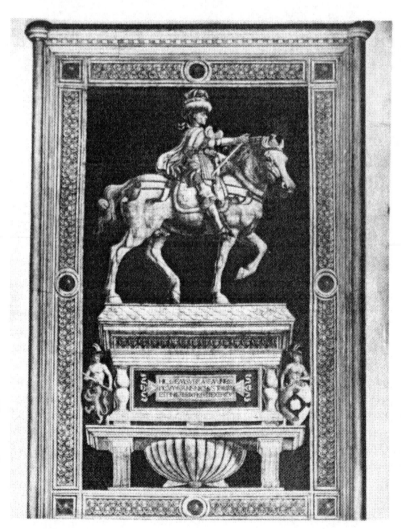

137. Andrea del Castagno, *Niccolò da Tolentino*, Duomo, Florence. Niccolò Maurucci, called Niccolò da Tolentino (c. 1350–1435), was the commander-in-chief of Florence in 1431. After a state funeral, he was buried in the cathedral of Florence in the presence of Pope Eugenius IV.

In 1456, two decades after Uccello's fresco, Andrea del Cas-
tagno, an accomplished and dramatic Florentine artist, painted an-
other large equestrian fresco [137] in the duomo as a counterpart
to *Hawkwood*. Also originally meant to be in stone, this is an image
of a famous soldier of fortune, Niccolò da Tolentino (died 1435).
This *condottiero* had been the hero of San Romano, the battle
immortalized by Paolo Uccello, and he also appears in a famous
series of heroes and heroines painted by Castagno for the Villa
Carducci, just outside Florence.

Although very dependent on Uccello's fresco, Castagno's
Niccolò da Tolentino is more vigorous: the horse turns toward us,
the cloak flaps in the wind, and the rider seems more resolute,
more intent on some unseen object off to our right. There is a
power about the fresco that, although not dependent on it, is
reminiscent of Simone's *Guidoriccio*.

Once again the inscribed sarcophagus and altar table appear,
although this time they are flanked by two small statues bearing
coats of arms. At the bottom of the fresco is a shell, a motif that
appears with some frequency on tombs as a symbol of birth and
rebirth.

Another painted equestrian figure, dating near the end of the
Renaissance, ranks among the greatest of the type. This is Titian's
remarkable *Emperor Charles V on Horseback* [138], painted in
Augsburg in 1548. A huge painting (332 × 279 cm), it is mon-
umental both in its size and in its image.

Before a darkening sky, a charger canters as his valiant spear-
carrying rider urges him into battle. Charles V's glistening armor
is that he wore at Mühlberg in 1547, when he defeated the German
Protestant princes. But Titian's painting is not merely a depiction
of a particular moment, although the armor does give it historical
reference. Rather, Charles is presented as the intrepid Catholic
emperor, the Protector of the Faith who, like the much earlier
Guidoriccio by Simone Martini, dominates all that he surveys. As
in Simone's fresco, Titian has made nature, the cantering horse,
and the rider work together to produce an isolated but powerful
and victorious image. Titian's *Charles V* was the first in a line of
painted imperial equestrian portraits, which continued into the
twentieth century. It, and a series of kindred pictures, helped shape
Europe's ideal of royalty.

Titian's *Charles V* was probably influenced by one of the
most distinguished sculptural examples of the type, Donatello's
great bronze statue [139] of Erasmo da Narni (called Gattamelata,

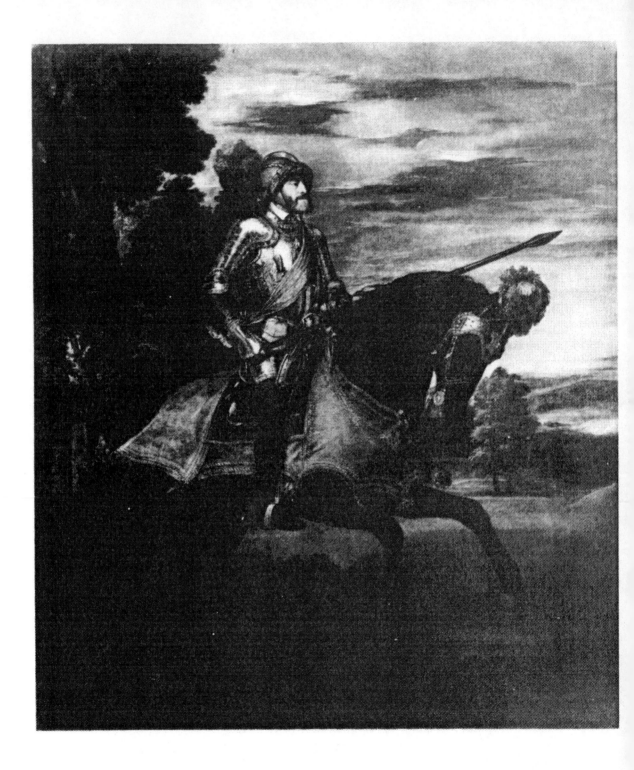

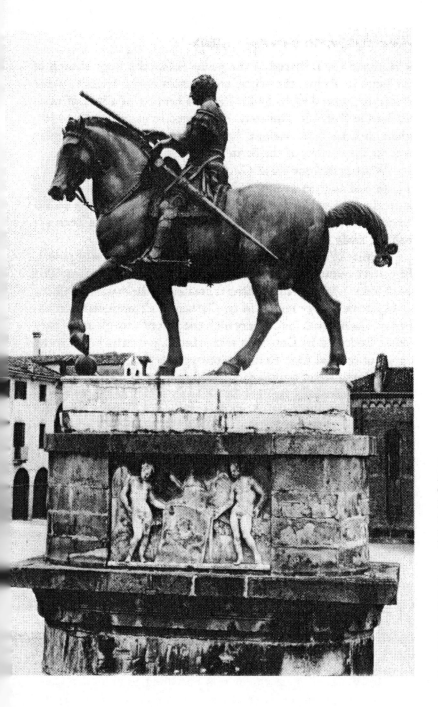

138. Titian, *Emperor Charles V on Horseback*, Prado, Madrid. Both Charles V and his successor, Philip II, were patrons of Titian. In fact, the painter was dubbed Knight of the Golden Spur and Count Palatine by Charles in 1537.

139. Donatello, *Gattamelata*, Piazza del Santo, Padua. Erasmo da Narni (1370–1443), called Gattamelata, was a soldier who became captain general of Venice. His tomb is inside the church of Sant'Antonio, before which Donatello's equestrian monument stands.

or Honeyed Cat). Placed in the piazza before the huge church of the Santo in Padua, the statue commemorates the famous soldier of fortune, who died in 1443. Perhaps because of a lack of commissions in Florence, Donatello had moved to Padua in the 1440s, where, besides *Gattamelata*, he executed the large and complex altar for the church of the Santo.

What strikes one about *Gattamelata* is the strength and unity of horse and rider; in size, proportion, and form, the figures interlock perfectly. The intimation of forward movement of Simone's *Guidoriccio* and Castagno's *Niccolò da Tolentino* has here been actualized, made inexorable.

Donatello's over life-sized bronze is the visualization of power, the perfect monument to a man whose livelihood was the controlled use of force. Much of this feeling is created by the massive stallion, his explosive energy reined in by Gattamelata's unquestioned authority. Gattamelata looks every inch the part of a tough mercenary soldier. Endowed by Donatello with a broad, powerful body, wearing armor derived from Roman prototypes (a link surely meant to recall the equestrian figures of Roman emperors), and possessed of a rugged, determined face set squarely on a bull neck, the figure of Gattamelata is formidable indeed. The two, horse and rider, appear relentless and invincible.

In Donatello's hands the equestrian figure comes alive, dominating its surroundings. *Gattamelata* strongly influenced Renaissance art and marked the boundaries for the subsequent development of the equestrian type.

In sculpture Donatello's *Gattamelata* has only one Renaissance rival: the over-life-sized equestrian statue [140] of Bartolomeo Colleoni of Bergamo, a wealthy and famous soldier of fortune who helped the Venetians gain much territory. Colleoni lived in great style in his castle in Malpaga near his native city, but when he died at seventy-six in 1476, he left much of his wealth to the city of Venice, with the proviso that a bronze equestrian statue of himself be erected in the Piazza San Marco, the city's principal square. Colleoni's bequest, while certainly generous, also demonstrates his desire to immortalize himself as a soldier.

The Venetian government was unwilling to abide by Colleoni's wishes (it wanted no monument to a foreign mercenary in the Piazza San Marco, which fronted the doges' palace) and instead relegated the statue to the insignificant Campo Santi Giovanni e Paolo. In 1480, after a competition among three sculptors, the

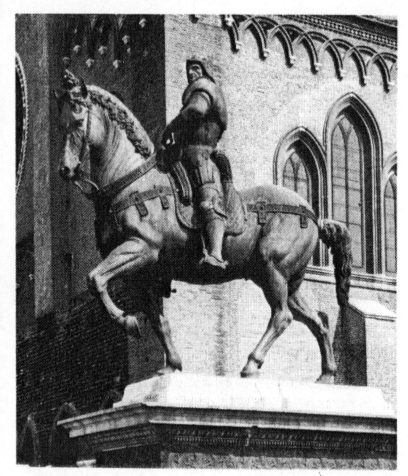

140. Verrocchio, *Colleoni*, Campo Santi Giovanni e Paolo, Venice. Andrea del Verrocchio (1435–1488) was the major Florentine sculptor of the second half of the fifteenth century. His style had considerable influence on his pupil Leonardo da Vinci.

commission was awarded to the Florentine Andrea del Verrocchio, the teacher of Leonardo da Vinci.

Verrocchio, while indebted to Donatello's *Gattamelata* and to the antique bronze horses that graced the church of San Marco in Venice, nevertheless created an original and striking image. Again, there is much emphasis on the horse, a tour de force of bronze casting; but it is the rider, standing in the stirrups, who is one of the most remarkable images of a soldier in the entire history of art, the ultimate Renaissance personification of machismo tinged with arrogance.

The outward trappings of power were the stock-in-trade of the soldier of fortune, who had to look and act the part in order to be employed. Colleoni was no exception: his name means "big balls" (mercenary captains often took descriptive names), and one of the objects on his coat of arms, carved into the base elevating the statue high above the pavement of the piazza, is the ultimate symbol of manhood, a pair of testicles.

A much more elaborate equestrian monument was designed by Leonardo da Vinci, about 1511. Leonardo, who was living in Milan, never executed the large-scale tomb-monument for the general Gian Giacomo Trivulzio.[14]

A series of sketches and studies [141] show Leonardo planned the life-sized horse and rider to stand atop a large, elaborately detailed base, into which was set an effigy of the deceased, supported by harpies and a number of life-sized figures. This ornate tomb base was something new in the history of the equestrian monument, although there was a tradition of adorning tombs with equestrian figures dating back to the late fourteenth century. The tomb of Colleoni in Bergamo, for instance, incorporated a large wooden equestrian statue of the soldier of fortune by a German woodcarver.

But Leonardo's work was to be more monument than tomb. The artist continually experimented with the horse and rider, striving for the most dynamic form possible. Versions with the horse prancing, walking, and rearing are all known. Leonardo also doggedly reworked the rider's position and gesture. He considered placing a defeated foe under the horse, and he made versions of Trivulzio and his mount alone. Clearly this was going to be something extraordinary, something that would make *Gattamelata* and *Colleoni* seem tame. In the end, nothing concrete came of Leonardo's grand scheme. But the idea of the colossal monument topped by an equestrian figure had great influence on other artists, who knew it from Leonardo's drawings and copies made after them. Leonardo's thoughts influenced later and even more elaborate equestrian monuments in all parts of Europe and, eventually, in the United States.

So far the civic world has been discussed in terms of public images commissioned by those who governed or ruled the Renaissance city. Many of the same men, and hundreds of others who had little or no connection with the government, belonged to guilds and confraternities. These organizations bonded the social and economic fabric of Renaissance life.[15] In some ways the guilds corresponded roughly to present-day unions and professional organizations, although often they participated in the governance of the city. Guilds were also social organizations with rigidly restricted matriculation. Often equipped with their own churches or, at least, with their own chapels, the guilds spent much money on paintings and sculptures.

Perhaps the most visible example of guild power and patronage is found in the church of Orsanmichele in Florence. On the outside walls of this building (which began as a communal grain storehouse

141. Leonardo da Vinci, Sketches for the Trivulzio monument, Windsor Castle Collection, Windsor, England. Gian Giacomo Trivulzio (1441-1518) was a Milanese soldier of fortune who fought for the French. He became the French governor in Milan.

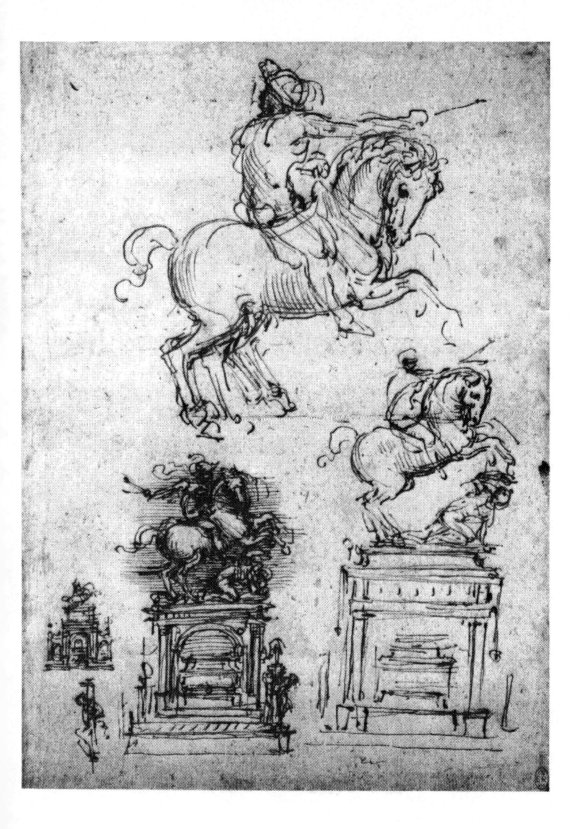

185

and became, through the presence of a miracle-working Madonna and Child on its lower floor, a church) are niches. Each niche was given to a Florentine guild, which furnished it with a statue of its patron saint. In this way the guilds were commemorated, and their combined efforts graced the city of which they were such a vital part.

Nanni di Banco's *Quattro Santi Coronati* [142] on Orsanmichele was created about 1413 for the niche assigned to the Maestri di Pietra e Legname, the guild of woodworkers and masons, which included sculptors. The *Quattro Santi Coronati* (Four Crowned Saints) were early Christian sculptors who were executed for refusing to make pagan images: ideal patron saints for those Florentines who worked in stone and wood. Some of the other guild statues on Orsanmichele, including Ghiberti's *Saint John the Baptist* and *Saint Mark* by Donatello, became among the most renowned of all Renaissance statues; but in the fifteenth century they were seen primarily as figurative coats of arms of the various guilds that they represented on Orsanmichele.

Lay confraternities (*compagnie*), like the guilds, exerted widespread influence on Renaissance society. Found in almost every

142. Nanni di Banco, *Quattro Santi Coronati*, Orsanmichele, Florence. Nanni di Banco (c. 1385–1421) was a talented Florentine sculptor who executed several major works on the cathedral and Orsanmichele, along with Donatello and Ghiberti.

city in the Italian peninsula, these widely varied groups were social, charitable, and quasi-religious. Functioning as a sort of club (they could be very exclusive), formed both for mutual self-interest and for the desire to do good works in the community, the confraternities gave a sense of identity to the Renaissance citizen, while providing many necessary services for society at large.[16]

Some of the functions of the confraternity are illustrated by a series of frescoes in the Florentine meetinghouse-chapel of the Buonomini di San Martino, a confraternity. Founded in 1441, this association is still active. Its members are dedicated to raise and distribute alms, to keep all acts of charity secret, and to give all accumulated funds away in charity.

During the late fifteenth century, the charitable acts of the confraternity of the Buonomini were illustrated in fresco on the walls of their meetinghouse by a follower of the popular Florentine artist Domenico Ghirlandaio. The deeds illustrated in the Buonomini frescoes and in other such pictures done for other confraternities were not entirely secular, for they were often based on the Seven Acts of Mercy, which were sanctioned and encouraged by the church.

One of the Buonomini frescoes [143] is devoted to a crucial

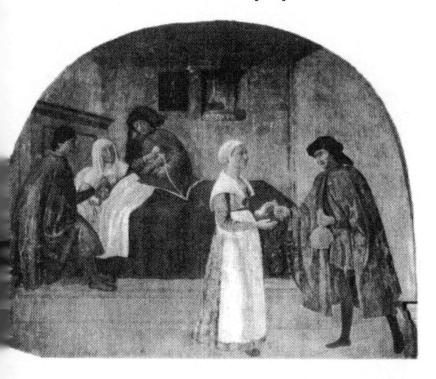

143. Follower of Domenico Ghirlandaio, *Visiting the Sick*, Meetinghouse of the Buonomini di San Martino, Florence. The Buonomini frescoes are a fascinating record of the everyday life of the Renaissance. They provide valuable records of the humble objects of the modest domestic interior; beds, flasks, wine bottles, and other common household items are depicted with care.

task in a society without governmental social agencies: the care of the sick. Here we see the members of the Confraternity of the Buonomini visiting a woman and a small child. Since both mother and child are in bed, it is not quite clear if this is a post-partum visit or if both of the figures are ill. In any case, visiting the bed-ridden and providing them with food—the man at the left brings food and drink—were important functions of the confraternity.

The Buonomini frescoes also give us a rare glimpse of the interior of the modest Renaissance home. In *Visiting the Sick* we see the simple, unadorned room of a small house. The bed is raised above the floor by a wooden platform, which also serves as a step and a compartment for storage. Only one picture hangs in the room, a small crucifix placed next to the niche on the far wall. The austerity of this room bespeaks the poverty of its occupants, who seem deserving of the charity so obviously given them by the Buonomini.

Another fresco [144] from the Buonomini series also shows an interior, but this time it is a storeroom where the members of the confraternity feed the hungry. Children and their mothers receive wine from a large storage vat and round loaves of bread

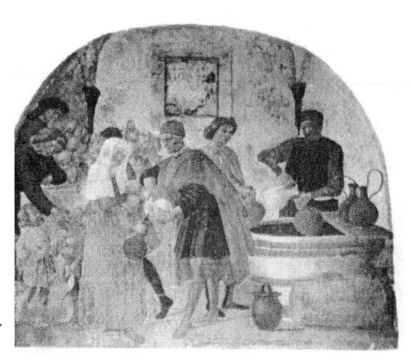

144. Follower of Domenico Ghirlandaio, *Feeding the Hungry,* Meetinghouse of the Buonomini di San Martino, Florence.

from a pile in the room's left corner. The faces of the Buonomini are too generalized and bland to be portraits; portraits of men who dispensed charity secretly would have been contradictory, at that.

Other scenes in the meetinghouse of the Buonomini depict the members of the confraternity visiting prisoners, burying the dead, and performing other good and useful deeds. The frescoes on the walls were both decoration and a constant reminder to the Buonomini of their high purpose.

Some of the services provided by the Buonomini were also undertaken by the Confraternity of the Misericordia: in an age when there were few government-run agencies established for the order and well-being of the city, the task of performing necessary social functions often was shared by several groups of citizens. The Misericordia became an important confraternity during the Black Death, the bubonic epidemic that in 1348 killed tens of thousands in the Italian peninsula and throughout the rest of Europe. Members of the Misericordia helped the sick and buried the dead; this association with the stricken still continues, and in many cities in Italy the Misericordia runs the communal ambulance service.

The Misericordia's association with the plague is clearly seen in the great altarpiece [145] made for the members of the confraternity in Sansepolcro. Painted by Piero della Francesca, the author of the *Resurrection* discussed above, this altarpiece was commissioned in 1445 for the oratory-church of the Misericordia in Sansepolcro.

In the center of the polyptych, Piero painted a Madonna della Misericordia, the image of the standing Madonna enfolding the kneeling members of the confraternity (one of them wearing a hood used to make their charity anonymous) in her cloak. As the role of the Madonna suggests, the type probably originated during a plague and subsequently was associated with the Misericordia. Moreover, the Saint Sebastian at the far left of the altarpiece was thought to offer protection against the plague, and his image appears with great frequency during the Renaissance.

Equally iconic was another group of images commissioned and used by the many confraternities of the Renaissance: painted procession banners—those large, highly visible standards still carried in religious processions in modern-day Italy. Banners were made in various types, sizes, and subjects, depending on their particular function. The preferred material was linen or some other fabric that combined considerable size (many of the banners are

145. Piero della Francesca, *Misericordia Altarpiece,* Pinacoteca, Sansepolcro. Piero's *Misericordia Altarpiece,* now reassembled in a modern frame, is the artist's earliest extant work. The contract for its commission stipulates that the painting had to be finished within three years and had to be the work of Piero's hand entirely. The painter ignored both stipulations.

between one and three meters high) with the light weight requisite for carrying during the procession.[17]

The banner's function dictated its composition. Both sides had to convey clearly legible messages as the banner streamed past the assembled spectators. One such double-faced processional standard (c. 1470, now in the Pinacoteca Comunale of Deruta, a small Umbrian town) is by Niccolò di Liberatore, called L'Alunno [146 and 147]. On the front of the rectangular banner is the enthroned Saint Anthony Abbot, who blesses the spectators as two flying angels place his miter on his head. Below kneel hooded members of a confraternity of flagellants, recognizable both by their white robes and by the area of skin on their backs exposed to their own lashes.

Anthony was thought to bring protection against Saint Anthony's fire, a dreaded and painful disease endemic in the Renaissance. The thousands of images of the saint were talismans against

the disease, believed to be brought on by supernatural causes. Paraded through the town during an actual outbreak or in hopes of averting one, the image on the banner was not only supernatural, and therefore capable of a cure, it was also comforting and full of promise.

Above Saint Anthony is the Crucifixion with Mary and Saint John the Evangelist. The two angels who collect blood from Christ's wounds also console the viewer: the blood of Christ, the ultimate sacrifice for humanity, will save and redeem those who watch the standard sway by.

The back of the banner is also related to its function. Here Saint Francis and Saint Bernardino of Siena (both frequently appear on banners) look and motion toward the Flagellation above. They are placed before a damasked drapery, which, like the neutral gold

146. Niccolò di Liberatore, called L'Alunno, Banner front, Pinacoteca Comunale, Deruta. Plague banners seem to have been especially numerous in Umbria during the Renaissance. It is from this area that most of our knowledge of these highly specialized paintings derives.

147. Niccolò di Liberatore, called L'Alunno, Banner back, Pinacoteca Comunale, Deruta.

background behind the Saint Anthony on the front, stops the recession of space and keeps the figures near the picture plane, close to the spectator. Both the forms and the gestures of the two saints are simplified and bold, designed to be intelligible to those standing some distance from the banner.

The saints draw all eyes to the Flagellation of Christ, a scene often painted for flagellant confraternities. L'Alunno's version of it, like many on banners, is extremely violent and awful; even the briefest glimpse as the banner passed would be enough to strongly impress the spectator.

A processional standard [148], in the Museo Nazionale di San Matteo in Pisa, presents another saint with power over sickness. This image of Saint Donatus (Donnino) was painted about 1400 by the Sienese Taddeo di Bartolo for the Confraternity of San Donnino, whose members are seen kneeling at the right. When not in use, the standard was kept in the chapel owned by the confraternity in the Pisan church of San Marco.

Donatus, like Sebastian and Anthony, could be implored for supernatural cures. Donatus was particularly important because he had cured a man with rabies, a disease as dreaded then as now. And it was believed that any liquid, even poison, drunk from Donatus's chalice, kept in the cathedral of Pisa, could also cure rabies. This aspect of Donatus's legend is seen at the lower left, where a man attacked by a mad dog kneels before the saint.

Carried in a religious procession, the standard must have been a much-worshiped icon whose power could avert one of the most frightening illnesses of the Renaissance. The huge scale of the frontal saint, the little figures kneeling in adoration, and the glimmering, dimensionless gold background intensified the supernatural aura of the image.

Elements of narrative appear in other processional banners, such as the large painted one [149] by Bartolomeo Caporali in 1482 for the small Umbrian town of Montone. Now in the church of San Francesco, Montone, this banner was probably commissioned by the local Confraternity of the Misericordia, whose members kneel around the feet of the painted Madonna della Misericordia. That it was meant for a Franciscan church is evident from the three Franciscan saints (Francis, Anthony of Padua, Bernardino of Siena). Also included is Saint Sebastian, who, with Saint Bernardino, appears on many of the plague banners.

The presence of Saint Sebastian alerts the viewer that the banner is an icon intended to ward off the plague, and, in fact, at

148. Taddeo di Bartolo, Processional standard, Museo Nazionale di San Matteo, Pisa. Taddeo di Bartolo (c. 1360–1426) was an original and influential painter of early-fifteenth-century Siena. Aside from this banner, he painted frescoes and altarpieces in Pisa, a city that often employed foreign artists.

149. Bartolomeo Caporali, Processional banner, San Francesco, Montone. Bartolomeo Caporali (c. 1420–c. 1505), of Perugia, was an eclectic Umbrian artist influenced by both Piero della Francesca and Perugino. Many of his modest works still remain in Perugia and in small towns around that city.

150. Francesco Melanzio, *Madonna del Soccorso,* Museo di San Francesco, Montefalco. Montefalco, situated in Umbria not far from Perugia and Assisi, commissioned works of art from several foreign artists. Among the most famous of these is a large fresco cycle by the Florentine Benozzo Gozzoli, a pupil of Fra Angelico.

the top of the painting is the vengeful Christ holding arrows of the plague. These arrows are deflected and broken on the mantle of the Madonna, who protects the imploring citizens and spares the city of Montone, stretching across the bottom of the banner.

The depiction of cities on plague banners was common, and the various buildings are usually rendered with considerable accuracy, as though verisimilitude were necessary for the magic of supernatural salvation to work. In an age when doctors and their medicine were almost helpless against epidemics, the banners, with their miraculous images, often offered the only hope of salvation.

An extremely interesting image, the Madonna del Soccorso, also appeared on banners. An example of this rather bizarre subject is found on a banner [150] painted about 1500 by the Umbrian artist Francesco Melanzio for the Confraternity of San Niccolò da Tolentino, in the picturesque but remote hill town of Montefalco.

Like that of virtually all banners, the message of this painting is expressed in simple, almost crude forms that are both easily readable and powerful in their elemental simplicity. Illustrated in

Melanzio's banner is the story of the mother who, in a fit of anger, wished her child sent to the devil. In an instant the devil appeared and began to drag the child away. Horrified, the repentant woman prayed to the Virgin, who appeared and beat the devil off with a club.

This image of the Madonna del Soccorso, which seems to appear exclusively in Umbria and Tuscany, must have been invoked for the protection of children. During the Renaissance the child mortality rate was high, and icons such as the Madonna del Soccorso offered a measure of hope and protection. In all the images of the Madonna del Soccorso, the Virgin appears as huge and strong, more than a match for the devil, who was thought always to be lurking. The genitalia of the devil have been obliterated by fearful citizens of Montefalco, graphic proof of the potency of his image.

One of the duties of certain confraternities was to assist and comfort those condemned to death by the civil authorities. The Confraternity of Saint Andrea della Giustizia of Perugia was such an organization.[18] In 1501, its members commissioned Pietro Vannucci, called Perugino, to paint a new banner for them [151].

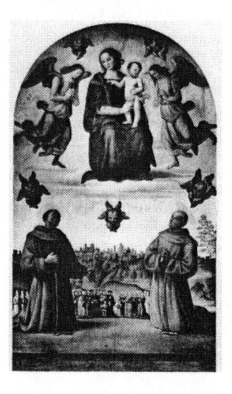

151. Pietro Perugino, Processional banner, Galleria Nazionale dell'Umbria, Perugia. Pietro Perugino (active 1472–1523) was the major figure of the Umbrian Renaissance and the teacher of Raphael. Perugino attained considerable fame outside his native Umbria, receiving commissions from Florence and the pope.

Saints Francis of Assisi and Bernardino of Siena—figures regularly associated with plague banners—are depicted kneeling in adoration of the Virgin and Child, who float overhead attended by two graceful angels. In the panoramic landscape, which includes a view of the city of Perugia, with its churches and tall towers, the members of the confraternity and their families kneel.

Perugino's banner is one of the most accomplished in the history of the type, but it represents a fundamental shift away from the older tradition. As we have seen in the history of the altarpiece and other types, about 1500 the formal properties of a painting began to become as important as its function. Banners express this change also. For instance, the panoramic landscape in Perugino's standard punches a wide, deep spatial hole in the banner, negating the flatness so fundamental to earlier examples. Moreover, the figures are now smaller, more complicated, more complexly set into space; consequently, the work is less readable from afar and lacks much of the austere iconic vigor of its predecessors. Here Perugino is painting a *picture,* something to be admired, rather than a sacred object infused with miraculous protective and healing power. The change of attitude on the part of the artist and his patrons is striking, even if we cannot fully understand why it took place. We appreciate Perugino's banner for its form, for its color, and for its sylvan, lilting landscape, but we are not awed by it; nor does it seem as powerful as earlier examples of the type.

The processions in which the banners were carried were religious. The supernatural nature of the images and the presence of the clergy who accompanied the banners gave the procession a sacral nature. This was reinforced by other objects carried by the marchers.

Along with banners, one of the most common objects carried in the procession was the processional crucifix. Probably some of the smaller crucifixes that hung in the apses and chapels of the town churches were taken down and used for this purpose, but others were commissioned specifically for processional use.[19]

One of these crosses, preserved in the Cleveland Museum of Art, is a small painting [152] meant to be carried on a pole held above the heads of the marchers. Double-faced like the banners, it represents on one side the crucified Christ with the Virgin, Saint Francis, John the Evangelist, and an angel; on the other side, Christ, Mary, the angel, and John are repeated, but Saint Clare now takes the place of Saint Francis. Thus, with some minor modifications of placement and gesture, the two sides of the cross are almost

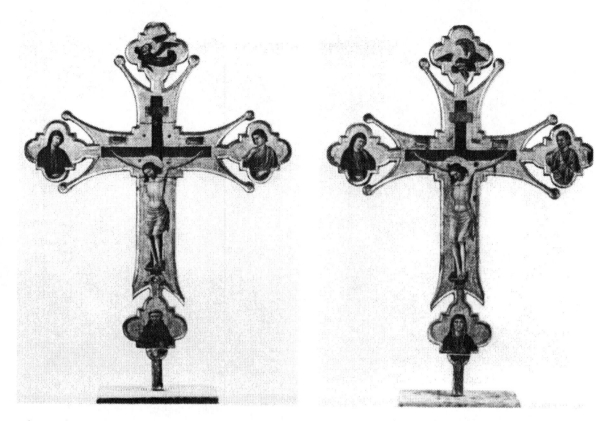

identical. Probably made in Rimini toward the end of the fourteenth century, in a Franciscan milieu, it was most likely just one of many crucifixes that accompanied the scores of religious processions held in the Renaissance city. Several other surviving processional crosses are of a similar shape, and they, like the Cleveland type, have nearly identical images on back and front. When these crosses were not being carried, they were probably set up in the meeting halls of the confraternities or in the chapels owned by these groups.

One of the most important functions of the confraternities was to assist in burial. Confraternity members were responsible for transporting the body to its final resting place and for organizing the funeral. Naturally, banners and portable crucifixes would be held by the marchers, but the artists of the Renaissance also furnished the decorated bier on which the defunct was carried.

These paintings on the headboard and footboard of the stretcher-like bier survive in considerable numbers in Siena and in the small surrounding towns. Like the banners, these biers were sometimes painted by the major artists of the city, who were commissioned to lend their skill and prestige to objects often on public display.

152. Riminese(?), Front and back of processional crucifix, Cleveland Museum of Art. Rimini, a city on the east coast of Italy, where this small cross was probably made, was the location of a flourishing school of fourteenth-century painting. But by about 1400 Riminese art had lost much of its vigor and originality, and the city's paintings and sculptures were often done by foreign artists.

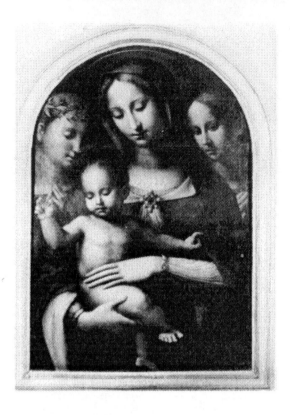 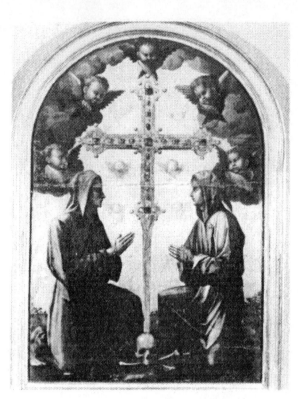

153. Sodoma, Front of bier headboard, Pinacoteca, Siena. Although they seem to have been used in many areas of the Italian peninsula, the painted bier headboard survives in greatest numbers in and around Siena; perhaps this is because they were carefully preserved by the local confraternities that commissioned them.

154. Sodoma, Back of bier headboard, Pinacoteca, Siena.

Painted about 1530, a double-faced bier headboard [153 and 154] of high quality attributed to Giovanni Antonio Bazzi, called Sodoma, displays many of the characteristics of the type. On the side that faced the corpse are the Madonna, Child, and two angels, their gaze on the deceased. Sodoma has placed them close to the picture plane so that they seem near the defunct, who also receives the special blessing of the infant Christ.

All of the figures emerge from a strange half light that seems to emanate from below. There is an enigmatic, mystical quality about this picture (which in composition is a variant of a Madonna and Child type found on contemporary altarpieces) that enhances the sadness expressed by the figures, a sadness most appropriate for the work's function.

The side of the headboard that faced the spectators watching the processions depicts two hooded members of the Compagnia della Chiesa di Fontegiusta, the confraternity that owned the bier, kneeling in adoration before a bejeweled cross. With its pole for carrying and its elaborate ends, the depicted cross is of the type seen in the small crucifix in Cleveland, actually carried in procession. In fact, the cross pictured in Sodoma's painting could have been owned by the confraternity and carried in procession with the bier.

The seraphim hovering in banks of swirling clouds around the picture's arch, the shimmering gold background against which the two dark figures adore the cross, and the reappearance of the same mysterious light seen on the painting's other face all make the work strangely emblematic, related in feeling and composition to the iconic processional banners. Other subjects found on surviving bier heads, including the Dead Christ Supported by Angels, Christ in the Tomb, and various saints, share many of the same visual and emotional characteristics developed in response to the bier's sad function.

Each of the confraternities had a location where it met and worshiped. This could be a chapel in a church or in a modest meetinghouse such as that of the Buonomini discussed above. Or, in the case of the powerful and wealthy confraternities, the group might have headquarters of considerable size and magnificence. Most of these meeting places were decorated with the banners, altarpieces, and crosses owned by the organization and used by the members in procession.

Confraternity walls were decorated with frescoes. On the outside walls of the Florentine Confraternity of the Bigallo, for instance, several paintings, much like the frescoes on the inside of the meetinghouse of the Buonomini, clearly depicted the functions of the confraternity. Thus, the fresco [155] of about 1390 by the Florentine Niccolò di Pietro Gerini shows the members of the company uniting children with their adoptive mothers. The Bigallo, which was run by the Misericordia, was an orphanage that found

155. Niccolò di Pietro Gerini, *Members of the Bigallo Uniting Children with Their Adoptive Mothers,* Museo del Bigallo, Florence. Gerini's painting was originally on the outside of the Bigallo building, which stands across from the baptistry and cathedral of Florence. In its original location, the fresco would have advertised an important function of the confraternity in the heart of the city.

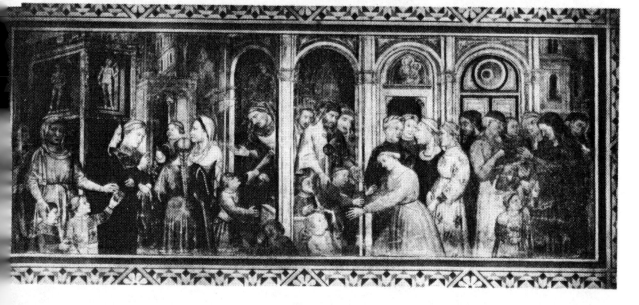

mothers for orphans and abandoned children. In Gerini's painting the members of the Bigallo are shown inside a rather free portrait of the loggia still standing across from the cathedral of Florence. The happy children and the joyous mothers are abundant proof of the good works performed by the confraternity. Gerini's painting both advertised the Bigallo and confirmed its social worth.

Works commissioned for the decoration of a confraternity's headquarters could rise to the level of masterpieces. The frescoes painted by Andrea del Sarto for the cloister of the confraternity of the Scalzo in Florence are such a case. Actually named the Confraternity of Saint John the Baptist, the brotherhood acquired the name *scalzo* (barefoot) because some of their members who carried the cross in procession went without shoes as a sign of humility.

Sarto's frescoes, done in 1514–1526, are devoted to the life of Saint John the Baptist, the Scalzo's patron. The frescoes are painted around a small, graceful courtyard loggia. Around the frescoes runs a border of skulls and bones; these also appear on the architecture, suggesting that the structure was used as a lying-in-state location for the defunct members of the confraternity. Such a function might explain why four of the scenes of the Baptist's life are devoted to his capture and death. Moreover, the work is painted in a somber, nearly monochromatic palette.

In many of the frescoes, such as *Baptism of the People* [156], Sarto has created a feeling of great sobriety, as monumental figures in a barren landscape engage in a solemn rite. Each of the frescoes conveys the weight and import of the significant episodes in the life and death of the Baptist.

In Venice the confraternities, or *scuole* as they were called there, also played a major role in the life of the city. Well established and wealthy, they could often afford large and sumptuous meeting halls. They spared no expense in commissioning the city's most important painters to decorate the meeting hall's large expanses of ceilings and walls.[20]

A famous example of the decoration of a Venetian confraternity is the series of paintings from about 1500 of the Miracle of the Relic of the True Cross, by Gentile Bellini (the brother of the more famous Giovanni Bellini) and several other prominent masters, for the Scuola Grande di San Giovanni Evangelista. These eight canvases, now in the Accademia of Venice, were commissioned for the room that housed the confraternity's most prized treasure: a relic of the Holy Cross. Thus these large pictures had

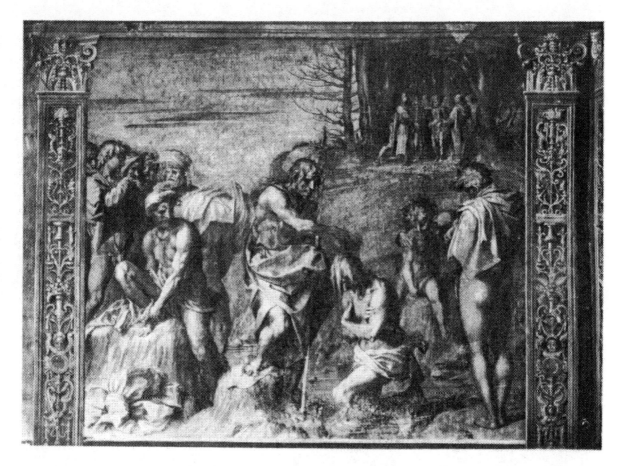

not only to narrate their subjects, but they also had to beautify and decorate the room.

Gentile Bellini's *Procession in Piazza San Marco* (1496) is one of the three canvases he painted for the *scuola* [157]. It depicts the miracle of April 1444: during a procession in the city's main square in which the *scuola*'s sacred relic of the Holy Cross was being carried, a merchant from Brescia prayed that his dying son be saved. At that very moment the son recovered, proving the efficacy of the relic and the sanctity of the procession.

Although *Procession in Piazza San Marco* is the depiction of a miracle and was so understood by its contemporary audience, it is a remarkably mundane picture. Bellini's major goal, which he accomplished admirably, was to present a realistic, detailed portrait of mid-fifteenth-century Venice. Nowhere is the actual miracle depicted; rather, the picture is a record of the remarkable architecture of Venice, of the atmosphere, color, and texture of its major square, and of the worthy members of the confraternity who paraded that miraculous day in April.

156. Andrea del Sarto, *Baptism of the People*, Chiostro dello Scalzo, Florence. Andrea del Sarto (1486–1531) was an artist who, along with Fra Bartolomeo and Michelangelo, was instrumental in introducing a new, classical style into early-sixteenth-century Florence. Sarto and the painter Franciabigio painted a cycle of frescoes in the Chiostro dello Scalzo.

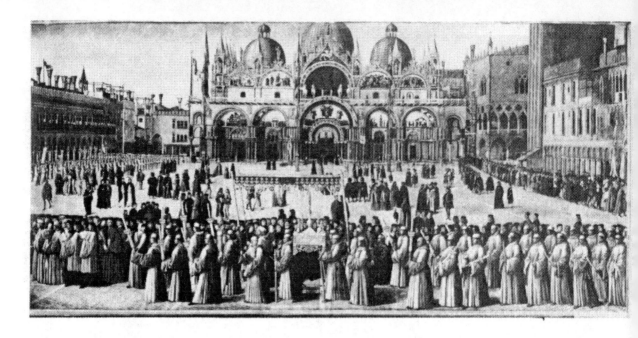

157. Gentile Bellini, *Procession in Piazza San Marco,* Accademia, Venice. The members of the Scuola of San Giovanni Evangelista, the patrons of Bellini's picture, are seen in the foreground wearing the white habit with red cross and cap of their confraternity. In a column at the right march the doge and members of the Venetian government.

158. Giovanni Mansueti, *Miraculous Healing of the Daughter of Benvegnudo of San Paolo,* Accademia, Venice. Mansueti's painting is fascinating for its accurate depiction of early-sixteenth-century Venice. It affords an unusually detailed record of the various types of costume: here, as in *all Renaissance* dress, color, cut, and material indicate social and economic standing.

The intermingling of the sacred and the secular was a part of the life of the confraternity and, indeed, of the entire Renaissance. Religious life and religious ritual permeated the entire fabric of society, leaving nothing wholly secular, wholly removed from the spiritual and the divine. So, even in this most matter-of-fact portrayal of a procession, the presence of the golden reliquary with its precious contents turns the square into the setting for a solemn, sacred event.

In another painting from the series of the Miracle of the Relic of the True Cross, a great house becomes the site of a miracle. About 1505, Giovanni Mansueti depicted another cure by the confraternity's relic of the Holy Cross in his *Miraculous Healing of the Daughter of Benvegnudo of San Paolo* [158]. A little girl, the paralyzed daughter of Benvegnudo of San Paolo, is restored to health by the touch of candles previously placed on the relic.

As in Bellini's *Procession in Piazza San Marco,* the viewer is almost overwhelmed by a profusion of fascinating detail; it is only after careful observation that the actual miracle is discovered, occurring before the window.

Of equal, or perhaps greater, importance here is the life of Venice and the representation of the members of the confraternity whose portraits appear around the elaborate flight of stairs. Once again, real, everyday Venice and its inhabitants have been transformed. Bathed in the watery light of Venice streaming in the windows, there is a solemnity and gravity about the scene that elevates it into a sacred realm.

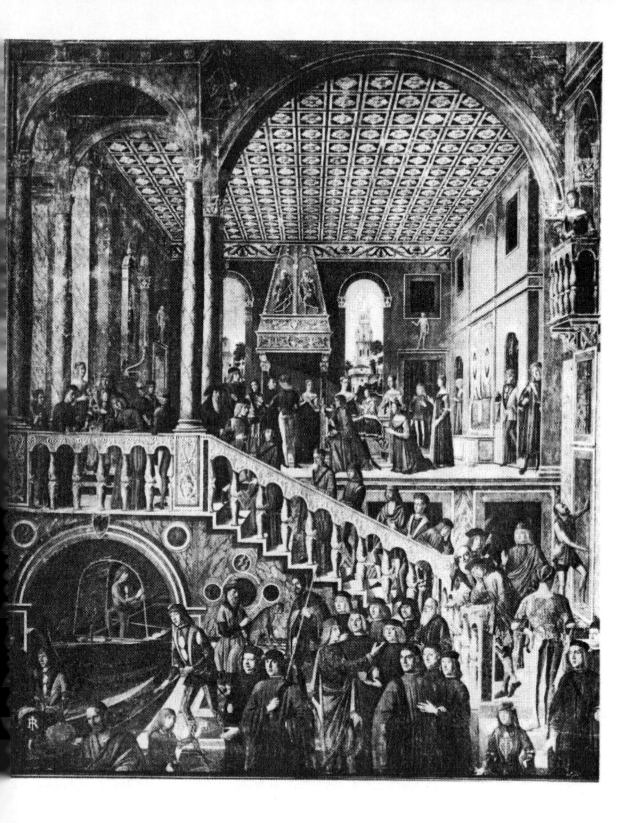

Mansueti's highly detailed canvas offers a splendid illustration of an ideal patrician Venetian home. The great arches, the coffered and decorated ceiling, the splendid marble staircase leading down to the canal, and the elaborately carved and gilded fireplace testify to the status and wealth of the palazzo's owners.

The splendid room is decorated with some types we have already seen. On the left wall is a painting of a single figure, the Madonna, enclosed in a gilded tabernacle before which burns a single candle. Above each of the doors are statues that cannot be identified with certainty, although the carving above the door to the right looks like a figure of Saint John the Baptist. A *cassone* and a cloth hanging complete the sparse but elegant decoration.

In 1490, the first of a major series of paintings for the Venetian Confraternity of Saint Ursula was finished by Vittore Carpaccio. Like Gentile Bellini, Carpaccio had a style and an interpretative sense perfect for the painting of large-scale narratives destined for the headquarters of the Venetian *scuole*. The eight Saint Ursula paintings completed by him are a memorable blend of the mundane and the spiritual, all set within a Venetian dreamland.

Each of the large canvases relates an episode of the legend of Saint Ursula, the confraternity's patron. One of the most enchanting of these, and a good example of how art made for Venetian confraternities often rises to a very high level indeed, is the complex double narrative [159] of Saint Ursula Meeting Conon (her betrothed) and the Departure of Ursula and Conon and Their Attendants for Rome. These scenes, which were the first in a series of events leading to the martyrdom of the couple, unfold against a panoramic background filled with noble castles, sparkling skies, and still water. This is not England, the supposed locale of the action, but a mythicized Venice and the Veneto, the expanse to the west of the city. There is realism enough in the accurate depiction of the graceful ships and Venetian-like buildings with gleaming marble, but the atmosphere is that of a fairy tale. The pomp and ceremony beloved by Venetian confraternities are here, but they are tempered by a radiant light and an atmosphere aglow with color. Magical Venice, the city of the exotic and fabulous, comes alive in the inventive strokes of Carpaccio's brush.

Inventiveness is also the hallmark of Jacopo Tintoretto's remarkable decoration in the Venetian Scuola Grande di San Rocco. The Scuola San Rocco was a wealthy confraternity devoted to the care of the sick, especially those stricken with the plague. San Rocco (Saint Roch) was, with Saint Sebastian, the principal plague

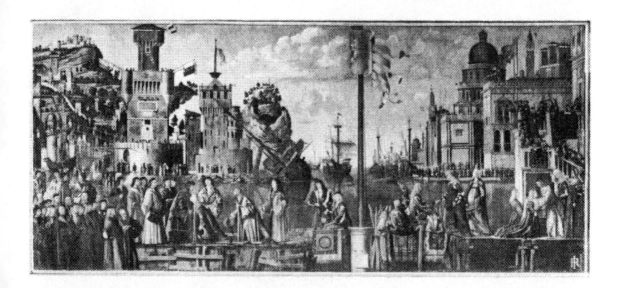

saint, and his image appeared on many altarpieces and banners. Two floors of the *scuola* are decorated with large canvases (begun in the 1560s) by Tintoretto and his workshop, set into the ceiling and walls. The ensemble, with its pictures in elaborately carved and gilded frames, is breathtaking; the sheer scope and energy of the figure-filled paintings have seldom been matched in the history of art.

Tintoretto was a highly inventive artist, and each of his scenes in the Scuola San Rocco, while serving as part of an overall decoration, is a reinterpretation of its traditional theme. The *Baptism of Christ* [160], for example, depicts the familiar story with a new dramatic urgency. Set in a striking landscape whose space rapidly recedes into a boiling sky pierced by the blinding light of the holy spirit, the act of baptism takes place with a fervor rare in the history of the scene. Witnessed by a multitude of wraithlike creatures on the far bank and closed in the foreground by perfectly drawn figures of great beauty and complexity, the *Baptism of Christ* has a power and spirituality unique to Tintoretto.

In Tintoretto's paintings for the Scuola San Rocco new attitudes toward art and its function emerge. Unlike the distinguished series of canvases by Gentile Bellini and Carpaccio for the Venetian *scuole*, the paintings by Tintoretto have an independence that transcends their role as units in a decorative whole. Instead, each is conceived as an integral and independent work of art, a highly personal vision of the artist. True, the ensemble of the Scuola San Rocco has a harmony of color and size and a coherent interrelationship among the various paintings and their subjects; yet the

159. Vittore Carpaccio, *Saint Ursula Meeting Conon and the Departure of Ursula and Conon and Their Attendants for Rome,* Accademia, Venice. Ursula, the daughter of a king of Brittany, married Conon on the condition that he be baptized a Christian; the pope baptized him in Rome, with the name Etherius. Etherius and Ursula were martyred at Cologne, and both were later canonized.

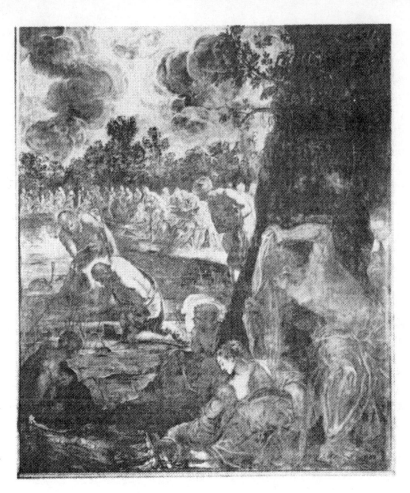

160. Tintoretto, *Baptism of Christ,* Scuola San Rocco, Venice. Jacopo Robusti (1518–1594), called Tintoretto, probably started his career with a brief stay in the shop of Titian. His large canvases in the Scuola San Rocco and other Venetian institutions are notable for their invention and daring.

paintings linger in the spectator's memory as individual works, rather than as parts of a whole.

Like the early-sixteenth-century altarpiece, the individual character and style of Tintoretto's paintings were now assessed mainly on their own terms; each canvas was now more independent and, consequently, seen less in terms of function. The individual units of the overall decorative schemes were becoming important, self-contained works of art in their own right.

As the *scuole,* or confraternities, another communal institution, the hospital, was also the object of decoration, some of it lavish and expensive. The Renaissance hospital took care of the sick, but it also performed other socially useful services. For instance, hospitals were often foundling homes and charitable centers that educated their charges and furnished the all-important dowry for their female wards.

One of the most famous hospitals was the Scala in Siena.

Already an ancient institution by the time of the Renaissance, the Scala was headquartered in a large building across from the cathedral, and it had numerous branches in the Sienese countryside. Run by a committee of prominent Sienese citizens, the hospital, like many of the confraternities, was an institution that conferred prestige on those who were associated with its administration.

A series of early-fifteenth-century frescoes that decorated the rooms of the Scala today furnish a unique view of the functioning of a Renaissance hospital. Remarkably, the Scala remains one of the principal hospitals of Siena, and the frescoes decorate wards still in use.

In a Scala fresco [161] by the Sienese painter Domenico di Bartolo, the spectator sees a crowded ward. Doctors and the superintendents of the hospital minister to the sick, who lie or sit in a large room closed off from the rest of the hospital by a wrought-iron gate. The walls of the room bear a pattern meant to imitate animal pelts; similar decoration was quite common on the walls of private palazzos.

161. Domenico di Bartolo, *Ward of the Scala,* Spedale di Santa Maria della Scala, Siena. Domenico di Bartolo was a Sienese artist of the early fifteenth century who carefully studied and borrowed, with substantial modifications, the newest Florentine pictorial inventions. Many of these borrowings appear in his highly detailed record of the activities of the hospital of the Scala in Siena.

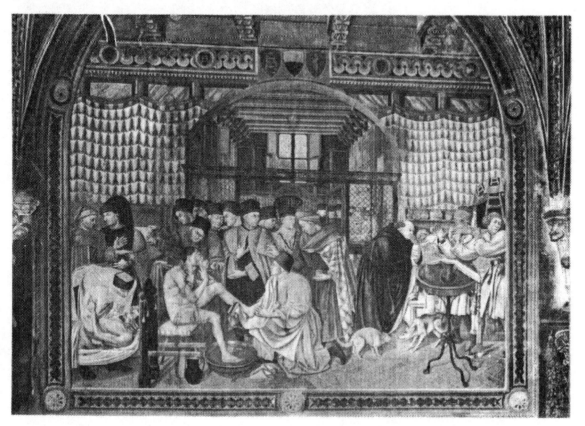

At the center of the picture is a shivering nude man who is being washed by one of the superintendents, identifiable by his soft round hat. The sick man is about to be treated by the doctor (designated by his turban-like headdress), who holds an ointment jar in his left hand. Obviously the doctor is a man of substance, for his robe is lined with fur, very much like that pictured on the wall behind.

At the far left, two doctors confer; one holds a beaker, which may contain the urine of the man who is being helped into bed in the foreground. At the right, other ill men lie in beds, attended by a friar. The ward is a bustling public place where the attendants outnumber the patients.

Of course, the reason for the inclusion of so many of the superintendents is that, in a way, this fresco is a group portrait as

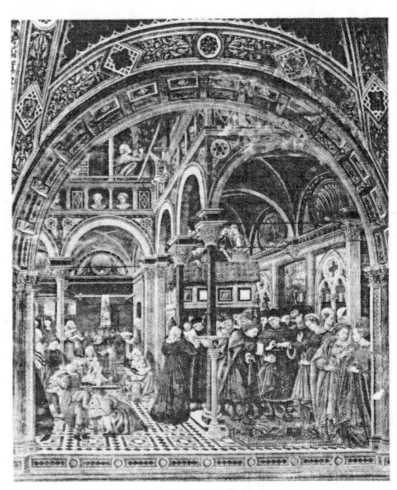

162. Domenico di Bartolo, *Education and Betrothal of the Scala's Foundlings,* Spedale di Santa Maria della Scala, Siena. The betrothal in Domenico di Bartolo's fresco is unusual for its depiction of a singing gallery. Located behind the betrothal group, it is occupied by women singing and playing various musical instruments.

well as a record of the good deeds of those who ran the hospital in the fifteenth century. This fresco is the distant ancestor of the administrators' group portrait, which finds its greatest exponents in sixteenth-century Venice and in the Holland of Rembrandt and Hals.

Domenico di Bartolo probably had no prototype for this scene, and, consequently, he did what most painters of the fifteenth century did in the absence of a model: he based his work on a story that had certain similarities to his subject. Domenico used the Washing of the Feet, where Christ washes the Apostles' feet at the Last Supper, as his model for the scene he had been commissioned to paint; the likeness between it and the depiction on the Scala's ward must have served to remind the viewer that, like Christ, the superintendents of the hospital were performing acts of humility and love.

In another fresco [162] for the wards of the Scala, Domenico di Bartolo depicts two of the most important functions of the institution: the education of the foundlings and their betrothal. In a building that must have been owned by the Scala (note the font with the ladder, the Scala's symbol), the two events unfold. At the left, the young foundlings are fed, bathed, and taught their lessons by a stern schoolmaster. It is as though all the many steps of child rearing are telescoped into this moment in this courtyard, with its fantastic architectural decoration and roaring fireplace.

In the loggia to the right, a betrothal takes place. Betrothal was an important act in Renaissance life, for it signified parental consent and the fixing of the dowry, the woman's required endowment to the marriage. One of the superintendents of the Scala holds the dowry in his right hand as he steadies the hand of the girl about to receive the engagement ring offered by the young man. The betrothal was a lay ceremony that could be performed at the home, although the singing gallery and choir in Domenico di Bartolo's picture seem to place the event in a sacred setting; as in the depiction of the education of the foundlings, this may be an attempt to compress time and space into one comprehensible whole.

During the fifteenth century, the administration of urban hospitals shifted increasingly from religious to guild control; prominent citizens now founded hospitals and endowed them. They and their descendants also paid for the numerous frescoes, altarpieces, and other works by Renaissance artists that were a necessary part of the hospital complex.

One notable example of later hospital decoration is the large glazed terracotta frieze by the Florentine Giovanni della Robbia and his workshop, executed about 1525 for the Ospedale del Ceppo in Pistoia. The subject is the Seven Acts of Mercy, the essential social responsibilities undertaken mainly by the confraternities and other civic organizations. Many of the Acts of Mercy appear on the wall of the headquarters of the Florentine Buonomini and deco-rate other confraternities throughout the Italian peninsula.[21]

Visiting the Sick [163] from the Ceppo frieze gives us another glimpse into the ward of a Renaissance hospital. To either side, the sick lie in beds, each marked by a large Roman numeral above its headboard. Around the patients cluster the various doctors: one takes the pulse, another looks at a urine specimen, while yet another examines a man's head. In the center of the frieze stand other physicians and a black man holding a hat. The identity of this figure is uncertain, but most likely he is a slave. Slavery was endemic in the Italian peninsula during the Renaissance, and many African and Oriental slaves lived and worked in the palaces and villas of the wealthy. These slaves make their appearance in art

163. Giovanni della Robbia, *Visiting the Sick*, Ospedale del Ceppo, Pistoia. The Ospedale del Ceppo (charity hospital) of Pistoia was probably founded in the thirteenth century. It was, however, only in 1514 that the portico was erected, on which the della Robbia frieze was then installed.

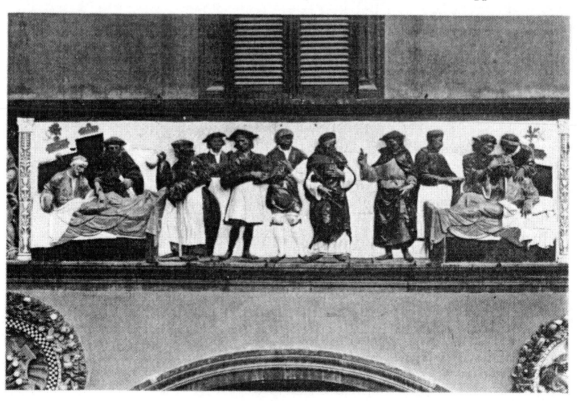

when they are used as models for heathens or exotics; occasionally, as in Mantegna's Camera degli Sposi frescoes, their portraits appear.[22]

A communal necessity, even more important than the hospital, was water. Defensibility, rather than convenience, had often been the chief criteria for the location of Renaissance towns, and to bring in water cities spent large amounts of money and time on the construction of aqueducts and pipes. Necessary for all functions of city life, water was precious, obtained only through careful planning and long, arduous labor.

Water thus brought into the city was piped to fountains located in the various neighborhoods. These fountains were often simple affairs with little or no decoration, just a stone receptacle for the water. But when the fountains were located in important piazzas, the commune, as a matter of civic pride, sometimes spent vast sums on their construction and decoration.[23]

The Fontana Maggiore [164], built in the hill town of Perugia under the supervision of the sculptor Nicola Pisano, demonstrates just how much the commune was willing to spend on a fountain.

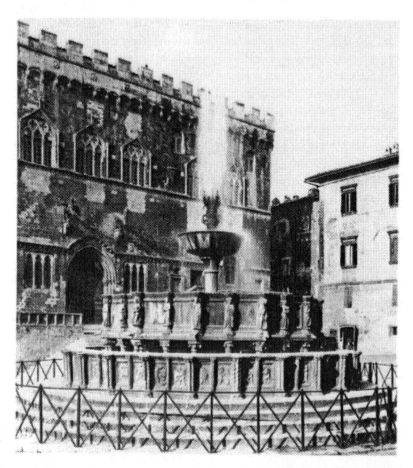

164. Nicola Pisano, Fontana Maggiore, Perugia. Nicola Pisano (active 1258–1278) seems to have been born in Apulia, a region in the south of the Italian peninsula. He carved pulpits in Pisa and Siena, which, along with the Fontana Maggiore, established a new realism and monumentality in the art of Tuscany.

211

Planning for an aqueduct to carry the water from a mountain three miles from Perugia had begun in the 1250s, but the fountain itself was not completed until 1278. A massive structure of two large basins and a third smaller one rising from the center of a column, the fountain is placed in the city's most important piazza, between the town hall and the cathedral.

The sculptural decoration of the fountain is both complex and learned. For instance, the upper basin is decorated with stone reliefs symbolizing nearby cities and Lake Trasimeno (a large lake near Perugia), saints, Old Testament figures, and a likeness of Ernano di Sasseferrato, the Perugian Capitano del Popolo when the fountain was built.

On the lowest basin the decoration is equally complex. Here are, among others, the Labors of the Months (some of them the most charming sculptures of the entire thirteenth century); the Liberal Arts; the Fall and Expulsion from Paradise; and David and Goliath.

Today the intricate program of the fountain is obscure, its richly woven iconography undecipherable. We have lost much of the learning that informs the carved symbols; but to the thirteenth-century citizen of Perugia or to the visitor, the scenes decorating the massive fountain glorified Perugia and testified to its wealth, power, and learning. Like the town hall or the statues in the piazzas, the fountain was both a functional object and a civic symbol.

Together the citizens had planned, built, decorated, and paid for the aqueducts, pipes, and basins that brought the precious water to the piazzas of their city, and the fountain stood as a monument to their efforts. This pride and the sense of overcoming major obstacles was also evident in Siena, when the graceful Fonte Gaia [165] by the native sculptor Jacopo della Quercia was completed in 1419 after years of sporadic work.

Quercia's Fonte Gaia, which was built on the site of an earlier fountain, was located in the Campo, the city's major civic piazza. The present fountain is a copy of Quercia's, which now exists only in fragments. Directly across from the town hall, it was one of Siena's most visible civic monuments and a major source of water for the hill town.

The Fonte Gaia consisted of one long rectangular unit, decorated with niches filled by reliefs. Two shorter diagonal wings, similarly decorated, projected from the ends of the rectangular block. The wings and the main rectangular unit enclosed a basin that held the water. Such a shape was obviously designed to make

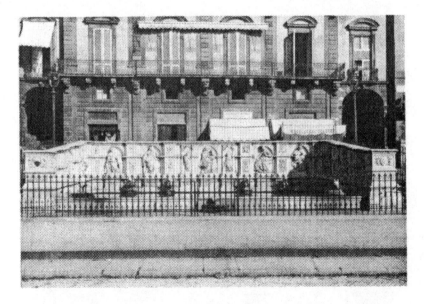

165. Jacopo della Quercia, Fonte Gaia, Campo, Siena. By the nineteenth century, the soft stone of Jacopo della Quercia's Fonte Gaia was in a state of advanced decrepitude. What remained was taken into the Palazzo Pubblico, and a copy of the fountain, illustrated here, was commissioned.

a near-perfect response to the fan-shaped Campo. This was a quiet fountain, agitated only when the wind rippled the water stored in the basin.

There were many fountains in Siena, some of them housed in loggia-like buildings; but none had the pictorial program of the Fonte Gaia. Decorated with the Creation of Adam, the Expulsion of Adam and Eve, and two fully round statues which stood on the wings, the fountain was a major work of art.

Like the decoration on the fountain of Perugia, the reliefs and statues of the Fonte Gaia each had reference to the city. For instance, the Acca Larentia and the Rea Silvia on the wings were important personages in the Sienese mythology of the foundation of their city during Roman times. These figures, like all the images on the Fonte Gaia and the Fontana Maggiore in Perugia, were part of a learned overall scheme planned by a scholar or cleric to glorify the city.

During the fifteenth century the size of the fountain remained relatively small, but the 1500s witnessed an increase in the size and complexity of the type. In Florence, for instance, about 1575 a large fountain [166] was completed whose decoration revolved around a gigantic marble figure of Neptune. Made of white marble and carved by the Florentine sculptor Bartolomeo Ammanati, this huge figure competes in scale with the other large statues that stand near it in the Piazza della Signoria.

In fact, Ammanati, working with a colossal block damaged by another sculptor, made the Neptune (or *Biancone,* "big white man," as the figure is called by the Florentines) disproportionately

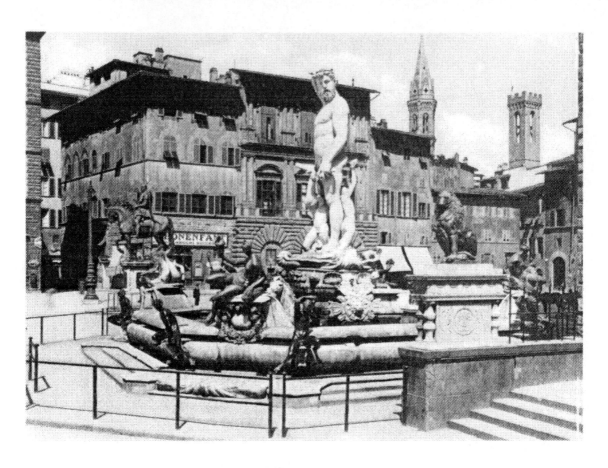

166. Bartolomeo Ammanati, Neptune Fountain, Piazza della Signoria, Florence. Bartolomeo Ammanati (1511–1592) was born in Settignano, a small town near Florence. Probably trained in Pisa, he worked in Venice, Florence, and Rome. He was a noteworthy architect as well as a sculptor and designed the famous Ponte Santa Trinita in Florence (1567–1570).

large for the attendant bronze figures of fauns, marine gods, and satyrs arranged around the fountain's basin.

Even with the seventy or so jets that originally spewed water into the basin, Ammanati's creation was more a huge, complex, freestanding sculpture than a fountain. In a way, the fountain was an excuse for another sculpture, like Cellini's *Perseus,* which embodied the power and glory of Florence and its Medici rulers. The connection between fountain decoration and civic iconography stretches back to the earliest examples, such as the Fontana Maggiore in Perugia.

Cosimo de' Medici, the great duke, had dreams of making Florence a sea power and was at the time building a fleet of galleys. The Emperor Charles V had given Cosimo a port at Portoferraio, which was rapidly developing into an important naval stronghold. Ammanati's fountain, with its colossal figure of Neptune, its marine demigods, and its splashing water, must have been seen as a paean to Cosimo's dreams of naval power, just as *Perseus* by Cellini was viewed as a symbol of Medici might.

214

The Neptune Fountain has a physical purpose: to bring water into the Florentine Piazza della Signoria. But the fountain was also an object of civic concern and pride; its symbols and decoration were a reflection not only of its function but also of the ideals and ambitions of those who paid for it. Much the same is true for all the objects made by artists for the civic world. These things had to be useful, skillfully carved, and well painted, but they also had to be meaningful.

A vast network of communal and governmental organizations ordered life in the Renaissance city. Each owned certain necessary painted and carved objects, which had evolved their own distinct iconographies and meanings. Although functional, these objects were also symbolic of the organization and its purpose. They were, of course, very much more than works of art in our sense of the word, although this is how they are seen today. Instead, from the large narrative fresco for a hospital to the simplest banner for a confraternity, these objects were part of a vital communal structure that touched the lives of every citizen. Beauty and dignity graced the rooms these objects decorated and the rituals in which they were used; many also expressed the communal and civic nature of the organization that had commissioned them. Only toward the end of our period was this communal nature, in at least some places in the Italian peninsula, replaced by monuments like the Neptune Fountain, where the ambitions of a single powerful ruler dominate. Yet, for the most part, Renaissance life, even Renaissance life under a prince, was highly corporate. And it is this complex, subtle aspect of Renaissance society that is still mirrored in many of the Renaissance works that have come down to us.

IV
RENAISSANCE IMAGES
AND IDEALS

Liturgical, moral, decorative, political, dynastic—art was one of the chief conduits of the dreams and realities of the men and women of the Renaissance. It expressed individual ideals and expectations, it shaped public identities, it educated and instructed citizens, and, on occasion, it even performed miracles.

The Renaissance artist was an image maker in every sense: he both expressed and created the consciousness of society in his work. Nowhere can this be seen more clearly than in the art of portraiture. Beyond the individual and his or her appearance and position in Renaissance society, we can, from depictions of ancient and modern history and from representations of contemporary places and events, discover something about how the society of the Renaissance saw itself and how it viewed the past and the future.

The portrait was one of the most widespread and important types in the Renaissance.[1] Virtually extinguished in the long centuries after the fall of the Roman Empire, its renascence began in the early years of the fourteenth century, when historical and contemporary figures were represented with some frequency. These were not actual portraits of the individual's face, but rather depictions of types: old, middle-aged, handsome, ugly, and so forth, much in the way the saints were represented as stock characters. So, for example, Simone Martini's *Guidoriccio* is the representation of a type—a middle-aged soldier of fortune—rather than an accurate reproduction of the body and face of the individual.

This convention of portraiture started to change about the middle of the fifteenth century, when artists began to approximate the face of the sitter. Often idealized and usually highly schematized, nevertheless these early portraits strove to record the actual face. Of course, this was not the first time in the history of European art that realistic or quasi-realistic portraiture appeared. The Romans were fascinated with the face, as the hundreds of surviving portrait busts of Roman men and women, some of them unflinchingly realistic, demonstrate.[2]

The reemergence of the realistic portrait had many impetuses. Certainly, it had much to do with a new awareness of the worth and uniqueness of the individual and a desire to leave a record of one's likeness. Little is known about the function of many of the early portraits, other than the fact that they were displayed in the home, but they often must have had a memorial purpose. Many of the portraits appear to have been painted after the sitter died, but even those done while he or she was alive must have been intended mainly to preserve the likeness of the person after his or her death. The early Renaissance believed intensely in the magic power of images; such portraits were thought to capture some of the spirit of the sitter.

A portrait [167] of a young man, now in Chambéry, attributed to Paolo Uccello and probably painted about 1450, exhibits many

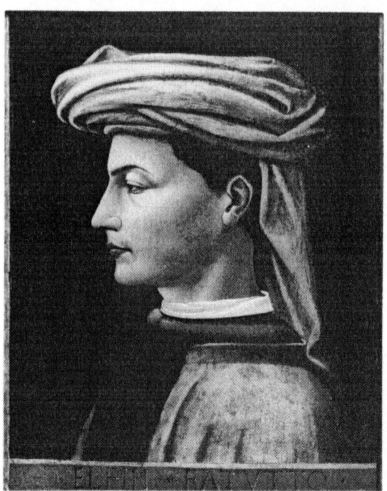

167. Attributed to Paolo Uccello, *Portrait of a Young Man*, Musée Benoit-Molin, Chambéry. The memorial nature of this portrait is indicated by the inscription running across the parapet: EL FIN FATVTTO (death takes all). Such an inscription is unique on Italian portraits, but it may have been influenced by northern examples of the type.

of the characteristics of the early portrait type. Perhaps the most conspicuous feature of this portrait is its strict profile, used by the artist to make a pattern of the outlines of the face, turban, and tunic. The artist delighted in these abstract shapes and was, in fact, more interested in them than in a realistic portrayal of the young man's face. No doubt we would recognize the man from his portrait if we met him on the street, but much of the stereotypical, formulaic qualities of the earlier, nonrealistic types remain.

In fact, the Chambéry portrait gives us only the barest essentials of the man it portrays. If one compares it to a Flemish portrait of the same period that presents the sitter full face, a striking difference between the two is evident at once.[3] A northern portrait intimates the sitter's mood and something of his personality and the way his mind works, often in a highly detailed, resolutely realistic representation. The early Florentine portraits, instead, are more like anthropomorphic coats of arms; they are images of the sitter's face and clothes reduced to their most essential qualities. They tell us what the sitter looked like, how he dressed, and, from the clothes and the occasional inscription, something about his social station. The strict profile prevents us from meeting the sitter face to face and, consequently, from learning much about him as a person.

In many cases, the strong emphasis on form produces portraits of extraordinary, almost abstract beauty. In Domenico Ghirlandaio's portrait of Giovanna degli Albizzi [168], painted about 1490, the shape made by the face functions in the same way as the pattern on the costly dress or the severe rectangle of the window. Once again, we would recognize the face; but we would have little clue as to what this lovely young woman was like.

Much of the aloofness we so strongly sense in this superb portrait comes from the artist's keen understanding of its memorial function. In 1488, Giovanna died in childbirth; Ghirlandaio's portrait of her, taken from a similar image in a fresco cycle he did in the Florentine church of Santa Maria Novella about 1490, is posthumous. The inscription behind Giovanna reads "O art, if you were able to depict the conduct and the soul, no lovelier painting would exist on earth," and it is dated 1488, the year of her death.

Certainly, then, this is a memorial portrait, a splendid visual record of the essential features of the commemorated woman. It must have been valued for its beauty, but its major function was as an object preserving something of Giovanna's appearance for future generations, a fragment of immortality.

During the second half of the fifteenth century, an important change in portraiture took place. The face of the sitter turned from a strict profile to a three-quarter or a full face. This development took place slowly and sporadically, but it is seen in many examples of the type. Apart from its formal implications, the shift from profile to three-quarter or full face marks a dramatic change in the meaning and purpose of the portrait.

The new positions of the sitters bring them closer to the viewer; they begin to make eye contact with those who look at them. A new and more personal relation is achieved as the spectator begins to glimpse the personality and mood of the painted person. The history of the portrait, both painted and carved, from mid-century onward is, generally speaking, one of increasing contact between the sitter and viewer, and the emotions and personality of the sitter are often keenly felt.

The developments in painted portraiture can be traced in sculpture as well. The carved stone portrait became increasingly popular after the middle of the fifteenth century. Such portraits had not been made in the Italian peninsula since late-Roman times, and, in fact, their revival may have been partially motivated by the Renaissance passion for the antique. In imitation of the Romans, who revered portraits of their ancestors, Renaissance citizens from bankers to popes commissioned sculptors to carve likenesses of themselves and their relatives.

The bust [169] of Battista Sforza, duchess of Urbino, by Francesco Laurana, is a three-dimensional translation of the spirit and aesthetic of the early painted profile portraits. The same highly stylized, almost obsessive rendition of flesh into shape is seen in many of the carved busts from the second half of the fifteenth century.[4]

But Laurana's bust is much more than an elegant form. It is the transformation of a mortal being into an icon. Like the tragic Giovanna in Ghirlandaio's painted portrait, Battista Sforza is a beautiful but remote image. The perfection of her highly abstracted and delicately carved face, with its nearly pictographic features, gives her a serene, almost mystical, otherworldly beauty. This is a memorial to the spirit rather than to the flesh. In fact, it was carved about 1475, after the sitter's death: Laurana probably based his image on a painting by Piero della Francesca, which is discussed below.

Laurana's image of Battista Sforza almost certainly came from a painted portrait; but other artists used death masks to create

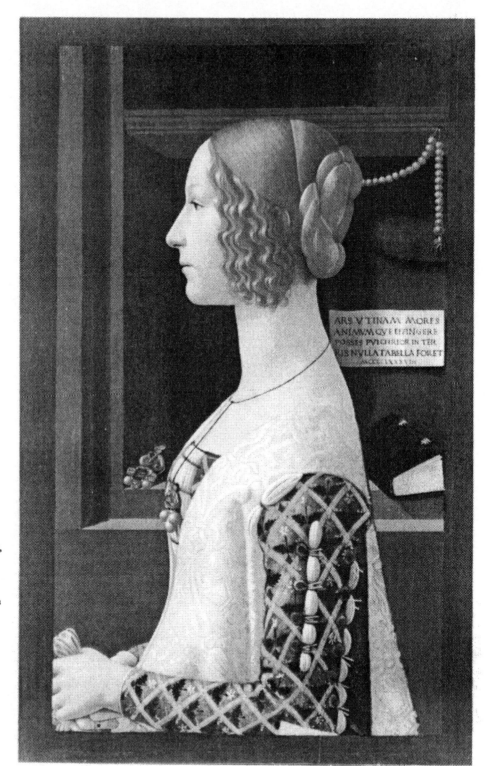

168. Domenico Ghirlandaio,
Giovanna degli Albizzi.
Thyssen-Bornemisza
Collection, Castagnola.
Giovanna degli Albizzi was a
member of a powerful and
prominent Florentine family.
She married Lorenzo
Tornabuoni in 1486.
Lorenzo's father
commissioned an extensive
fresco cycle in his chapel in
Santa Maria Novella from
Domenico Ghirlandaio; the
image seen in this portrait
first appeared in a fresco
here.

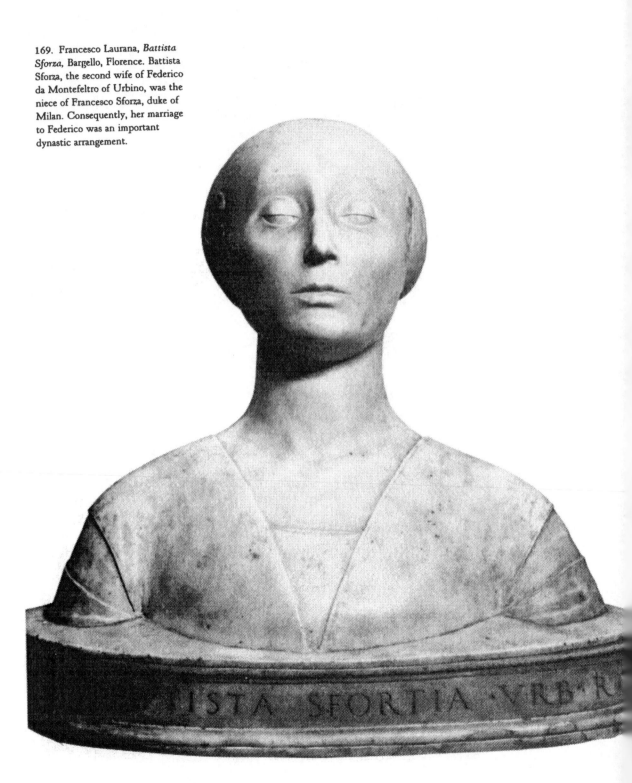

169. Francesco Laurana, *Battista
Sforza*, Bargello, Florence. Battista
Sforza, the second wife of Federico
da Montefeltro of Urbino, was the
niece of Francesco Sforza, duke of
Milan. Consequently, her marriage
to Federico was an important
dynastic arrangement.

memorial images. Death (and life) masks were cast directly from the face by applying a coat of plaster over the skin. Such masks were made with some frequency in the Renaissance, and their existence testifies to the same sort of memorializing impulse that lies behind the carved and painted portrait. It is not known if these masks were displayed; however, many of them may have been made to serve as models for later painting and sculpture.[5]

Regardless of its abstraction and formal refinement, the bust of Battista Sforza confronts the viewer face to face and assumes therefore a different relation with him than does the profile portrait; it is this face-to-face, eye-to-eye confrontation that also begins to appear in painted portraiture about 1450.

A noteworthy example of the painted three-quarter view is Botticelli's *Man Holding a Medal* [170] of about 1475. In a radical

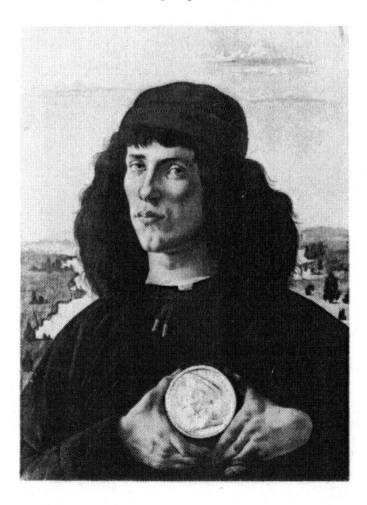

170. Botticelli, *Man Holding a Medal*, Uffizi, Florence. The medal the man holds is a gilded stucco cast of a Florentine bronze medal of Cosimo de' Medici made about 1470. Who the man is and why he holds that particular medal remain unknown.

departure from the earlier, strict profile type—a type found in the artist's own work—the sitter turns to face us, his body parallel to ours, his face drawn to our glance. At once, a dialogue is begun. Likeness becomes persona; form is infused with mood and personality; we look for—and find—clues and associations impossible in the distant profiles of the lovely faces discussed above. A psychological tension is set up between us and the wonderfully asymmetrical face that looks out at us from Botticelli's picture.

Also to be noted in this haunting portrait is the background, with its distant view of placid water and landscape. High above this view, the sitter seems as though he were standing on a parapet or a mountainside. This device, common to many portraits of the fifteenth century, allows us to focus on the sitter at very close range, yet also to be diverted by the distant views of landscape and cloud-streaked sky.

An even more direct contact between sitter and observer is made by the youth in Botticelli's famous portrait [171] from about

171. Botticelli, *Portrait of a Youth*, National Gallery, London. Botticelli and his shop made dozens of portraits. While varied in length, pose, and background, each seems to depict the sitter in a muted, pensive mood; they remain among the most introspective of Florentine portraits.

1480, now in the National Gallery in London. We meet the boy face to face; no space is projected between him and the picture plane. No landscape or vista relieves the encounter: all our attention is turned upon the boy, who looks back, unruffled, only mildly curious. The large liquid eyes, strong jaw, and cascading brown hair form an attractive but enigmatic image, its secrets just beyond our grasp.

This same closeness between sitter and viewer is found in a number of contemporary portrait busts. Antonio Rossellino's portrait (dated 1468) of the poet Matteo Palmieri, while probably based on a Roman type, speaks to the observer in a clear and frank way [172]. Originally placed over a doorway in Palmieri's house in Florence, it tells us something about the poet's personality. A welcoming openness and warmth suffuse the face. The nose, lips, and curly hair could only belong to Palmieri. The remoteness of the earlier, more idealized portrait is gone, and the viewer begins to feel that he knows something about the sitter.

We have seen this evolution before. During the second half

172. Antonio Rossellino, *Matteo Palmieri*, Bargello, Florence. The Florentine Matteo Palmieri (1406–1475) was a poet and a historian. His most famous work, *Della vita civile*, was an important precursor of Castiglione's *Courtier*.

of the fifteenth century, portraits changed from remote, static rep-
resentations—the worldly equivalent of icons—to expressions of
particular living presences. If the message given by the earlier por-
traits was "here is what I looked like," that of mid-century might
be said to be "here is what I am." And, if the earliest portraits
were made to preserve a likeness, these later ones were intended
to preserve a personality as well.

Like the bust of Matteo Palmieri, many portraits must have
been set over doorways in imitation of the ancient Roman custom,
which the Renaissance knew from classical texts. Most of the
others must have been placed in the home, but where and for what
audience we do not know.

Thus far we have discussed the portrait as a memorial type,
but there were, in fact, many other functions of Renaissance por-
traiture. Occasionally the boundary between these types is blurred
by individual examples, especially those by the great original mas-
ters; nevertheless, each of the subtypes had its own history, de-
velopment, and function.

Portraiture was not limited to the depiction of a single sitter;
there were double portraits and group portraits of considerable size
and complexity. Portraits also had many different functions: they
could memorialize or propagandize, they could celebrate a betrothal,
or they could, toward the end of our period, simply be works of
art meant to be collected and treasured for their formal properties.

The portrait of the ruler was a necessary and widespread
Renaissance type. It was vital that the ruler's image be known
throughout his territory, for this likeness carried with it an iconic
power, much in the way the images of ancient emperors on coins
had a supernatural majesty.

Many Renaissance artists found employment in the smaller
courts of the Italian peninsula. The dukes and other nobility of
these courts were eager to use art for propaganda and status. The
more splendid their court, the more works of art, the wealthier
and more majestic they would appear.[6]

Portraits of rulers sometimes appear in fresco, either inserted
in larger religious narratives or by themselves. An example of the
latter is Piero della Francesca's fresco [173] of the duke of Rimini,
Sigismondo Malatesta. This is a notable example of the ruler por-
trait, even if its propagandistic and self-aggrandizing properties are
strained to their limits.

Painted in 1451 for the church of San Francesco in Rimini,
a church closely associated with its patron, Sigismondo Malatesta,

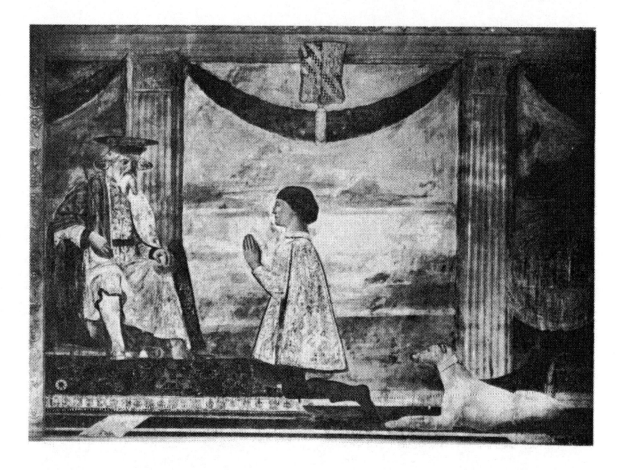

the fresco depicts the duke kneeling before his patron saint, Sigismund. Surprisingly, the principal protagonist is not, as one would expect, the saint, but rather the duke. Kneeling close to the picture plane, Sigismondo occupies the central area of the fresco; he, and not the saint, is the pivot around which the painting revolves.

Saint Sigismund is pushed back into the left corner of the fresco, where he sits, accepting the adoration of his namesake. The saint is not much more important than the view of the duke's castle seen through the round window or the splendid hunting dogs who wait for their master. Piero has understood the true purpose of the fresco: to glorify the duke, even if it is at the expense of the saint.

Smaller portraits of rulers also were produced with great frequency during the Renaissance. These portraits, like that of Sigismondo Malatesta, say much about the sitter's self-image and the way he or she wished this image projected to the spectator. Of course, the sitter's wishes had to be interpreted by the painter or sculptor in paint, stone, or bronze. Naturally, all artists added much

173. Piero della Francesca, *Sigismondo Malatesta,* San Francesco, Rimini. Sigismondo Malatesta (1417–1468) became ruler of Rimini in 1432. By 1450 he had begun the rebuilding of the church of San Francesco (the Tempio Malatestiano), with the help of the writer and architect Leon Battista Alberti and the Florentine sculptor Matteo de' Pasti.

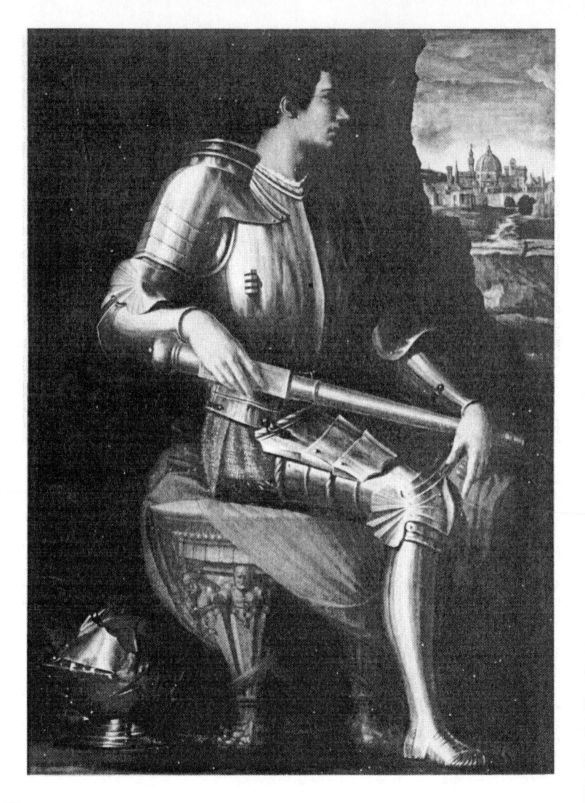

228

of their own personality and ideals to the portrait, so the image becomes a composite of sitter and artist, filtered by the spectator's interpretation.

The intention of many portraits is to present the ruler as a powerful, dominating figure, much the way the equestrian image of the soldier of fortune was conceived. Indeed, some rulers were professional mercenary soldiers.[7] Power radiates from Giorgio Vasari's memorable portrait [174] of Alessandro de' Medici. Alessandro became ruler of Florence after a short-lived republican government had been overthrown by the Medici. From 1529, he was the virtual dictator of the city, where his heavy-handed rule made him a figure of considerable unpopularity: he was assassinated in 1537.

Alessandro had to rely on force to rule Florence. The chilling image by Vasari depicts him in full armor, staring out toward the city of Florence, recognizable by its town hall and cathedral. The hardness and bulk of the armor, the strict profile pose that conceals as much as it reveals of the face, and the dark and menacing cavelike setting combine to create an image of overbearing, indomitable power that both glorifies and intimidates.

When another Medici, Cosimo I, came to power after Alessandro, he was quick to put art in service of his ambition. We have already seen his self-aggrandizing commissions for Cellini's *Perseus* and the Neptune Fountain in the Piazza della Signoria, but he also quickly realized the propagandistic value of the portrait. Many artists painted the duke, but a portrait [175] of 1545 by Bronzino seems to have been especially favored by Cosimo.

Cosimo is depicted in half length, dressed in white armor, resting his hand on a helmet with visor. This portrait is known in many versions, sure proof of its popularity. It is probable that Cosimo commissioned the original and copies from Bronzino and his shop and had them dispatched to those he wished to impress. And, in fact, the portrait is a most impressive work, a brilliant mixture of strength and wily intelligence. Here is Cosimo as soldier, ready to defend his imperative with force, if need be. The glance to the spectator's left avoids direct eye contact, but makes Cosimo seem alert, about to spring into action. Bronzino expressed Cosimo's public persona perfectly, and the image-conscious duke must have been pleased to have such a representation to disseminate.

The same duke also inspired one of the most impressive and memorable sculptural portraits of the Renaissance, the over life-

174. Giorgio Vasari, *Alessandro de' Medici*, Uffizi, Florence. Giorgio Vasari (1511–1574) was a busy painter who executed many commissions for the Medici. However, his fame rests on his *Lives of the Most Excellent Painters, Sculptors, and Architects* (published in 1550 and revised extensively in 1568), an invaluable source of information and attitudes about Renaissance art.

175. Agnolo Bronzino, *Cosimo I,* Uffizi, Florence. Bronzino (1503–1572) was one of the principal mannerist artists of Florence. He executed a number of formal, highly polished portraits of Cosimo I and members of his family and court.

176. Benvenuto Cellini, *Cosimo I,* Bargello, Florence. Cellini began this bust in 1545 and finished it two years later. From 1557 until 1781 it stood above the entrance to the fort built by Cosimo I at Portoferraio on the island of Elba.

sized bronze bust [176] by Benvenuto Cellini. Completed in 1547, it, like Bronzino's portrait, represents Cosimo in armor, although this time the armor is inspired by Roman examples. The influence from the ancient world is not limited to the armor but informs the whole piece, which is much indebted to Roman portrait busts then being rediscovered by sculptors. This association with the venerable Roman past, and, in Cosimo's case, with imperial Rome, certainly must have increased the authority and majesty of Cellini's bronze sculpture.

Yet the real power of Cellini's work arises not from its sitter's costume nor from its association with Roman imperial types, but rather from the almost neurotic energy of the duke's face. The turned head, the taut cords of the neck, the bulging eyes, and the curling beard all imply a personality just barely under control. This is not the placid, content image of the ruler so often seen in the Renaissance, but rather someone full of dark energy and power, a willful and dangerous person. Like the other statues associated with Cosimo (*Perseus,* the Neptune Fountain, and the equestrian

figure of Cosimo), the bust conveys power, majesty, and authority, attributes expected of a ruler.

Power often shared expression with wisdom and magnanimity in ruler portraits, especially when the ruler's power derived from consensus instead of force. This more benevolent countenance is often seen in Venice, which had a long tradition of splendid portraits of the doges, the heads of the government.[8]

Giovanni Bellini's famous portrait [177] of Doge Leonardo Loredan presents the sitter in three-quarter view. The softness and luminosity of the doge's volumetric face, his eyes lost in thought, make an image resonant with humanity. This aging chief of a powerful and far-flung state is wise and benevolent in Bellini's conception.

But Bellini, who painted the portrait in 1503 or 1504, has taken great care not to make the doge too approachable, too familiar. The dignity and majesty of the sitter's office are emphasized by the separation from the viewer's space provided by the stone ledge. There is some confusion about the exact relation of the sitter's

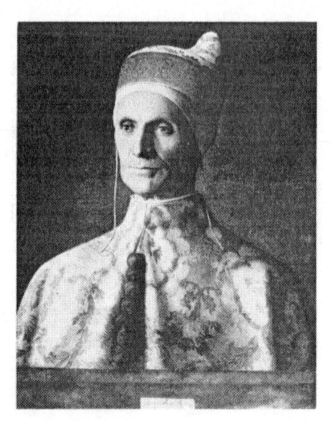

177. Giovanni Bellini, *Doge Leonardo Loredan*, National Gallery, London. Leonardo Loredan (1438–1521) was doge of Venice from 1501 to 1521. The Loredans, an illustrious Venetian family, produced two doges, Leonardo and Pietro.

body to the ledge; one reading of the picture suggests that, like a carved or cast bust-length portrait, the doge's upper torso rests on the stone base instead of behind it. This sculptural feeling helps remove the doge from our realm of reality, as do the gaze and the symmetrical arrangement of body and official robes.

The portrait [178] of Doge Andrea Gritti (probably finished a year or so after the sitter's death in 1538) is a magnificent essay on power and authority by Bellini's great pupil, Titian. Everything about the work, from the swelling forms of the chest and shoulders to the forceful turn of the head, denotes command. The bearded old doge concentrates intensely on something just to the left of the viewer, but Gritti's staring eyes and clenched jaws leave no doubt that he is a man of determination and vigor.

Contrast this portrait of authority with that of the neurotic Cosimo by Cellini. There is much action and drama in both images. In Titian's the large, imposing doge seems to be caught in a frozen moment of time; soon he will release his robe, move forward, and devote his attention to some pressing problem. Cellini's bust is more about psychic action and drama; its outward signs of power and authority are not so obvious, and the force of Cosimo's personality is read through the tensed neck and popping eyes.

Not all images of authority were majestic. The many portraits of Venetian senators by Tintoretto bespeak authority arisen from age and experience. In the *Portrait of an Elderly Senator* [179] from about 1575, Tintoretto has endowed the aged, bearded face with a lifetime's wisdom and knowledge. The magnificent crimson fur-lined robes—so symbolic of authority in Titian's portrait— make a sad, almost ironic, comment on the wizened face and bony hands they cover in Tintoretto's work.

Lost in reverie, the old man seems to move his right hand almost unconsciously. The dulled eyes with their reddened rims and absent gaze hint at oncoming senility. Here is a complex picture that at once elicits our sympathy and our respect for the enfeebled old man. Very different from the more bravura treatment of Titian, it allows us much closer to this ancient figure of authority.

Like secular rulers, the great ecclesiastical figures of the Renaissance sat for many portraits. Among the most remarkable of these pictures and sculptures are the images of the popes. With some notable exceptions, images of the pontiff before the mid-fifteenth century are schematic representations rather than portraits. However, during the last years of the fifteenth century, the papal portrait became more sophisticated and profound.

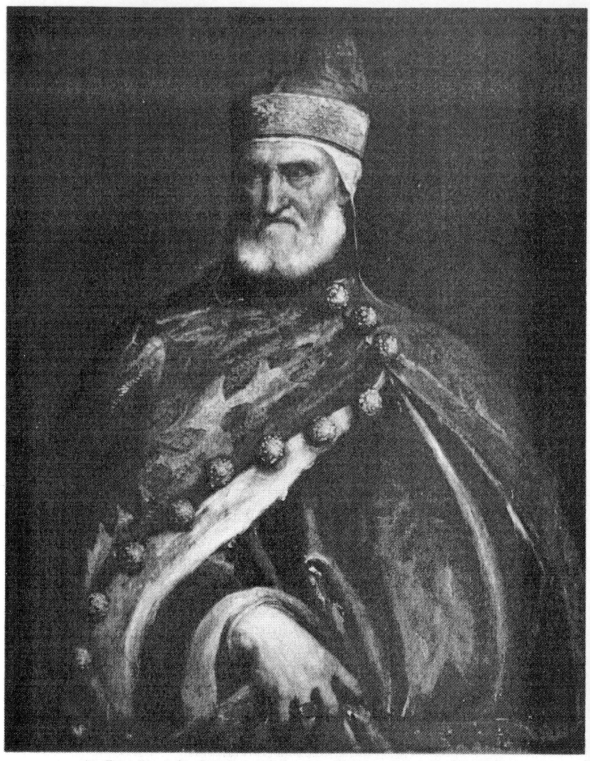

178. Titian, *Doge Andrea Gritti*, National Gallery of Art, Washington, D.C. Andrea Gritti (1455–1538) began as a merchant, but soon became a renowned military expert and commander. He was doge of Venice from 1532 until 1538.

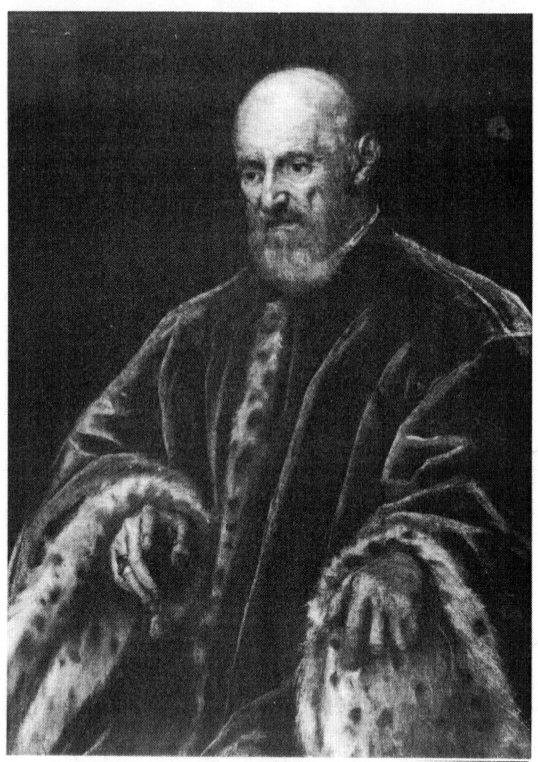

179. Tintoretto, *Portrait of an Elderly Senator,* National Gallery of Ireland, Dublin. Tintoretto was a superb painter of the aged. His many dignified portraits of elderly senators, generals, and other ancient worthies introduced a new and poignant note into Venetian painting of the sixteenth century.

The grandeur of the pope and the nature of his accomplishments are central themes of a fresco [180] by Melozzo da Forlì, now in the Vatican. Done about 1470, this fresco depicts Sixtus IV in his splendid library. In front of marble columns and below an elaborately coffered and carved ceiling, the old pontiff sits surrounded by scholars and prelates, including the future Julius II. Magnificence, power, wealth, learning, and wisdom, all the attributes of the perfect image of a pope, are expressed.

Melozzo's portrait is also very secular; it emphasizes the worldly splendor rather than the religious and spiritual authority of the pope. A rotund Sixtus sits amidst a group of other men, all of them portraits, none idealized. Like many a princely portrait, the accoutrements of the pope's position and not the condition of his soul are stressed.

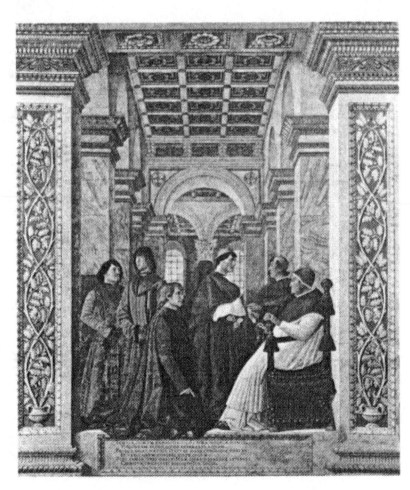

180. Melozzo da Forlì, *Inauguration of the Library of Sixtus IV*, Pinacoteca, Vatican City. Melozzo da Forlì (1438–1496) was probably a pupil of Piero della Francesca. In this fresco he has introduced accurate portraits not only of the pope and Giuliano della Rovere (the future Julius II) but also of several other notables of Sixtus's Roman circle.

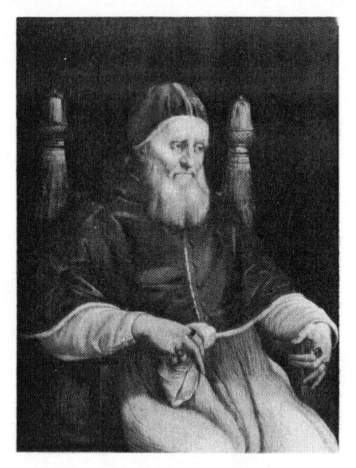

181. Raphael, *Pope Julius II*, Uffizi, Florence. Nephew of Sixtus IV, Julius II (1443–1513) was a great administrator and patron. He commissioned works from Raphael, enriched the Vatican library, got Michelangelo to paint the Sistine ceiling, and began the new St. Peter's.

A very different attitude appears in the well-known portrait [181] of about 1512 by Raphael and his shop, now in the Uffizi. Here the pope, Julius II, is brought up to the picture plane but at an angle to it. We are close to the pope, but the diagonal placement and the three-quarter view of the face do not encourage a visual dialogue between spectator and sitter.

Unlike the fresco by Melozzo, the pope's setting tells us nothing. His chair emerges from the darkness of the background. All attention is concentrated on the sympathetic portrait of the introspective old man. Except for the ecclesiastical robes and hat, there are no signs of the pope's sanctity or his power. Instead, there is an aged man lost in thought, unaware of his own surroundings or our presence. This portrait is the direct forerunner of the portrait of the Venetian senator by Tintoretto, discussed above. Raphael's portrayal of the psychological nature of the pope, rather than of his station, revolutionized the papal portrait and influenced the way old age was depicted for generations.

About five years after his painting of Pope Julius, Raphael

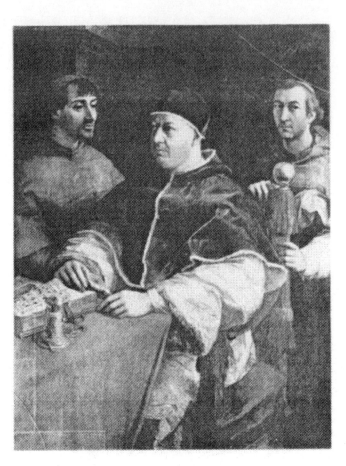

182. Raphael, *Pope Leo X,* Uffizi, Florence. Leo X (1475–1521), the son of Lorenzo de' Medici, did much to restore Rome and make it a great Renaissance city. He, like his predecessor, Julius II, was a generous and knowledgeable patron.

painted a portrait [182] of another pope, Leo X. This painting, of about 1517, also contains likenesses of the cardinals Giulio de' Medici and Luigi de' Rossi, the pope's nephews. The group, or multiple, portrait was known before the sixteenth century, but it did not have the importance that it later assumed. As is clear from Raphael's painting, the complexities of portraying more than one likeness and of weaving the various likenesses together were considerable.

Raphael has underlined the pope's importance by making him the largest figure and by placing him closest to the viewer; moreover, Leo's substantial form overlaps the smaller figures behind him. All three figures emerge from the darkness of a room whose limits are partially demarcated by the architectural molding seen in the upper left, but the major focus is on the seated pontiff, whose hands rest on a table holding a sumptuous book and a bell.

This portrait is far from idealized. The pope's corpulent body molds an expanse of drapery, and his fleshy, sensual face suggests interests that are more profane than sacred. Also unidealized are

the two cardinals, especially the dark Giulio de' Medici, who was to be pope Clement VII.

Each figure in the painting seems to be posing for Raphael's brush, oblivious of the other. In fact, Raphael probably drew each of the sitters separately and then combined his sketches for the final group portrait. The figures are wonderfully knit together, but the drama of the picture lies in their individuality, not in their interactions.

A much different papal group portrait [183] was done by Titian in 1546, about thirty years after Raphael's *Leo X*. This unfinished picture depicts Pope Paul III and his grandsons in the interior of a large room. Probably indebted to Raphael's *Leo X* for the pope's placement and the position of the two lateral figures, Titian's great picture is an insightful essay on the uneasy relation between the pope and his progeny.

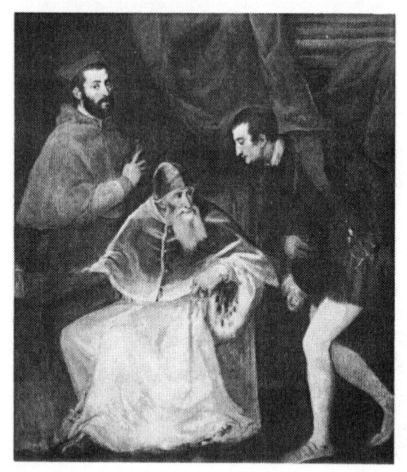

183. Titian, *Pope Paul III and Grandsons*, Capodimonte, Naples. The bowing Ottavio Farnese was the husband of Margaret of Austria, a natural daughter of Charles V and the widow of Alessandro de' Medici. The cardinal, Alessandro Farnese, was a famous churchman and a founder of the Jesuits.

184. Piero della Francesca, *Battista Sforza, Duchess of Urbino,* Uffizi, Florence.

185. Piero della Francesca, *Federico da Montefeltro, Duke of Urbino,* Uffizi, Florence. Federico da Montefeltro (1422–1482) was signore of Urbino until 1474, when he was created a duke. An able soldier and benevolent ruler, he was a patron of Piero della Francesca, Francesco Laurana, and other talented artists, who enriched his court and city.

Withered, bent, but still crafty, the pope is the object of the fawning attention of his grandsons, especially the unctious courtier bowing at the right. Posture and position masterfully explicate the psychological tension of the meeting. Titian has turned the group portrait into a silent drama enacted before the viewer's eyes: three portraits that distill three personalities are integrated into a compelling narrative. The crackling action of Titian's painting is very far from the self-contained and muted portrait of Leo X by Raphael.

A wide variety of sitters was portrayed in the group format. One of the earliest examples of the type is the double portrait [184 and 185] of the duke and duchess of Urbino by Piero della Francesca, done about the middle of the fifteenth century. Painted on two separate panels, the figures are united by glance, by size, and by a continuous landscape background glimpsed below them in the distance. Although both figures are the strict profiles of the early portrait type, there are many harbingers of the future in the painting. The atmospheric panorama (which not only ties the figures together but also suggests the vastness of their domains) and

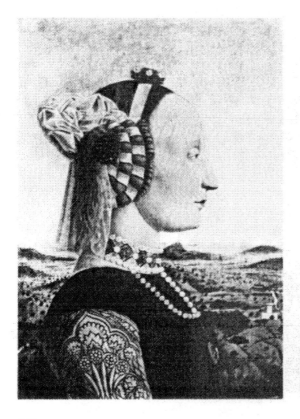

the elevation of the sitters became important conventions in later portraiture. For example, Leonardo's *Mona Lisa* contains many of the same elements noted in Piero's painting.

Piero did not strive for the subtle and unfathomable expression of *Mona Lisa* in his portraits of the duke and duchess. His portraits are figural emblems: at a glance they convey the exalted station of the sitters and something of their dignity and serenity.

On the back of these portraits Piero painted two scenes of triumphal processions [186 and 187]. The Triumph of an allegorical figure, a Virtue or a Vice, was a common Renaissance subject, found both in the visual arts and in literature.[9] Springing from antiquity and the prose of Petrarch, the Triumph allowed the reader or viewer to visualize clearly the great human themes of love, fidelity, chastity, and so forth.

In Piero's Triumphs the principal figures are the duke and duchess themselves. Drawn in processional chariots (standard fix-tures of the triumphal procession), they are surrounded by Virtues, who give concrete proof of the sitters' goodness. The two inscrip-

186. Piero della Francesca, *Triumph of the Duke of Urbino*, Uffizi, Florence. The inscriptions tout Federico as equal to the greatest generals and describe his wife Battista as one who was modest in success and honored by the deeds of her triumphant husband.

187. Piero della Francesca, *Triumph of the Duchess of Urbino*, Uffizi, Florence.

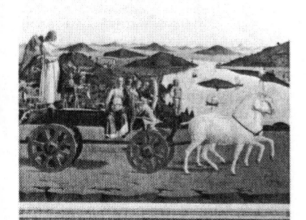

CLARVS INSIGNI VEHITVR TRIVMPHO ·
QVEM PAREM SVMMIS DVCIBVS PERHENNIS ·
FAMA VIRTVTVM CELEBRAT DECENTER ·
SCEPTRA TENENTEM ·

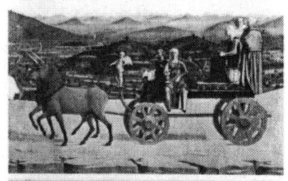

QVE MODVM REBVS TENVIT SECVNDIS ·
CONIVGIS MAGNI DECORATA RERVM ·
LAVDE GESTARVM VOLITAT PER ORA ·
CVNCTA VIRORVM ·

tions laud the great and moderate nature of the sitters, and both emphasize the considerable accomplishments of the duke. Federico is crowned by a figure of Victory, and his wife's chariot is pulled by unicorns, symbols of chastity, a virtue much admired in Renaissance women.

The double-faced construction of Piero's portraits is medallic in nature; it presents an obverse and a reverse, with the sitter's bust-length profile on the front and a narrative or scene on the back. A number of Renaissance medals, usually of bronze, are similar in their imagery, and some of them may well be indebted to Piero's painting. The medal became a popular type in the second half of the fifteenth century and was often used to present and popularize the images of famous men and women.[10]

Not all of the double portraits were of royal or aristocratic sitters; a small number of double portraits of men and women exist that were probably painted to commemorate betrothals or weddings. An early example [188] of this type, now in the Metropolitan Museum of Art, is convincingly attributed to the Florentine artist Fra Filippo Lippi, who probably painted it about 1440.

Lippi's work shares certain elements with Piero's contemporaneous portrait of the duke and duchess of Urbino: the strict profile, the opposition of the two faces, and the view of a landscape seen from above. But these components in Lippi's picture appear in an almost totally different context. Here the scene occurs within a ground-floor room of a palace ornamented with stone window moldings and a coffered ceiling. Palace, clothes, jewels all bespeak the sitters' status. The woman's sumptuous dress, with its pleated midriff and voluminous embroidered sleeves, the large jewel-encrusted brooch, and the pearl necklace were objects of conspicuous consumption. Pearls were a symbol of purity and wealth, and the crowning glory of the woman's costume, the pearl-bordered peaked cap with its elaborate train, sets off her high, rounded forehead (already emphasized by the mid-fifteenth-century fashion for shaving the hair well up the forehead).

Facing the woman is a young man wearing the same type of hat worn by the duke of Urbino. He leans on the windowsill, his hands making a gesture whose exact meaning has been lost, his eyes gazing up at the woman with an expression we cannot fathom.[11] As with the duke and duchess of Urbino, the psyches of these sitters remain unexplored. Rather, they are icons of fashion and wealth; in fact, they are a little like the coat of arms that rests below the man's hands: emblems of family and station.

188. Fra Filippo Lippi, *Double Portrait*, The Metropolitan Museum of Art, New York. The identities of the sitters are unknown, but the arms are those of the Scolari family. It may be that this double portrait is a pictorial record of a betrothal or a wedding.

A glimpse of a cityscape seen through the window—a tree-lined street, a walled building, and, in the far distance, homes and other edifices that make up a Renaissance city—tells us the sitters are town dwellers. While the panoramic vista of Piero's painting signified the station and dominion of the sitters, Lippi's civilized landscape simply offers information about the environment in which his subjects lived.

The tradition of the betrothal or marriage portrait was still alive a century after Lippi's painting, as is demonstrated by a picture by the enigmatic Venetian artist Lorenzo Lotto. In his double portrait (1523) of Messer Marsilio and his betrothed [189], Lotto poses both sitters nearly full face, looking out toward the viewer.

189. Lorenzo Lotto, *Betrothal Portrait*, Prado, Madrid. The yoke and the ring are both symbols of the couple's betrothal and marriage vows. Messer Marsilio was from Bergamo, a northern city under Venetian sway, where Lotto executed a number of noteworthy paintings.

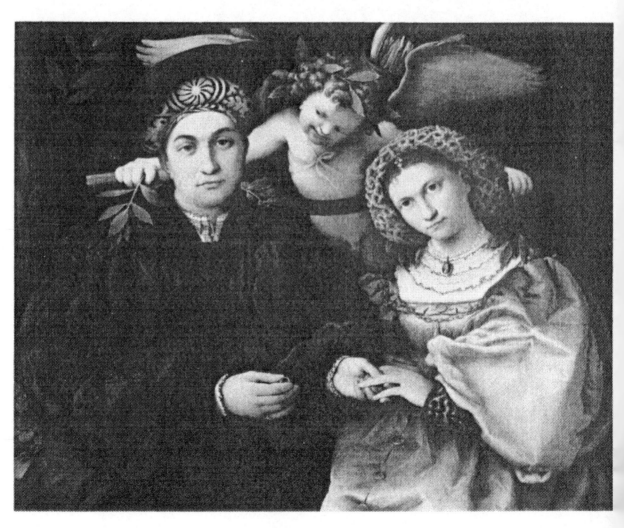

The young man and woman are united physically and spiritually by the figure of Cupid, who places a yoke around their necks. The two large bodies, which fill the picture's space, and the intertwining of both hands and yoke are the formal equivalents of the binding vows being taken by the sitters.[12]

But the picture is more than a record of the sitters' vows, for all three protagonists make direct contact with the viewer, but not with each other. The least revealing face belongs to the woman, who looks lost in thought. Messer Marsilio's face is tinged with melancholy, typical of many of Lotto's male sitters. By far the most animated expression belongs to Cupid, who slyly turns his smirking glance to the man, as if to suggest that something much more than vows is involved here. The contrast among the three faces, so close, yet so isolated, gives the picture a tension that turns it into subtle drama.

Lotto also painted a number of family pictures. The family portrait, resembling in many respects the formal family photograph of today, thrived in northern Italy in the sixteenth century. Several earlier non-Venetian examples of the type exist, but its highest development was reached in and around Venice. Family portraiture also appears in sacred narrative frescoes and in altarpieces through-out the Italian peninsula. Placed in these pictures are highly realistic portraits of the donors, their families, and their friends. Often these donors are of the same scale and almost the same importance as the sacred figures.

In Lotto's *Giovanni della Volta and Family* of about 1547 [190], we see the family around the table. All the facts—age, physical type, dress (of the latest fashion), and location—are set down for our scrutiny. But this picture is more than just the sum of its factual notations, for it emits a mood that tells us much about how Lotto saw this family. The beautiful but bleak view, with a lowering sky, seen through the window placed between the heads of the adults; the lack of psychological contact among the family members; and the wary, sad faces of the husband and wife all create an inescapable sense of loneliness and loss. The work is alive with subtle psychological suggestions, which the onlooker em-broiders with his own experience and imagination.

There are also many portraits of various members of a family: two sisters and a brother, a mother and children, a father and his son or daughter. Uncles, aunts, and grandparents were also por-trayed with children.

The painting [191] by Ghirlandaio of about 1480 now in the

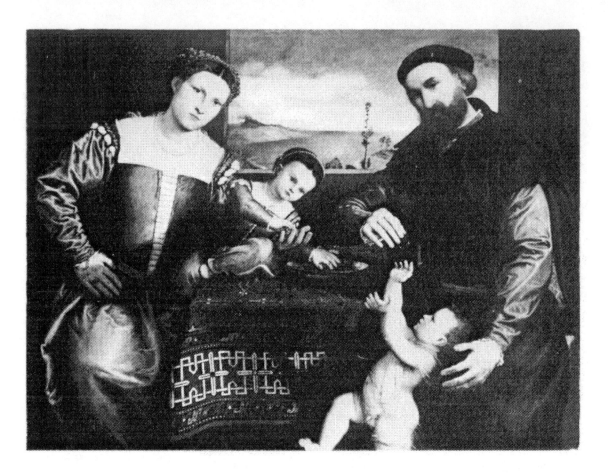

190. Lorenzo Lotto, *Giovanni della Volta and Family*, National Gallery, London. Giovanni della Volta was Lotto's landlord in Venice. This painting seems to be the one mentioned in the painter's account book in September 1547.

191. Domenico Ghirlandaio, *Portrait of an Old Man and a Boy*, Louvre, Paris. The portrait of the old man seems to be based on a drawing of the face of a corpse made by Ghirlandaio. In both images the man suffers from rhinophyma.

Louvre is sometimes called *Portrait of a Grandfather with His Grandson*, but this identification seems to be no more than a guess based on the age difference between the two sitters. Renaissance men often married late, so this may be the portrait of an elderly father and his son, or of an uncle and nephew. Whatever the relationship of the sitters, they express a familial love and tenderness for each other, despite the possibility that the man's portrait may be posthumous.

The L-shape window frame unites the figures, whose closeness is also shown by their physical proximity and the glances they exchange. In a gesture full of trust and love, the little boy reaches toward the old man, accepting him totally, oblivious to his deformity. Ghirlandaio has captured an emotion central to the human psyche, and his honest, unadorned portrait rings as true today as it did at the time of its creation.

During the Renaissance the portraits of men and women as representatives of particular occupations were painted in considerable numbers for the first time. Portraits alluding to the sitter by

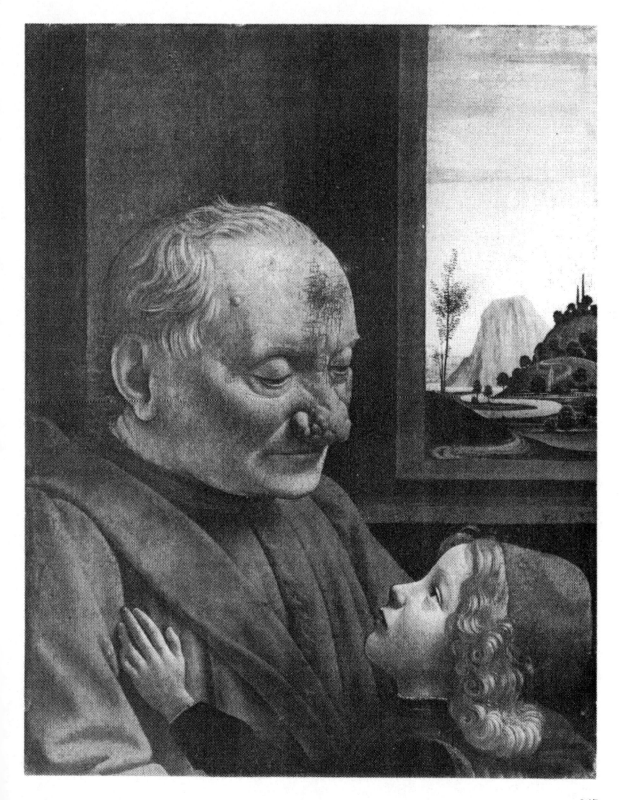

247

occupation—as musician, as architect, or as artist—not only de-scribe the sitter but also make some comment on his work. (In this sense it might be said that the first of these were the portraits of rulers.) This can be seen clearly in a portrait [192] painted about 1480 by Giovanni Bellini, now in the National Gallery of Art, Washington, D.C. The identity of this sitter is not known, al-though he has traditionally been called Bartolomeo Colleoni. How-ever, this identification has been challenged, and the names of several other soldiers of fortune have been advanced. Whoever this is, he reminds one immediately of the images of *condottieri* by Donatello and Verrocchio seen in Chapter III.

The figure fills almost the entire space. By placing the man so close to the picture plane, Bellini has created a visual confron-tation between sitter and viewer. Moreover, the figure is made monumental by the pyramidal shape of the body and head. There is a sturdiness and intransigence about the sitter that is perfectly in keeping with his presumed occupation. The rugged, frowning

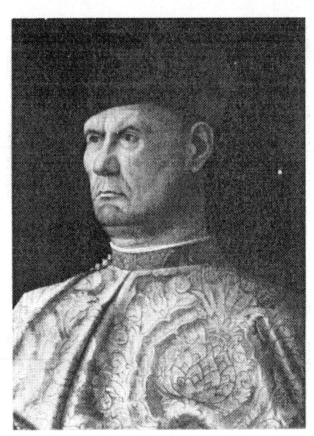

192. Giovanni Bellini, *Portrait of a Man,* National Gallery of Art, Washington, D.C. The names of Giacomo Marcello, captain general of Venice, and Bartolomeo d'Alviano, another Venetian captain, have both been suggested for this commanding portrait. That this is a man of action seems abundantly clear.

face, with its set jaws and bull neck, reminds one of a boxer. The picture is permeated by a tough, belligerent, imperious spirit, which is found in many other portraits of mercenaries, including *Colleoni* and *Gattamelata*. This had to be the case, for the *condottiero*'s employment was linked to his reputation as a brave, strong, and resolute soldier. His portrait not only had to be a likeness, but it also had to serve as an advertisement that pictured him as he wished to be seen by his clients and potential clients.

A much more attractive sitter and benign occupation are found in Venice, famed throughout Renaissance Europe for its courtesans. Often highly cultivated and intelligent, courtesans (and their salons) attracted members of the European ruling class and the intelligentsia. A considerable demand for images of these women, commissioned by courtesans themselves and by their clients, can be postulated from the large number of surviving examples.[13]

Not all the portraits were straightforward: some were thinly disguised as allegory, with the attributes of Venus (an excellent excuse for a full-length nude), Flora, or another mythological goddess adding a veneer of respectability. Moreover, the portrayal of a beautiful woman nude or in dishabille provided the painter with an opportunity to express sensuous forms not afforded by the ordinary female portrait type.

A double portrait [193] of two Venetian courtesans with a

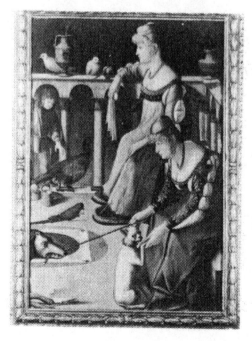

193. Vittore Carpaccio, *Two Venetian Courtesans*, Museo Correr, Venice. Vittore Carpaccio (active c. 1488–1525) seems to have begun his career in the workshop of Giovanni Bellini. Although he painted portraits and altarpieces, his major works were narratives for the Venetian confraternities, or *scuole*.

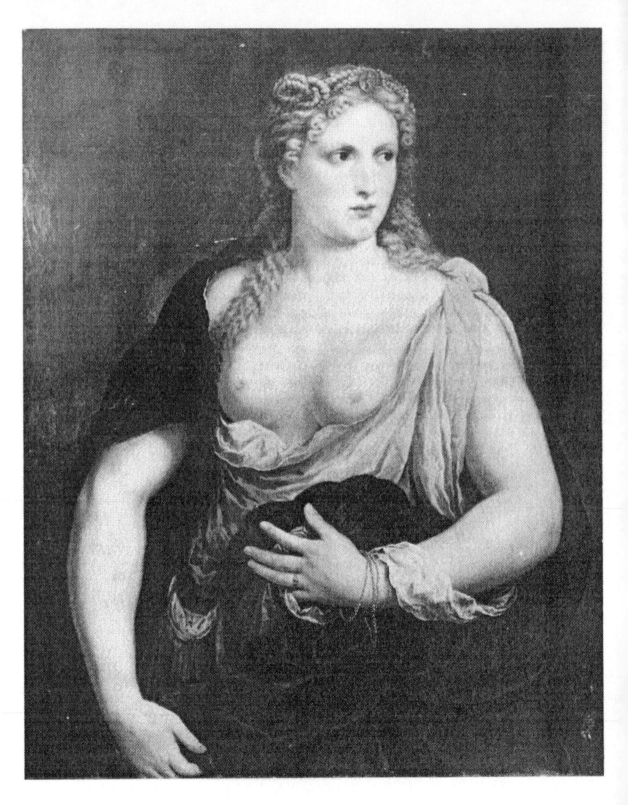

250

dwarf, painted by Vittore Carpaccio about 1500, reveals not the glamour of the women, but the boredom they often must have felt in their gilded existence. Details were important to the artist, as they were to all Venetian painters of the time. With their carefully depicted little caps, low-cut necklines, fancy sleeves, and enormous high-heeled shoes, these two women were paragons of Venetian fashion. The luxury in which they lived is clear from the dwarf and pets (a veritable menagerie) kept to amuse them. These courtesans are not amused: Carpaccio has marvelously captured the vacancy of their stares. Ironically, the courtesans themselves remind us of exotic animals confined for the amusement of others.

The courtesan as a much more desirable figure appears in many paintings by sixteenth-century Venetian artists. A very explicit example of the type is Paris Bordone's *Portrait of a Woman in a Green Mantle* [194], painted about 1550. Set in a large room suggested by the architectural elements in the background, the woman's body is frontal, yet her gaze avoids the spectator. Sometimes Venetian courtesans look alluringly out at the observer, but not here. The lack of contact with the spectator makes the body of the half-nude woman the center of attention. The state of undress is important, for this furnishes the crucial note of transition to the picture: this is a woman who is disrobing in front of the viewer; such an act suggests a nearness and intimacy, reinforced by the frontal body placed close to the picture plane. The loose hair falling over the swelling breast and the woman's undergarments, which have slipped down over her shoulder, add to the eroticism of the work.

Here Paris Bordone, like many of his contemporaries, treads a fine line between idealization and realism. Certainly one would recognize this woman on the street, even fully clothed; but, the regularity of the soft, youthful face with its rosy complexion is idealized and, as such, is made even more appealing and somehow even chaste.

Artists also painted many likenesses of themselves and their fellow painters and sculptors. There are many reasons for the widespread popularity of the artist portrait, not the least that the self-portrait afforded the artist his most patient and cooperative model. By looking in the mirror the artist could practice painting the face from several angles and under different light. The mirror also taught him how to capture facial expressions. Moreover, the mirror afforded a look into the artist's soul; from the glass he could analyze how his own face reflected the inner workings of his mind.

194. Paris Bordone, *Portrait of a Woman in a Green Mantle*, Kunsthistorisches Museum, Vienna. Paris Bordone (1500–1571) was born in Treviso, but probably studied with Titian in Venice. Although active in that city, like Titian he also worked in Augsburg, and he seems to have been in France at the court of François II.

Artists also found their colleagues available and willing sub-jects. Assistants and apprentices could be pressed into service as models for sketches and studies to be utilized in paintings and sculpture.

As the stature of artists rose and as their works entered private collections, the demand for their portraits and self-portraits grew. These men were now considered important, and the pictures that portrayed them were considered worthy of admiration and collec-tion. Especially interesting are the self-portraits. As the artist became the object of considerable admiration in the early six-teenth century, his own self-image developed complexity and sophistication.[14]

Five of the earliest images of artists are found in a group portrait [195] now in the Louvre. This is a mysterious work by an unknown Florentine, probably done about the end of the fif-teenth century. It represents five men: the writer Antonio Manetti, and Giotto, Paolo Uccello, Donatello, and Brunelleschi, four im-portant Florentine artists. These portraits are certainly not taken from life; instead, as the variation of size, scale, and view suggests, they were copied from other works of art, probably frescoes.

From the late fourteenth century, portraits of donors scattered among the groups of onlookers in religious narratives increasingly are seen in large frescoes. In these groups the artist's self-portrait sometimes appeared. From the Renaissance to the present day, admirers of artists have diligently searched the crowd scenes for the artist's self-portrait; not unreasonably, they want to see the likeness of the person who created the images that so fascinate them. So, when a self-portrait cannot be identified with certainty, a figure in the work is often assigned the honor.

In the Louvre portrait, for instance, we see the portrait of

195. Florentine, *Portrait of Five Men*, Louvre, Paris. In the sixteenth century, this panel was attributed by Vasari first to Masaccio and then to Paolo Uccello. While the question of its authorship is still open, the style seems closest to Uccello.

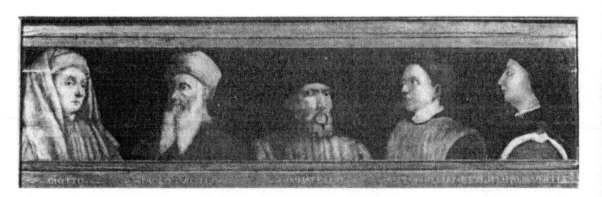

Giotto dressed in clothes that belong to a period about a hundred and fifty years after he lived. The lost image from which this portrait was taken was somehow associated with Giotto and became, through tradition, his putative portrait. When the artist of the Louvre portrait wished to include a likeness of Giotto, he simply copied the so-called Giotto's face and updated the costume. Much the same process seems to lie behind each of the other faces in the multiple portrait.

Yet the most important and interesting facet of the Louvre painting is not how it was done, but why. Someone, perhaps the artist himself, wished to memorialize this particular group of painters and sculptors. Perhaps the painting in the Louvre honors some of the founders of the new style of the early quattrocento. This would be a sophisticated historical concept, and it would, if it were indeed the case, document a real awareness of the stylistic history of the early quattrocento, something clearly impossible before about 1500. The fact that artists, and not princes, prelates, or soldiers of fortune, are here memorialized suggests that the artist was being recognized as something more than an anonymous craftsman.

A measure of the increasing self-worth felt by the artist is seen in a candid self-portrait [196] by the Umbrian Pietro Perugino. This fresco, of about 1500, is found below a series of large frescoes by Perugino painted in the Collegio del Cambio of Perugia. The Cambio was a combination currency exchange, aid society, and tribunal dealing with financial matters.

The introduction of the artist's self-portrait into a large narrative fresco was accepted practice by the late fifteenth century, but the appearance of the painter's likeness outside a painted crowd was unusual. Furthermore, Perugino's self-portrait calls attention to itself with a fictive surrounding frame and a long inscription, which hails the artist as a renewer of painting.

Curiously enough, this prominent likeness-signature of the artist depicts Perugino without a trace of pomp or pretension. Simply dressed, with disheveled hair, puffy cheeks, and double chin, the artist meets the spectator eye to eye; there is a most appealing honesty and straightforwardness about the work. Here is the maker of some of the most gentle and lilting images of the Renaissance, looking rather like the neighborhood butcher or plumber. Here also is an artist still unencumbered by the trappings of celebrity. This was soon to change.

Quite a different interpretation of an artist's face is to be found in a self-portrait bust [197] of the painter Andrea Mantegna

PETRVS PERVSINVS EGREGIVS
PICTOR·
PERDITA SI FVERAT PINGENDI·
HIC RETTVLIT ARTEM·
SI NVSQVAM INVENTA EST
HACTENVS: IPSE DEDIT·

196. Pietro Perugino, *Self-Portrait,* Collegio del Cambio, Perugia. Perugino's self-portrait has a painted frame and is fictively hung from the wall, on a painted cord. The self-portrait is meant to be seen as something separate, attached to the wall, rather than as an image painted on it.

254

197. Andrea Mantegna, *Self-Portrait Bust*, Sant'Andrea, Mantua. Andrea Mantegna (active 1441–1506) was the brother-in-law of the Venetian artist Giovanni Bellini. From 1460, Mantegna worked for the ruling Gonzaga family in Mantua, where he became the principal court painter.

in the church of Sant'Andrea in Mantua. Made for Mantegna's tomb and memorial chapel, the bust was probably modeled by the painter but cast and chased by someone else around 1490.

Although Mantegna was both wealthy (he owned a splendid house in Mantua) and successful, his likeness is full of disquiet, stress, and anger. The careworn face is unidealized; the glaring eyes and firmly set jaw reflect an inner agitation that dominates the likeness. There is nothing placid nor self-content about Mantegna's turbulent image, which is more about mind and spirit than it is about appearance.

That is also true of Titian's remarkable self-portrait (c. 1566), now in West Berlin, which shows the artist about age seventy-six [198]. Titian's furs, his fine shirt, and his gold chains all broadcast his wealth; but it is the charged, massive body of the painter that commands attention and establishes his presence.

Separated from the viewer by a table and set at a slight diagonal, Titian fills the space with his vital, forceful personality.

198. Titian, *Self-Portrait*, Staatliche Museen, West Berlin. Titian's social status is revealed in this self-portrait not only by his commanding stance and leonine face, but also by the gold chain, which is the insignia of the knighthood given him by Charles V in 1533.

This feeling of complete command is reinforced and echoed by the great bearded face with down-turned mouth. Regally, Titian disregards the viewer, preoccupied with something important outside the painting.

Titian makes no reference to his occupation. It is not as a painter that he pictures himself, but as a famous personality, the friend of Emperor Charles V, the recipient of a knighthood, the wealthy owner of a substantial home in Venice.

The elevated self-image of Titian and many of his contemporaries was new. It documents the artist's emergence from the communal world of the fourteenth and fifteenth centuries. Not all artists came to think of themselves as did Titian, as extraordinary beings endowed with the divine power to create. Many painters and sculptors were content to be comfortably enmeshed in the web of the craftsman's world. But these men looked backward, for the true heralds of the modern artist, the gifted creator who stands apart from society, were the artists already involved with their unique inspiration and creativity.

On occasion this involvement with oneself could be almost overwhelming. For instance, a self-portrait [199] by Palma Giovane

199. Palma Giovane, *Self-Portrait,* Brera, Milan. Palma Giovane (1544–1628) carried the tradition of Venetian painting, albeit in a diluted form, into the seventeenth century. He was the great-nephew of Palma Vecchio (c. 1480–1528), a talented contemporary painter of Titian.

painted about 1590 reaches an almost unparalleled height of self-indulgence and vanity. Turning from his easel toward the spectator, Palma presents himself as an urbane dandy dressed in a jaunty hat and furs, so sophisticated and skillful he can paint in his costly clothes.

He is at work on a Transfiguration. By the time of Palma's self-portrait, the mystical and miraculous sacred images of earlier centuries had often become simply subjects for works of art, aesthetic and intellectual challenges. Nowhere is this better illustrated than in Palma's remarkable work.

Yet even in a painting so thoroughly secularized, there remains something of the old attitudes, for Palma (no shrinking violet) has made himself the focus of the painted Christ's attention. The levitating figure in the Transfiguration is placed just behind the painter and gives him what appears to be a personal blessing. But not even Christ takes center stage from the painter.

Some Renaissance artists wished to immortalize their families as well as themselves. These family portraits are scarcer than artists' portraits and self-portraits, but the limited number that do exist are interesting.

A puzzling example of this type by an unknown artist is the portrait [200] of three members of the Gaddi family, now in the Uffizi. Probably painted during the second half of the fifteenth century, the picture represents three generations of famous Gaddi

200. Florentine, *Portrait of Three Members of the Gaddi Family*, Uffizi, Florence. That each of the faces in this triple portrait comes from a different source is evident in the confused, uncomfortable juxtaposition of the bodies. Also, the flatness of the face at the right seems strangely out of place with the strongly modeled heads of the other Gaddis.

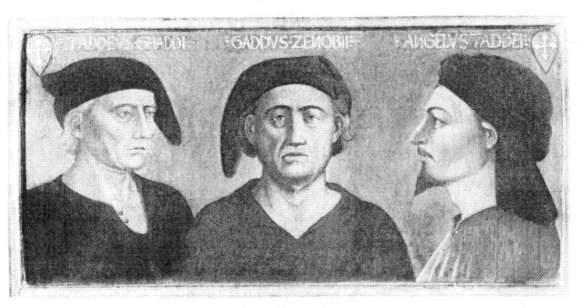

artists. By the late 1400s, the Gaddi family had become wealthy and powerful, and these portraits were probably commissioned to depict its artistic ancestry and fame. That such an origin stirred pride demonstrates how the status of artists had risen; a century before, artistic ancestors of a wealthy family might have been a bit of an embarrassment.

The three Gaddis represented are, from left to right: Taddeo, a pupil of Giotto and one of the major Florentine artists of the early fourteenth century; Taddeo's father, Zanobi, a shadowy figure who founded the family art business in the 1200s; and Agnolo, Taddeo's son, the last of the famous Gaddi painters and the brother of the family member who founded the clan's wealth.

This work is very much in the tradition of the Louvre portrait of the famous Florentine artists discussed above. Its images have almost certainly been lifted from narrative frescoes and may or may not be likenesses of the persons named above each head. The portrait of Agnolo Gaddi, for example, comes straight from the artist's fresco in Santa Croce, Florence. But accuracy did not really matter to the patrons: if a portrait of the ancestor did not exist, then it had to be invented. This Gaddi triple portrait is not a historical document but a dynastic statement. It must have conferred prestige and honor on the family whose coats of arms are seen in the picture's upper corners.

Bernardino Licinio's painting (about 1535) of his brother Arrigo and his family is a very different sort of artist's portrait [201]. Both Bernardino (who is last documented in 1549) and Arrigo were painters. The latter's sons, Fabio, who holds a small reproduction of the Belvedere torso (a famous antique statue), and Giulio, holding a basket of roses, also became artists. Art was the Licinio family business.

The portrait of Arrigo and family is a charming and intimate work very different from the much sterner Gaddi triple portrait. It is an unabashed record of what the family looked like, in no way idealized or even prettified. Arrigo's wife seems slightly careworn, but a sturdy and self-sacrificing mother and wife nonetheless. She is the center of the picture and the hub around which the others revolve. Her white dress with red sleeves and her slightly reddened skin are also the brightest notes of color.

This picture is not dramatic; it tells no story. It resembles the family photographs of today, in which members of the family are assembled, posed, and their images frozen in time. There is intimacy and charm, but the painting is static—a record, not an event.

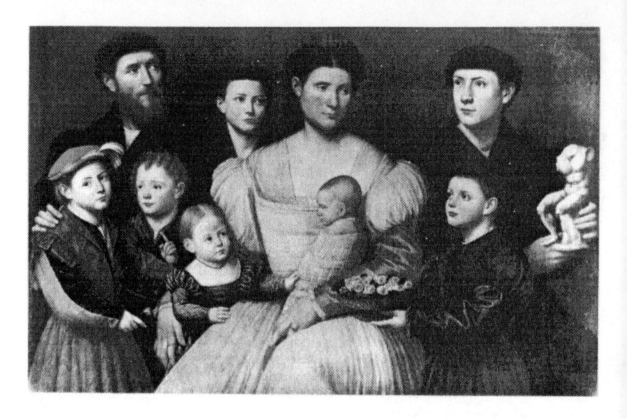

201. Bernardino Licinio, *Portrait of Arrigo Licinio and His Family,* Galleria Borghese, Rome. Bernardino Licinio (c. 1490–c. 1530) may have trained with Giovanni Bellini, the teacher of many notable Venetian painters. An inscription on the upper right corner of this portrait states that, with his art, Bernardino prolonged life for himself and his brother's family. The desire to leave one's likeness to the future was a strong impulse behind much Renaissance portraiture.

A type of portrait related to that of the artist's family, but even rarer, is that which depicts the artist and members of his shop. Although there are a number of depictions of painters and sculptors in their shops before the sixteenth century, these are representations of the occupation of sculptor or painter rather than actual likenesses of specific persons. It was not until the 1500s that there was enough interest in the shop to spur portraits of the artist and his apprentices (some of whom were, of course, relatives) in their shop.

One of these shop portraits was done about 1540 by Bernardino Licinio, the author of the charming portrait of his brother Arrigo and family. In fact, this picture of an artist and his pupils [202] contains likenesses of Arrigo and his two artist sons. Moreover, it shows the young men learning to draw, one of the fundamental skills of the Renaissance artist.

Fabio Licinio grasps a copy after an antique statue while he carefully draws it on a sheet of paper placed on the table. The younger brother, Giulio, eagerly holds out his drawing for his father's approval. On the table are some drawing tools: a pen, an ink-pot, and statuettes for copying. Of course, Bernardino's portrait does not represent the actual clutter of an artist's workshop; rather,

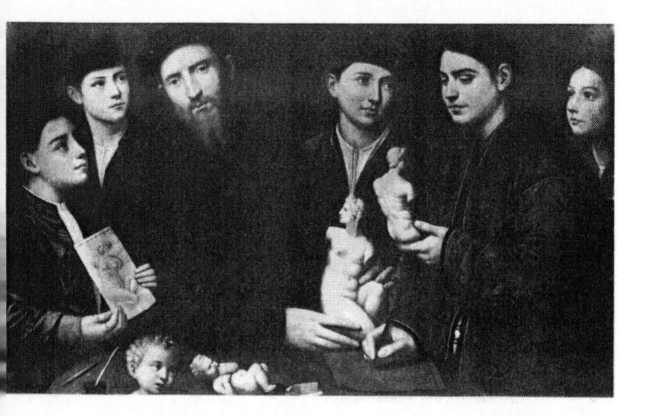

this is a formal sitting in which the artists wear their best clothes and are conscious of the spectator. It is about the learning of art instead of the making of art.

From the late fifteenth century, collectors avidly acquired works of art for their private galleries. For the most part, what they bought was appreciated for its form and for its secular or mythological content. They collected works from the ancient and the modern worlds with equal glee. As we have seen in Chapter II, even commissions for sacred pictures were now highly influenced by the desire for art as form and aesthetic expression.

One such collector, Andrea Odoni, has been immortalized in a portrait [203] by Lorenzo Lotto. This wonderful painting of 1527 depicts Odoni, who had a notable collection of antiquities, literally surrounded by his objects. Yet, as in many of Lotto's portraits, the sitter seems plaintive and disturbed. Here clearly is someone who not only amasses these objects, but thinks about them. These beautiful things remain from a noble but lost civilization; they demonstrate the transitory nature of even the best of human endeavors. Perhaps all these objects remind Odoni of his own mortality. We shall never know exactly what Lotto makes Odoni think, but this sense of introspection is a far cry from the

202. Bernardino Licinio, *Arrigo Licinio and His Pupils*, Collection of the Duke of Northumberland, Alnwick Castle. The brother of Bernardino Licinio, Arrigo (died 1551) was also a painter, as was his son Giulio. Giulio was trained by Bernardino, who was the most talented of the family.

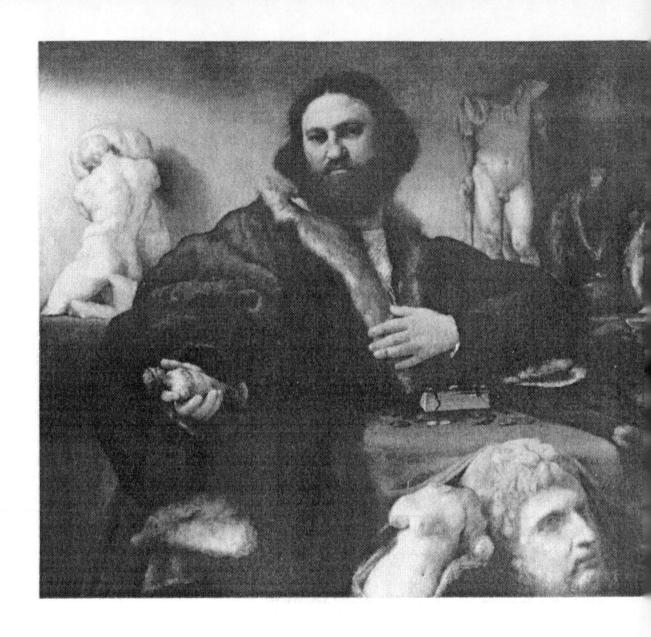

203. Lorenzo Lotto, *Portrait of Andrea Odoni,* Collection of Her Majesty the Queen, Hampton Court. Andrea Odoni, a famous Venetian collector, holds a statuette of Diana of Ephesus. This goddess may stand for nature's continuity in an otherwise transitory world. Similar symbolism is found in Lotto's other portraits.

more imperious portraits of almost blindly acquisitive Renaissance collectors such as Jacopo Strada.

Strada was a learned historian and a prosperous dealer in art, yet his 1568 portrait [204] by Titian is far from flattering. One wonders if Strada was perceptive enough to see this, and if so, whether he accepted scorn as the price he had to pay for owning a work by the great Titian.

That Titian had a low opinion of Strada is clear at first glance. The way Strada holds the nude statuette suggests a mixture of

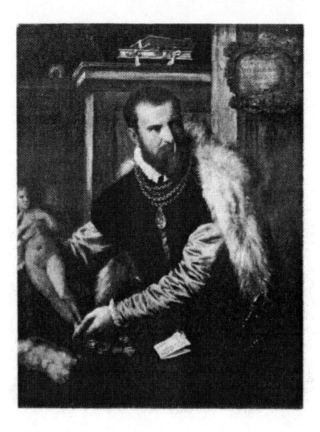

204. Titian, *Portrait of Jacopo Strada,* Kunsthistorisches Museum, Vienna. Jacopo Strada (1515?–1558) was a painter, goldsmith, architect, historian, and antiquarian, Strada's library is reputed to have held three thousand books in over a dozen languages. In his hands he holds a Roman copy of Aphrodite (Venus) by the Greek sculptor Praxiteles.

avarice and temptation; it is *his* statue, as the furs, heavy gold chains, and coins on the table are his, but all just might be for sale if a buyer wanted them badly enough.

Strada's head, with its close-cropped hair and pointed beard, does not invite sympathy or trust. The grasping nature of this sly man is found in his face and eyes as well as in the protective but offering gesture he makes with his body. In Titian's fascinating portrait we see the dealer as tempter and exploiter, someone not to be trusted. How different this is from Lotto's much more sympathetic portrait of the troubled Andrea Odoni.

All the men and women whose portraits we have seen, along with the artists who painted them, shared certain common assumptions and views of the world in which they lived. Some of these views, which were often widely different from our own received ideas, were recorded in paint and stone much in the way likenesses of those who believed in them took shape under the painter's brush or the sculptor's chisel.

The Renaissance cosmos and the earth's place in it are graphically portrayed in a number of religious narratives. Giovanni di Paolo's *Expulsion of Adam and Eve* [205], once part of a large

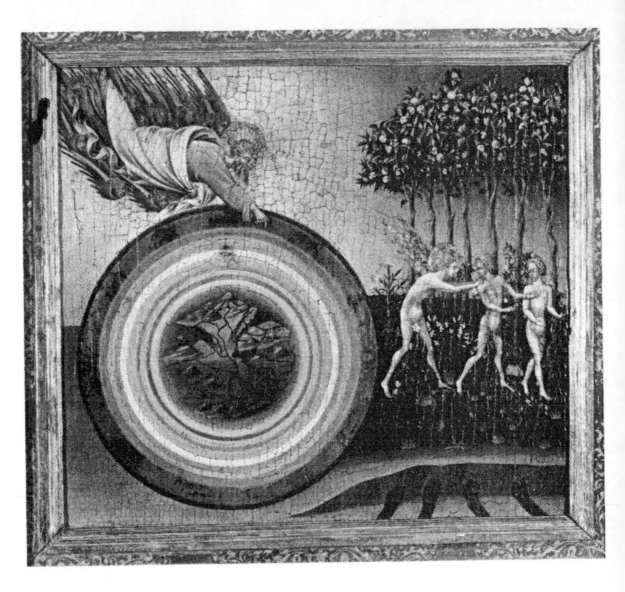

205. Giovanni di Paolo, *Expulsion of Adam and Eve,* The Metropolitan Museum of Art, Lehman Collection, New York. The lush foliage of paradise—the trees bear golden apples—makes stark contrast to the barren, arid earth at the center of the pulsating cosmos, around whose outermost ring are the symbols of the zodiac.

altarpiece painted about 1445, depicts God holding the whirling cosmos as Adam and Eve are evicted from paradise. This universe, which revolves around the earth, is made up of various multicolored spheres of the other planets, a visualization that corresponds to the Renaissance concept of the heavens. When Renaissance men and women looked into the skies, they firmly believed they did so from the very center of the universe. It was not until the early seventeenth century that Galileo and several of his contemporaries questioned this geocentric concept of the universe.[15]

The questioning, empirical attitude of Galileo, which revo-lutionized thinking about the universe, also characterizes the many

Renaissance explorers and map makers who began to both define and describe the physical limits of their world. Our period, in fact, begins about the time of Marco Polo, spans the voyages of Columbus, and closes near the great circumnavigation of Magellan's ships. Out of all this arose a new geophysical reality.

Of course, painters and sculptors had been analyzing and defining the earth in their paintings and sculptures throughout the period.[16] What they produced gives us a sharp reflection of how the natural environment was perceived by the thoughtful Renaissance mind. One of the earliest large-scale depictions of landscape is found in the fresco of *Good Government* [120 and 121] by Ambrogio Lorenzetti in Siena's Palazzo Pubblico, which was discussed in Chapter III. As we have seen, this depicts life in the city and countryside under a good and just government. Here peace and plenty reign, in contrast to the opposite fresco, which depicts the effects of bad government on the city and land.

What strikes one first about the *Good Government* fresco, painted about 1340, is its realism. Nearly the same view of a prosperous, well-kept town and its gentle manicured countryside is visible from the room's windows. Certainly this fresco is part of an allegory of the well-governed city, but it is also realistic, and inviting. Here is a peaceful and fruitful land that nourishes those who live on it and cultivate it. Nature is not hostile, nor does it appear to be in any way mysterious. In truth, this early view of nature is surprisingly like our own.

This is certainly not the case in the work of many other artists, especially in their religious narratives. About a century after Ambrogio Lorenzetti's frescoes, in the city of Siena, Giovanni di Paolo, the author of the *Expulsion of Adam and Eve,* painted landscapes [206] of extraordinary weirdness. His preternatural vision of strange, erupting mountains, tiny toy towns, patchwork plains more like quilts than soil, and scudding clouds is a world made magical by the artist's thought and touch, a space beyond the rule of reason. Yet the contemporary antithesis of Giovanni di Paolo's world view is found only fifty or so miles away in Florence.

Even a cursory look at Masaccio's frescoes of the legend of Saint Peter in the Brancacci Chapel in Santa Maria del Carmine in Florence reveals a conception of the physical world widely at variance with Giovanni di Paolo and most of his Sienese contemporaries. Painted in the late 1420s, Masaccio's frescoes present a rational, ordered, familiar world. The hills of the Arno Valley, the location of Masaccio's hometown, seen in *Tribute Money* [207],

206. Giovanni di Paolo, *Saint John the Baptist in the Wilderness*, Art Institute of Chicago. The conceptual differences between the perspective system of the Florentines and the nearly hallucinatory space of Giovanni di Paolo are even more striking when one realizes that Giovanni knew and could easily imitate—but rejected—the latest Florentine developments.

lie dormant in the thin winter light. The spectator can almost feel the cold, fresh air on his cheeks. Skillful figure construction and placement heighten the reality of the scene.

This is a heroic world, all of a piece, where stately figures move slowly through a vast landscape filled with light and air. It is the milieu of the spectator, elevated by its very rationality to a

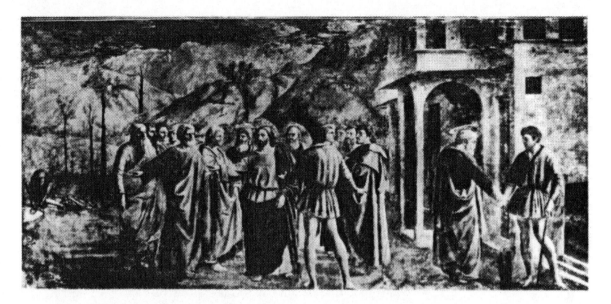

sacred plane. The earth regains its holiness and the sacred protag-
onists are given a historical and corporeal substance new in the
history of painting.

The realism of Masaccio's snow-capped mountains is part of
the strong empirical vision that characterizes much of Florentine
art. The analytical observation and notation of nature by Floren-
tines, however, often are subordinated to the demands of art. Land-
scape is molded and adjusted to become, like color or line, just one
component—albeit a very important one—of painting.

This Florentine attitude toward the depiction of the natural
world is well illustrated in one of Michelangelo's most famous
paintings, the *Temptation and Expulsion from Paradise* (c. 1510),
from the Sistine ceiling [208]. Here the horizon, the rocky ledge
to the left, and the tree function as armatures around which the
story unfolds: they give structure, order, and meaning to the drama.
The human figure and the psychological drama are what really
interest Michelangelo here, not nature for its own sake. It is a
cerebral, intellectual view of the world.

This approach to nature is vastly unlike Giovanni di Paolo's
fantastic version of the Expulsion, but it also represents an entirely
different vision than that seen in the several distinguished Venetian
paintings discussed below, where landscape plays a much more
central role.

It is axiomatic that the depiction of the physical world reflects
the artist's and society's conception of reality. The mystical world
of Giovanni di Paolo or the winter landscape of Masaccio reveal
two dramatically different ways of thinking about sacred narrative

207. Masaccio, *Tribute Money*,
Santa Maria del Carmine, Florence.
Masaccio (1401–1428) was one of
the first artists of Florence to paint
recognizable locations. Other
frescoes by him in the Brancacci
Chapel accurately depict the streets,
buildings, and light of Renaissance
Florence.

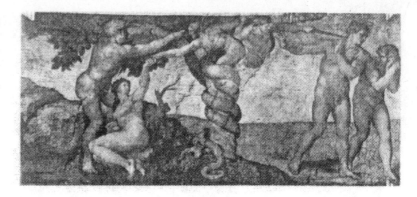

208. Michelangelo, *Temptation and Expulsion from Paradise*, Sistine Ceiling, Vatican City. Michelangelo Buonarroti (1475–1564) started his career in the workshop of Domenico Ghirlandaio, a talented but decidedly undramatic storyteller. From this unlikely beginning he developed into a sculptor and painter of remarkable invention and power. The heroic and tragic view of human beings, seen in this fresco, was to be his principal legacy to Western art.

and the real world. Yet another way of conceptualizing the visual world first occurred in late-fifteenth-century Venice.

In the works of Giovanni Bellini, the earth is a full participant in the spirit of the narrative. Unlike that of Masaccio and his contemporaries, Bellini's world is expressive, capable of mirroring human emotions. One of these is hope, embodied in the natural world in myriad subtle ways. In the *Resurrection* [73], now in Berlin, of about 1480, a shining Christ hovers above a hushed world. It is dawn, and the first pink rays of the sun have touched the clouds, which streak the pale sky. This fresh dawn heralds the coming of a new day and a new era, crystalizing the idea of renewal so much a part of the Resurrection.

The earth itself is dawning. There is the subtle anticipatory feeling about the landscape of the earliest spring days, when all living things stretch toward the renewing warmth of the sun. In Bellini's world one sees no tender green shoots or buds, but one senses them pushing through the reawakening earth toward the still, pale sun. Like the rabbits who cavort on the hillside, this land is fertile and promising. The dark shadows of the valleys will soon be dispersed by the sun's light, just as mankind will be reborn and saved through Christ's death and resurrection.

The Venetian painters of the sixteenth century learned much from Bellini about landscape as a reflection of human feeling, and they utilized this knowledge to describe not only heaven but a paradise on earth as well. This paradise was the sylvan world of myth, where the ancient gods and goddesses acted much like their human counterparts, governed by the whole range of human emotions—love, fear, jealousy, compassion, and hope.[17]

Venetian artists, Titian perhaps most of all, envisioned the land inhabited by the gods as a Garden of Eden where the sun always shone on a peaceful, verdant summer landscape. In this earthly paradise the comely goddesses and handsome gods with

their attendant satyrs and other creatures lived, loved, and died. We have seen how popular the myths became in the late fifteenth century; and much of their appeal must have come from their paradisiacal setting. Occasionally the landscape threatened and the sky above it dimmed, as in Veronese's remarkable *Venus and Adonis* [32], but, more often, the mood was bucolic and beckoning.

In early-sixteenth-century Venice there occurred another decisive development in the perception of landscape that had been foreshadowed by the emotionally compelling backgrounds of Giovanni Bellini's paintings. This was the creation by members of Bellini's shop, most notably Giorgione and Titian working under their master's pioneering example, of *poesie*, pictures without traditional subjects.

In one of the most famous examples of these works that depict figures in landscape settings of surpassing beauty, the *Fête Champêtre* (c. 1510), attributed both to Giorgione and Titian, four figures relax in a sylvan landscape filled with light, atmosphere, and color [209]. The meaning of this informal concert with its voluptuous women and well-dressed men is not clear, and, in fact, the painting probably has no narrative subject.

The Venetians of the Renaissance themselves called such works *poesie*, and indeed the subtle, poetic feelings and association of these scenes are their most important and memorable characteristics. The spell of benevolent, peaceful nature cast upon languorous, sensuous lovers is new in the history of art, and it is specifically Venetian; the more analytical Florentines saw nature in an entirely different way. Moreover, such painting with only a nominal subject will become the spiritual foundation of Watteau, Turner, Picasso, and other artists of superior poetic sensibilities.

The myths and *poesie* take place before time, when the earth was young and still populated by the gods. But the artist was often called on to depict a more specific, historical time. How painters and sculptors conceptualized and visualized this time reveals their attitudes about the society in which they lived.

In the fourteenth century religious narratives of the Old Testament and of the Christian drama were often set in a sort of eternal time; there was little or no attempt to depict a specific historical setting, and events unfolded before a background often made of small sheets of gold. Occasionally artists included props that denoted a certain time or place (for instance, a broken column or arch indicated ancient Rome), but these devices did not really break the timelessness of the narrative.

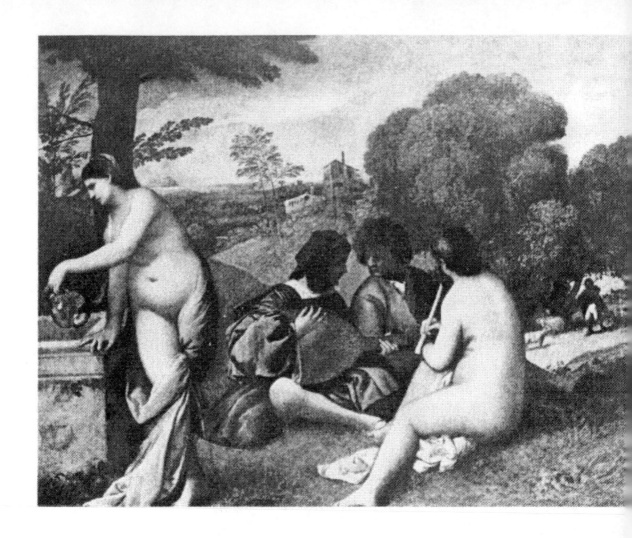

209. Giorgione or Titian, *Fête Champêtre*, Louvre, Paris. Giorgio da Castelfranco, called Giorgione (1478?–1510), probably trained in Venice with Giovanni Bellini. What remains of his work suggests that his atmospheric landscapes and enigmatic subjects were influential in the development of Venetian Renaissance painting.

More specificity was introduced into religious narrative in the early fifteenth century with the realistic portrayal of locale, season, and time of day.[18] We have already seen how Masaccio's frescoes gave religious drama an earthly setting and invested the spectator's world with a new sanctity. Scores of artists, like Masaccio, reveled in depicting the actual environment in which they lived.

Fascination with the world and the role of man in it pervaded Renaissance society. A burgeoning interest in history, in the lives of famous men and women, in exploration, and in town planning were only a few of the many indications that a reassessment of the individual and his or her place in the world and in society was under way. In the arts this spirit is reflected in the rationalization of space through the use of one-point perspective and in a fasci-

nation with the figure, its anatomy, and its placement in space. The same empirical, searching mentality of the great Renaissance historians and explorers can also be found in the work of the period's best artists.

As the fifteenth century wore on, the increasing fascination with the antique past led to a more historical approach to the Christian drama. The scenes of Christ and his followers were sprinkled with depictions of what the Renaissance thought Roman architecture looked like and with figures wearing Roman armor and antique clothing. For the most part painters and sculptors did not strive for historical accuracy; rather, they were content to let the many props inform the viewer that the scene was a historical one and that it took place in the ancient world.

The exception to this vague historicism was the Paduan painter Mantegna, whose self-portrait we have already examined. Mantegna raised the level of specific knowledge about the Romans by giving his religious dramas historically accurate settings. Mantegna had made an extensive study of Roman remains, and he was able to paint them with an archaeological veracity that must have astounded most of his contemporaries. But Mantegna's accuracy and his near-obsession with historical detail often made the parts of his sacred pictures greater than their sums [210]. The spectator is sometimes lost in the welter of crisp, accurate detail that distracts him from the central spiritual or dogmatic message of the holy narrative; it is probably because of this that Mantegna's antiquarianism had only a limited following among his contemporaries.

Mantegna also located his mythological paintings in historical time and introduced into them the attention to learned detail seen in the sacred narratives. But again this specificity was generally rejected by Renaissance artists painting mythological scenes. In the fifteenth century, scenes from mythology and from ancient history were given contemporary settings. Mars became a fifteenth-century knight, Venus an elegant contemporary princess. Gods and goddesses, Roman heroes, and senators all became courtly, chivalric figures, as if antiquity had stretched unbroken into the Renaissance. Anachronisms abounded in everything from clothing to ideals.

But Mantegna and a number of other artists working in the late fifteenth century exhibit a newfound historical sense that is paralleled in the work of humanist historians of the period. The realization that there was a vast gulf of time, the Middle Ages, between the ancient past and the present was a major achievement

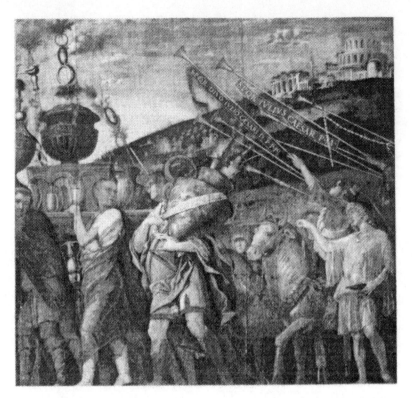

210. Andrea Mantegna, *A Triumph of Caesar*, Collection of Her Majesty the Queen, Hampton Court. Mantegna's Nine Triumphs, to which this painting belongs, occupied him for several years. Painted on canvas for the Gonzaga court at Mantua, they were certainly meant to form backdrops to special events; for example, they were used in 1501 in a theatrical performance.

of Renaissance and Western thought. Antiquity was now seen historically, as something distant and lost.

Yet, as soon as this concept had been accepted by much of Renaissance society, many artists began to mythicize the past. The power of their art and the impact of myth were dampened by too much accuracy, but their decisions to include or exclude (as in the case of Veronese's *Venus and Adonis*) accurate or detailed historical settings from the ancient world proved the developed historical consciousness of the later Renaissance.[19]

The Renaissance, in its artistic production, was not fascinated with the future as we are, at least not with the future of earth. Renaissance thoughts of the future most often dwelt on the afterlife of the individual soul. The visual representation of the future for most Renaissance men and women was not some futuristic view of society; it was the Last Judgment, the universal fate which none could escape, no matter how sophisticated and worldly.

Last Judgment scenes were found in almost every Renaissance church, where they would be explicated by preachers who constantly referred to their imagery and meaning. On Judgment Day all souls would be weighed, and those found wanting would be consigned to hell. The image of the Last Judgment was a powerful

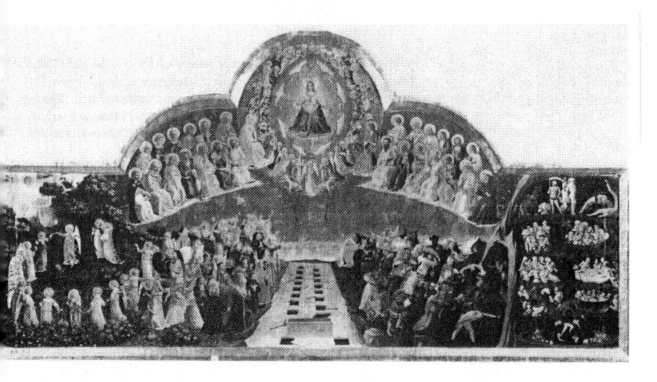

agent of social control, which tempered the lives of all who lived in Renaissance society.

A microcosm of this society is seen in a famous Last Judgment [211] painted about 1430 by the Florentine artist Fra Angelico. This work seems to have formed part of a chair used by the priest when he celebrated High Mass. Such a function for the Last Judgment would certainly reinforce the priest's role in the scheme of Christian salvation, for it was only through the Mass that the communicant could be saved. The priest, in other words, was a central agent in the communicant's future, and the painting graphically showed what awaited.

Every rank of Renaissance society discussed in this book is included among those being judged in Fra Angelico's picture. Monks, nuns, cardinals, popes, kings, burghers, all who commissioned and lived with the paintings and sculpture discussed, are judged. The Last Judgment was socially egalitarian: station and wealth counted for nothing and, in fact, often made it harder for the rich and powerful to enter heaven. Renaissance men and women would be granted entry to paradise or condemned to hell on their faith and earthly goodness, rather than on the size of their purse or the length of their titles.

To either side of the men and women being judged in Fra Angelico's painting are their ultimate destinations, heaven and

211. Fra Angelico, *Last Judgment,* San Marco, Florence. Fra Angelico (active c. 1418–1455) was a Dominican who became prior of his Florentine convent in 1449. Trained outside the convent, he nevertheless spent much of his artistic life in the service of his fellow Dominicans.

hell. These would be the eternal homes of those who heard the Mass in front of this work. Ordered and graceful, the beautiful grove of paradise contrasts with the packed circles of hell. These depictions of devilish torment were also lessons, warnings to the wicked to change their ways before Judgment Day and eternal damnation.

Rising above the joy of the blessed and the agony of the newly damned are the elect, the followers of Christ, who himself sits in a mandorla of seraphim flanked by Mary and Saint John the Baptist. It was to this ultimate figure that the Renaissance celebrant looked for personal salvation.

EPILOGUE

This survey of many of the types and functions of Renaissance painting and sculpture has sought to relate art to the society that produced it. In the process, several basic developments in the history of Renaissance art have become apparent.

One of the major trends—perhaps the one that had the most direct bearing on the subsequent history of art—was the gradual transformation, over several centuries, of icon into work of art. As the Renaissance unfolded, the very nature of art, both in its religious and secular spheres, changed from something invested with a miraculous, totemic presence to something that centered on the nature of art itself. By the end of our period, patrons paid for works that were appreciated as much for their style and beauty as for the functions that they continued to fulfill. This development signals one of the major changes in the history of Western art.

Concomitant with the elevated estimation of art as an independent entity was the new appraisal of the artist himself. For the first time in any sustained way, artists were viewed as more than skilled craftsmen. By the end of our period, several artists of great talent, men such as Raphael, Michelangelo, and Titian, were seen as divinely gifted creators different from ordinary mankind. This was the genesis of the idea of the romantic, inspired artist who is so familiar to us. And indeed, from Michelangelo and his biographer Giorgio Vasari onward, artists themselves began to feel like special beings set apart by their talent and calling from ordinary society.

By the last years of our period, the structure of the world of Renaissance art, its shops and commissions, was much like it had been for centuries. But the nature of what the shops produced had begun to change. The various functions were no longer so clear; art was now something that could be collected as well as used, and some of those who made this art no longer fit so neatly into the slots in society they had held for so long. Moreover, art now strove to express many sophisticated layers of the individual psyche, both that of the patron and that of the artist himself. All sorts of new elements—fantasy, eroticism, rational space, exoticism—had entered into the great stream of Renaissance art.

It is safe to say that by 1550 art was radically different from what it had been in 1250. It was also probably less a part of society than it had been before, somewhat more private and personal in nature. The developments studied through Renaissance type and function marked the first steps on the long road that led, for better or worse, to our own ideas about art and artists.

NOTES

Chapter I: Domestic Life

1. Renaissance house: A. Schiaparelli, *La Casa fiorentina e i suoi arredi nei secoli XIV e XV*, Florence, 1908 (reprint with valuable annotations: ed. M. Sframeli and L. Pagnotta, Florence, 1983, 2 vols.); P. Murray, *The Architecture of the Italian Renaissance*, London, 1963; G. Chierici, *Il Palazzo italiano dal secolo XI al secolo XIX*, Milan, 1964; R. Goldthwaite, *The Building of Renaissance Florence*, Baltimore, 1980. See also D. Herlihy and C. Klapish-Zuber, *Tuscans and Their Families*, New Haven, 1985.

2. Datini: I. Origo's *The Merchant of Prato: Francesco di Marco Datini*, New York, 1957, is a superior biography of Datini. See also F. Melis, *Aspetti della vita economica: Studi nel Archivio Datini di Prato*, 1, Florence, 1962; B. Cole, "The Interior Decoration of the Palazzo Datini in Prato," *Mitteilungen des Kunsthistorischen Institutes in Florenz*, 13, 1967, 61–82.

3. Leon Battista Alberti: L. B. Alberti, *On Painting and Sculpture*, trans. C. Grayson, London, 1972; Andrea di Tommaso, "Alberti," *Dictionary of Italian Literature*, ed. P. and J. Bondanella, Westport, Conn., 1979, 4–6.

4. The villa: G. Masson, *Italian Villas and Palaces*, London, 1966; L. Heydenreich and W. Lotz, *Architecture in Italy, 1400–1600*, Harmondsworth, 1974; D. Coffin, *The Villa in the Life of Renaissance Rome*, Princeton, 1979.

5. Behavior of a courtier: B. Castiglione, *The Book of the Courtier*, trans. C. Singleton, New York, 1959. Castiglione's book was first published in 1528 and remains a vivid picture of life at one of the many small Italian courts. For a nearly contemporary, but quite different, view of Renaissance governance, see N. Machiavelli, *The Prince*, trans. P. Bondanella and M. Musa, Oxford, 1984.

6. The Este and their commissions: E. Gardner, *Dukes and Poets in Ferrara*, London, 1904; E. Gardner, *The Painters of the School of Ferrara*, London, 1911; W. Gundersheimer, *Ferrara: The Style of a Renaissance Despotism*, Princeton, 1973.

7. Astrology and art: A. Warburg, *Italienische Kunst und internationale Astrologie in Palazzo Schifanoja zu Ferrara*, Rome, 1922; J. Seznec, *The Survival of the Pagan Gods*, Princeton, 1953; P. D'Ancona, *The Schifanoia Months at Ferrara*, Milan, 1954; F. Saxl, "The Revival of Late Antique Astrology," *A Heritage of Images*, London, 1970, 27–41.

8. Images of famous men: J. Hall, *A History of Ideas and Images in Italian Art*, New York, 1983, 238–239.

9. Villa Farnesina: F. Saxl, "La Fede astrologica di Agostino Chigi," *La Farnesina*, 1, Rome, 1934; P. D'Ancona, *Gli Affreschi della Farnesina in Rome*, Milan, 1955; P. Murray, *The Architecture of the Italian Renaissance*, London, 1963; S. Freedberg, *Painting of the High Renaissance in Rome and Florence*, New York, 1972.

10. Palladio and the Venetian villa: R. Pane, *Andrea Palladio*, Turin, 1961; J. Ackerman, *Palladio*, Harmondsworth, 1966.

11. Venetian painters of the sixteenth century: B. Berenson, *Italian Pictures of the Renaissance: Venetian School*, London, 1957, 2 vols.; J. Steer, *A Concise History of Venetian Painting*, New York, 1970.

12. *Cassoni*: P. Schubring, *Cassoni, Truhen und Truhenbilder der italienischen Frührenaissance*, Leipzig, 1915, 2 vols.; E. Callman, *Apollonio di Giovanni*, Oxford, 1974; J. Pope-Hennessy and K. Christiansen, *Secular Painting in 15th-Century Tuscany*, New York, 1980.

13. Boccaccio's *Decameron*: Giovanni Boccaccio, *The Decameron*, trans. M. Musa and P. Bondanella, New York, 1982. For Boccaccio's life and work see T. Bergin, *Boccaccio*, New York, 1981.

14. Ancient history and other antique subjects in Renaissance painting: M. Greenhalgh, *The Classical Tradition in Art*, New York, 1978; J. Hall, *A History of Ideas and Images in Italian Art*, New York, 1983.

15. Apollonio di Giovanni and *cassone* workshops: see note 12.

16. Boccaccio's *Famous Women*: Giovanni Boc-

caccio, *Concerning Famous Women*, trans. G. Guarino, New Brunswick, 1963; see also note 13.

17. Sienese heroes and heroines: G. Coor, *Neroccio de' Landi*, Princeton, 1961, 94–96.

18. Studies of commissions of Duke Alfonso I: J. Walker, *Bellini and Titian at Ferrara*, London, 1956; H. Wethy, *The Painting of Titian*, 3, London, 1975, 29–41. For another Renaissance *studiolo* see: J. Cartwright, *Isabella d'Este*, London, 1903, 2 vols.; G. Marek, *The Bed and the Throne: The Life of Isabella d'Este*, New York, 1976.

19. Original location of Madonna of the Pazzi: M. Horster, *Andrea del Castagno*, London, 1980, 174–175.

20. Portable triptychs: E. Garrison, *Italian Romanesque Panel Painting: An Illustrated Index*, Florence, 1949.

21. Diptychs: E. Garrison, *Italian Romanesque Panel Painting: An Illustrated Index*, Florence, 1949.

22. Popular religious paintings: B. Cole, "A Popular Painting from the Early Trecento," *Apollo*, 101, 1975, 9–13.

23. Imitations of famous works: B. Cole, "Old in New in the Early Quattrocento," *Mitteilungen des Kunsthistorischen Institutes in Florenz*, 17, 1973, 229–298.

24. *Deschi da parto*: J. Pope-Hennessy and K. Christiansen, *Secular Painting in 15th-Century Tuscany*, New York, 1980, 6–11; E. Callmann, *Beyond Nobility: Art for the Private Citizen in the Early Renaissance*, Allentown, 1980.

25. Triumphs: G. Carandente, *I Trionfi nel primo rinascimento*, Naples, 1963; J. Hall, *A History of Ideas and Images in Italian Art*, New York, 1983.

26. Renaissance furniture: A. Schiaparelli, *La Casa fiorentina e i suoi arredi nei secoli XIV e XV*, Florence, 1908 (reprint with valuable annotations: ed. M. Sframeli and L. Pagnotta, Florence, 1983, 2 vols.); W. Odom, *A History of Italian Furniture from the Fourteenth to the Early Nineteenth Century*, New York, 1918–1919, 2 vols.; W. Bode, *Italian Renaissance Furniture*, New York, 1921; F. Schottmüller, *Furniture and Interior Decoration of the Italian Renaissance*, New York, 1928.

27. Terracotta: *La Civiltà del cotto*, ed. A. Paolucci, Florence, 1980; J. Pope-Hennessy, *Luca della Robbia*, Ithaca, N.Y., 1980.

28. Renaissance small bronzes: W. Bode, *The Italian Bronze Statuettes of the Renaissance*, London, 1907–1912, 2 vols.; J. Pope-Hennessy, *Renaissance Bronzes from the Samuel H. Kress Collection*, London, 1965; M. Ciardi Dupre dal Poggetto, *Small Renaissance Bronzes*, Milan, 1966; J. Pope-Hennessy, *Essays on Italian Sculpture*, London, 1968.

29. *Images de chevet*: J. Pope-Hennessy, *Renaissance Bronzes from the Samuel H. Kress Collection*, London, 1965.

30. Bronze reliefs: J. Pope-Hennessy, *Renaissance Bronzes from the Samuel H. Kress Collection*, London, 1965; J. Pope-Hennessy, *Italian Renaissance Sculpture*, London, 1971.

31. Bronze statuettes: see note 28 and H. Weihrauch, *Europäische Bronzestatuetten*, Braunschweig, 1967.

32. Bronze utilitarian objects: J. Pope-Hennessy, *Renaissance Bronzes from the Samuel H. Kress Collection*, London, 1965.

33. Mortars: G. Lise and B. Bearzi, *Antichi mortai di farmacia*, Milan, 1975; U. Middeldorf, *Fifty Mortars: A Catalogue*, Florence, 1981.

Chapter II: Worship

1. Survey of Renaissance churches: W. and E. Paatz, *Die Kirchen von Florenz*, Frankfurt-am-Main, 1940–1954, 6 vols., contains the most thorough survey of individual Renaissance churches.

2. Monasteries: W. Braunfels, *Monasteries of Western Europe: The Architecture of the Orders*, Princeton, 1980.

3. The Mass: J. Jungmann, *The Mass of the Roman Rite*, New York, 1959; J. Jungmann, *The Eucharistic Prayer*, London, 1966.

4. Iconographic program of the Sistine Chapel: L. Ettlinger, *The Sistine Chapel Before Michelangelo*, Oxford, 1965; J. Wilde, *Michelangelo*, Oxford, 1978, 48–84.

5. History of the altarpiece: H. Hager, *Die Anfänge des italienischen Altarbildes*, Munich, 1962; M. Cammerer-George, *Die Rahmung der toskanische Altarbildes im Trecento*, Strasbourg, 1966; H. van Os, *Sienese Altarpieces*, 1, Groningen, 1984.

6. Liturgical function of the altarpiece: for the clearest study of the major relationships between the liturgy and the altarpiece, albeit in Netherlandish painting, see B. Lane, *The Altar and the Altarpiece*, New York, 1984; see also H. van Os, *Sienese Altarpieces*, 1, Groningen, 1984.

7. Classification of altarpieces: B. Cole, *The Renaissance Artist at Work*, New York, 1983.

8. Saints: the most important and detailed works

on Italian saints are the following volumes by G. Kaftal: *The Iconography of the Saints in Tuscan Painting,* Florence, 1952; *The Iconography of the Saints in Central and South Italian Schools of Painting,* Florence, 1965, 2 vols.; *The Iconography of the Saints in the Painting of North-East Italy,* Florence, 1978. See also D. Attwater, *The Penguin Dictionary of Saints,* Harmondsworth, 1965; J. Hall, *Dictionary of Subjects and Symbols in Art,* New York, 1974.

9. Image of Madonna and Child: A. Jameson, *Legends of the Madonna as Represented in the Fine Arts, Sacred and Legendary Art,* 3, London, 1864; E. Sandberg-Vavalà, *Iconografia della Madonna col Bambino nella pittura italiana del dugento,* Siena, 1934; D. Shorr, *The Christ Child in Devotional Images in Italy During the XIV Century,* New York, 1954.

10. The plague and art: M. Meiss, *Painting in Florence and Siena After the Black Death,* New York, 1964; H. van Os, "The Black Death and Sienese Painting: A Problem of Interpretation," *Art History,* 4, 1981, 237–249; B. Cole, "Some Thoughts on Orcagna and the Black Death Style," *Antichità viva,* 22, 1983, 27–37.

11. Masaccio and the changes in religious imagery: B. Cole, *Masaccio and the Art of Early Renaissance Florence,* Bloomington, In., 1980.

12. Change in attitude toward art about 1500: B. Cole, *The Renaissance Artist at Work,* New York, 1983.

13. Carved tabernacles: J. Pope-Hennessy, *Italian Renaissance Sculpture,* London, 1971.

14. The pax: J. Pope-Hennessy, *Renaissance Bronzes from the Samuel H. Kress Collection,* London, 1965; *The Oxford Dictionary of the Christian Church,* ed. F. Cross, London, 1957, 1037.

15. The crucifix: see Chapter III, note 19.

16. Doubts on the attribution of the Santa Maria Novella crucifix: E. Baccheschi, *The Complete Paintings of Giotto,* New York, 1966.

17. The wooden crucifix: M. Lisner, *Holzkruzifixe in Florenz und in der Toskana von der Zeit um 1300 bis zum frühen Cinquecento,* Munich, 1970.

18. Terracotta groups: J. Pope-Hennessy, *Italian Renaissance Sculpture,* London, 1971; *La Civiltà del cotto,* ed. A. Paolucci, Florence, 1980.

19. Single statues: J. Pope-Hennessy, *Italian Renaissance Sculpture,* London, 1971.

20. Renaissance tombs: J. Pope-Hennessy, *Italian Gothic Sculpture,* London, 1972; J. Pope-Hennessy, *Italian Renaissance Sculpture,* London, 1971; J. Pope-Hennessy, *Italian High Renaissance and Baroque Sculpture,* London, 1970.

21. Refectory decoration: L. Vertova, *I Cenacoli fiorentini,* Turin, 1965.

Chapter III: The Civic World

1. Physical characteristics of the Renaissance city: G. Argan, *The Renaissance City,* New York, 1969. For the medieval forerunners of the Renaissance cities, see W. Braunfels, *Mittelalterliche Stadtbaukunst in der Toskana,* Berlin, 1966, and H. Saalman, *Medieval Cities,* New York, 1968.

2. H. Wieruszowski, "Art and the Commune in the Time of Dante," *Speculum,* 19, 1944, 14–33; S. Edgerton, Jr., *Pictures and Punishment,* Ithaca, N.Y., 1985.

3. Town hall decoration: N. Rodolico and G. Marchini, *I Palazzi del popolo nei comuni toscani del medio evo,* Milan, 1962; A. Cairola and E. Carli, *Il Palazzo Pubblico di Siena,* Rome, 1963; E. Southard, *The Frescoes in Siena's Palazzo Pubblico, 1289–1539: Studies in Imagery and Relations to Other Communal Palaces in Tuscany,* New York, 1978.

4. Roman history in Renaissance life: G. Kristeller, *The Classics and Renaissance Thought,* Cambridge, Mass., 1955; R. Wiess, *The Renaissance Discovery of Classical Antiquity,* Oxford, 1969.

5. Decoration of the Hall of the Great Council: J. Wilde, "The Hall of the Great Council of Florence," *Renaissance Art,* ed. C. Gilbert, New York, 1970; H. Hibbard, *Michelangelo,* New York, 1974.

6. Venetian painted ceilings: J. Schulz, *Venetian Painted Ceilings of the Renaissance,* Berkeley and Los Angeles, 1968.

7. Allegory: J. Hall, *A History of Ideas and Images in Italian Art,* New York, 1983.

8. Antique statue in Siena's Campo: F. Schevill, *Siena: The History of a Medieval Commune,* New York, 1964.

9. Florentine symbols: H. Baron, *The Crisis of the Early Italian Renaissance,* Princeton, 1955, 2 vols.; F. Hartt, "Art and Freedom in Quattrocento Florence," *Essays in Memory of Karl Lehmann,* New York, 1964.

10. Cosimo I and the later Medici: E. Cochrane, *Florence in the Forgotten Centuries,* Chicago, 1973.

11. Cellini's account of casting *Perseus:* Benvenuto Cellini, *Autobiography,* trans. G. Bull, Harmondsworth, 1977.

12. Renaissance mercenaries: G. Thease, *The Condottieri,* New York, 1971; M. Mallett, *Mercenaries*

and *Their Masters*, Totowa, N.J., 1974; J. Hale, *War and Society in Renaissance Europe, 1450–1620*, Baltimore, 1985.

13. Guidoriccio debate: E. Carli, *La Pittura sienese del trecento*, Milan, 1981.

14. Leonardo's equestrian projects: A. Popham, *The Drawings of Leonardo da Vinci*, London, 1946; K. Clark, *Leonardo da Vinci*, Harmondsworth, 1959.

15. Renaissance guilds: P. Burke, "Guilds," *A Concise Encyclopaedia of the Italian Renaissance*, ed. J. Hale, New York, 1981.

16. Confraternities: G. Monti, *Le Confraternite medievali dell' alta e media italia*, Venice, 1927, 2 vols.; R. Weissman, *Ritual Brotherhood in Renaissance Florence*, New York, 1981.

17. Processional banners: F. Santi, *Gonfaloni umbri del Rinascimento*, Perugia, 1976.

18. Art and execution: S. Edgerton, Jr., *Pictures and Punishment*, Ithaca, N.Y., 1985.

19. Crosses and cross types: E. Sandberg-Vavalà, *La Croce dipinta e l'iconografia della Passione*, Verona, 1929; E. Garrison, *Italian Romanesque Panel Painting, an Illustrated Index*, Florence, 1949.

20. The Venetian *scuole*: *Le Scuole di Venezia*, ed. T. Pignatti, Milan, 1981.

21. Seven Acts of Mercy: six acts come from Matt. 23:35–36; the Act of Burying the Dead was added in the thirteenth century.

22. Slaves in the Renaissance: I. Origo, "The Domestic Enemy: Eastern Slaves in Tuscany in the Fourteenth and Fifteenth Centuries," *Speculum*, 39, 1955, 321–366; I. Origo, *The Merchant of Prato: Francesco di Marco Datini*, New York, 1957.

23. Renaissance fountains: A. Colasanti, *Le Fontane d'Italia*, Milan, 1926.

Chapter IV: Renaissance Images and Ideals

1. Renaissance portraits: J. Alazard, *The Florentine Portrait*, New York, 1968; J. Pope-Hennessy, *The Portrait in the Renaissance*, Princeton, 1976.

2. Roman portraits: R. Hinks, *Greek and Roman Portrait-Sculpture*, London, 1935; R. Brilliant, *Roman Art*, London, 1974.

3. Northern portraits: J. Pope-Hennessy, *The Portrait in the Renaissance*, Princeton, 1976.

4. Carved portraits: J. Pope-Hennessy, *Italian High Renaissance and Baroque Sculpture*, London, 1970; J. Pope-Hennessy, *Italian Renaissance Sculpture*, London, 1971; J. Pope-Hennessy, *The Portrait in the Renaissance*, Princeton, 1976.

5. Masks: see note 4.

6. Courts and art: M. Levey, *Painting at Court*, New York, 1971; R. Strong, *Splendor at Court: Renaissance Spectacle and the Theater of Power*, Boston, 1973; B. Mitchell, *Italian Civic Pageantry in the High Renaissance*, Florence, 1979.

7. Mercenaries: see Chapter III, note 12.

8. Portraits of the doge and Venetian portraiture: J. Steer, *A Concise History of Venetian Painting*, New York, 1970.

9. Renaissance Triumphs: J. Burckhardt, *The Civilization of the Renaissance in Italy*, New York, 1958, 2 vols.; A. Nagler, *Theatre Festivals of the Medici, 1539–1637*, New Haven, 1964; R. Strong, *Splendor at Court: Renaissance Spectacle and the Theater of Power*, Boston, 1973.

10. Renaissance medals: G. Hill, *A Corpus of Italian Medals of the Renaissance Before Cellini*, London, 1930, 2 vols.; G. Hill, *Medals of the Renaissance* (revised and enlarged by G. Pollard), London, 1978; U. Middeldorf, *Renaissance Medals and Plaquettes*, Florence, 1983.

11. Renaissance gesture: M. Baxandall, *Painting and Experience in Fifteenth-Century Italy*, Oxford, 1972.

12. Betrothal and marriage portraits: J. Pope-Hennessy, *The Portrait in the Renaissance*, Princeton, 1979.

13. Venetian courtesans: P. Larivaille, *La vie quotidienne des courtisanes en Italie au temps de la Renaissance*, Paris, 1975; G. Masson, *Courtesans of the Italian Renaissance*, New York, 1975.

14. Renaissance artists' portraits: E. Benkard, *Das Selbstbildnis vom 15. bis zum Beginn des 18. Jahrhunderts*, Berlin, 1927; W. Prinz, *Vasaris Sammlung von Künstlerbildnissen*, Florence, 1966; J. Pope-Hennessy, *The Portrait in the Renaissance*, Princeton, 1979.

15. Science in the Renaissance: M. Boas, *The Scientific Renaissance, 1450–1630*, New York, 1966; W. Wightman, *Science in Renaissance Society*, London, 1972; W. Shumaker, *The Occult Sciences in the Renaissance*, Berkeley, 1979.

16. Renaissance landscape: R. Turner, *The Vision of Landscape in Renaissance Italy*, Princeton, 1966.

17. Mythology in the Renaissance: J. Seznec, *The Survival of the Pagan Gods*, Princeton, 1953; E. Wind, *Pagan Mysteries in the Renaissance*, New Haven, 1958; J. Hall, *A History of Ideas and Images in Italian Art*, New York, 1983.

18. Renaissance perspective: J. White, *The Birth and Rebirth of Pictorial Space,* New York, 1972; S. Edgerton, Jr., *The Rediscovery of Linear Perspective,* New York, 1976.

19. Renaissance humanist historians: L. Martines, *The Social World of the Florentine Humanists: 1390–* *1460,* Princeton, 1963; D. Wilcox, *The Development of Florentine Humanist Historiography in the Fifteenth Century,* Cambridge, Mass., 1969; N. Struever, *The Language of History in the Renaissance,* Princeton, 1970; P. Bondanella, *Machiavelli and the Art of Renaissance History,* Detroit, 1973.

BIBLIOGRAPHICAL ESSAY

This bibliographical essay lists selected books in English under the categories of history, surveys of Renaissance art, and iconography. Many of these books contain extensive bibliographies, which will lead the reader to more specialized writings.

History

The classic formulation of the Renaissance remains Jacob Burckhardt's *Civilization of the Renaissance in Italy,* New York, 1958, 2 vols.; first published in 1860, this book has been of seminal importance. More modern surveys of various aspects of Renaissance Italy are found in the *Studies in Cultural History Series* edited by J. Hale: J. Larner, *Culture and Society in Italy, 1290–1420,* New York, 1971; P. Burke, *Culture and Society in Italy, 1420–1540,* New York, 1972; O. Logan, *Culture and Society in Venice, 1500–1800,* New York, 1972. All of these books are particularly interesting for the connections they make between art and society.

There are also many general surveys of the Renaissance. Among the best are: J. Plumb, *The Italian Renaissance,* New York, 1965; D. Hay, *The Italian Renaissance and Its Historical Background,* Cambridge, England, 1966; L. Martines, *Power and Imagination: City-States in Renaissance Italy,* New York, 1980.

The last several decades have seen the publication of some noteworthy surveys of individual Italian cities: F. Lane, *Venice: A Maritime Republic,* Baltimore, 1977; P. Partner, *Renaissance Rome, 1500–1559,* Berkeley, 1976; J. Hook, *Siena: A City and Its History,* London, 1979; W. Gundersheimer, *Ferrara: The Style of a Renaissance Despotism,* Princeton, 1973; D. Herlihy, *Medieval and Renaissance Pistoia,* New Haven, 1976; M. Becker, *Florence in Transition,* Baltimore, 1967 and 1968, 2 vols.; G. Brucker, *Renaissance Florence,* New York, 1969; J. Hyde, *Padua in the Age of Dante,* Manchester, 1966.

Also useful for a number of historical topics is *A Concise Encyclopaedia of the Italian Renaissance,* ed. J. Hale, New York, 1981.

Surveys of Renaissance Art

One of the earliest and still most valuable sources for Renaissance artists is a book by Giorgio Vasari, a painter and follower of Michelangelo. The most available complete translation is by A. Hind, *Giorgio Vasari: The Lives of the Most Excellent Painters, Sculptors, and Architects,* London, 1966, 4 vols. The sculptor Cellini's famous autobiography, *The Life of Benvenuto Cellini Written by Himself,* trans. G. Symonds, London, 1960, is a font of fascinating material on Renaissance artists and their patrons, albeit seen through Cellini's egotistical eyes.

Informative Renaissance documents and records are translated in three collections: D. Chambers, *Patrons and Artists in the Italian Renaissance,* Columbia, S.C., 1971; G. Brucker, *The Society of Renaissance Florence,* New York, 1971; C. Gilbert, *Italian Art, 1400–1500,* Englewood Cliffs, N.J., 1980.

Several studies have attempted to relate Renaissance art to a particular aspect of the society that produced it. F. Antal, *Florentine Painting and Its Social Background,* London, 1947, has a Marxist view. See also M. Meiss, *Painting in Florence and Siena After the Black Death,* New York, 1964; M. Baxandall, *Painting and Experience in Fifteenth-Century Italy,* Oxford, 1972.

Material, technical, and workshop aspects of Renaissance art are discussed in B. Cole, *The Renaissance Artist at Work,* New York, 1983. Very helpful in understanding the physical structure of painting is D. Thompson, *The Materials and Techniques of Medieval Painting,* New York, 1956. D. Thompson has also translated and edited an important shop manual of the early Renaissance, Cennino Cennini's *The Craftsman's Handbook: Il Libro dell'Arte,* New Haven, 1933.

There are several multivolume histories of Italian art. Still fundamental is J. Crowe and G. Cavalcaselle, *A New History of Painting in Italy,* London, 1864, 3 vols., and later editions. This monumental work attains a depth and completeness seldom achieved in later works. Also fundamental for an understanding of Italian painting are the series of essays and lists written by B. Ber-

enson about 1900, all of which have been republished: *Italian Pictures of the Renaissance: Venetian School*, London, 1957, 2 vols.; *Italian Pictures of the Renaissance: Florentine School*, London, 1963, 2 vols.; *Italian Pictures of the Renaissance: Central and North Italian Schools*, London, 1968, 2 vols.; *The Italian Painters of the Renaissance*, London, 1952. All of these books contain many good illustrations. Also useful for the many illustrations it contains is R. van Marle, *The Development of the Italian Schools of Painting*, The Hague, 1923–1938, 9 vols.

A helpful introduction is F. Hartt, *History of Italian Renaissance Art*, Englewood Cliffs, N.J., 1979.

There are numerous specialized studies of periods of Italian Renaissance painting. For the earlier years see J. White, *Art and Architecture in Italy, 1250–1400*, Harmondsworth, 1966; R. Oertel, *Early Italian Painting to 1400*, New York, 1968. Later painting is discussed in S. Freedberg, *Painting in Italy, 1500–1600*, Harmondsworth, 1975.

Some of the more important regional schools have been the subjects of study: F. Mather, Jr., *Venetian Painters*, New York, 1936 (somewhat out of date but still valuable); J. Steer, *A Concise History of Venetian Painting*, New York, 1970 (a first-rate introduction); J. Wilde, *Venetian Painting from Bellini to Titian*, Oxford, 1974; J. Pope-Hennessy, *Sienese Quattrocento Painting*, London, 1948; E. Sandberg-Vavalà, *Sienese Studies*, Florence, 1953; B. Cole, *Sienese Painting from Its Origin to the Fifteenth Century*, New York, 1980; B. Cole, *Sienese Painting in the Age of the Renaissance*, Bloomington, IN., 1985; E. Gardner, *The Painters of the School of Ferrara*, London, 1911; E. Sandberg-Vavalà, *Uffizi Studies*, Florence, 1948; E. Sandberg-Vavalà, *Studies in the Florentine Churches*, Florence, 1959; R. Fremantle, *Florentine Gothic Painters from Giotto to Masaccio*, London, 1975; B. Cole, *Giotto and Florentine Painting, 1280–1375*, New York, 1976; B. Cole, *Masaccio and the Art of Early Renaissance Florence*, Bloomington, IN., 1980.

The study of Renaissance sculpture is now founded on many books by J. Pope-Hennessy: *Italian Gothic Sculpture*, London, 1972; *Italian Renaissance Sculpture*, London, 1971; *Italian High Renaissance and Baroque*

Sculpture, London, 1963; *Essays on Italian Sculpture*, London, 1968; *The Study and Criticism of Italian Sculpture*, New York, 1980 (the last three books have now been published in paperback). See also C. Seymour, *Sculpture in Italy, 1400–1500*, Harmondsworth, 1966; R. Wittkower, *Sculpture: Process and Principles*, New York, 1977.

Many specialized studies on various types and subjects exist: B. Berenson, *The Drawings of the Florentine Painters*, Chicago, 1938, 3 vols.; H. Tietze and E. Tietze-Conrat, *The Drawings of the Venetian Painters*, New York, 1944, 2 vols.; F. Ames-Lewis, *Drawing in Renaissance Italy*, New Haven, 1981; P. Barolsky, *Infinite Jest: Wit and Humor in the Italian Renaissance*, Columbia, Mo., 1978.

Influential collections of essays are found in W. Pater, *The Renaissance*, New York, 1959. Originally published in the nineteenth century, Pater's essays remain among the most beautiful and imaginative writings on the Renaissance. See also B. Berenson, *The Study and Criticism of Italian Art*, London, 1901; F. Saxl, *Lectures*, London, 1957, 2 vols.; M. Meiss, *The Painter's Choice: Problems in the Interpretation of Renaissance Art*, New York, 1976; R. Offner, *Studies in Florentine Painting*, New York, 1927 and 1972; U. Middeldorf, *Raccolta di Scritti: Collected Writings*, Florence, 1979, 3 vols.; K. Clark, *The Art of Humanism*, New York, 1983.

Iconography

J. Hall has written two very helpful handbooks: *Dictionary of Subjects and Symbols in Art*, New York, 1974; *A History of Ideas and Images in Italian Art*, New York, 1983. The role of the myth and cult of the Virgin is amply covered in M. Warner, *Alone of All Her Sex*, New York, 1983. The standard works on Italian saints are by G. Kaftal: *The Iconography of the Saints in Tuscan Painting*, Florence, 1952; *The Iconography of the Saints in Central and South Italian Schools of Painting*, Florence, 1965, 2 vols.; *The Iconography of the Saints in the Painting of North-East Italy*, Florence, 1978; *The Iconography of the Saints in the Painting of North-West Italy*, Florence, 1985.

INDEX